SHADOW MODERNISM

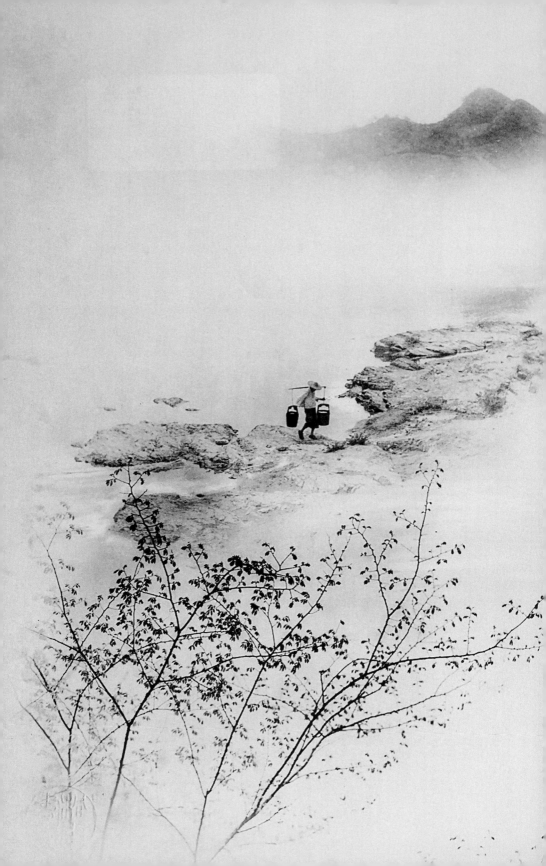

William Schaefer

SHADOW MODERNISM

PHOTOGRAPHY, WRITING, AND SPACE

IN SHANGHAI, 1925–1937

Duke University Press Durham and London 2017

© 2017 Duke University Press

All rights reserved

Printed in the United States of America on acid-free paper ∞

Text designed by Mindy Basinger Hill

Typeset in Garamond Premier Pro by Tseng Information Systems, Inc.

Library of Congress Cataloging-in-Publication Data

Names: Schaefer, William, author.

Title: Shadow modernism : photography, writing,
and space in Shanghai, 1925–1937 / William Schaefer.

Description: Durham : Duke University Press, 2017. | Includes
bibliographical references and index. | Description based on print
version record and CIP data provided by publisher; resource not viewed.

Identifiers: LCCN 2017007583 (print)

LCCN 2017011500 (ebook)

ISBN 9780822372523 (ebook)

ISBN 9780822368939 (hardcover : alk. paper)

ISBN 9780822369196 (pbk. : alk. paper)

Subjects: LCSH: Photography — China — Shanghai — History — 20th century. |
Modernism (Art) — China — Shanghai. | Shanghai (China) —
Civilization — 20th century.

Classification: LCC TR102.S43 (ebook) | LCC TR102.S43 S33 2017 (print) |
DDC 770.951/132 — dc23

LC record available at https://lccn.loc.gov/2017007583

Cover art: *Biaozhun Zhongguoren* [A standard Chinese man],
Shidai manhua (1936). Special Collections and University Archives,
Colgate University Libraries.

Duke University Press gratefully acknowledges the support
of the University of Rochester, Department of Modern
Languages and Cultures and the College of Arts, Sciences,
and Engineering, which provided funds toward the
publication of this book.

CONTENTS

Acknowledgments vii

Introduction 1

PART I MODERNISM AND PHOTOGRAPHY'S PLACES

1. Picturing Photography, Abstracting Pictures 25

2. False Portals 61

PART II LANDSCAPES OF IMAGES

3. Projected Pasts 113

4. Montage Landscapes 145

5. Shanghai Savage 180

Notes 221

Bibliography 263

Index 279

ACKNOWLEDGMENTS

What will have been is what makes the future perfect: for several years I have been imagining a future moment in which I would write of the communities that researching and writing this book constituted, and out of which the book gradually emerged. And in doing so, I have often felt a kind of Márquezian sense of time: not because at times writing the book seemed to take one hundred years of solitude but because many years later, as I faced publication, I would remember those long-ago moments when friends, teachers, and colleagues took me to discover this book.

Those moments are many. The earliest was discovering, with surprise and wonder, the intellectual and imaginative doors Shi Zhecun's writing could open with my fellow graduate student Haiyan Lee, as well as Shelley Stephenson, John Crespi, and Danny Wang, in a seminar run by Gregory Lee. I was able to develop the intellectual, critical, and imaginative tools for exploring the rich—and fascinatingly confused—cultural terrain of early twentieth-century Shanghai and its worlds through seminars, workshops, and many conversations with my mentors, teachers, and fellow students at the University of Chicago, even (or perhaps especially) as my work led in unexpected directions. Prasenjit Duara was always ready to discuss the intersections of narrative, space, and history with an intense engagement and wicked wit I still hear as I write. Lisa Ruddick opened unexpected yet utterly fitting ways of rethinking modernism and generously showed how archival work can be a critical and theoretical practice (all cultural studies takes, I remember her telling me, is "serendipity and pizzazz"). Xiaobing Tang, with his critical rigor, was helpfully skeptical of this work's more fanciful flights at its earlier moments and insisted that I always find a narrative thread through my montage of cultural fragments. Anthony Yu, who

directed the dissertation out of which this book grew, shared an infectious intellectual enthusiasm and warmth that carried this project through its most challenging times. I would never have entered the field in the first place were it not for Frank Doeringer and Peter Fritzell, Howard Goldblatt and Leo Ou-fan Lee. Wu Hung and Judith Zeitlin were the most encouraging of interlocutors at the most necessary of moments, at Chicago and since, as have been my fellow students Weihong Bao, Bonnie Cheng, Maki Fukuoka, Paize Keulemans, Ling Hon Lam, Jason McGrath, Richard G. Wang, and Melissa Wender. And the critical imagination and materialist skepticism of W. J. T. Mitchell and Joel Snyder, in both their texts and their courses, have been crucial to shaping every page. I can never adequately express my gratitude for how my education at the University of Chicago has shaped me intellectually.

Beyond Chicago, numerous friends, students, and colleagues nurtured the book as it grew from what had originated as a project on fictional, ethnographic, and historical narrative and into an exploration of the cultural politics of images in early twentieth-century China. I am grateful to Robert Ashmore (shtum, shtum), Pat Berger, Joanne Bernardi, Yomi Braester, Paul Festa, Greg Golley, Rachel Haidu, Ted Huters, June Hwang, Nick Kaldis, Eugenia Lean, Greg Levine, Li Tuo, Lydia Liu, Dan O'Neill, Marty Powers, Anna Rosensweig, Joan Saab, Shu-mei Shih, Jiwon Shin, Lillian Lan-ying Tseng, Ann Waltner, Eugene Wang, Wang Xiaoming, Steve West, and Wen-hsin Yeh for such enabling conversations, as I am to the graduate students who attended seminars in which I first tried out the ideas of archives, images, photography, and writing that I explore in these pages: most of all, John Alexander, Jenny Chio, Cecilia Chu, Victoria Gao, Harry Gu, Cindy Meng-hsin Horng, Liu Xiao, Jeannette Ng, and Alana Wolf-Johnson. In Shanghai, Gu Zheng, my favorite surrealist, provided valuable materials, opportunities to present my work, and generous hospitality, and shared an appreciation for "luosuo" architecture.

I am also indebted to the institutions that provided me with opportunities to present my work as it unfolded. These include the Chinese Literature Department of East China Normal University, Shanghai; the Department of East Asian Languages and Literatures, University of California, Irvine; the annual conference of the Association of Asian Studies; the De-

partment of Asian Languages and Literatures, University of Minnesota; the Department of East Asian Languages and Cultures, University of Illinois at Urbana-Champaign; the Department of Journalism and the Research Symposium on Visual Culture Communication in China, Fudan University; the Modernist Studies Association Annual Conference at the University of Wisconsin; the Center for Chinese Studies, University of California, Los Angeles; the Council on East Asian Studies, Yale University; the Department of Art History, University of Chicago; the Workshop on Visual Culture in Modern China and the Chinese Studies Program, University of Washington; the Department of the History of Art and Visual Culture at the University of California, Santa Cruz; the Conference on Comparative Approaches to East Asian Literature, Seoul National University; the Center for the Study of the Novel and the Symposium on the Politics of Culture and the Arts in Early Twentieth-Century China, Stanford University; the Workshop on Photography of/in China, Northwestern University; the Symposium on Chinese Visual Culture in the Twentieth Century, University of Texas at Austin; and the Graduate Program in Visual Culture at the University of Rochester. I am grateful to audiences, respondents, and co-panelists at all these venues for challenging and sharpening my thinking.

This book would not exist without the generous support of archives, fellowships, and research funding. For their allowing free and easy wandering to seek whatever was hidden in plain sight, I will always be grateful to the archivists at the Shanghai Library, University of Chicago, University of California, Berkeley, Stanford University, Yale University, Harvard University, Princeton University, the Needham Research Institute and the University Library at Cambridge University, and the Warburg Institute Library at the University of London. For fellowships and research funding, I am grateful to the University of Chicago; the Committee for Scholarly Communication with China; the Center of Chinese Studies at the University of California, Berkeley, for a postdoctoral fellowship, as well as the Department of East Asian Languages and Cultures and the Townsend Center at Berkeley for research funding and leave; the University of Minnesota; and the University of Rochester. The Department of Modern Languages and Cultures at Rochester generously made available subvention funding that enabled the publication of this book's many images, as did the Dean's Office

of the School of Arts and Sciences. And Tyler Brogan and Josh Boydstun not only made arranging my research so much easier but also have always been there with necessary ridiculousness, irreverence, and wit: what Tyler dubbed "The Administrative Diptych."

It was a privilege to correspond with Eva Long, the daughter of Lang Jingshan (Long Chin-san), and I am deeply grateful for her giving me permission to reproduce her father's photography. Special thanks are also due to Sarah Keen and Rachel Lavenda of Colgate University Library for kindly providing me with the beautiful scans of the *Modern Sketch* photomontages in their digital collection, and to John Crespi both for making this archive publicly available and for facilitating my use of it.

Robert Graham at Harvard University Asia Center generously offered valuable advice and help, which I greatly appreciate. And I am deeply grateful to Ken Wissoker, Elizabeth Ault, and Sara Leone at Duke University Press for enthusiastically and warmly giving an unconventional project an intellectual home and for so speedily, gracefully, and mindfully guiding it toward publication. Susan Ecklund's meticulous and tactful copyediting brought graceful clarity to the manuscript, even the most tangled of sentences. The book has benefited immeasurably from the insightfully challenging (and, at the right moments, disgruntled) comments of anonymous readers for the Harvard University Asia Center and Duke University Press, as it has from editors and anonymous readers for *Modern Chinese Literature and Culture* (when it was *Modern Chinese Literature*), in which I first attempted an interpretation of Shi Zhecun's fiction, *PMLA*, which published an earlier version of a small portion of chapter 3, and *positions: east asia cultures critique*, in whose special issue "The Afro-Asian Century," coedited by Andrew Jones and Nikhil Singh, an earlier version of chapter 5 first appeared.

Most of all, I thank friends, colleagues, and family, who were always there to sustain me when it mattered most. Eric Hill has been astonishing me for decades with his restlessly imaginative improvisation in music, ideas, outrage, stories, cartoons, and humor (the worse the better), always just a phone call away. Jeannette Ng read portions of the manuscript with a sympathetic ear and an eye for the right segue. June Hwang generously critiqued the introduction and has been a supportive advocate and ideal col-

league. I am indebted to Eugene Wang not only for inviting me to take part in his transformative conference, "The Chinese Art of Enlivenment," at Harvard University in October 2008 but also for so warmly and enthusiastically supporting my work and daring me to follow where it was leading me. I am profoundly grateful to Rachel Haidu for welcoming and challenging my thinking and writing, doing so much to support it with her characteristic combination of energy, kindness, generosity, and unbounded intellectual inquiry. My thanks to all of the faculty and graduate students of Rochester's Graduate Program in Visual and Cultural Studies for cultivating an intellectual environment of warmth, humor, conversation, and critical rigor in which a motley crew of art historians, film and media scholars, anthropologists, and even scholars wandering away from literary studies could feel equally at home. The turning point of what this book was to become was a long-ago conversation with Sabrina Carletti, which, along with many conversations ever since, cast shadows on the book that, paradoxically, brought it to light. And Andrew Jones, through both his friendship and his own quirkily original curiosity, has been there ever since the inception of this book and over the years has encouraged, cajoled, and most of all inspired me to keep looking at the overlooked and to imagine what is possible when modern Chinese cultural studies is taken to be not a destination but a point of departure — all the while demonstrating that the life of the mind can be a life well lived: from the Albany Bulb to Tropicália, from discovery through writing to knowing when it's time to go to the zoo.

And for keeping me connected to the real world (or this one, anyway), I can never thank enough my family: my sister, Sue, my nephews, Sean and Ryan, and the boundless love and belief and dedication of my mother and father, to whom this book is, quite simply, dedicated.

print media urgent questions of what images are and what they do. Such questions concerned the nature of differing modes of picturing and image-making and the media in which they take form, as well as the relations between images and the peoples, places, cultures, histories, and material realities they represent.

In this disorienting global geography of traveling images, however, it was place itself that was most widely depicted as composed of fragmented, circulating, and projected images — and no place more so than Shanghai. In 1933, the modernist writer Mu Shiying described Shanghai's streets as "transplanted from Europe" and "paved with shadows."[2] Photomontages published between 1934 and 1937 in the satirical magazine *Shidai manhua* (Modern sketch) depicted the Shanghai landscape as a violent assemblage of body parts and colonial artifacts; or Shanghai's racetrack as occupied by village huts juxtaposed against the city's high-rises; or a collapsed geography of Japanese colonialism in which Mount Fuji looms as a new background for the Shanghai waterfront. Shi Zhecun composed surrealist fictions of Shanghai's suburban landscapes and China's borderlands out of montages of projected images, remainders, and traces of the past, such as shadows, Egyptian mummies and tombs, and the bodily relics of figures from Chinese history. In these and many other photographs and texts scattered throughout the print media during this period, there is a sense that images circulating from around the globe and through Shanghai were taking on an uncanny materiality and even sentience, at the same time as the "real" people, places, and landscapes of Shanghai and China were taking on the immaterial and ghostly qualities that were associated with images.

Such depictions clearly struck a nerve. The critic Lou Shiyi claimed that a modernist like Shi Zhecun "deeply feels the collapse of the old society," but rather than "sense any danger in this collapse, discovers from within it a novel beauty," so that Shi "can only see the dark side of collapse, and never sees another layer rising from beneath the earth."[3] Lou dismissed such modernist literature and art as an "escape into abnormal fantasies."[4] But what if it was not? What, this book asks, did it mean to think through the formal experiments of modernist photography, art, and literature in terms of projected images and shadows, relics of the past and unstable landscapes? And what did it mean, as Fu Lei urged later in his 1934 text, to think photo-

graphic and montage practices as modes of critically engaging with what Fu called the "new fantastic" of modernity as experienced in Shanghai?

During the 1920s and 1930s, Shanghai was vividly experiencing the disjunctive spatial power of colonialist capitalism. This power was invisible (its centers were located in metropolises on other continents) and, at the same time, overwhelmingly present, having literally fragmented Shanghai into an old Chinese district and several foreign concessions. Furthermore, the modernizing and nationalist May Fourth Movement, which in the 1910s and early 1920s had called for a break with the past through Western science, realist literature and art, and cultural iconoclasm, had faltered by the late 1920s, while fragments of the rejected past seemed to remain stubbornly and uncannily present. At the same time, Shanghai was a center of conservative debates over "national essence" (*guocui*) and "ordering the national past" (*zhengli guogu*), debates that sought to rearrange these fragments into an authentic and seamless whole of cultural and even racial purity.

The terms of debate over colonialism, modernity, the place of the past, and the places of ethnic others, however, were dramatically altered by the transformation of picturing and the surge in the production and circulation of images made possible by photography. Since the turn of the twentieth century, photography had become an increasingly pervasive presence in everyday life. Cheap and easily portable cameras were newly available by the 1920s and 1930s. More important, the development during these decades of new technologies for reproducing photographs and other images in print both enabled and was driven by an explosion in the production of illustrated magazines, or *huabao*. These magazines became the most capacious of spaces for the collection, juxtaposition, and display of images that were produced, circulated, and reappropriated from across China and the world. This development of technologies for printing photographs and other images in illustrated magazines was inseparable from both a quest for immediacy of representation and an acute consciousness of just how mediated such new modes of representation really were. Illustrated magazines such as *Liangyou huabao* (The young companion) and *Dazhong* (The cosmopolitan) often featured demonstrations of how photographic technologies could make possible kinds of images never produced before. These included images that explored the realms of the momentary through ex-

tremely rapid exposure times or photographic blur; images that brought close the geographically distant; and images that rendered the most familiar objects strange, metamorphic, and abstract. Other images in the print media were made, in layouts that were a pervasive feature of such illustrated magazines, to produce binary oppositions of the traditional and the modern, the urban and the rural, the so-called civilized and the primitive, the Chinese and the foreign.

Many writers, photographers, and artists in Shanghai struggled to come to terms with the changing relations between texts and images brought about by these technologies and by their implication in a rapidly expanding world of images through which the transmission of China's own cultural past now appeared to be mediated. Nowhere was this perception more apparent than in the exploration of verbal and visual modernist aesthetic practices in both the literary and art journals and the popular illustrated magazines published in Shanghai during the 1920s and 1930s. The very complexity, materiality, fragmentation, mutability, and circulatability of modernist images and image-making practices displayed in illustrated magazines and art and literary journals in Shanghai opened to question the territories and boundaries of essentialist cultural geographies. Critical practices of modernism were animated by a dialectic of the dematerialization and rematerialization of Shanghai's place and the past through composites of images that were themselves understood as fragments or projections of divergent cultures, geographic locations, and historical moments. As I show throughout the book, experimental photographers and writers excavated and configured images whose cracks would make visible the shadows of modernity in Shanghai: the violence, the past, the ethnic and cultural multiplicity excluded and repressed yet hidden in plain sight.

This was particularly the case in the work of writers such as Shi Zhecun (1905–2003) and Mu Shiying (1912–1940); critics such as Fu Lei (1908–1966), Feng Zikai (1898–1975), and Zong Baihua (1892–1986); painters such as Pang Xunqin (1898–1975); and practitioners of various forms of composite photography ranging from Lang Jingshan (1892–1995) to the anonymous photomontage artists active in *Shidai manhua* during the early 1930s. At the crux of their work was the expression of geographic and cultural dislocation by means of formal experiments with images and texts

implicitly or explicitly informed by photography. They understood the material qualities of images and image-making technologies as fundamental to the mediation, transmission, and shaping of ideologies of history, ethnicity, and geographic space. Hence modernists in Shanghai debated such ideological foundations by constructing experimental images and texts deeply informed by photography's power not only to represent but also to transform that which it depicts into unstable and proliferating shadows and projections, spatial abstractions, or fragments to be juxtaposed in radically disjunctive combinations.

The career of Shi Zhecun, for instance, whose presence threads throughout this book, was particularly crucial to creating modernism in Shanghai and mapping its global context. Indeed, his own life was exemplary of the geographic dislocations and displacements his texts addressed in both formal and thematic terms. He was born in Hangzhou, a city with ancient and powerful associations with classical Chinese literature and art. When he was eight years old, his family moved to Songjiang, which at the time was a small country town just outside of Shanghai. After a high school education in which he was steeped in classical Chinese poetry, Shi attended Aurora University in the French Concession in Shanghai. Aurora was a Catholic institution established by the French in order to transmit French culture as part of their colonialist project in Shanghai; as Shu-mei Shih has observed, at Aurora one could gain access to Western languages and culture without traveling abroad.[5] Shi Zhecun learned French from priests who, as Leo Ou-fan Lee reports, assigned the works of Hugo and Balzac even as Shi secretly devoured the "decadent" symbolist poetry of Baudelaire, Verlaine, and Rimbaud.[6] By his late twenties, Shi had collaborated with friends and writers such as Mu Shiying, Liu Na'ou, and Dai Wangshu on several small, short-lived periodicals devoted to modernist literature and art, such as *Xin wenyi* (also given the French title, *La nouvelle litterature*), before he served as editor of the much larger-scale *Xiandai* from 1932 until 1935. Shi's career as an editor was short-lived, however, cut short by war with Japan and the Communist revolution; for much of his long life and until his death in 2003, Shi was a prominent scholar of classical Chinese literature.

As the editor of the influential literary magazine *Xiandai* — literally, "modern," but given the alternative title *Les Contemporains* — Shi explored

surrealist fiction, imagist and futurist poetry, and montage aesthetics, among other experimental techniques. Shi Zhecun's own fiction grapples with the intertwined questions of a global image culture and the constitution of colonialist modernity in China by fragmenting and reconstructing ancient and recent pasts. His texts do not, however, purport to visualize what really happened in the past, as a nationalist, positivist writing of linear historical narratives claimed to represent.[7] Rather, his narratives are composed — or describe the creation — of remainders, traces, and relics from China's geographic and ethnic margins and abroad, through which the past has been transmitted, or which reappear to haunt the urban present. These remainders of the past appear in Shi's fiction as various forms of images, ranging from the severed head of a half-Chinese, half-Tibetan general to Egyptian-style mummies to scenes of foreign pasts projected onto the landscapes of early twentieth-century China, and haunting, mutating photographs and shadows that dematerialize the bodies and objects that project them and take on lives of their own.

Other writers and artists experimented during the early 1930s with formally discontinuous texts and images in order to depict modern Shanghai as an unstable place of speculation, consumption, and desire. In his highly disjunctive urban fictions, for instance, Mu Shiying treated sentences and paragraphs as a series of photographic and cinematic images fragmented and juxtaposed on the page. Similarly, Pang Xunqin experimented with paintings depicting Paris and Shanghai with a technique evocative of a collage of overlapping projected images. By contrast, Lang Jingshan, who began his career as one of China's first photojournalists, experimented with modernist urban photography before developing a mode of composite photographs that consciously departed from contemporaneous uses of photomontage in advertising and the politically engaged art of the Dadaists, and instead reproduced the visual effects of Song dynasty Chinese ink landscape paintings. The painter and critic Feng Zikai, politically progressive unlike Lang, drew upon Chinese ink and brush painting to pioneer *manhua* cartoons that expressed both urban uprootedness and rural nostalgia with a gentle humanism. Feng was an equally influential educator and widely published writer on art, whose texts were often preoccupied with the nature of modernist painting, the place of traditional Chinese art in modernity and vis-à-

vis modernism, and the transformation of picture-making by photography and the commercial art of capitalist modernity. While hardly a conservative, Feng was highly conflicted about modernism: in some of his essays he claimed that the origins of pictorial abstraction lay within classical Chinese aesthetics, while in others he displayed an increasingly contentious, dismissive, and even hostile reaction to the most radical aesthetics of fragmentation and disjunction associated with cubism, futurism, Dadaism, and expressionism.[8]

Debating the nature of images was, of course, central to the cultural politics of modernity across the globe during the nineteenth and early twentieth centuries, in part given the rapid developments I have mentioned in such new media technologies as photography, illustrated magazines, and cinema. In the West as well as in China, this radical transformation and the questions of images it provoked were inseparable from the kinds of anxieties Fu Lei's and Feng Zikai's texts expressed over cultural difference as articulated across the changing global geography of colonialist modernity.[9] Certainly in China during the early twentieth century, pictorial forms based in a variety of photographic practices rapidly came to coexist with pictorial media with long histories, such as ink painting and printing. Photography's powers of recording, of radically extending the limits of perception, and its mass reproducibility and rapid circulation in print — all hallmarks of modern culture globally — were hence seen by critics such as Feng Zikai and the aesthetic philosopher Zong Baihua (1897–1986) not only as universal, or as the universalizing qualities of a supposedly transparent medium. More important, such critics saw these qualities as at the same time culturally specific in ways Western commentators did not. Chinese critics attributed to the West modes of picture-making such as single-point perspective and the depiction of minute detail, even as photography seemed to have a tremendous power to conceal or even naturalize such pictorial assumptions within an apparently objective and transparent transcription of the world. Photography at once assumed a tremendous degree of authority in China; inspired widespread exploration, experimentation and reflection; and provoked substantial resistance.

One common and problematic response in Chinese critical discourse was, I argue, to mark out and defend civilizational differences by declar-

ing an isomorphism of geography and culture, of national territory and modes of producing pictorial space. Such essentialism evacuated all difference and contradiction from within such culturally defined spaces even as it posited absolute differences between them. As I claim throughout these pages, thinking about (and through) photography was central to debates over images and their imbrication in the supposed civilizational differences between "East" and "West"; the writing of literature; the presence of the past in modernity; ethnicity and cultural identity; and the nature of space, place, and landscape in a world at a foundational moment of what is now known as globalization, namely, colonialism. Feng Zikai dismissed what he described as the photographic precision and detail of the representation of bodies, objects, and spaces in Western pictorial practices as "coldly objective imitation," a "deadly work," and argued that "the pictures Chinese people make are not transcriptions made in light of reality, but rather are made by deeply observing nature, stripping it of all unnecessary waste and grasping its most necessary essence." Hence Feng claimed the abstract painting of Wassily Kandinsky (1866–1944) to be not a manifestation of modernism but rather a sign of the "Easternization" of "Western" art. Feng and the aesthetic philosopher Zong Baihua, among others, resisted such new visual media by insisting that a mythic identity of image and writing was an essential civilizational marker of Chinese cultural identity. They did so by repeatedly appealing to, for instance, how ink painting and calligraphy share the same materials and many of the same techniques, and such clichés of Chinese aesthetics as the ideal that "in paintings there are poems, in poems there are paintings" (*hua zhong you shi, shi zhong you hua*).[10] The photographer Lang Jingshan concealed the fragmentation of place and the past by redefining in his theoretical writings modernist techniques such as composite photography and photomontage within traditional landscape aesthetics, and by using composite photography to overcome the perspectivalism of conventional photographs and produce what appear to be traditional ink paintings. These pictures were composed of projected and juxtaposed fragments of photographs Lang had made in the countryside, so that his "traditional Chinese landscapes" did not, strictly speaking, depict anywhere but virtual places that only existed, displaced and reassembled, in his Shanghai darkroom.

More radical photomontage artists associated with *Shidai manhua* as well as writers such as Shi Zhecun, however, used photography as a figure to think verbal and visual images as traces and projections of different places and times, and to create collages and montages whose disjunctions would disturb mainstream discourses of culture, history, ethnicity, and geography. The terms that were adopted to translate "photography" into Chinese provide a glimpse at what photography's capacities were understood to be. Photography did not seem to have been conceived, as it frequently was in the West, as a writing or inscription with light (photo-graphy).[11] The two terms used most widely in the texts examined in this book define photography's images in relation not to writing but to light and shadow. The first, *zhaoxiang*, combines the character *zhao*, meaning to illuminate, light up, shine, reflect, or mirror, with *xiang*, whose meaning includes looks, appearance, countenance, facial features, bearing, and posture, and, as a verb, to look at and appraise. By contrast, *sheying* is composed of the characters *she*, to summon, absorb, or assimilate, and *ying*, meaning primarily a shadow or reflection, a projected image.[12] *Zhaoxiang*, then, seems to conceive of the making of pictures as a matter of illuminating the external appearance of something, emphasizing not the image created by the photograph but the external appearance of the object itself (from which some evaluation of its internal nature might be derived).[13] *Sheying*, on the other hand, may have been coined, as the 1937 edition of the dictionary *Cihai* (Ocean of words) claims, as a Chinese equivalent of the English term "picture taking," but its semantic range suggests something more like what one of the inventors of photography, William Henry Fox Talbot, called "the art of fixing a shadow."[14] This ambiguous term seems to conceive of a photograph as a shadow, a projected image, an image cast off by the object represented and then absorbed by a photosensitive surface; alternatively, it seems to imagine images as free-floating things that are out there to be captured.[15] The etymology of these terms, taken together, discloses an emphasis on the material qualities of photographic representation that insists upon light, illumination, and projection rather than the inscription of traces.

Elsewhere in his 1934 text on modern literature's pursuit of the real from which I quote in the opening of this introduction, Fu Lei used the term *zhaoxiang*, emphasizing the illumination of an appearance or a flash

of insight. Shi Zhecun and a modernist poet and critic published in *Xiandai*, Xu Chi (1914–1996), both of whose texts were haunted by the traces of photographs, preferred terms such as *sheying* and *heiying*, designating photographs as shadow-images. While photography might not have been conceived of as a kind of writing, modernists such as Fu, Shi, and Xu did, as I will show, conceptualize writing as a kind of photography. This association of shadow and photography was a trope that decisively influenced emerging modernist discourses of writing and literature in Shanghai. It informed experimental photographs, fiction, and literary criticism in which shadows are images that do not depict but metamorphose the objects projecting them or the spaces on which they take form, or even — as in Mu Shiying's figure — constitute virtual spaces or come alive, uncannily independent of space and object.

Indeed, informed by this understanding of photography, critical and theoretical texts by Fu Lei and others consciously represented visual and literary modernism in and of itself — particularly the formal procedures of abstraction and of fragmentation and juxtaposition — as a spatial, geographic, and global aesthetic. Not only did modernist aesthetic practices become in Shanghai means of conceptualizing the changes in global space wrought by colonialist and capitalist modernity. Such practices themselves traveled and, arguably, were produced out of their global circulation. But if modernism's aspirations are often universal, its articulations are intensely local. Hence modernist practices were largely used to compose Shanghai's location as a center of modernity in China vis-à-vis China's own historical, geographic, cultural, and ethnic margins, even as Shanghai itself was thought of as lying on the margins of global modernity.

From its position in a city at once center and margin, at once on the edge of modernity and haunted by the past that, unlike the ancient cities of Beijing and Xi'an, it seemed to lack, modernism in Shanghai questioned the historical and geographic assumptions that motivated such familiar modernist themes as alienation or sensory overstimulation in the modern city, breaking with or essentializing the historical and cultural past, or the construction of exotic and "primitive" others against which to define modernity or provide an escape from modern life. Here is the crux of the politics of modernism in Shanghai — evinced, as I shall argue throughout this book,

not only in its thematic concerns but crucially in its formal experiments. Michel de Certeau eloquently claimed that discourses of the modern are themselves founded upon a "discourse of separation" that strives to create pure boundaries with which to manage troubling relationships between the self and the Others of the past, other places, and other peoples. This discourse of separation (de Certeau has in mind specifically the writing of history)

> promotes a selection between what can be *understood* and what must be *forgotten* in order to obtain the representation of a present intelligibility. But whatever this new understanding of the past holds to be irrelevant — shards created by the selection of materials, remainders left aside by an explication — comes back, despite everything, on the edges of discourse or in its rifts and crannies: "resistances," "survivals," or delays discreetly perturb the pretty order of a line of "progress" or a system of interpretation. . . . They symbolize a return of the repressed, that is, a return of what, at a given moment, has *become* unthinkable in order for a new identity to *become* thinkable.[16]

Such remainders, de Certeau argues, annihilate "the self-identity that had been acquired through the elimination of a 'remainder.' . . . Identity is not one, but two. *One and the other*. In the beginning, there is the plural."[17] In its later chapters, this book will claim that Shi Zhecun's surrealist urban fictions of projected pasts and his modernist historical fictions of border violence return through their subject matter and disjunctive formal experiments precisely the remainders, the survivals, the relics that had become unthinkable for both Chinese conservatives and iconoclasts, and which they had repressed or ejected from the texts and images through which they transmitted the past or defined modernity. But as I shall show throughout the book, writers such as Mu Shiying and Fu Lei, as well as Shi Zhecun, and artists experimenting with photography and photomontage, all sought out the relics, the projected images, and the fractures in landscapes that perturbed the cultural, historical, and geographic boundaries with which modernity was commonly made thinkable — or they cut across these boundaries with their juxtapositions of such shards and remainders. These artists and writers redefined the modern by means of close attention to how new forms of image-making could make visible the strange transfor-

mations, the dark and distorted shapes projected by artifacts of the modern city as well as the past: the shadows of modernity.

Now, this interpretation of modernism in Shanghai I am sketching departs significantly from its depiction in the scholarship of recent decades. Indeed, it is striking the degree to which this scholarship, while creating crucial maps of Chinese modernist art and literature, reproduces the early reception of modernism without always engaging critically with its terms. In his *Meeting of Eastern and Western Art*, first published in 1989, Michael Sullivan rehearses precisely the same logic of East versus West, and the same conflation of Kandinsky's aesthetic program and the empathy theory of Theodor Lipps and Wilhelm Worringer with Xie He's sixth-century artistic principle of spirit resonance (*qiyun*), that had animated texts like Feng Zikai's on Chinese painting and modernism from the 1930s.[18] Julia Andrews and Kuiyi Shen's more recent history, *The Art of Modern China*, situates "aesthetic or theoretical questions" along a line of progress, a narrative of the "path toward China's modernization" that seems to propose that one of the great challenges of modern Chinese art was to fulfill "the twentieth century's historical burden of restoring China's cultural stature in the world," while measuring modern Chinese art against "the course of development from realism to nonobjective art that had occurred in the art world of Europe."[19] Their map of modern Chinese art is unmatched in its comprehensiveness, and yet it is largely structured by a series of binary oppositions, namely, between "artistic connections to the universal, the international, the global, the central, [and] the present," on the one hand, and on the other, "ties to the personal, the national, the local, the peripheral, and the past."[20] Andrews and Shen observe that such dualisms — as well as that of "Chinese" and "modern" — "have comprised the fundamental concepts around which the art of the twentieth century has revolved." But, they add, "these are essentialist questions that a postmodern society may someday leave behind."[21] Such essentialist binaries did indeed structure much artistic, literary, and cultural discourse in early twentieth-century China, but I do not agree that we have to await a postmodernist future for them to dissipate, nor must we replicate them in current critical analysis. The fact is that such polarities were clearly under great stress and pressure in the 1920s and 1930s when they were being used or, more to the point, demar-

cated. And, as I argue throughout this book, central to modernist aesthetic practices in Shanghai was a *questioning* of such binaries, a crossing or dismantling of them. Thus it is crucial, it seems to me, not to perpetuate or reify those polarities but rather to critically examine them, to ask just what pressures and tensions and conflicts such differences were used to clarify or obscure. What differences were being suppressed? What differences were being reified? What differences do such differences make?

Perhaps one reason that Shanghai modernism's critical relationships to the antagonisms and contradictions of its own historical moment have been largely overlooked (beyond questions of nationalism, modernization, and utilitarianism) is because of the rather broad brush of political apathy with which modernism has often been painted. Writing in 1931, as I have mentioned, the critic Lou Shiyi decried what he saw as Shi Zhecun's fascination in his fiction with darkness and the collapse of the old as escapist fantasy. In her otherwise rigorous, illuminating, and theoretically nuanced analysis, published in 2001, of the complex political and cultural relationships between modernism and semicolonialism in China, *The Lure of the Modern: Writing Modernism in Semicolonial China, 1917–1937*, Shu-mei Shih similarly claims that Shi Zhecun's surrealist historical fiction had only "remote connections to [its] contemporary situation." While "at most," she writes, "one could read [such] stories about racial and national conflicts as allegories of Shanghai cosmopolitanism's ambivalent stance toward nationalism and national cultural identity," at the same time in Shi Zhecun's fiction history is "'modernized' and made ahistorical . . . negating the historicity of that past."[22] One of Shih's most suggestive insights is that the relationships between "the multiple, layered, as well as incomplete and fragmentary nature of China's colonial structure" and the "fragmentation in the political and cultural spheres . . . [enabled] the paradoxical emergence of culture in the fissures among different agents of control."[23] And yet her analysis of how fiction by Shi Zhecun, Mu Shiying, and others engaged with this situation is hampered by her reliance on binary oppositions between "high" modernism and mass culture, leftist politics and "pure aesthetic formalism."[24] As a result, while throughout her book Shih carefully situates Chinese modernism within the cultural politics and present-day theoretical discourses of semicolonialism and race, at the same time she argues, for instance, that

cum of information about the photographer and theorist Chen Chuanlin, whom I discuss in chapter 2.[28] But to limit a discussion of photography to those works about which we have such information on photographers or sources would be to exclude a vast amount of art and nonart photographs from scholarly inquiry. And one of my book's fundamental contributions to the literature on modern Chinese visual and cultural studies is, I hope, to expand and not to limit the impact these photographs had, even given their nearly anonymous status, on the rethinking of pictorial practices; the representation of urban space; the relations of text and image; and the past, landscape, and ethnicity. By the same token, I do not think that knowing the identities and influences of photographers, though of course important, exhausts the definition of the historical and material conditions of a photograph, nor does such knowledge exhaust the possibilities of providing an interpretation of what was possible for photography in early twentieth-century Shanghai. To my mind, such materiality is as much a matter of how photographs are actually made (kinds of cameras, lenses, films, papers, compositional strategies, etc.). It would be illuminating to be able to see the negatives from which the photographs I examine were originally printed — but for the most part they are lost. In the absence of records indicating how specific historical figures manipulated photographic materials and processes, what is abundantly available, however, is the information that can be inferred from close inspection of the composition, appearance, placement and juxtaposition of the photographs on the printed pages of illustrated magazines, and of the rhetoric of captions and other texts that accompany the photographs.

I pursue my argument in this book, then, through a series of close analyses of photographs, paintings, cartoons, and literary and critical texts from the Shanghai print media in order to identify the tensions they excavate or conceal, manifest or trouble, and to try to understand what they tell us about the culture they emerge from. The organization of my argument necessarily draws upon the montage aesthetics of fragmentation and juxtaposition of images and texts practiced by the modernists, in order to identify and pursue the logic of the kinds of questions they asked of their historical moment. At the same time, I focus the book on a fairly circumscribed historical period, from roughly 1925 through 1937. The year 1937 was when

full-scale war broke out in Japan, and most of the book's protagonists either fled Shanghai or were killed soon after. The starting point of the book is a bit more nebulous. One does find in the mass media a new popular fascination and unease with the presence of the past around 1925 (stories of the aftermath of the 1922 opening of Tutankhamen's tomb in Egypt, for example, start to appear in the print media at that time). And while over the decades preceding this time, a variety of illustrated print media had already appeared — most famously *Dianshi zhai huabao* (Touchstone Studio pictorial), which featured elaborate lithographs starting in 1884, followed by short-lived magazines such as *Zhenxiang huabao* (The true record; 1912) experimenting with printing photographs — the year 1926 is when the influential illustrated magazine, *Liangyou huabao*, began publication, marking the use of new technologies for the mass reproduction and circulation of photographs. Most of the materials I examine in this book, however, were published in or around 1934 (between the Japanese bombing of Shanghai in 1931 and the outbreak of war in 1937); there seems to have been a crescendo of interest in the aesthetics of fragmentation and juxtaposition in the making of images and literature as illustrated magazines grew in circulation and complexity of layout, and as the sense of impending crisis increased as well. There is, to be sure, a trade-off in limiting the historical frame of the book in this way: to cover a brief temporal span runs the risk of seeming ahistorical, while covering a longer temporal span risks a thin and sometimes misleading analysis of texts and images because it can involve overlooking much of the texture of historical context (which is what this book tries to capture).

By means of these methodological choices, I provide in this book what might be thought of as a geologic core sample of culture in early twentieth-century Shanghai that will enable me to connect areas of cultural production conventionally overlooked, ignored, or held apart in scholarly discourses of Chinese modernity — materials that, as de Certeau might have put it, seem to resist those discourses from their edges. What did it mean for the most important spaces for the collection, display, and circulation of images in China during the first half of the twentieth century — illustrated magazines such as *Liangyou huabao* — to feature alongside their canonical images of the modern city photographs of shadows, or of geometric abstrac-

tions produced by photomicrographs, or photographs of Chinese landscapes evoking traditional ink paintings, or images of mummies excavated in Egypt and of the ethnic minorities populating the peripheries of China? How, for instance, might engaging with the pervasive images and texts concerning race and the "primitive" in the early twentieth-century Shanghai print media affect a reading of Shi Zhecun's modernist historical fiction, or of Mu Shiying's depiction of African Americans in a story like "Five in a Nightclub"? Would Shi Zhecun's surrealist tale, "Mo dao" (Demon's way), narrated by a neurasthenic Shanghai man haunted by shadows and a mummy, appear quite so escapist if we account for the popularity of photographs of shadows or the Egyptomania so widespread in the Shanghai print media, and the ways they address the relations of colonialist modernity to the displaced past? How, for that matter, might our understanding of Feng Zikai's arguments about modernist abstraction shift if we acknowledge that, while abstraction was not practiced extensively in Chinese modernist painting at this time, viewers of illustrated magazines would have encountered abstract pictures in the form of urban photographs or even scientific images presented as art? How were all such images as constitutive a part of modernity in Shanghai as more familiar images of the modern city, and how might addressing them transform our understanding of Shanghai modernism? It is out of such forgotten and overlooked fragments and shards that I piece together in this book an account of modernity and modernism that shadows the Shanghai modern.

The chapters of the book proceed as follows. Part I, "Modernism and Photography's Places," reconstructs the early twentieth-century critical reception of photography out of the pictures and writing about pictures that appeared in the print media of Shanghai during the 1920s and 1930s. In the first chapter, "Picturing Photography, Abstracting Pictures," I show how the critical discourse of images defined different modes of picturing in terms that mark off perceived differences in the cultural domains of "East" and "West." This discourse, I argue, inadvertently revealed anxieties over how new image technologies undermined rather than reified such cultural essentialism. Critics such as Feng Zikai and Zong Baihua tried to differentiate

Chinese from Western modes of picturing on the basis of distinctions between a photographic transcription of reality and attention to perspectival depth they ascribed to the West, and various modes of abstraction and attention to the unseen and pictorial surface they ascribed to China; indeed, on this basis Feng saw modernism as the "Easternization" of Western art. And yet such stark civilizational binary oppositions were completely undone through actual practices of picturing in Chinese print culture at that time. This was particularly the case in illustrated magazines, which explored the power of photography not only to transcribe reality but also to transform it and render the unseen visible, demonstrations of the effects of cameras and darkroom techniques, and "design photographs" that abstracted everyday objects. As I shall show, the very pursuit of the transcription of reality in illustrated magazines through a faith in the transparency of photographs — a pursuit and a faith that Zong and especially Feng derided — led instead to a revelation of how photography's mimetic powers were inseparable from the kinds of abstraction and attention to surface widely attributed to Chinese modes of picturing. Indeed, the painter Liu Haisu's own essay in connecting Chinese painting and modernism — specifically the seventeenth-century painter Shitao and postimpressionists such as Paul Cézanne — skirts close to such an understanding of photography in ways that resonate with the conceptual and practical understandings of images and texts at work among modernists in Shanghai.

Chapter 2, "False Portals," explores the implications of this unmooring of images from visible likeness in the print media in Shanghai for modernist conceptions of pictorial and textual spaces and the representation of urban, rural, and global spaces. An image conceived of not as a window onto a visual representation but as an opaque surface upon which things of the material world were dissolved rather than depicted was, as the painter Li Zhongsheng called it, a key "point of departure of twentieth-century painting."[29] Such a mode of abstracting surfaces informed a formalist, modernist urban photography in illustrated magazines like *Liangyou huabao*. In such photographs, urban spaces and landscapes were frequently depicted as flat, abstract surfaces of lines and planes. The juxtaposition of images both based upon and abstracted from the visible forms depicted in such images was subsequently explored in another common feature in illustrated magazines,

the comparative layout. Comparisons between, say, the manifestation of "modern civilization" in the urban walls of New York and of "ancient civilization" in the Great Wall of China, or between urban and rural landscapes, seemed to materialize some of the key ideological distinctions underlying the cultural, geographic, and temporal spaces of modernity. And yet other layouts showing how photographic abstraction can make the material forms of everyday objects such as birdcages and lotus flowers mutable and interchangeable revealed the instability and arbitrariness underlying such essentialist comparisons. The opacity, materiality, spatiality, and mutability of images became persistent themes in the conceptualization and practice of modernist writing. As I show at the end of this and in subsequent chapters, a conception of language as a kind of material and visual image was central to modernist literature in Shanghai. Writers such as Shi Zhecun and Mu Shiying and critics such as Fu Lei and Zhao Jiabi, as well as Western modernists such as Pierre Reverdy, Apollinaire, and Ezra Pound, translated and published by Shi and his colleagues, rethought writing according to ideas of images as opaque and embodied, and as constituting unstable spaces. The "photographic," that is, did not necessarily provide a model of objective writing—let alone the transparency of the images and narratives on which dominant discourses of modernity in Shanghai insisted—but rather could be used to model images and writing as both material and ghostly, as projections, traces, and fragments of disparate times and spaces.

Throughout the chapters that make up part II, "Landscapes of Images," I show how such concepts of images were crucial to the critical explorations by modernist writers and artists of the presence of the past; the nature of space, place, and landscape; and ethnic difference in modern Chinese culture. I argue that modernist techniques of the fragmentation and juxtaposition of pictorial and textual surfaces became modes of shaping understandings of the unevenly developed, nonsynchronous, and contradictory spaces of modernity from outside the Western metropolis and from within metropolises outside the West.[30] Chapter 3, "Projected Pasts," opens part II with an exploration of the idea of the presence of the past in Shanghai's modernity. This presence was composed of shadowy and hallucinatory projections as well as relics and remainders, particularly in the popular genre of "shadow photographs," and in Shi Zhecun's surrealist fictions of modern

Shanghai, such as "Demon's Way." While Shanghai was the capital of Chinese modernity, a rootless place, it seemed, without a past, the modern city, as I will show, was everywhere haunted by the absent past's traces. In both photographs and cartoons published in the mass media and Shi Zhecun's fiction, "the past" could take the form of something historically specific (in discussions of China's historical past, say, or of archaeology); "the" past could also be a pastiche of pasts and their associated motifs (Egypt, Rome, etc.); or "the past" could take a more vague and shadowy form, a pervasive sense of "pastness" redolent of both nostalgia and disquiet. Often these different senses of the past, from the historical to the uncanny, permeated each other within the same images and texts. In his surrealist fiction of a modern Shanghai haunted by Egyptian mummies excavated from the Chinese suburban landscape and shadows detached from the bodies projecting them, Shi Zhecun's move was to return to the urban present in uncanny forms repressed and displaced fragments of historical pasts in order to critically disturb the spatial and temporal orders upon which the pervasive ideology of modernity and its linear, progressive narratives of history were based.[31] The past, that is, against which the pervasive ideology of modernity in Shanghai defined itself (and which it hence sought to denigrate or suppress), was disinterred, brought back to life, and circulated in the form of images through the very media that were a constitutive component of that modernity.

Given this unsettled place of a mediated past, chapter 4, "Montage Landscapes," goes on to explore how ideas of space, place, and landscape underlay numerous conceptions in China of modernism and its practices of fragmenting and juxtaposing images, as well as how the very idea of landscape at a moment of historical crisis was reconceived in Shanghai through modernist aesthetic procedures. The chapter surveys how understandings of global space were mapped in critical writings in Shanghai on collage and the montage fiction of John Dos Passos, as well as how landscape images were created in Lang Jingshan's composite photographs, the satirical photomontages in *Modern Sketch*, and Mu Shiying's montage fiction, to reconceive the location of China within global modernity. While Lang sought to assimilate the practice of photomontage within an essentialized Chinese aesthetics and erase the fissures between the fragments composing the landscapes of modernity, other practitioners exploited precisely those fissures

in order to explore the spatial contradictions of modernity in China that a conservative cultural politics such as Lang's sought to suppress.

The fifth and final chapter, "Shanghai Savage," goes on to explore one of the key imagined locations against which China in general and Shanghai in particular were persistently defined in mass media culture, namely, modernity's "savage" peripheries and associated stereotypes of racial otherness. The chapter considers not only the ways in which race was represented in the print culture of Shanghai at this time but also the ways in which race was used in conceptualizing representation itself. Through a genealogy of critical, ethnographic, and fictional texts and images, the chapter explores the ways in which understandings of literary modernism in Shanghai were paradoxically both complicit with and critical of the ways in which mass culture represented race both *through* and *as* images to be fragmented, circulated, and juxtaposed. Race often appears at crucial moments in writings on modernism reflecting on the changing nature of representation. Yet, as I show by way of conclusion, precisely because of the intertwining of race and representation that modernism's circular logic made visible, it is also in Shanghai modernist literary texts such as Shi Zhecun's story "Jiangjun di tou" (The general's head) that we find rare attempts to dismantle such racialized images. Shi's historical fiction narrates the production of such an image in the form of an uncanny relic of a mixed-race general on the border of China and what is now Tibet, even as Shi produces his modernist text from within the gaps in historical and poetic texts whose ordering of cultural identity could not assimilate such an excessive image.

This book as a whole, then, proceeds through a series of spaces, from the pictorial spaces of abstract images to the spaces of layouts in illustrated magazines, from the urban spaces of modernity to the borderlands of the historical past. But as the works of the writers, photographers, artists, and editors I examine disclose, such landscapes of the present and the past are themselves composites of highly charged, fragmented, unassimilated, projected, and montaged images: a shadow modernism. "I am," as the Mexican poet Octavio Paz put it in a line that has guided my composition of this book's own montage of cultural history, "the shadow my words cast."[32]

A note on titles: An English title after a forward slash is in the original source; an English title in parentheses is my own translation.

PART I

MODERNISM AND PHOTOGRAPHY'S PLACES

1

PICTURING PHOTOGRAPHY, ABSTRACTING PICTURES

Just what were images considered to be in Shanghai from the mid-1920s through the mid-1930s? How were the differing qualities and powers of images defined and understood, and what was at stake in such definitions? The definition and nature of images cannot, of course, be taken as self-evident or transcending historical and cultural context—as critics across the political spectrum in Shanghai were abundantly aware. Hence this chapter explores the conceptions of images and their relations to a changing cultural geography out of which Chinese modernism emerged. The nature of images was widely explored in the print media at this time, both in critical and theoretical texts and in vernacular, nonart images that were made, collected, and displayed in order to picture new modes of picturing. As I shall show, images produced and circulated through new photographic and printing technologies at this historical moment were understood to extend the powers of representation through a (presumed) ever-developing transparency, even as images were also understood to be opaque, transforming that which they represent. The new image technologies, in short, pushed to an extreme the ideas both of images as accurate likenesses and of images as fundamentally abstractions.

The discourses of images most prevalent at this time, however, engaged with this changing image culture by seeking to define and even defend the nature of representation and image-making in territorial terms. For instance, key texts by the artist, cartoonist, and essayist Feng Zikai and the aesthetic philosopher Zong Baihua tried to differentiate Chinese from Western modes of picturing on the basis of distinctions between, on the one hand, a photographic transcription of reality and attention to perspectival depth, which they ascribed to the West and deemed static and even

lifeless, and, on the other, various modes of abstraction, mutability and deformation, the visualization of the unseen, and attention to pictorial surface they ascribed to Chinese painting and what they saw as its qualities of vitality and life, or enlivenment (*shengdong*).[1]

These are just two instances of a striking number of texts published during the late 1920s and early 1930s in which differences in modes of picturing were used to mark off perceived differences in the cultural domains of an essentialized "East" and "West." I want to begin my discussion by examining the specific terms of such oppositions. For while the binary oppositions that structure these texts are highly tendentious and simplistic — despite the erudition and complexity of texts such as those by Feng and Zong — the sheer prevalence and even obsessive repetition of such binarisms in these and numerous other texts identify, I believe, what at this historical moment were the key stakes in thinking about images and also demonstrate how such thinking sought to map, clarify, simplify, and structure a bewilderingly complex cultural geography of images. What really seemed to drive the creation of these obsessive binaries was photography, for to numerous writers photography represented everything that marked the boundaries between "Eastern" and "Western" picturing. In actual practice and as presented in the print media, as I shall argue, however, photography did not reaffirm but rather completely undid such binary oppositions of cultural and geographic difference. Indeed, a notion of photographic images as both emerging out of and complicating prevailing conceptions of global cultural geography enabled modernists to engage through visual as well as verbal images questions of place, landscape, race, the past, and cultural identity in their work. My procedure in the following pages, then, is to situate one of the most prevalent critical discourses on pictures at this time within the context of the images actually published in the print media that sought to explore new modes of picturing. My hope is that this conjunction will bring to light some of the assumptions that brought pictures to life in Republican Shanghai.

Abstracting Pictures

Let me turn to the texts I have in mind. In the first, the artist and cartoonist Feng Zikai argues that modern artists' radical break from mimeticism

and turn to abstraction actually signify a fundamental rejection of Western aesthetic practices and the "Easternization" of Western art, or what he calls the "triumph" of Chinese painting over modern art.[2] As I have said, in his 1930 text Feng Zikai connects image-making practices and ways of seeing to binaries of civilizational difference. The idea of the formal characteristics of paintings as manifesting culturally specific ways of seeing, and of ways of seeing as standing in for specific cultures, was itself a conception that had circulated and been appropriated in a wide variety of cultural contexts at that time in both China and the West. Feng Zikai and Zong Baihua were writing at the same time as the Viennese art historians Hans Sedlmayr and Otto Pächt, for instance — "radical formalists," as Christopher S. Wood has observed, who "argued that a single work of art, if viewed properly, would reveal the deep structure of the world that produced it," as well as the visual cultures of nations and even "races."[3] All four of these critics knew the work of earlier theorists such as Alois Riegl and Heinrich Wölfflin, the latter of whose most influential work was structured by binary oppositions between formal techniques in painting, drawing, and architecture that, he claims, manifest differing forms of vision but do not map onto national cultures.[4] In another context Feng cites Wölfflin's notion of *Sehformen* (forms of seeing), according to which histories of vision might be read through a formal analysis of paintings.[5] What is most revealing about Feng's text, however, are not so much his larger claims about such differences but rather the particular qualities of pictures to which he calls attention — in other words, not what the binaries that structure his essay *are* so much as what they *do*. For the descriptive differences between Eastern and Western painting that structure Feng's text quickly become prescriptive judgments. Feng both admires and finds excessive in Western realist art what he considers to be the precision and detail of its representations of bodies, objects, and spaces — an excess of physical details that would muddy up the clarity and simplicity of line that he argues is central to what he calls "Eastern" art. Or worse: for what he calls the "coldly objective imitation" of realist pictorial practices is not enlivening but, to the contrary, he remarks, a "deadly work."[6]

This is not to say, however, that Feng believes Western pictures are naively mimetic. Yet Feng is suspicious of Western pictures for at least attempting to copy the world, for their "desire to 'pass themselves off as real things.'"[7]

Here Feng makes a crucial distinction. For, he argues, "the pictures Chinese people make are not transcriptions made in light of reality, but rather are made according to [a process of] deeply observing nature, stripping it of all unnecessary waste and grasping its most necessary essence."[8] This is a canny move on Feng's part, for he manages both to suggest by implication that the transcription of the real in Western pictures is excessive in its attention to detail, or, in his words, "unnecessary waste," and that its very nonselective copying of the real is the result of its scientism, its methodological attention to the material qualities of the real. And yet he also detaches the very capacity one would assume underlies such methodical attention — "observation," or *guancha*, at least with its modern connotations of an investigatory objective, analytical, scientific mode of vision — and defines observation as fundamental to Chinese art, for all of its putative qualities of illusion and unreality. For Feng understands such observation to be part of an ongoing and subjectively mediated process of "accumulating experiences of observation and thought," which he attributes to Chinese artists, in contrast to the "direct" and virtually immediate transcript of reality he attributes to Western painting.[9] Indeed, for Feng, "observation" is not so much a careful examination of the material surfaces of the world as it is a form of vision that penetrates surfaces. Or more: it is both a rhetoric and a vision credited with tactile, even violent powers. For what such vision "strips away" are precisely the external and contingent details and surfaces — the "unnecessary" waste, as Feng's text calls them — that conceal, so the argument goes, the "necessary essence" of things. In short, Feng's conception of observation here is one of a process of abstracting.

Abstracting observation, then, as opposed to transcription of the real in all its material, arbitrary, and contingent detail. And while the aesthetic philosopher Zong Baihua, in contrast to Feng, does consider science and art both to be modes of investigation (even if different in their expressive purposes), for Zong such investigation is manifest in the practice of art as a process of abstracting forms.[10] "Form in art," Zong argues in a 1934 text rich in the terminology of modernist aesthetics, is a "structure interwoven out of abstract points, lines, planes, and volumes."[11] Formal analysis of the real, according to Zong, involves both an analytical separation of an image from

the real through framing, and then an active weaving together of abstract elements into a composition. Only the "most enlivened [*shengdong*] artistic forms"—which for Zong include the abstract forms of calligraphy and the shapes and patterns on Chinese bronze vessels—"can express that which cannot be put into words or given appearance."[12] But how this general process is actually practiced differs, for Zong, according to cultural context, and here Zong also resorts to a series of sharp binary oppositions to define what he calls the "sources and foundations" of Chinese and Western modes of picturing. The drawing techniques of Chinese pictures, as Zong defines them, are dynamic with an emphasis on line, rather than static with an emphasis on likeness.[13] As a result, he writes, Western pictures traditionally are concerned with delineating separate three-dimensional forms within an imagined space that renders the surface of the picture transparent—like the window in Leon Battista Alberti's seminal formulation in his fifteenth-century treatise *Della pittura* (On painting). A Chinese painting, by contrast, "is like a dance. . . . Its spirit and emphasis lie in the rhythmic life of its entire surface and are not mired in the delineation of separate likenesses [*xingxiang*]. The saturation and thinness [*nongdan*] of the artist's brush and ink, the interweaving of points and lines, the mirroring of light and shade and fullness and emptiness, the openness and closedness of form and manner, all are composed into musical and dancelike designs [*tu'an*]."[14] Even the "likenesses" of animals and humans in the earliest Chinese pictures are "completely dissolved into the dynamic lines [*xianwen*] and patterns of a design [*tu'an*] across the entire surface."[15] Despite the initial similarity in formal analysis that Zong finds in both Chinese and Western pictures, then, in the end Zong sees in Western pictures a three-dimensional rendering of spaces and volumes through light and shadow, while again Chinese painting does the work of abstraction not through observation, as in Feng, but through the dissolving and interweaving of forms into a design constituting the surface of the picture. In short, "Images dissolve into pattern," Zong writes. "Each [image] is enlivened, and each one is abstracted."[16] The work of abstraction, that is, brings Chinese pictures to life.

Now it is noteworthy the degree to which both Feng and Zong use a modernist rhetoric of abstraction to describe Chinese painting, from Zong's ac-

Kandinsky's processes of abstraction resonate less with Feng's text than with Zong's account of Chinese images as a dissolution of likenesses into designs whose dance brings a pictorial surface to rhythmic life.

The very circularity of Feng's and Zong's arguments regarding abstraction and enlivenment arguably stems from their attempts, whether explicit or implicit, to recuperate modernism as a fundamentally "Eastern" mode of painting. While, as was recognized in a key text important both to Kandinsky and Feng, *Abstraction and Empathy* (1908) by Wilhelm Worringer, abstraction in and of itself was not original to modern art (even if its valuation and definition did change). Feng's understanding of abstraction in terms of enlivenment is what enables modernism to cross the absolute boundary he draws between "Eastern" and "Western" modes of picture-making. Furthermore, the kinds of technological and social factors most often brought in to account for practices of abstraction — such as the invention of photography, the emergence of a modern mass print media, scientific theories of light and visual perception, and, most of all, the reconfiguration of space and time under industrial capitalism — do not enter the picture, their role replaced entirely by "Eastern" art. And yet technological change is not entirely absent from either Feng's or Zong's essays. At various moments in their texts, they define the distinctions they make between Western picturing and Chinese through references to photography. For Feng, most Western paintings before impressionism "give one a feeling that they are the same as photographs."[28] Particularly the realist paintings such as those of Courbet and Millet "simply are the scenic photographs of the present" — not, that is, "like" photographs; they simply "are" photographs.[29] Of course, to say realist paintings seem photographic is hardly unusual. Indeed, it would have been all the easier for Feng to make this comparison, as most if not all of what he would have seen of Courbet and others would have been reproductions and prints — quite literally, photographs of their paintings. In such printed photographs of paintings, as Feng observed elsewhere, "there are no traces of painting to be found"; that is, photographs in general do not depict but rather filter out the textures of the pictorial surfaces that mark them as material, opaque objects (rather than Albertian windows).[30] And Zong's text redefines Western painting as a mixed — and anachronistic — medium. In contrast to China's ancient "pattern and design pictures"

(*huawen tu'an hua*), Zong writes, early Western pictures, "like the murals seen in the ruins of the ancient city of Pompeii, could be said to transplant statues to the pictorial surface; seen from afar they are just like photographs of three-dimensional sculptures."[31]

Precisely because of how photography functions in Feng's and Zong's arguments as that which cannot be assimilated or recuperated to enlivenment in the way that modernist abstraction can, I want to argue that it is around the problem of photography that the stakes of their texts lie. Extended discussions of photography per se, however, do not appear in either Feng's or Zong's texts. Rather, a notion of photography that was generalized, as we have seen, to describe paintings, a notion not so much of the medium of photography per se but rather of its effects, of the ways it is understood as an "essence" of Western picturing at all times — a notion that I would thus like to call the "photographic," to distinguish it from actual photography — this notion of the photographic comes to stand for the transcription both texts attribute to Western pictures, whether this means the transcription of detail or of three-dimensional forms. Simply put, the photographic is the concept that not only defines these and many of the other discussions of civilizational difference in picturing at this time; the photographic motivates such discussions as well, even (or especially) when the term is largely submerged within such texts. In both Feng's and Zong's arguments, the photographic is situated — without fear of anachronism — as a marker of difference between essentialized pictorial orders as mapped onto a global space divided between "East" and "West." Indeed, taken together Zong's entire schema of binary oppositions — which define Chinese picturing as fluid and Western picturing as static; Chinese as calligraphic and Western as perspectival; Chinese as emphasizing line, pictorial surface, and the unseeable and Western as emphasizing likeness, the depiction of depth, and the visible real — composes an overriding opposition between two general kinds of pictures, namely, between abstract designs and the photographic.[32] Similarly, for Feng the photographic and its "deadly work" of transcribing the excessive and contingent detail of the real marks the difference of Western picturing from the abstracting power of observation and clarity of line — the very enlivenment — he attributes to Chinese picturing. The "triumph" of Chinese painting that Feng goes on in his essay to declare over

modern Western art, then, is an overcoming of deadly photographic transcription by enlivening deformation, abstraction, and design. The narrative of Feng's essay creates a distinctive global geography split between Chinese abstraction and Western photographic transcription — which is then crossed when Chinese art travels and overcomes the West.

Photographic Transcription: Clarity and Opacity

Two of the primary instruments of photography, cameras and film, were marketed at this time in China in ways that would seem to bear out Feng's and Zong's claims. Advertisements for the Rolleiflex camera emphasized its "accuracy and clarity [*mingxi*]," while the cheaper Rolleicord, made available in 1934 (the same year as Zong's text), was touted as a camera that "everyone can use to take sharp [*qingxi*] photographs."[33] Kodak Verichrome film, newly introduced in 1931, was similarly advertised for its "increased sharpness and liveliness [*jingcai*]" over earlier film, a clarity and sharpness in both highlight and shadow areas of its photographs, the text continued, even in fast exposures, so that there was a pleasing balance of "density and thinness [*nongdan*]" in the negatives.[34] And yet *nongdan* — not only meaning density and thinness but also indicating the resulting contrast and even dialectic of darkness and light — is the term Zong Baihua used to describe the work of a Chinese artist's brush in manipulating the saturation and thinness of ink. Indeed, the choice of this term in the advertisement inadvertently points to the irony that even as increasing sharpness and clarity were being sought in photographic technologies, Chinese art photographers sought to overcome that clarity, sharing the belief Feng's text articulates, that excessive clarity and sharpness cannot be artistic.[35] A long 1931 text published in the popular pictorial *Liangyou huabao* (The young companion), for instance, introduced the bromoil process, in which gelatin photographic prints are applied with an oil-based ink to produce painterly images with softened detail and a "pleasing [range of] darkness and light [*nongdan*]."[36] Four years later, a layout in the same magazine demonstrated the making of "photographical paintings" (figure 1.1), photographs "to form artistic paintings, sketches, and etchings."[37] This latter process involved the use of various kinds of screens in a darkroom enlarger to filter the image projected from a

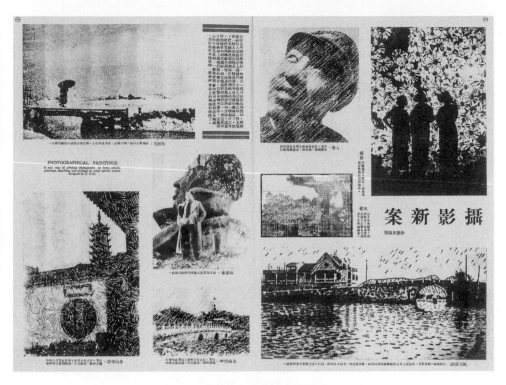

FIGURE 1.1 Xu Dexian, "Sheying xin'an/Photographical Paintings,"
Liangyou huabao 116 (1935).

negative onto photographic paper, in order to suppress photographic clarity and sharpness and instead create the effects of hatching and brushstrokes. In both the bromoil and screening processes, addressing the material qualities of photosensitive surfaces and of light rendered the supposed transparency of photographic images opaque.

But even without resorting to complex manipulations of darkroom processes, a widespread convention in Chinese art photography at that time sought to reproduce the subject matter and effects of literati ink painting in photographs by employing the soft-focusing lenses characteristic of a pictorialist aesthetic. The subject of a photograph made by Lang Jingshan in 1929, for instance, was, according to its oddly worded caption, "originally a collection of a few unremarkable bamboo leaves, but as soon as it underwent the photographic process, it was refined into a painting" (figure 1.2).[38]

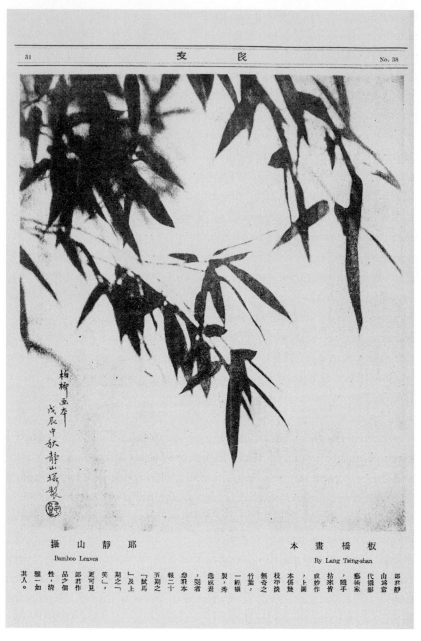

攝　山　靜　郎
Bamboo Leaves

本　畫　橋　板
By Lang Tsing-shan

其人。　　雅一如　　性，清　　品之個　　邱君作　　更可見　　笑」，　　期之「　　」及上　　「試馬　　五期之　　報二十　　叁狖本　　，閱者　　逸成斿　　製，秀　　一絛撮　　竹葉，　　無奇之　　枝平淡　　本係幾　　，上圖　　成妙作　　枯淡者　　藝術家　　，隨手　　代攝影　　山為當　　邱君靜

FIGURE 1.2 Lang Jingshan, *Banqiao huaben/Bamboo Leaves*
[An album by Banqiao], *Liangyou huabao* 38 (1929).

Here photography is hardly opposed to Chinese painting through its un-reflective transcription of "unnecessary" detail; rather, the registration of a silhouette on the photosensitive surface (aided, perhaps, by a strong red fil-ter in either the taking or printing of the photograph) suppresses almost all detail and texture, transforming the real into what appears to be a bamboo painting, the leaves appearing to be precisely the brushstrokes, the carefully modulated line, that Feng sets in opposition to the photographic. Indeed, Lang seems to insist on collapsing the distinction between photography and ink painting by inscribing his photograph with a brush the title *Ban-qiao huaben* (An album by Banqiao), as if the image were referring to the work of Zheng Banqiao (1693–1765), one of the most prominent special-ists in bamboo painting, as much as it does to the bamboo it depicts. It is perhaps a small irony that the work this photograph and its caption stage in the transformation of bamboo leaves into "painting" is described in a text Feng cites with approval in his essay in order to capture the work of abandoning formal likeness to attain spirit resonance. The text, Guo Xi's eleventh-century work *Linquan gaozhi* (The lofty message of forests and springs), advises, "To learn how to paint bamboo, take a branch of bam-boo, and on a moonlit night project its shadow on a wall, and the bamboo's true form will appear."[39] While shadows as such rarely, if ever, are depicted in Chinese ink painting, here in this early painting manual shadows do the work of the lighting or filter in Lang's photograph, namely, to suppress the materiality and details of the physical forms of bamboo leaves and instead to enable the apprehension of their "true forms" from the ephemeral, pro-jected forms of shadows; the work of ink, that is, is now done by the process of photography.[40]

All this is to say that there was a striking disjunction between the abso-lute claims of Feng and Zong and the kaleidoscopic array of actual picto-rial practices of their time. Indeed, so strongly engaged are the arguments Feng and Zong make, yet so divorced their arguments seem to be from those pictorial practices, that it is tempting to read their essays as a kind of dreamwork of the image culture of their historical moment—particularly the ways in which the medium of photography is largely both suppressed and distorted into an idea of the photographic that haunts their cultural geography of picturing. For in the context of that image culture, the work

Feng's and Zong's texts do to situate the photographic as a marker of different pictorial orders and their attendant desire to demarcate clearly the boundaries between East and West bespeak an anxiety: in practice, photography did not demarcate borders but rather was precisely the medium that crossed borders most, crossing international borders, of course, but also complicating distinctions between different ideas of picturing. And while both ink painting and Western-style realist oil painting were indeed practiced at this time, they hardly dominated the print media in which, as I have said, the widest variety of pictures were collected and circulated. The picture looks entirely different, however, if one considers the wider domain of images at this time, the vast majority of which are, of course, to borrow James Elkins's phrase, images that are not art, a plethora of other kinds of images that either pictured the world or pictured the processes of picturing itself, or both.[41]

For although photography's complicating of pictorial distinctions is certainly made visible in a photograph like *Banqiao huaben*, photography's transformation of image culture was most evident not in art practice but in the central arena and medium of printed images at this time: illustrated magazines. From the mid-1920s on, illustrated magazines were a crucial site of a global image culture in Shanghai, as in numerous cities around the world, spurred in part by rapid advances in print technology enabling the cheap and high-quality publication of photographs and other pictures. Such magazines were the format upon whose surfaces the greatest number and variety of images — photographs, Chinese ink paintings, Western-style oil paintings, traditional and modern art, woodblock prints, designs, cartoons, and texts — were gathered together for display in print form to collect and represent the world at home and abroad. Indeed, Lang Jingshan's bamboo photograph was published in the most prominent of the illustrated magazines, *Liangyou huabao*, in 1929.

As can be gleaned from the editors' comments in *Liangyou huabao* during the late 1920s through the early 1930s — a period of rapid transition in technologies for printing images and texts — the editors believed the technological and epistemological aspects of the making and printing of images to be crucially intertwined. One of the magazine's editors, Wu Liande, makes this connection most explicit at the opening of the magazine's mani-

festo in 1928, arguing for a material and technological foundation for the pedagogical project—characteristic of this era—of enlightening the Chinese people. Part of Wu's argument is the unsurprising claim that the increasing mechanization of publishing enables the wider circulation and accessibility of books and periodicals, and hence wider literacy and education.[42] Wu's more significant claim, however, concerns not the increased quantity of printed material but what he characterizes as the "progress" of the aesthetic qualities of print and the assumptions about images that both drove and were driven by technological refinements in print quality. Unlike Chinese periodicals of the previous forty years, he writes, *Liangyou huabao* does not consist simply of

> white paper printed with black ink, nor is it simply a collection of the same old articles prattling on about the same old empty principles. In the area of printing, we have added a variety of colors to provide viewers with a kind of amusement that gives rise to beautiful visions. And as for our contents, we've added to all those words buzzing around the page a cornucopia of pictures to delight the eyes and ease comprehension. These two points are the unique qualities of *Liangyou huabao*, and are also an expression of our efforts over the past two years to improve it.[43]

What is noteworthy about Wu's rhetoric, very much steeped in the evolutionist discourses of progress prevalent at that time, is the way in which it connects what he sees as the technological limitations of black print on white paper to the empty repetition of outmoded content, and the fullness of delight and comprehension to the profusion of pictures and color new printing technologies made possible. Such a linking of image technology, pictorial representation, and thought and perception would figure prominently in both editorials and features in *Liangyou huabao* during the following several years.

In a feature on the technological history of illustrated magazines from the "lithographic era" of the late nineteenth century through the early twentieth century, to the "photogravure era" starting around 1930, for instance, Huang Tianpeng, the editor of *Baoxue yuekan* (Periodical studies monthly), saw a connection between what he regarded as the simplicity of lithography as used in early illustrated magazines such as *Dianshi zhai*

huabao (Touchstone pictorial) and the "crude eye" with which the pictures printed were chosen. Indeed, Huang's term for crude, *cuxian*, which literally refers to rough-hewn lines, seems to conflate the eye and the quality of print.[44] The pictures in *Dianshi zhai* were, however, actually finely detailed line drawings, but according to a feature published in 1934 in another pictorial, *Dazhong* (The cosmopolitan), their limitation was that "the realities represented in the pictures all depended on the artist's imagination [*xiangxiang*] or a sketch"; lithography was only resorted to, according to the text, because "the art of photography was not yet very accomplished."[45] With the introduction of copperplate printing and later photogravure in the illustrated magazines of the 1920s through the 1930s, however, the feature claims, "news and current events were no longer drawn images [*yixiang*, literally, "idea-images"], but rather were photographs that presented the real situation before readers' eyes."[46] The exploration of such new printing technologies became something of an obsession for *Liangyou huabao*'s editors as, already boasting in 1933 "the sharpest [*jing*] printing in the world of illustrated magazines," they sought printing technologies that would enable "even greater clarity [*qingchu*], fineness of detail, and [would] be even more pleasing to the eye than at present."[47] Technology and epistemology were seen to be intertwined, for the increasing printability of photographs was seen as transforming the kinds of knowledge and information that could be transmitted by the magazines.

The actual experience of publishing *Liangyou huabao*, however, reveals that the transformation from "idea-images" to sharp "realistic" photographs was not as clear-cut as the feature in *Dazhong* claimed; indeed, at first the publishing of photographs entailed a step away from the ideal of clarity (both aesthetic and epistemological). For like numerous other illustrated magazines of this period, *Liangyou huabao* began its publication of photographs by using letterpress halftones printed with copperplates.[48] While this technology enabled for the first time the cheap printing of photographs in mass-circulation publications worldwide, its liability was that the tiny dots with which a halftone is printed, and which give it its characteristic appearance, produced pictures of low resolution and thick lines, high contrast, and an overall rough appearance, as compared with a photographic print.[49] Indeed, in its comparisons of lithographs and photographs in the feature

in *Dazhong*, it is most decidedly the lithographs that appear clear and sharp and the photographs that appear crude and rough, in spite of the text's claims to the contrary. As one of *Liangyou huabao*'s editors complained in 1930, with the growing print runs of each issue, the copperplates quickly wore out, so that the print quality was less "pleasing to the eye," while the letterpress technology with which copperplates were used necessitated grid-like page layouts and designs, which, "having been read, hardly leave a deep impression."[50] The first solution was an experiment in issue number 43 with duotone printing, a technology similar to halftone, but whose two sets of overlain dots of black and gray afforded a smoother and more subtle tonal scale to printed photographs. *Liangyou huabao*'s experiment with duotone was, however, deemed by its editors to have been a "failure," primarily due to the poor quality of the paper.[51] The turning point was the adoption, beginning in 1930 with issue number 45, of photogravure (*yingxieban*). Photogravure produced a long and subtle tonal range in its printed photographs, although the editorial of that issue emphasized that "it can print in greater quantities without losing its sharpness and beauty."[52] As Huang Tianpeng put it, photogravure led to "the enlivenment of pictures" (*tupian zhi shengdong*) — that most essential quality of pictures animating Feng Zikai's text on Chinese and modernist art.[53]

And yet what the editors of *Liangyou huabao* and other periodicals were describing through this succession of printing technologies ran contrary to the belief they shared with Feng Zikai in the sharpness, fineness of detail, and clarity — the transparency — of photographs and their representation of the real. For what they were struggling with throughout these experiments with printing was the resistance of printed pictures to clarity or, more generally, the stubborn materiality of images. If sharpness and clarity were definitive of the photographic, as Feng would have it, then to a considerable degree lithographs were more "photographic" than many printed photographs. Hence these editors' narratives of overcoming the limitations of already-existing image technologies manifest a consciousness of such technologies not simply as transmitting or amplifying the real but rather as filtering the real.[54] Earlier image technologies are always seen in the texts of this period as filtering the real because of their perceived crudeness — filtering out, that is, a level of detail deemed necessary for a persuasive and

accurate level of representation — whereas these narratives of technological development also manifest a faith in the perfectibility and ultimate transparency of their media, a dream of the immediacy of media. And yet the editors' obsessive pursuit of ever greater clarity of printing was haunted by a wariness of the sheer and stubborn opacity and even near incomprehensibility of images. Indeed, the very materiality of the media that, the editors believed, enabled the increasing mimeticism of images at the same time abstracted the real such images depicted.

Picturing Photography, Abstracting Likeness

Even as the editors of *Liangyou huabao* pursued greater clarity and transparency of pictures through print, the opacity and materiality of images, and in particular their abstraction, became an increasing area of fascination in many of the photographs printed in illustrated magazines. Here I do not have in mind the layouts of images in such magazines — representing world events, mass culture, the arts, manufacture, the modern woman, the novel excitement of the modern metropolis, current events, and the world of cinema, its venues, and its stars — that are all too familiar in current scholarship on Shanghai. For such materials constituted only a portion of the contents of illustrated magazines. Much of their subject matter consisted of the mundane, the everyday, the overlooked, the unseen, and the very novelty and even strangeness of the mundane as transformed through new visualizing and imaging technologies. Indeed, a considerable portion of the images published did not so much represent the world as demonstrate or test the possibilities and limits of new imaging technologies, picturing the limits of picturing at times to the point of abstraction.

A typical layout of such pictures, published in *Liangyou huabao* in 1933, demonstrated to the viewer a variety of what it called the "wonders of photographic art" (*sheying shu de qiqu*; figure 1.3). Such wonders include high-speed photographs capturing moments 1/75,000 of a second in duration, including a cup of coffee smashing on the floor the moment before the coffee spills out, and a hammer smashing a light bulb at just the moment before the bulb explodes. In both of these photographs it is the very pursuit of the real that leads not to a transcription of that which can be

FIGURE 1.3 "Shcying shu de qiqu/Wonders of Photographic Art,"
Liangyou huabao 82 (1933).

seen but rather to an instance of what Walter Benjamin famously called the optical unconscious—those things we "see" but cannot see quickly enough to register in our consciousness: the unseen and unseeable made visible through the transformative vision of the camera.[55] Another form of high-speed photograph, taken at a more conventional shutter speed, demonstrates the effects of blur as a skier whizzes past too rapidly for the camera to capture its form clearly and sharply. The other photographic wonders are produced not through the camera but rather through darkroom processes: a sunset photograph rendered oddly graphic and tactile through the process of bas-relief printing; ceramic figures rendered unworldly, printed in negative; a nude woman shrunk through composite printing to pose among gigantic perfume bottles; and a ghostly gloved hand calling a crowd to a halt, produced through a double print of negative film and what appears

to be a cameraless rayogram of the hand on the same photographic paper. And finally, a double exposure produced in a camera of the same person sitting and reading and standing in attendance—the sort of photograph of "Myself and Myself" that the prominent twentieth-century writer Lu Xun famously ridiculed in his essay on photography.[56]

Now, to recall Feng's and Zong's terms, these photographs may all be transcriptions of the real, but if they are, then they only demonstrate that a transcription of the real does not necessarily produce a direct likeness of the world. While the photographs of the smashing cup and lightbulb might be said to be likenesses of that which we cannot see, in the blurry photograph of the skier the materiality of the real is not so much transcribed in all its excessive detail as it is attenuated, so that the figure appears at once opaque and, at its edges, translucent. Moreover, this attenuation has no relationship to ordinary visual experience, conscious or unconscious. It obviously is not as if the viewer "saw" such a blur, or that the camera perfectly transcribed the image of a blurry skier. Indeed, this shadowy figure is hardly a visible figure at all, but rather a product of the interaction of light, the mechanical movement of the camera shutter, and the photosensitive surface of the film. But, then, most photographs are the products of such processes; it is only that a photograph like this makes such a process visible, so to speak. And as the multiple exposures, bas-relief, and negative prints show, the pictures that can be produced through photography are not so much transcripts of the world as the transcription of a variety of photomechanical effects on the surface of film. Indeed, this may be the "wonder of photographic art" that all the pictures in this layout have in common.

Which raises a question concerning all the photographs in this layout: If they are likenesses, as Feng and Zong would have it, then what exactly are they likenesses of? As a writer by the name of Wang Jiezhi observed in 1936, a likeness of an object produced through photography does not necessarily resemble the actual object depicted, whether because of the temporal distortion of objects by rapid or slow exposure times, or spatial and perspectival distortion by camera placement and the choice of lens focal length. Hence "all too often when people criticize [photographs for] problems of likeness and nonlikeness [*xiang yu buxiang*]" to the persons, objects, and scenes they depict, they do so because they are not taking "the

accuracy of perspective and transcription, or lack thereof, as criteria, or in other words, the criteria of a 'true likeness,' but rather their criteria are the everyday conceptions they derive from the objects themselves."[57] All too often, that is, people see photographs as windows, not pictures. Certainly that which these pictures depict is entirely unverifiable by ordinary visual experience; rather, the only way to verify what the photographs show would be by producing more of the same sort of photographs. Illustrated magazines may have been premised on the idea of the world as picture, but these are hardly the kinds of pictures their manifestos promised. Instead, photographs enabled not simply a form of observation, and certainly not pictures that were *reproductions* of the world, but rather a method of making visible the unseen through, as Joel Snyder has put it, *constituting* pictures of the world by means of the material qualities of photography.[58] And this power of enabling a new form of vision owed less to photography's purported immediacy and transparency of representation than precisely to its very materiality and even opacity.

The picturing of photography in other layouts in *Liangyou huabao* raised even more questions to trouble the idea of photography as the stable marker of difference in pictorial orders Feng and Zong assumed it to be. This was particularly the case in another area of photography prominently displayed in *Liangyou huabao* and other illustrated magazines, namely, photomicrography. Layouts such as one from 1935 (figure 1.4) displayed common household objects, magnified seventy times and shot at exposure times ranging, as the text is careful to point out, from a moment 1/100 of a second in duration to more than fifteen hours. Such photographs, as the text accompanying the "wondrous view" of the colors of soap bubbles in plate 1 suggest, rendered everyday, unremarkable, and commonly seen objects into strange miniatures — literally, in the words of the text, "shrunken images" — of the universe, ever-changing shapes of colors and lines. And they did so neither through creating direct transcriptions of reality nor through an accumulation of observation, to recall the terms of Feng Zikai's opposition between Western and Chinese picturing, but through the slow accumulation of light over the course of long exposure times. Indeed, as an unnamed writer for *Liangyou huabao* seemed to be aware, such photographs confounded received and reified definitions of different kinds of pictures, even as they

FIGURE 1.4 "Fangda sheying yu sheying fangda/Photomicrography"
[Enlarged photographs and photographic enlargement],
Liangyou huabao 120 (1935).

suggested ways of imagining new pictorial forms. As the text accompanying a feature (plate 2) on color photomicrographs of butterfly wings and saline solution puts it:

> Since primitive times, the fine arts have been influenced by the natural world. The elements of scenery move the human heart to respond, and are drawn into pictures. This until modern times when every form and color has been used up to the point of extinction, and the art world has been quite overcome with panic even to the point of a trend of reviving the past [*fugu*]. And yet one could hardly have imagined that the forms and colors of heaven and earth are eternally inexhaustible, and especially that one can seek them out through science.[59]

The text reasserts a cliché of classical Chinese aesthetics, namely, that a basis of art is the human heart's response to scenes and the phenomena of the world. The threat to such a concept of aesthetic practice by the exhaustion of forms in modernity can be met, the text suggests, not by an archaic reassertion of tradition but by a turn to science as a new mode of perceiving and responding to the natural world. That is, scientifically produced photographs such as the images in the layout reveal possibilities for picturing that are an alternative to the kinds of revivals of the past of which writers like Feng and Zong could well be accused, even as such images are conceptualized in part through the rhetoric of classical Chinese aesthetics.

But the presentation of these photographs suggests something far more radical. For it was precisely in the pursuit of a penetrating vision that photographic "likenesses" dissolved, to recall Zong Baihua's terms, familiar forms into dynamic lines and patterns through the flattening of three-dimensional material objects into thin surfaces, creating not likenesses but designs. That is, these pictures were neither the photographic likenesses nor the abstract designs that writers like Feng and Zong held to mark essential differences in pictorial orders; rather, as they are labeled in the layout in plate 2, they were "natural designs" (*tianran tu'an*) produced through photography — or, as many of such pictures published in *Liangyou huabao* and elsewhere were called, they were examples of "design photography" (*tu'an sheying*). Subsequent layouts of design photographs included a collection from 1931, which reprints photomicrographs of snow crystals whose forms, the accompanying text points out, "create extremely beautiful designs which can serve as resources for the industrial arts."[60] Such abstract designs, however, cannot be produced through an accumulation of direct observations. Indeed, as the text puts it, the very nature of snowflakes, both transient and microscopic, creates "a blockage to observation" (*guancha*), a resistance that can only be overcome through photography.[61] Not all design photographs were based upon photomicrography, however. A 1932 layout, for instance, includes photographs by the German Karl Blossfeldt, whose compositions famously objectified sections of plants through close-ups and blank backgrounds to create what Blossfeldt called "Urformen der Kunst," or, to use its English title, "Art Forms in Nature." The Chinese text in the *Liangyou huabao* layout, entitled "Botanical Art" or even "The Art of Plants" (Zhiwu de

yishu), echoes the text on butterfly wing photographs in claiming that the "wonders of the natural world are inexhaustible" sources for what it calls "natural design photographs" (*tianran tu'an sheying*).[62] Elsewhere, design itself was understood to be a process of transformation, or *tu'an hua*, as a 1930 layout of photographs of work by the modernist photographer Zhang Jingwen terms it (figure 1.5). This process through which mundane objects are transformed into designs here involves the heavy projection of shadows, as well as the cropping and repetition of forms — a repetition that itself seems to play upon the fact that the objects depicted in Zhang's photographs are produced through mass manufacture, itself a process of the repetition of forms. Unlike most such layouts, however, there is no accompanying text to elucidate these photographs' own process of production; rather, the reader is simply presented with labels identifying the depicted objects,

FIGURE 1.5 Chang Ching-wen [Zhang Jingwen], "Tu'an hua de sheying/ A Study of Designs by Photographs" [Photographs transformed into designs], *Liangyou huabao* 48 (1930).

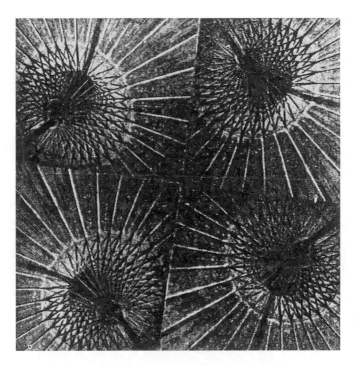

FIGURE 1.6 Huang Jiezhi, "Tu'an sheying tan"
[Discussion of design photography], *Changhong* 1, no. 10 (1935).

and a title — "Tu'an hua de sheying" — whose meaning is somewhat ambiguous as to whether what is shown here is understood to be photographs that have been transformed into designs, or the transformation of objects into designs through photography.

A text outlining one process for making design photographs, published in the photography magazine *Changhong* (Rainbow) in 1935, however, clearly understands design photographs to be the product of the transformation of objects and the transformation of photographs into designs at the same time (figure 1.6). The process the article suggests also begins in taking photographs of mundane objects (such as a headlight, a fence, or, in figure 1.6 an umbrella), whose compositions emphasize their "design qualities: curving lines and clear shadows and patterns," in which forms are heavily cropped and off center.[63] But now the process takes a step further from previous design photography, for the forms depicted within the

lytical. He develops this conception by comparing the seventeenth-century Chinese painter Shitao with late nineteenth-century and early twentieth-century Western painters like Vincent van Gogh, Paul Gauguin, and in particular, Paul Cézanne.[65] Departing significantly from Feng Zikai's and Zong Baihua's superficially similar texts, Liu's pair of essays, "Shitao de yishu jiqi yishu lun" (Shitao's art and his discourse on art; 1932), and "Shitao yu hou-qiyinxiangpai" (Shitao and Postimpressionism; 1936), proposes resonances between Chinese painting and modernism without conflating one with the other. More significantly, the conceptions of nonrepresentational pictures in Liu's essays are saturated and driven by the kinds of powers of photography to transform and synthesize manifest, as I have shown, in the print media of Shanghai — even though his texts scarcely mention photography directly. While for Feng and Zong the photographic serves as the grounds for their East-West dualisms, I want to consider, by way of conclusion, how a conception of the photographic that orients the artistic and intellectual coordinates of Liu's essays enables him not only to leave behind a conception of images grounded in such dualisms, but instead to propose a conception that resonates deeply with those widely and variously explored in modernist images and texts in Shanghai.

Liu answers this question of representation and, crucially, the nature of nonrepresentational pictures, or what he calls "expression," in terms that at first glance seem to restate those of Feng Zikai's text. Representation, as Liu defines it, is "adapting from nature, it is not making; it is a reflection of the external, it is not artistic expression; it is a photographic record from the exterior to the interior. Every [kind of] matter and object that comes into contact with our sense organs, giving rise to some sort of influence on our consciousness — this is an impression; this work of displaying impressions that originate from outside is called representation."[66] Realist art and naturalist art, Liu writes, "take natural phenomena and transcribe them in all their fullness, reflecting them in their every single detail so that such artworks can induce in the viewer a feeling of reality because they are representations."[67] Expression differs from representation, for Liu, primarily in its processing and display of the same sensory impressions recorded in the work of representation. The work of expression, as Liu defines it, is to "take all kinds of impression, let them undergo a mental processing, synthe-

tize them according to one's own laws, and then display a new and whole world."[68] In contrast to representation's dependence on detail, key to expression is "simplification" (*danchun*)—a term with overtones of "purification"—which Liu defines as an "abbreviated method of painting" in which one "seizes the most important points that directly express a likeness [*xingxiang*] and discards the rest."[69]

Here the work of expression for Liu is reminiscent of Feng Zikai's formulation of the work of observation in Chinese painting as "stripping [nature] of all unnecessary waste" to make pictures that are not "transcriptions made in light of reality."[70] Indeed, elsewhere in his own essay, Feng cites simplification (*danchun*) as well as deformation (*jixinghua*) and the importance of line as fundamental to the work of expression in both Chinese and postimpressionist painting.[71] "Simplification . . . and line are in a reciprocal [relationship] of cause and effect," Feng writes. "That is because if one seeks the simplification of natural forms, one uses an uncomplicated [*jiandan*] line to depict; because one uses line as a tool of depiction, what one expresses [*biaoxian*] will be all the more simple [or pure, *danchun*]." Deformation, in turn, "has a direct connection to simplification."[72] Through the use of the methods of simplification and deformation, Feng writes at the end of his essay, "landscapes in Chinese painting are not like real landscapes, they are . . . the landscapes one would see in dreams. Here there is certainly a secret to transformation [*bianhua*]," which Feng likens to "Western methods of design [*tu'an*]."[73]

But while Feng finds these commonalities between postimpressionism and Chinese painting—and, for that matter, design pictures—to be sure signs that "the thinking of postimpressionist painters is clearly an offshoot of Chinese discourses on painting from past eras," Liu Haisu opens his essay "Shitao and Postimpressionism" (1936) by acknowledging the sheer strangeness and even, he puts it, "ludicrousness" of bringing such historically disparate artists together into the same discussion.[74] "Given the gap of more than three hundred years between the respective eras of Shitao and the postimpressionists," Liu comments, "it's very clear that in reality there was no relationship of direct influence between them whatsoever. . . . Shitao of course was not influenced by the postimpressionism of modern Europe, and not one of the postimpressionist painters had ever heard of

or been influenced by Shitao or his paintings."[75] What Liu aims to explore in his 1936 essay, then, are "coincidences in their fundamental thinking," for "what western Europeans call new thinking and new art had already been manifest in Shitao three hundred years ago."[76] While this latter part of Liu's claim sounds similar to Feng's, it is a claim he makes only in passing rather than structure his entire argument around it. Indeed, the differences between Liu's and Feng's essays are crucial. In making his claims, Feng turns to the work of the eighth-century painter Wang Wei and the influential aesthetic discourses of Xie He's Six Principles (*Liufa*) of painting from the sixth century and of the artist and poet Su Dongpo from the eleventh, in which, for Feng, are defined what he elsewhere calls the "distinguishing qualities of Chinese painting."[77] Liu Haisu, however, focuses exclusively on Shitao's paintings and texts from the seventeenth century and stresses repeatedly the artist's uniqueness, originality, and even iconoclasm within the history of Chinese art, citing with approval Shitao's own critique of the painting of the past in favor of what Liu characterizes as Shitao's drive for self-expression.[78] In short, for all of the richer erudition displayed in Feng's text, Feng's claim that modernism is an offshoot of Chinese painting depends upon his assertion of absolute difference and of historically unsubstantiated influence, while Liu's insistence on the historical gap between Shitao and postimpressionism paradoxically allows him to explore the resonances between their respective modes of painterly thinking. For, to be sure, Shitao and a painter like Cézanne do share a profound concern with the relations among perception, the world perceived, the act of painting, and the conception of images. Moreover, both Shitao and Cézanne were arguably engaging with experiences of modernity as articulated within their respective historical moments and cultural locations.[79]

Now, at stake in my own argument is not primarily what Liu Haisu claims about Shitao, or the resonances he discovers between Shitao and painters like Cézanne, but rather what juxtaposing them enables Liu to articulate about the nature of images and nonrepresentational pictures in his own historical and cultural moment. Liu devotes much of his 1936 text to quoting extended passages from Shitao's influential treatise, *Huayu lu* (Recorded remarks on painting) — specifically, Shitao's chapters on method

and on the practice and conceptualization of painting as the marking of traces on surfaces.[80] Liu's underlying claim, as he states it in his 1932 essay, is that "Shitao's painted images [*huaxiang*] are synthesizing, not analytical. When a painted image makes use of the analytical, the more complex it is, the closer it will come to the real; in using synthesis, the more simplified it is, the closer it will come to the conceptual. Expressive art is synthesizing, and in order to synthesize one should abbreviate."[81] Hence, what draws Liu's attention in his 1936 essay is Shitao's concept of the *yihua*, or Holistic Brushstroke, as a gesture that at once simplifies and synthesizes. Liu quotes the opening chapter of Shitao's *Recorded Remarks on Painting* on the Holistic Brushstroke almost in its entirety; the chapter's opening sentences run as follows: "In remote antiquity there were no methods; the Primordial Simplicity had not yet disintegrated. When the Primordial Simplicity disintegrated, then methods were established. On what basis were methods established? They were established on the basis of the [Holistic Brushstroke]. Now the [Holistic Brushstroke] is the origin of all things, the root of all phenomena [*wanxiang*, literally, ten thousand images]."[82]

The Holistic Brushstroke is not an expression of a primordial unity or wholeness, but rather a compensation for its disintegration. This "unity of the movements of the brush and the materiality of the ink on the painting surface," as Jonathan Hay puts it, a capacity of the Holistic Brushstroke Shitao calls "fusion" (*yinyun*), collapses together mind, perception, and gesture, expression and the materiality of the image, rendering the pictorial surface "an energized presentational (rather than representational) environment, structured by the trace."[83] Liu describes Shitao's procedure in his 1932 essay as "taking all kinds of natural elements and combining them into a kind of new life, combining them into a complete universe — this kind of combination is what is meant by mental synthesis, creativity, expression. . . . His pictorial surface [*huamian*] has his entire personhood concealed within it."[84] Here the rhetoric of Liu's account of Shitao seems to have been informed in part by his engagement with postimpressionism and in particular the rhetoric surrounding Cézanne's paintings; indeed, both Liu's and Feng's texts show traces of the influential memoirs and conversations with Cézanne by Émile Bernard published in 1904 and by Joachim Gasquet

in 1926. Bernard described Cézanne's paintings as an "expressive synthesis" made possible through the painter's giving "himself over to phenomena," while Gasquet reported Cézanne as describing what he called the pictorial "motif" of his landscapes as an interlocking synthesis of scattered, dispersed pieces.[85] Furthermore, Liu Haisu seems to have been informed by Gasquet's report of Cézanne's conception of the process of painting in which "the landscape reflects itself, humanizes itself, thinks itself in me. I objectify it, project it, fix it on my canvas. . . . I would see myself as the subjective consciousness of that landscape and my canvas as its objective consciousness" — a claim that in the context of Liu's essay sounds like an echo of Shitao's claim, which Liu cites in his 1936 essay, that "landscape entrusts me to speak in its name; landscape is born of me and I am born of it."[86] Or, in a more literal translation, "Mountains and rivers appropriate the embryo through me, I appropriate the embryo through mountains and rivers."[87]

And yet, while in their texts both Liu and Feng refer (without explicit citation) to Cézanne's well-known conversations with Gasquet, they also both stop short of the figure Cézanne returns to again and again just before and just after making this remark about the intersubjective relationships between the painter, the landscape, and the picture: namely, that of the painter as being a sensitized photographic plate. "While an artist is at work, his brain should be unencumbered, like a sensitized plate," Gasquet reports Cézanne as saying. "After repeated dipping in experiences" — or what Cézanne a bit later calls the "bath of experience, so to speak, in which the sensitized plate has to be soaked" — "this sensitized plate reaches such a level of receptivity that it becomes saturated [*s'imprégner*] with the exact image of things."[88] The term Cézanne uses in Gasquet's account — *s'imprégner* — is related to the word, *imprégner*, meaning "to soak" or "permeate," but with an obsolete meaning of "to impregnate"; indeed, Cézanne's sometime friend, Émile Zola, had played upon this association of the word in his novel, *Dr. Pascal* (1893).[89] Whether or not Cézanne was conscious of this association as he spoke, in the conversation as Gasquet reports it the figure of the photographic for Cézanne takes the place of that of the embryo for Shitao as a figure for a state of interactive receptivity on the part of a painter (impregnated with the exact image of things) in which "art has a

harmony which parallels that of nature" and thus the painter "must silence all the voices of prejudice within him, he must forget, forget, be silent, become a perfect echo. And then the entire landscape will engrave itself on the sensitive plate of his being."[90] This relationship between artist, landscape, and picture that Cézanne imagines in photographic terms stands in marked contrast to Feng Zikai's account of Cézanne, in which he quotes Cézanne as saying, "All phenomena [*wanwu*, the ten thousand things] are borne of me [literally, "exist because of my birth"]. I am myself, and at the same time am the origin of all phenomena."[91] This account of Cézanne shifts a state of receptivity and interaction to one of origin and domination, from a painter as a sensitive plate impregnated or "saturated [*s'imprégner*] with the exact image of things" to a self of which all phenomena are born. And while Feng's account of Cézanne is inaccurate, judging from Gasquet's and Bernard's own accounts of Cézanne's pronouncements to which Feng seems to have had access, the inaccuracy is telling: for Feng also omits the photographic rhetoric that saturates Cézanne's statements.

In making visible problems of synthesis and expression and receptivity by means of his juxtaposition of the painterly thinking of Shitao and Cézanne, Liu Haisu's primary concern was the problem of painting as "depending on methods of still, quiet observation [*jingguan*] in its attempts to represent" an "objective reality ceaselessly changing"—an experience of the world that for Shitao might have had its philosophical roots in Daoism, but was characteristic of modernity that the French poet Charles Baudelaire famously described as "the transient, the fleeting, the contingent."[92] At the moment in Liu's essay on Shitao's art and art discourse in which Liu turns from a concept of pictures as objective representations of a stable reality to one of pictures as subjective representations of flux synthesized of fragments, Liu turns to the work of the French philosopher Henri Bergson. Liu quotes Bergson as saying that "life is fundamentally flux, objective changes are without cease even for a moment, but because our senses are slow, the impressions we obtain are just a fragment of the flux, a still space, segmented from the continuity of time."[93] What crucially informs Bergson's account of the perception of a world in constant change—and which Liu's citation of Bergson, like his references to Cézanne, skirts close to but avoids—is

seemingly unguarded moment in an essay on the "distinguishing quality of Chinese painting" when he writes, "Chinese paintings are photographs of the dreamworlds of the Chinese people."[98] Just what kinds of portals onto the landscapes and dreamworlds of Shanghai and the world beyond would be made and displayed through modernist images and texts through such a conception of photography is the subject of the next chapter.

2

FALSE PORTALS

While the plasticity of photography as practiced and displayed in the print media in Shanghai during the 1920s and 1930s blurred rather than enforced the boundary between likeness and abstraction that Feng Zikai and Zong Baihua insisted upon as dividing Chinese images from the photographic, for both Feng and Zong the force that enabled a break from likeness to abstraction was enlivenment (*shengdong*). As I showed in the previous chapter, Zong Baihua's account of early Chinese pictures — in which he figures the dissolution of likenesses into dynamic lines and patterns across a pictorial surface as a kind of dance giving rhythmic life to an image — suggests that for him, enlivenment is a formalism that does not so much structure as animate a surface. Similarly for Feng Zikai, the independence of line in Chinese and modernist painting from the delineation of depicted forms leads not to a formalism but rather to a "deformation," a mutation of depicted persons and objects. Enlivenment, that is, awakens images from a fixed formalism as much as it awakens them from the "deadly work" of realism. For both critics, this turn away from delineating the forms of depicted objects within the virtual space of a picture and toward an emphasis on line, pattern, and form is a turn toward the surface of a picture: the pictorial surface, that is, becomes the crucial site for thinking abstraction as enlivenment.

This conception of an image as not primarily a window onto a visual representation but rather an abstract and opaque surface was, of course, as the painter Li Zhongsheng called it, a key "point of departure of twentieth-century painting."[1] In a 1934 text, Li articulates some of the surficial and spatial qualities of pictures by differentiating between the "visible" (*keshiwu*), or objects (*wu*) that can be seen by the eye, and the "visual" (*keshidide*), a

"pure vision that is not only psychological vision, and is not physiological vision, but simply indicates pure seeing" — a seeing, that is, abstracted from its embodiment in mind and eye — an abstraction from the body as such.[2] This sense of the visual manifests itself in art in the form of "painterly" (*huihuadide*) pictures, which, Li explains, are not concerned with the "likenesses of external objects" (*waiwu de xingsi*) or the "transcription of appearances of objects" (*moxie wuxiang*) that constitute the "visible." Rather, the "occasion for painting, seen concretely, is the pictorial surface [*huamian*]. The goal of 'painterly' painting can be considered as being concerned entirely with matters of surface. No matter how exquisite the painting or the kinds of painterly thinking involved, none of it can be manifest [*biaoxian*] beyond the pictorial surface."[3] Following this logic, "the goal of painting is absolutely not the material bodies depicted" but a space, "a depicted arena [*bei miaoxie de changsuo*]. . . . When an artist faces a particular thing, he does not initially see it in individual parts; what is projected into his spirit must be the thing as a totality. This is what we call direct observation [*zhiguan*]."[4]

What Li considers to be the fundamental assumption of twentieth-century painting is highly reminiscent of the aspects of pictures Feng Zikai and Zong Baihua most valued in their texts, a form of visuality that is understood not to be located in the eye's apprehension of the external appearances of individual objects but rather to be a form of visual thinking that operates across the totality of the material surface of a picture. In Li's account, however, such direct observation does not lead to enlivenment — a term that does not appear in his text. The concept that instead underlies Li's decoupling of vision from materiality, the "visual" from the "visible" — namely, the "painterly" — is clearly drawn from the art historian Heinrich Wölfflin's once-influential concept of "das Malerisch" (the German term appears in Li's text alongside his Chinese translation, *huihuadide*). As Li along with other artists and critics of his generation in China would have read, Wölfflin constructed a binary opposition distinguishing the "painterly" from the "linear," which he claimed to be not only two differing styles of painting but different forms of vision. "Linear style sees in lines," Wölfflin wrote. In linear vision, "the sense and beauty of things is first sought in the outline . . . [and] the eye is led along the boundaries and induced to feel along the edges." A painterly style, by contrast, sees in masses; "the atten-

tion withdraws from the edges . . . [and] the outline has become more or less indifferent to the eye as the path of vision."[5] The linear, that is, is a tactile mode of seeing and picturing (Li's "visible"), while the painterly produces what Wölfflin calls a "visual picture."[6] As a result, in a painterly picture, "not the separate form but the total picture is the thing that counts, for it is only in the whole that that mysterious interflow of form and light and colour can take effect, and it is obvious that here the immaterial and incorporeal must mean as much as concrete objects."[7]

Wölfflin's binarist schema addresses the manner in which persons and objects represented within a picture are depicted, and his analysis begins with an opposition between Albrecht Dürer (representing the linear) and Rembrandt (representing the painterly). But if we shift our attention from the objects represented within the virtual space of a picture to the differing manner in which the surface of a picture is addressed, a paradox emerges. For in depicting the tactile qualities of represented objects, a linear style must assume a certain transparency of representation: the surface of the picture, in other words, must be treated as if it were something to be seen through, as if it had no tactile qualities of its own. A painterly style, on the other hand, may withdraw its attention from the tactile qualities of represented objects, so that "not the separate form but the total picture" is what counts, and "the immaterial and incorporeal must mean as much as concrete objects." But this withdrawal from a tactility of representation can imply a greater tactility of pictorial surface: at a certain extreme a picture is treated not as a transparent window onto a three-dimensional world but as a flat, opaque surface. Hence, while Wölfflin's own range of reference addresses painting before the twentieth century, Li Zhongsheng grasped the implications of Wölfflin's schema for modernism, assuming that a "pure seeing" takes place across the totality of a pictorial surface. "The tactile picture has become a visual picture," Wölfflin declares of a transition from the linear to the painterly. But if one considers modernist abstraction's treatment of pictorial surface, surely it is the visual picture that has become the tactile picture.[8] Indeed, years later, Clement Greenberg would invoke Wölfflin's concept of the painterly to create a genealogy for the abstract expressionism of Jackson Pollock and others, opining not only that abstract expressionism might be more accurately called "painterly abstraction" but

also that "abstract art itself may have been born amid the painterliness" of the early twentieth-century artist Wassily Kandinsky, among others.[9]

It is a notable feature of Li's conception of abstraction as the materialization of a pictorial surface, however, that it depends upon the dematerialization of bodies: both the "physiological vision" of the painter and viewer, and the "material objects" that a modernist painting does not so much depict as dissolve into its surface. Such a dematerialization or even evacuation of bodies and objects in the abstracting of surfaces, or in pictures in which the immaterial and incorporeal are as important as or even more important than concrete objects, was a common feature, as this chapter will show, of a formalist, modernist urban photography displayed prominently in illustrated magazines like *Liangyou huabao* (The young companion pictorial). And yet, another common feature in illustrated magazines, the comparative layout, explores how the juxtaposition of images (such as the Great Wall and Broadway, or lotus blossoms and puppet shadows) could create unlikely comparisons both based upon and abstracted from the visible forms depicted in such images. Such a mode of abstraction, far from being based upon the evacuation of objects, bodies, and spaces, suggests instead their interchangeability, deformation, and mutability. While this redefinition of abstraction in illustrated magazines as mutation and transformation seems to resonate with Feng Zikai and Zong Baihua's conception of abstraction as an enlivenment of pictorial surfaces, it took place through an ongoing renegotiation of the relations between opaque picture planes and depicted urban and global spaces that was, crucially, staged upon photographic surfaces.

As I will argue in the following pages, this transformation of photographic transcription into a process of enlivenment became one of the fundamental projects driving modernism in Shanghai. This was the case both in the production of modernist images and, as I shall begin to show at the end of this chapter, in modernist conceptualizations of language. In both illustrated magazines and modernist literary journals, language was set in uneasy relation to images specifically conceived of as opaque, material, and mutating surfaces—the aspects of images that, paradoxically, most resist translation into verbal form.[10] At stake in all such enlivened abstractions was a treatment of the surface of an image, and the pictorial surface as a

literary figure, not as a window but as a false portal. Such abstraction did not, as Henri Lefebvre put it in another context, homogenize space and reduce the real to the "flatness . . . of an image" (as was arguably the case in the formalist urban photographs printed in *Liangyou huabao*).[11] Rather, in its practice in modernist images and texts in Shanghai, abstraction opened objects, bodies, and spaces to contradiction and critical difference. As shall be seen in part II, such a complex of ideas about images informed modernist conceptions of the past, of cultural geography, and of ethnicity and cultural difference.

Pictorial Surfaces, Urban Spaces

Among the many photographs depicting the urban spaces of Shanghai that appeared in *Liangyou huabao*, there threads a significant number of pictures that insistently elicit a language of formalism. This insistence is in part the work of the pictures' titles, which refer not to specific urban locations but rather to *Walls and Corners* (Wujiao qianggen), for example, or *Geometry* (Jihe). But most of all it is the work of the photographs' compositions, which compress or even collapse figure and ground, dissolving the forms of urban spaces into abstractions of points, lines, and planes on their pictorial surfaces. The photographs, of course, are not representations of an urban abstraction that was inherently there to be seen in Shanghai or other cities. Rather, the compositional strategies of such photographs, and the relationships between the picture plane and represented urban spaces they proposed, became practices for engaging with, resituating, and mediating a variety of urban sites, rendering those sites equivalent in the printed spaces of illustrated magazines, and treating disparate urban spaces as homogeneous images. To come to terms with the stakes of the pictorial thinking embodied in these images will necessitate following for a few pages the formalist logic of their compositions and the contemporaneous discourses that situated them.

The title of a photograph like *Wujiao qianggen* (given the English title *Walls and Corners*; figure 2.1), by the pseudonymous Leng Can, printed in 1928 in one of the earliest issues of *Liangyou huabao*, abstracts the image from the specificities of place (presumably Shanghai). In the image, the hard

nesses that appear within the tableau [*huamian*]."[18] Chen calls attention to such photographs' staging of the conjunctions of represented space and pictorial surface as itself a kind of material space through his repeated use of the term *huamian*. In a number of the texts I have been considering, *huamian* can mean tableau, picture plane, or pictorial surface; Chen's text plays off of these multiple meanings, and at times the term even shuttles between these meanings within a single paragraph. Indeed, both Chen's text and, as I have been arguing, the urban photographs in *Liangyou huabao* and elsewhere are structured upon just this ambiguity and tension between *huamian* as tableau, or virtual, depicted space, and *huamian* as pictorial surface. The likenesses of depicted bodies and forms are dissolved or abstracted into the surfaces depicted in a photograph even as the tableau as a whole is collapsed into the picture plane.[19] Paradoxically, however, the street in a photograph like *Geometry* is brought up close to the picture plane by depicting it from a considerable distance. Distance, that is, makes the street proximate. In a manner quite the opposite of the extreme close-ups of the photomicrographs published elsewhere in *Liangyou huabao*, the abstraction of the urban landscape in these photographs depends on such distancing. Distancing is what reduces bodies to points and makes those points appear to be contained within the lines of the streetcar tracks. But such distancing and containment is also what makes locations in Paris and Shanghai equivalent as geometric abstractions.

The tensions between such pictorial practices and the places they represent become particularly fraught in a 1932 photograph by one Liang Huang, *Shizi jietou* (At the crossroad; figure 2.4). In subject matter and its figures Liang Huang's photograph is quite similar to the repeated, rhyming forms of *Geometry*, which had been published four issues previously: the empty space of a pavement marked by circles (a platform for a traffic policeman and its shadow in Liang Huang's photograph, a traffic circle with lamp and the curving streetcar tracks in *Geometry*), human figures, cast shadows, and lines (parallel power lines in *At the Crossroad* replacing the parallel tracks in *Geometry*). But Liang Huang filters all these elements through a pictorialist softness more reminiscent of *Walls and Corners* than of the sharpness of line and form in *Geometry*. Furthermore, he transforms these elements by reframing them within an almost entirely blank space, the clutter and busy-

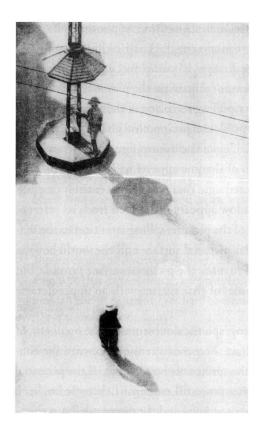

ness in *Geometry* here mostly erased and the elements that remain, particularly the pedestrians, appearing calm, almost stilled. Indeed, even more than was the case in *Geometry*, the figures here are more markers of the blank surface rather than distinct human forms in motion or activity. Even the "crossroad" that the title claims to be the subject matter is literally beyond the picture's frame. That is, the emptied abstraction of the picture is also built upon the emptying out of urban space it depicts, so that the space of Shanghai appears silent and placid — not only empty of the bustling traffic of streetcars, cars, rickshaws, and pedestrians that crowded so many representations of Shanghai at this time but also empty of, one might go so far as to say, the strife such traffic so often manifested at that time, that is, empty of the contingency, the ceaseless transformation of the lived history of the streets. By making contingent arrangements of the street surface, bodies,

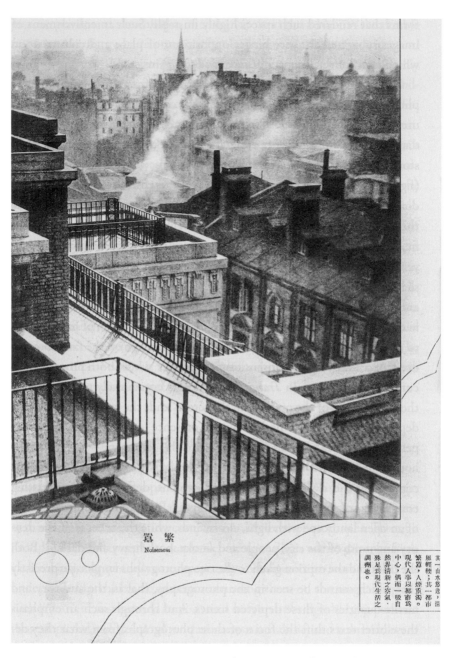

繁　囂
Noiseness

其一山水悠遠，活
趨輕快；其一都市
繁囂，人煙重濁。
現代人事以都市爲
中心，偶而一吸自
然界清新之空氣，
殊足爲現代生活之
調劑也。

FIGURES 2.5 AND 2.6 Lang Jingshan, "Lang Jingshan meishu
sheying zuopin/Artistic photographs by C. S. Lang: *Fanxiao* [Noise] and *Youyi*
[Tranquillity]," *Liangyou huabao* 63 (1931).

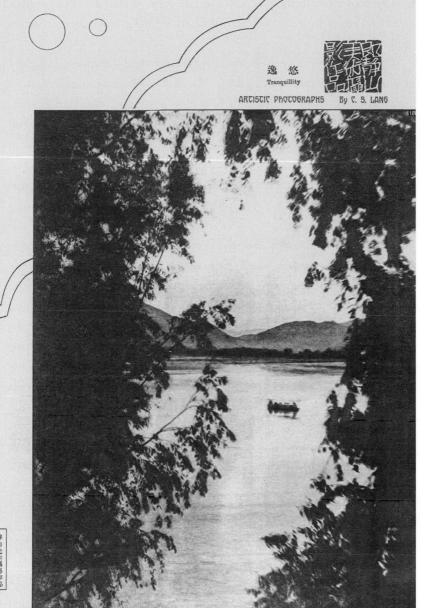

悠 逸
Tranquillity

ARTISTIC PHOTOGRAPHS By C. S. LANG

from reference to specific places and situate them instead within a contrast in which they represent two clearly defined, separate, and opposing senses of place.

While variations of such comparative layouts were common in a variety of illustrated magazines, in *Liangyou huabao* this feature appeared at its most simple and emphatic: each layout composed of two facing pages forming a comparison of two photographs, each of which occupied the full space of a single facing page. Given the large size of the magazine, it was rare for photographs to be printed on such a scale. But as the first appearance of this feature in 1930 seemed to promise (figures 2.7 and 2.8), the two-page layout offered a clear-cut visual binary opposition, and it did so through offering a view that seems to pass through the flatness and opacity of the picture plane as if through an open portal—literally in this first instance—and into the seeming depth and clarity of the kind of cultural, geographic, and temporal differences that could be represented through comparison. As the caption insists, these two photographs, of the Great Wall of China and of lower Broadway in New York, "are not independent photographs but rather have each other as their counterparts."[32] And it is through this interdependence that they "create a contrast of ancient and modern, Chinese and foreign. Eastern civilization is broad, open, and vast, manifesting a meditative and leisurely atmosphere, while Western civilization is vertically imposing, manifesting scenes of worldly affairs and commerce."[33]

It is the very interdependence of the two photographs, the text claims, that creates the terms of their contrast: like any binary opposition, that is, the meaning of each seemingly absolute and essential and unique term ("ancient and modern, Chinese and foreign") depends for its identity upon the opposing term. And the parallelism of the photographs is reinforced by the parallelism of the text, a contrast between the meditative and the frenetic reminiscent of the two kinds of atmosphere in the Lang Jingshan layout, only now the same contrast between country and city, and the "balance" the text asserts they create for modern life, are resituated in a contrast and competition between the ancient and the modern, the Chinese and the Western.

As the critic Fu Lei argued in his essay, "Wenxue duiyu waijie xianshi di zhuiqiu" (Literature's pursuit of the external world's reality; 1934), how-

ever, not only the terms of such comparisons but the very form of "the comparison" as such created "novel stimulations" (*xinqi ciji*), which he believed to be definitive of modernity. For, as Fu Lei elaborated, the comparison

> can lead readers to look at realms far more distant than those that can be investigated directly. . . . In the past, people used the comparison in order to expand their material field of vision, but in the present, however, it is this shrinking and narrowing that make the objects of comparison even more distinctive. . . . "The comparison" does not begin from obvious and particular points, but rather draws upon images with the most familiar or crude of surfaces in order to reach (or return to) the particular.[34]

The comparison, that is, is not simply "reflective" of modern experience; rather, precisely through the juxtaposition of two disjunctive images made possible through new print technology, it *produces* a central modern experience, namely, "stimulation" (*ciji*), a term frequently associated with modernity, particularly in Shanghai, in the media culture at this time.[35] This experience of novelty, however, does not necessarily arise from the strange or the unfamiliar but rather from the juxtaposition of the most familiar and mundane of images. Furthermore, the specific nature of the stimulation is here conceived of precisely in spatial terms: as a bringing of distant images together into close juxtaposition through a collapsing of the space that presumably separates their original contexts. And the stimulation is sparked not by the "particular points" within either of the images but rather through a sense of the particular that is inherent in neither image but is sparked through the collapsed space and resulting intensity of the "interdependence" of disjunctive images that lies both between and beyond them.

Such comparisons in illustrated magazines, I want to argue, were a vernacular form of such modernist practices of juxtaposition as montage.[36] Their appeal may have emerged out of experiences of disjunction between country and city or China and the foreign or even, as Ernst Bloch called it at this time, the "simultaneity of the non-simultaneous," the idea that an experience definitive of modernity is the simultaneous experience of disjunctive historical moments, collapsed together in space (visualized in the layout in figures 2.7 and 2.8 as the simultaneity of the "modern" and the

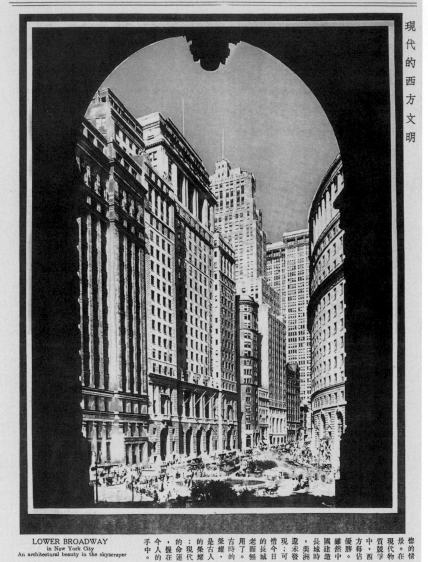

現代的西方文明

LOWER BROADWAY
in New York City
An architectural beauty in the skyscraper

手今，的；的是榮右用右老的惜現邊，長國雕優方中質現景惕
中人擢的現命耀時了耀老面今；未美城建然勝每，競代。的
。的在運代時人，人城日可發洲時造中。佔西爭物在
於的，榮右榮，的。無城日可發洲時遷選中。佔西爭物在

FIGURES 2.7 AND 2.8 "Gudai de Dongfang wenming/
Xiandai de Xifang wenming" [Ancient Eastern civilization/modern
Western civilization], *Liangyou huabao* 46 (1930).

古代的東方文明

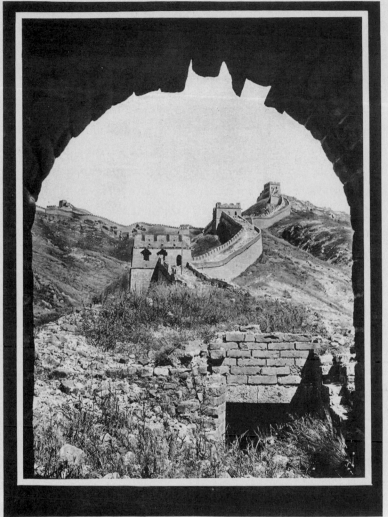

THE GREAT WALL
of China
A wonderful achievement of human labor

上圖是萬里長城，所刊是本頁左角，高約數十尺，綿長數百里，是我國最老的城垣遺路匯闊，可並馳，偶無遺漏，獨有一幅照片可作古今中外的對照。東方文明表現着宏壯的氣象，悠逸的高明；西方文明表現着縱的是人事俗着，表現的明。

"ancient").[37] Indeed, given the prevalence and even repetition of such layouts, they arguably captured through their very abruptness an experience that felt so sudden that conventional narrative could not articulate it—or at least so it was argued at the time, a point I will return to in chapter 4. The effect of collapsing the "spaces between" in such layouts, however, blanked out any sense of transition, change, process, or history mediating two images. Such layouts, as Fu Lei observed, produced this sense of disjuncture and produced what appear to be the hard-and-fast distinctions between the two images, precisely through this visual form.

Disjunction and difference, however, also depended upon an assertion of similarity. But it was a similarity based, in Fu Lei's terms, not upon the obvious, particular subjects of the images per se but rather upon the images' surfaces or surficial appearances (*waibiao*). In a layout like the comparison between the Great Wall and Broadway, such similarity through attention to surface was created through the composition of the photographs. As Andrew Jones has observed of this layout, "The sloping uphill curve of the Great Wall mirrors the contours of the skyscraper on Broadway, while the horizontal crenellations of its defensive emplacements seem to mimic the windows punctuating the skyscraper's vertiginous walls."[38] The composition, that is, connects the contours and textures of these divergent walls, creating a mimetic relationship between the qualities of their surfaces. At the same time, however, the composition literally foregrounds the relations between the photographs' depicted depths and their pictorial surfaces through their particular mode of framing, even as the framing also works, as Jones argues, to transform these built spaces into "civilizational synecdoches" of "East" and "West." For "the porticoes in these pictures simultaneously enclose and disclose the places in the pictures, distancing the viewer just enough to allow for the interpretative transformation of these buildings from specific sites to synecdoche, while at the same time opening a visual passageway between the civilizations and histories they have been enlisted to represent."[39]

The depiction of the porticoes in these photographs, that is, literalizes the claim the layout makes that these images are transparent portals onto the worlds of difference they depict, framing the particular identities of these places within the terms of the (civilizational) comparison. And yet,

transformed as they are into silhouettes abstracted from surface detail, the porticoes are brought up so close to the photographs' picture planes that they also call attention to the surfaces of the photographs themselves not as transparent portals onto three-dimensional spaces but as opaque and flat. And such portals do not so much offer what Kandinsky called a "plunge into the outside reality," providing entry into the built spaces they represent, as they gesture toward the abstracting power of the pictorial surfaces as such, whose formalist layout in the present case appears to abstract what Fu Lei called the "particulars" of the images into the universalist claims of civilizational difference.

If such comparative layouts promised a view of fixed and stable binaries through their portals, however, that promise was almost immediately undermined in the second layout in the series (figures 2.9 and 2.10), which appeared in 1930 in the issue immediately following that with the Great Wall and Broadway layout. For in this layout's comparison of birdcages and lotus leaves, the appeal to civilizational synecdoche to provide meaning for the relationship between the two photographs has of course been evacuated entirely, leaving only a play upon the similarity and differences between the surfaces of the images. Indeed, the identical, laconic captions for both of the photographs — "a complex yet harmonious design photograph" — identify them as variations on the vernacular abstraction of design photographs (tu'an sheying) examined in chapter 1.[40] Hence their juxtaposition links them only through the visual rhyme of the circular forms of lotus leaves and cages, a linkage that calls attention to their differences. For the flatness of the lotus leaves, each rimmed with reflected light, and the dark, featureless, opaque water to which they adhere both flatten the depicted space against the picture plane. As in numerous other design photographs, tableau and picture plane collapse into a surface with little suggestion of depth, this flattening enabling the transformation of the depicted forms. The angular placement of the cages in the other photograph, however, emphasizes their schematic three-dimensionality, while their mostly silhouetted figures, suspended with no clear orientation of up or down, and their lightly projected shadows visible through the bars, leave the depicted space of the entire photograph, for all its rhythmic clutter, light and airy and of ambiguous depth. As the eye shuttles between the forms of lotus leaves and

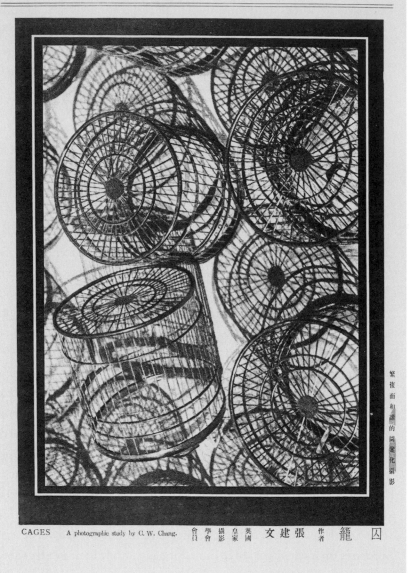

CAGES　　A photographic study by C. W. Chang.　英國皇家攝影學會會員　張建文　作者　囚籠

FIGURES 2.9 AND 2.10 "Fanfu er hexie de tu'anhua sheying"
[Complex yet harmonious design photographs], *Liangyou huabao* 47 (1930).

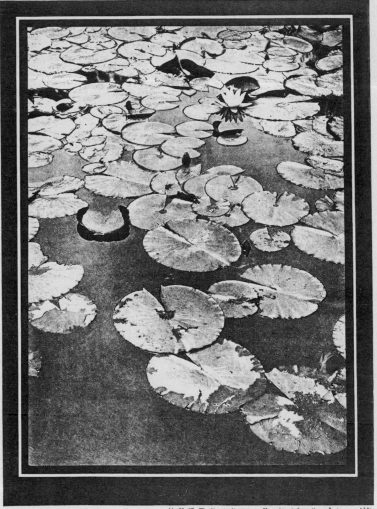

繁複而和諧的圖案化攝影二

A POND OF LOTUS　Photo by Sinroll Chung.

日本高等工藝專門學校攝影科高材生

作者　蓮沼鍾辛茹

cages abstracted by these design photographs, then, the surface and opacity of the lotus leaf photograph are transformed into the depth and transparency of the cages, even as that depth and transparency remind the viewer that these very qualities which one might associate with water are precisely what is obscured in the depicted water of the pond.

The abstraction of these layouts, then, does not remove ambiguity and contradiction in order to assert clearly defined essences but rather creates ambiguities through juxtaposing and connecting distant and random realities for comparison. Indeed, a subsequent layout in the series makes explicit this instability of forms (figures 2.11 and 2.12) — and an instability not only created through the physical and conceptual space between two images but now staged explicitly within each photograph. On the right is the figure of a fisherman, formed of the projected shadow of a hand that is itself largely depicted by the shadow attached to its own skin that makes of it a silhouette. On the left is the figure of a woman formed of a photograph of a lotus flower and leaves turned on its side. The basis of comparison and transformation between the two photographs here is not thematic, as in the Great Wall–Broadway layout, or formal, as in the lotus leaves and cage layout. Rather, the basis of comparison is mutability as such, as created by images formed through projection — whether a hand is transformed into a fisherman through its shadow, or a lotus is transformed into a woman through photographic processes of soft focus, projected light registered on black-and-white film and paper, cropping, and rotation. What the images depict (a fisherman, a woman), that is, is detached from what the images actually show (a hand and shadow, a lotus), while the layout as a whole demonstrates that the work of comparison as such is necessarily detached from the mimetic, resemblance or likeness, and is rather based in the mutability, not the essential stability, of forms. Furthermore, these photographs seem to claim, this process of the transformation of nonsentient, concrete realities into projected images brings their mutating forms to sentient, human life, such as the hand brought to life in shadow form. Indeed, if, as Feng Zikai had complained, an excessive attention to the materiality, surfaces, details, and likenesses of things created dead images, while abstraction from materiality in Chinese painting and Kandinskian modernism brought images to life,

these photographs detach formal likeness from the materiality of things precisely through the picturing of surfaces; indeed, the very enlivenment of these images depends upon such materialist abstraction. Photographic processes, as a subsequent layout would declare in an amalgam of Buddhist rhetoric and reference to the Midas touch, "touch stone and transform it into gold" (*dian shi cheng jin*); through composition, the use of appropriate light, and an "eye of penetrating insight" (*huiyan*), a photographer can "make physical bodies transcend the mortal world and enter the sacred."[41]

But the enlivenment, or even reenchantment, of objects that this practice so persistently imagined had another quality: their gendering. If a lotus flower and leaves could be photographically transformed into the head and torso of a woman, then, as was demonstrated in another comparative layout published in 1935, "Wanwu de nüxing biaoqing" (Expressions of the feminine in myriad things; figure 2.13), the imaginative investment of the forms of everyday things (such as ducks, a lamp, a leaning tree, a camel, and a leaning pagoda) with feminine form is based in the abstraction of "feminine form" from women and the most literal-minded objectification of gender. In still other layouts, groups of women are transformed into flowers paired with didactic captions about the brevity of life and the value of hard work, purity, and subservience, or arrayed into snow crystals and labeled as abstract "designs" (*tu'an*; figure 2.14).[42] Now it would be belaboring the obvious to say that women are repeatedly objectified, abstracted, and transformed in these layouts in ways that men are not, although that is certainly the case. But taken together, these comparative layouts do suggest that, when they are gendered at all, the abstraction, transformation, and instability of images and the forms made visible through images — indeed, mutability as such — were gendered female. Furthermore, the images that are enlivened or even seem to have lives of their own and which, in their unfixity and mutability seemed to threaten a sense of stability, clarity, and order, were almost always gendered female. And while such transformation in the illustrated magazines was at best objectifying and at worst misogynistic, a critical refunctioning of opaque, mutating, and living images, gendered female, would animate some of the first experiments with modernist fiction in Shanghai, as shall be seen in chapter 3. Indeed, much of this fic-

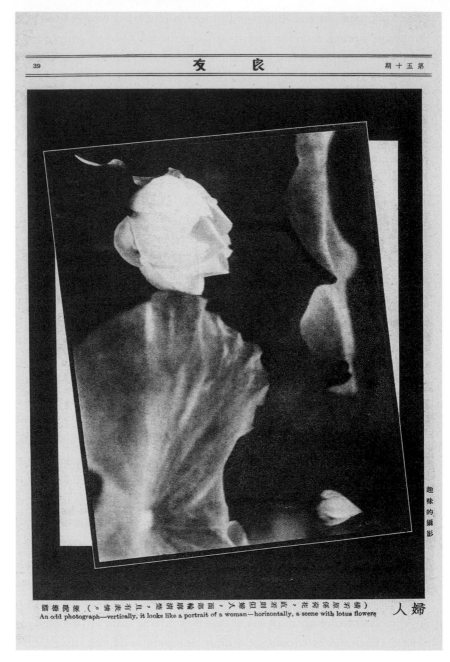

趣味的攝影

攝德昂陳　(　。奇　有　且　趣　清　淸　顯　更　而　，　人　婦　似　則　置　倒　，　花　荷　係　原　幀　一此　)

An odd photograph—vertically, it looks like a portrait of a woman—horizontally, a scene with lotus flowers

婦人

FIGURES 2.11 AND 2.12 "Quweide shcying" [Curious photography],
Liangyou huabao 50 (1930).

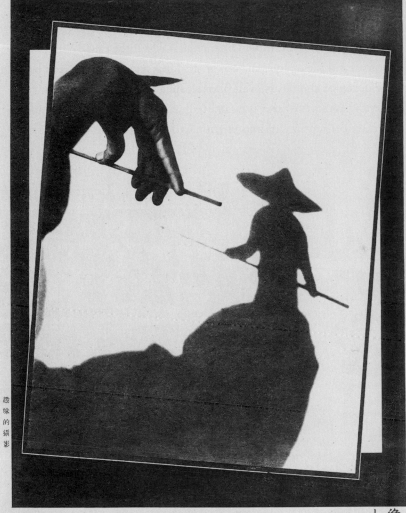

攝僧唐　　　　A fisherman, (a hand formation in shadows)　　　（壁上手影）　漁人

tion, as well as the experimental photographs and paintings that were its contemporaries, radicalizes a possibility that the *Liangyou huabao* layouts suggested but did not allow. For it is composed of images whose opacity and projection onto surfaces, mutability, and enlivenment were produced out of comparison and difference, but which then destabilize some of the fundamental differences of past and present and geocultural space structuring the ideologies of modernity in Shanghai. It is as if the mutability of the lotus-woman and the opaque surface of the lotus pond could be read back onto the portal of the Great Wall photograph. But before considering in subsequent chapters how this was so, I will close this chapter by considering how these conceptions of images animated modernist ideas of language.

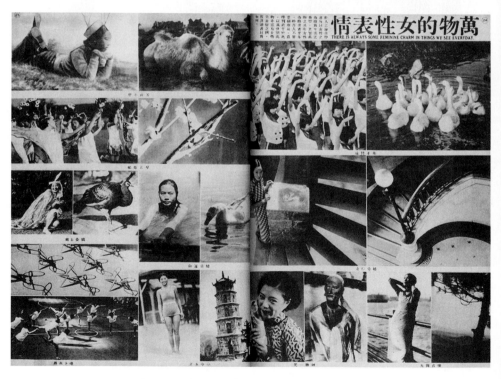

FIGURE 2.13 "Wanwu de nüxing biaoqing/There Is Always Some Feminine Charm in Things We See Every Day" [Expressions of the feminine in myriad things], *Liangyou huabao* 102 (1935).

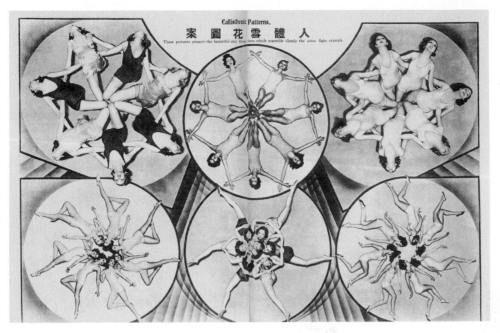

FIGURE 2.14 "Renti xuehua tu'an" [Human bodies forming snowflake designs], *Liangyou huabao* 76 (1933).

Beyond Words

Given their format, in which writing and images were considered in close proximity, illustrated magazines were crucial sites for the reconceptualization of language in the context of the image culture I have been describing. In most of their layouts texts play an important role, whether as titles or longer captions, but the emphasis is always on the images themselves, with the texts functioning to direct or mediate their placement and reception. Some layouts, however, made the relationships between images and language as such their central focus. Layouts such as "Juemiao xingrongci tujie" (Pictorial interpretations of ingenious turns of phrase; figure 2.15), appearing in *Liangyou huabao* in 1935, sought a one-to-one correspondence between the figurative language of a quoted text and a photograph that literalizes what in the text is figurative (as, for example, in figure 2.16). Yet while such a layout seemed to claim a greater directness for the image

than the text it interpreted, the seeming literalness of the image arguably depends on the text's simile to make sense of the relations between depicted elements such as the clock and scissors. A layout appearing in *Dazhong* (The cosmopolitan) in the same year purporting to put "letters under the X-ray" (figure 2.17) imagines a different relationship between image and text. Here the opacity of the envelope's paper and ink is made transparent by an imagined X-ray process. But what such a process pictures are not the material forms of the letters inside—which remain invisible within the layout—but photographs of either the recipients of the letters or the situations described within them; the texts of the letters are reprinted outside the pictures, as captions. In other words, the material surfaces of writing are rendered transparent and invisible by the visual technology of the

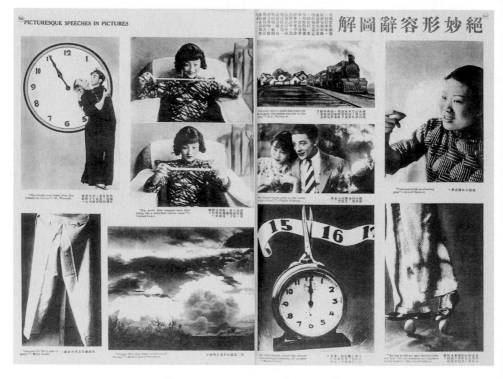

FIGURE 2.15 "Juemiao xingrongci tujie" [Pictorial interpretations of ingenious turns of phrase], *Liangyou huabao* 103 (1935).

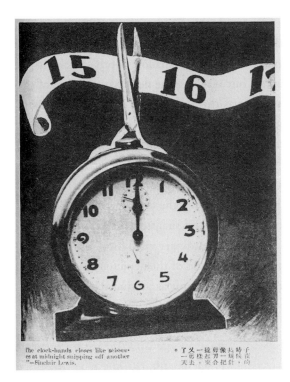

FIGURE 2.16 Detail from "Juemiao xingrongci tujie" [Pictorial interpretations of ingenious turns of phrase], *Liangyou huabao* 103 (1935).

X-ray, the layout seems to suggest, while at the same time writing is both literalized as image and displaced beyond the envelope and image entirely.

If such layouts asserted a power of imaging to make transparent what is concealed within a text's figurative language, another photograph published several years earlier and the caption for the layout of which it is part connects the opacity of an image to the silence of language (figure 2.18). The caption itself is quite banal: "Silence is the most beautiful of words, silence is the most sincere [form] of speech. . . . Because words float in hyperbole, the only thing that can expose the deepest and truest feelings is silence."[43] The photograph, a silhouette of a perching bird, would be as banal as the caption, were it not for the blur that fills most of the image. A slight background blur does appear in many photographs published in the print media in Shanghai at this time, but this photograph, which, at half a page in size, is printed larger than most photographs in *Liangyou*

promise of a new form of seeing both utterly accurate and transparent seems to have resonated with conceptions of realist literary writing in the 1920s and 1930s, practitioners and critics of literary modernism in Shanghai repeatedly figured verbal images through a rhetoric of the materiality of visual images and new image-making technologies and practices. Fu Lei's essay which I cited earlier is an exploration of the conditions of literary modernism, particularly surrealism, in the context of new media technologies and the materiality and abstraction of images. Indeed, the starting point for his reflections on the purpose of modern literature is very close to the assumptions about images manifest in the layouts of illustrated magazines as well as in texts as various as those of Feng Zikai and Li Zhongsheng. "If we can admit that one of modern literature's important responsibilities," Fu Lei writes, "is to discover within reality phenomena as yet unseen, then we should expect the gestation of new and stimulating [*xinqi ciji*] forms" in order to do so.[44] In its rhetoric of the unseen and of stimulation, Fu echoes one of the expressed goals of the print media — the extension of perception — even as he goes on to call attention to precisely that which the illustrated magazines both repeatedly manifest and disavowed: the irreality, materiality, and abstraction of photographic representation. Considering the break with similitude in modern painting, Fu comments that "even a photograph taken of a moving [*shengdong*] object can leave one at a loss for explanation," while a film seen in slow motion can reveal that which is beyond ordinary perception.[45] In Fu's text, that is, photographic images serve as a model of images that do not resemble that which they depict; and much of his essay is devoted to exploring how language might, through the use of "new and stimulating forms," be reconceived photographically. For, according to Fu,

> people no longer depend upon the [practical] functions of language in order
> to represent before our eyes a realm of fantasy or memory; rather, they seek
> a flash of illumination that for a fleeting moment penetrates the darkness;
> in this way we feel as if we were touching the innermost core of nature with
> our fingers; the essential elements of objects are thus truly revealed — this
> should precisely be called revelation, because now this is not at all the work
> of the spirit ... but rather is the work of direct perception [*zhijue*], taking the

"truth" of things concealed within language when it is unbroken and displaying it right in front of our faces.[46]

If the unseen lies concealed within ordinary and functional uses of language, and if "there is a permanently close relationship between thought and syntax," Fu's argument goes, then by fragmenting language, separating every word in a text from the others — that is, breaking them free from the mediation of the syntactic and narrative logic of functional uses of language — words "can embody a fullness of meaning and possess the entirety of their powers of stimulation," or even shock, flashing with the momentary light of revelation.[47] "Ever since the simplest elements of inner life gained a new valuation, the simplest elements of speech — words — have come to assume an unexpected position in literature. A word is actually closely responsive to perception — it impacts us in the same way, and can transmit a perception almost like a photograph, completely in accord with it, and preserving all its suddenness."[48] Words become like photographs, revealing the unseen and transmitting perceptions, when they are treated as nonmimetic — not, that is, treated as linguistic elements joined within a conventional narrative logic but rather as tactile and visual images, materialist abstractions, cut apart and reconnected through a photographic logic of projection and juxtaposition.

Although its range of reference draws primarily upon the modernist French literature with which he was most familiar, in the context of Shanghai modernism Fu Lei's text could be read somewhat retrospectively, as it appeared toward the end of the experiments with abstraction and comparison in illustrated magazines like *Liangyou huabao*; it also appeared toward the end of several years of literary experimentation by Shi Zhecun, Mu Shiying, and others. For the thinking of writers, translators, and editors of literary modernism such as Shi Zhecun, Liu Na'ou, and Mu Shiying about the composition of texts was persistently animated by conceptions of images as marked and opaque, tactile and projected, bodily and enlivened surfaces that transform that which they depict. Numerous texts published in modernist journals such as *Xin wenyi*, *Xiandai*, and *Wenyi fengjing* often question, if not completely subvert, realist assumptions of transparency by engaging with visual images as material traces with the capacity to be cropped,

fragmented, circulated, recomposed, or juxtaposed, creating new temporal and geographic landscapes and pictorial spaces. Running throughout these journals are ongoing interests in cubism, imagism, and montage. *Xin wenyi* (also given the French title *La nouvelle litterature*), which Shi Zhecun co-edited with Liu Na'ou from 1929 to 1930, included, for instance, translations of the poetry of Mallarmé and an extended essay by the Japanese Marxist critic Kurahara Korehito on cubism, futurism, and Soviet constructivism, and an introduction to Argentinean *modernismo*. Shi's later journal, *Wenyi fengjing* (Literary landscape), which he edited in 1934, included discussions and translations of the work of Gertrude Stein and Ezra Pound, as well as Sergei Eisenstein's theories of cinematic montage. Between these two little journals, Shi — first alone, and then with Du Heng — edited *Xiandai zazhi* (which Shi gave the French title *Les Contemporains*) from 1932 to 1934, in its time the most widely circulated literary magazine in China. Given the large scale of the magazine, as well as the political difficulties of steering between the conservative Nationalist regime and the influential League of Left-Wing Writers, *Xiandai* was not a purely modernist journal and included work of such May Fourth writers as Lu Xun and Mao Dun. But *Xiandai* distinguished itself by featuring the work of modernists in Shanghai and abroad. This included the imagist poetry of Ezra Pound, Amy Lowell, and H.D., which the poet and critic Shao Xunmei described as using "material words" (*shizhi de ziyan*) to create "transparent carvings" (*touming de diaoke*); Evelyn Scott's poetry, which the translator An Yi characterized as using "the methods of design painting" (*tu'an huifa*) akin to the design images we have already seen; montage fiction of Mu Shiying, Liu Na'ou, and John Dos Passos; and texts by the "cubist" writers Guillaume Apollinaire and Pierre Reverdy.[49]

I will examine conceptualizations in Shanghai modernism of imagism in chapter 3, and of montage in chapter 4. By way of closing the present chapter, I want to consider briefly two texts featured in the opening issues of *Xiandai* by Apollinaire, an early critic of cubism whom the translator Chen Yuyue refers to as a "cubist" writer, and Reverdy, whose poetry the same translator discusses in photographic and cinematic terms.[50] Both texts are structured around the relationships in visual images between represented spaces and objects and the materiality of their surfaces, the creation

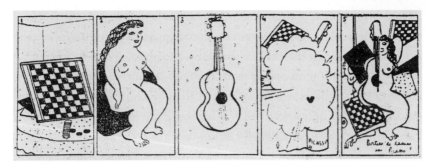

FIGURE 2.19 "Litipai ji litipai yihou gezhong zhuguan hui biaoxianfa biyu tu" [A comparative table of methods of expression in cubist and postcubist subjective painting], *Yifeng* 4, no. 7 (1936).

of which they figure through a depicted or implicit violence to the human body. While Reverdy vehemently rejected the very idea of cubist poetry, both of these writers took a strong cue from modernist practices in the visual arts, particularly the cubist paintings and collages of Pablo Picasso and Georges Braque, with their experiments in simultaneous and multiple perspectives and the fragmentation and flattening of figure and ground.[51] The representational violence of such practices — and their frequent gendering — was depicted in a derisive French cartoon reprinted in 1936 in *Yifeng* (Art wind) with the incongruously pompous caption, "A Comparative Table of Methods of Expression in Cubist and Postcubist Subjective Painting" (figure 2.19).

The Apollinaire text featured in the first issue of *Xiandai*, a short story entitled "La serviette des poètes" (Shiren de shijin), figures the creation of pictures through fragmentation and juxtaposition not of a fragmented body as in the cartoon but rather through the juxtaposition of bodily traces.[52] "La serviette des poètes" tells the story of a painter, his lover, and the four poets they bring together through a single napkin. The painter invites each of the poets to his home for dinner in turn, so that they are never present simultaneously at the table, but he gives them the same napkin to use for each meal without ever washing it and without ever telling them. The text formally underscores the separation of the poets by telling of each visit of a single poet through a fragment of dialogue separated by

a blank space. Because the napkin is never washed, however, and because each poet leaves lip prints, traces of food, and sputum on its surface, it is the materiality of the cloth's surface that links the poets to one another. One poet's tuberculosis, however, spreads through the increasingly filthy napkin to the other poets, and they all die. Their traces, juxtaposed together on the surface of the napkin, create what the text refers to as a "miraculous image" (*shenqi de huaxiang*; *image miraculeuse*) of each of the poet's faces.[53] In keeping with the playfully sacrilegious tone of his book, *L'heresiarque et cie*, in which the story appears, Apollinaire's text calls this napkin a "cloth of St. Veronica," referring to a handkerchief miraculously printed with the image of Christ's face when St. Veronica offered it to him to wipe his face on the way to Cavalry.[54]

In the context of *Xiandai*, the miracle the text stages is a transformation of language into a visual image. Or, put more strongly, this transformation is a creation of a visual image out of the silencing of language, itself figured through the slow violence of a disease whose spread is enabled by a painter. The very materialization of the image in the form of surface markings is what kills the poets. And yet, while the poets leave no apparent verbal trace, and their own bodies are dematerialized by death, it is crucial that the miraculous image they leave behind is composed, in short, of the juxtaposed fragmentary traces of the organs of speech where words, embodied, are materialized. The violence of Apollinaire's text, like the cartoon on cubist methods, calls attention to an important paradox: the processes of image-making it depicts are as physical and tactile as they are visual, shifting the emphasis of a representation from the representation of space to the pictorial surface as a space of representation. Richard Schiff and Jennifer Pap have argued that the new form of vision which cubism's image-making practices afforded was itself the product of an emphasis in modernist painting on the tactile over the visual. As Pap remarks, quoting Schiff, "Modernism has replaced the metaphor of painting as a window onto reality with the 'metonymic exchange between an artist's or a viewer's human physicality, and the material, constructed physicality of an artwork.' . . . If we add to this the changed representation of the human body in cubist painting, we see that the physical being of spectators was challenged along with their habits of viewing."[55]

According to Pap, the consequence of an emphasis on touch over vision would be to "reduce the spectator's sense of control" and, precisely through treating visual images as primarily material objects to be juxtaposed, or as themselves composed of material traces, to dismantle the idea of a viewing subject and viewed location apparently fixed in place by a "transparent image." The image as a window is, through a moment of violence, revealed to be a false portal.

One of Pierre Reverdy's most important poems, "Fausse porte ou portrait" (Jiamen huo xiaoxiang; False portal or portrait), which Chen Yuyue translated and Shi Zhecun featured in the second issue of *Xiandai*, represents this situation as a radical indeterminacy in which a body depicted in a picture, the body of a viewer of the picture, and the pictorial surface are virtually indistinguishable.

> In the unmoving space
> Within four lines
> A square for the play of white
> The hand which propped your cheek
> The moon
> A face illumined
> Another's profile
> But your eyes
> I follow the lamp which guides me
> A finger on a moist lid
> In the middle
> Tears are rolling through this space
> Within four lines
> A mirror[56]

Chen Yuyue's translation:

> 假門或肖像
> 在不動地在那面的一塊地方
> 在四條線之間
> 白色在那兒映掩著的方形
> 那托住你的頰兒的手

Chen's use of metaphors of visual technologies plays on the ambiguity of images as verbal and tactile, immaterial and material. Indeed, he highlights this ambiguity in these metaphors by writing them not through an ocular rhetoric but through a rhetoric of the hand and touch: the word Chen uses to indicate Reverdy's cinematic "technique" literally means "hand and wrist" (*shouwan*), and the images he "captures" with it could also be said to be "grasped" (*zhuozhu*; *zhuo* includes the hand radical). This highly tactile and material conception emphasizes that such brief moments as a passing bird and a gleam of light cannot be made visible through the human eye but can only be captured and held still by the visual and material technology of a photographic snapshot. Visual (and, in one case, aural) impressions that make up Reverdy's poetry are thus made visible by being made material as photographic traces, which then, according to Chen, allow these images to be handled, manipulated, cut and pasted. This conception of verbal images as visual impressions become material traces is what, according to Chen, makes "those things that cannot be captured" become poems. But that is not all. Chen conceives of the power of Reverdy's poetry as deriving from its composition out of a multiplicity of such images. For, in addition to capturing images, the other half of the poems' "cinematic skill" is montage, through whose juxtapositions these fragmentary images create spaces that other kinds of poems cannot: the kind of space glimpsed "through" Reverdy's false portal.

This latter remark of Chen's seems to allude to Reverdy's statement on the composition of an image that, crucially, puts space at its center:

The image is a pure creation of the mind.

It cannot be born from a comparison but from a juxtaposition of two more or less distant realities.

The more the relationship between the two juxtaposed realities is distant and true, the stronger the image will be—the greater its emotional power and poetic reality.[62]

Here, as in "Fausse porte ou portrait," Reverdy's conception of an image is both immaterial ("a pure creation of the mind") and material. This materiality is emphasized by the strikingly constructivist figure Reverdy uses else-

where when he comments that "the poet thinks in unconnected fragments, separate ideas, images formed by contiguity, . . . different parts of the work" which "the poet juxtaposes and rivets."[63] Meaning for Reverdy, however, is created not simply by the juxtaposition of distant realities but within the space created *between* those realities through their juxtaposition. If "meaning for Reverdy . . . is intersticial,"[64] then an effective image does not gloss over or obscure the space or distance or difference between its juxtaposed parts but rather makes that space a structural and even thematic part of an image.[65]

The translation of Apollinaire and, especially, Reverdy in the opening issues of *Xiandai* can be taken as a symptom of widespread conceptions of images crucial to modernist literary and artistic practices in Shanghai: the uneasy conflation of pictorial surfaces and fragmented bodies, and the making of images out of the juxtaposition of projected fragments. Indeed, Shi Zhecun, Mu Shiying, and other modernists seemed concerned less with the idea of an image as "a pure creation of the mind" than with taking quite literally the materialist rhetoric with which Reverdy figures his abstract conception of an image. Or better, for Shi and others, an image created of juxtaposition both was imagined *and* composed a real place. Literally writing and making pictures on a fragmented border space between China and the West—that is, Shanghai—an aesthetic practice founded upon the juxtaposition or joining of different edges or margins, and on the exploration of the spaces between such "distant realities" could enable one to imagine how to put together fragments to represent and even create particular spaces and subjectivities in Shanghai. Constituted of fragmented bodies, the pictorial surface is where place, culture, historical time, global location and cultural geography, the ethnic body, are themselves mediated and constituted. Crucial to such practices was a reconception of both images and writing through photography, a photography not understood to be a transparent window onto the world or accurate reflection or depiction of the world, but rather an understanding of photography as manifest in the practices and discourses I have been exploring in these chapters: photographic images as opaque, tactile, and surficial, making visible the unseen and unmoored from likeness, enlivened through their abstraction, composed out of the collapse and juxtaposition of conceptually and spatially distant realities

3

PROJECTED PASTS

The foundations of the global cities of the present and of cities striving to become global are firmly rooted in the colonial past—whether one considers a metropolitan center like London or cities whose development lies in colonialism, like Bombay, Hong Kong, and Shanghai.[1] Yet it is arguably in all such cities that questions of foundations, roots, and the past are most problematic. Shanghai, for instance, has long been regarded, both in the early twentieth century and in recent decades, as the capital of Chinese modernity. And yet in the present remaking of the city, its multiply colonized past has become a kind of virtual reality; such redevelopment projects as the recent Xintiandi district, in which an entire neighborhood was emptied of its residents, restored to its appearance during the colonial era, and transformed into a shopping and entertainment complex, offer nostalgic fantasies of the past to the visitor as drained of critical understanding as the marshy ground beneath the project has been of water in order to prevent it all from sinking.[2] This perception of Shanghai and its past as a virtual reality produced out of a history of colonialism is, however, hardly new, and indeed was a perception that haunted self-representations of Shanghai at the height of the colonial era during the first half of the twentieth century. The modernist writer Mu Shiying, as I observed in the introduction, described Shanghai's streets in a 1933 text as "transplanted from Europe" and "paved with shadows."[3]

Mu Shiying's words conceive of Shanghai's space as built out of images both projected and circulated from other places. Such images, as I have tried to show in the preceding two chapters, were widely conceptualized as clearly representing realities both close and distant, and were themselves

defined within a distinct and stable global geography; at the same time, such images were shown to be opaque, abstracting, unfixed, and mutating, transforming the realities and spaces they represented as they were themselves detached from or transgressing the borders and boundaries upon which such cultural geographies depended. In short, images were both mutable and mobile, and if place and the past were mediated by—or even, as Mu's text suggests, composed of—such images, then the very idea of the past and its places was rendered fragmentary, mutable, and mobile. Modern nationalist ideologies, as Prasenjit Duara has argued, tried to contain such disruptive fragments within linear historical narratives that figured both the forward development of the nation and an unchanging core of national identity. This essential core was represented through a trope that Duara calls the "stillness of the true," which combined the idea of the old home, a place in the countryside supposedly untouched by historical time and urban modernity, together with the idea of pure women who stayed behind in such homes of the authentic past.[4] And yet such gendered narratives of historical authenticity, articulated both in official discourse and in the print media, were shadowed, even haunted, by images unfixed from place and time.

Shi Zhecun drew together such fragmentary images of mutation and displacement, place and the past, in his story "Mo dao" (Demon's way; 1931) in order to recompose the landscape of Shanghai and its environs out of a global bricolage of fragmented images and texts of various demonic pasts. The neurotic narrator of the story is haunted and gradually deranged by the uncanny persistence of the past into the modern present. The shocks that give rise to his nervous condition derive not only from the alienating pace and mechanization of urban life but also from the rapid and jarring juxtaposition of fragments of different times and places within the space of the modernizing city. The sight of a billboard that blocks his view of the countryside, for example, leads him to look at an old woman in black, whom he fears is a sorceress. This sense of the uncanny simultaneity of past and present, however, is greatly intensified by a weekend trip the narrator takes to the countryside on the outskirts of Shanghai to rest his battered nerves. As he looks out the window of the train, his thoughts run as follows:

Since I've been living in the city, I haven't seen such a broad stretch of natural green fields for so long. Over there, there must be a large earthen mound, rising from the ground. If this were in the Central Plains, there of course would be somebody who could do some textual research and say this is the tomb of Prince So-and-so's concubine of the Such-and-such Dynasty. Then, of course, somebody would go and excavate it. . . . Inside lies . . . the mummy of a beautiful concubine from antiquity, supposing she were to come walking into our city, how it would shock people![5]

The narrator imagines an ordinary hillock to be a tomb containing a royal concubine, a remainder of the past that returns to life to haunt modern Shanghai. The royal concubine's remains, however, appear to the narrator as an Egyptian-style mummy in a scene of excavation reminiscent of a Western horror movie: that is, the remains of the Chinese past are bound in a shroud of colonialist gothic. The narrator intends to stay with a friend in the countryside but imagines himself pursued by the sorceress's shadow and the mummy's image, both of which he projects onto the rural landscape and even onto his friend's wife. He imagines a brief flirtation with his friend's wife but quickly flees, only to find the projected images of shadows and mummies everywhere in Shanghai. Throughout the story, Shi Zhecun represents the anxious experience of the return of a repressed Chinese past as completely enmeshed in a network of globally circulating culture.

Such fiction provoked a strong and telling reaction. Writing soon after "Demon's Way" first appeared, the critic Lou Shiyi denounced Shi as a surrealist and claimed that the obsession with blackness that runs throughout "Demon's Way" is a sign of abnormal psychology, and indeed that the story as a whole is at best an "escape into abnormal fantasies."[6] Such invective was unintentionally accurate in connecting abnormal psychology and an obsession with blackness or, more properly, black shadows, to a consciousness of living between the collapse of the old and the emergence of the new. For while this story has often been read as a case study in the "abnormal psychology" of a modern city dweller, given Shi Zhecun's reputation as a writer interested in Freudian psychoanalysis, in practice Shi uses a particular conception of abnormal psychology to make visible this sense of temporal and spatial dislocation. An article by Guo Renyuan published

in 1927 in *Dongfang zazhi* suggests that in Shanghai at this time, "abnormal psychology" was taken to mean behavior that largely results from an inability to cope with a sudden change in circumstances.[7] What this means, however, is that one's thought and behavior do not tally with — or are even out of joint with — the space, time, and society in which one is located.[8] This sense of spatial and temporal dislocation results in such behavior as a split into a "double personality" (*erchong renge*) — a term Shi often used in his fiction to describe the psychic maladies of his characters — and hallucinations, or literally, "illusory images" (*huanxiang*). Hallucinations, Guo informs us, are "responses that are completely inappropriate to objective phenomena. For example, a patient may frequently hear certain sounds, or see certain people, yet actually those sounds and people are not manifest in their surroundings."[9]

Shi Zhecun drew upon such conceptions of abnormal psychology in order to conceptualize his characters — not, I want to suggest, to "psychoanalyze" them but rather to use such subjective experience as a lens through which to explore the temporal and spatial unevenness of Shanghai as manifest in and mediated by the image culture of this time. Hence it might be better to say that the psychological model in Shi's fiction was not so much one of hidden depths as it was of *surfaces* — that is, not simply a conflict between different layers of the self but a projection of images of depths onto spaces, such as the catacombs and mummy's tomb of "Demon's Way." Freud's classic definition of the uncanny is that which has been repressed in hidden depths and, made strange by the repression, has come back to light to haunt the present.[10] Shi's Shanghai fiction goes further. Shi's characters are indeed haunted by the return of a past estranged by repression, but the depths from which the past returns are entirely *projected* by the characters onto the landscape. In Shi's Shanghai fictions, an identity is built upon, or rather split by, projected images of the past, as a result of being out of joint with time or space — or, perhaps, from a sense that time and space are themselves out of joint.

Shi Zhecun uses these fantastic projections of landscape and the past in order to engage with the cultural condition of colonial Shanghai through appropriating the aesthetic practices of what Lou Shiyi rightly observed was one of Shi's central literary interests: surrealism.[11] Indeed, the abnor-

mal psyche of the narrator of "Demon's Way" manifests the symptoms of what André Breton called "the mind which plunges into Surrealism." "In the shadow we again see a precious terror," Breton writes. "With a shudder, we cross what occultists call dangerous territory. In my wake I raise up monsters that are lying in wait."[12] Shi's fiction traces a surreality not simply in the minds of his protagonists but more crucially in the shadows of Shanghai's modernity, in the form of ruins as well as shadows, uncanny moments, and images beneath or alongside the modern. Shi drew such projected images from a variety of media to imagine the temporal landscape of an apparently pastless Shanghai as a place that was both the modern margin of China and located by the West on the margins of global modernity.

Shi Zhecun's literary project thus shared with the surrealists with which it was contemporary an attraction to what Elza Adamowicz describes as "images already cut off from their original cultural space, images which are defunct or devalued, past or exotic, ephemera whose meanings are eroded through distance, whether topographical, historical, ethnographic or utilitarian."[13] Adamowicz's observation comes in the context of increasing scholarly attention over the past few decades to surrealism not simply as an expression of irrationality but as a form of cultural critique. The locus classicus of this approach, however, is not recent at all, but is to be found in Walter Benjamin's 1929 essay on surrealism, in which he identifies André Breton's "extraordinary discovery" of "the revolutionary energies that appear in the 'outmoded.'"[14] In writings by Breton, Louis Aragon, and others, this outmoded appears within particular places, yet also, as Adamowicz shows, it appears out of place. Thus while Breton identifies surrealism as a dangerous territory of shadows and monsters, Aragon writes in *Paris Peasant* of cities as "peopled with unrecognized sphinxes," and the outmoded sites of a city as creating a "ghostly landscape."[15] One way of understanding surrealism, then, is as the experience of sites of both temporal and spatial displacement. Indeed, as Hal Foster has argued, "The Surrealist concern with the marvelous and the uncanny, with the return of familiar images made strange by repression, is related to the Marxian concern with the outmoded and the nonsynchronous, with the persistence of old cultural forms in the uneven development of productive modes and social formations."[16] Such "outmoded spaces" often appear as haunted, for "the outmoded not

a moment, Shi writes of this picture as if it *were* a photograph of the play's protagonists, suppressing any mention of the obvious fact that these are actors mediating the classical dramatic text and the modern photographic image. Only after this does he gleefully call attention to the photograph's fictionality.

Yet as a photograph, this picture does have a special property. Most commonly, a photograph is the recording, fixing, and development of a physical trace upon a photosensitive surface of an image created through a lens in a camera by light and shadow reflected from something that was actually before the camera at a particular moment in the past.[22] For Shi Zhecun, a photograph is not, as many believed, a transparent and unmediated representation of reality but rather something opaque, both a representation of a presence *and* a material trace of a presence that has now vanished. As an image, it is a specter; as an object, it is a relic. Shi's photograph is doubly spectral, as it is a relic of an event that never happened. But it is not the image in the photograph that really disturbs Shi. Indeed, the title of Shi's essay, "Written on the Back of a Photograph of Xiangguo Temple," calls attention to the *materiality* of the photograph as much as or even more than it calls attention to the image on its surface. Yet the *consequences* of this conception of a photograph being a material trace or relic are what link the chain of associations that structures Shi's entire essay. Shi begins by expressing a desire to escape from the noisy modern city and to view some traditional Chinese architecture. Indeed, an old scene in classical Chinese literature is that of returning to the site of the past, or, in Chinese, a *guji*. This term recurs throughout Shi's essay, equally manifesting the force of its customary meaning, "ruin" or "historical site," and its literal meaning, "ancient trace." However, the place to which Shi "returns," and which sets off his meditation, is a photograph, a "place" that represents Xiangguo Temple, and, as a photograph — easily reproduced, proliferated, and circulated — is itself unfixed in place. It is tempting to say that Shi Zhecun regards a photograph as a *guji*, but the matter is more complicated than that. For not only does a photograph lead Shi to look for ancient traces in texts and landscapes; it seems to have transformed the way in which Shi conceived of ancient traces themselves, as well as their unsettling behavior. Looking at ruins through a photograph leads Shi to write of remainders of the past as

at once objects and images, material and immaterial, both creating a place and out of place. Thus, in Shi's retelling of this scene of return to a place of the past, it is a photograph that leads to a search for ruins, and finally to the bizarre scene of Yuefei's tomb emptied of its relics and occupied by Napoleon's corpse, which was circulated from abroad. According to this linkage that the essay's structure suggests, if a photograph is itself a kind of relic, it is also one that is highly mobile and easily circulated and can be brought together with others in any combination. This chain of association in the essay—from a photograph of a virtual past, to a search for relics in the landscape, and finally to the excavation or circulation of the past's remains—creates connections among texts, images, landscapes, and the past that, I believe, would be crucial for Shi Zhecun's subsequent modernist project. Indeed, this linkage seems to have composed for Shi a crucial lens through which he viewed local and global culture in Shanghai.

Now, the predominant image of Shanghai in Chinese photography, illustrated magazines, cinema, and fiction at this time was composed of art deco skyscrapers, the world of speculation and finance, modern women and modern men, and so on. While ancient cities like Beijing, Nanjing, and Xi'an seemed to be rooted in layers of history, Shanghai was the capital of Chinese modernity, a rootless place, it seemed, without a past. And yet, Shanghai was everywhere haunted by the absent past's traces. In the mass media, "the past" could take the form of something historically specific (in discussions of China's historical past, say, or of archaeology); "the" past could also be a pastiche of pasts and their associated motifs (Egypt, Rome, etc.); or "the past" could take a more vague and shadowy form, a pervasive sense of "pastness" redolent of both nostalgia and disquiet. Often these different senses of the past, from the historical to the uncanny, permeated each other within the same images and texts, as repressed historical pasts circulated and returned in uncanny forms (and it is this multiple sense of past that I use in this chapter). Thus numerous popular descriptions of Shanghai's modernity were disturbed by a rhetoric of the lingering past, in which the old can reappear anywhere, out of time and out of place. In a 1932 essay by Xu Shushan, for instance, simply entitled "Shanghai," a contradiction between old and new is played out through movement across urban space and its hidden depths. Xu mocks tourists who look down on

Shanghai for being a commercial city and head off in search of pagodas and arched bridges, for, he claims, "They only seek a 'dream' that comes from looking at magazine illustrations. Let them linger at the edge of a lotus pond, and sigh, right until the stings of mosquitoes drive them from the territory of the numb; we who have abandoned all set and defined 'dreams' (dreams of Persia, dreams of India, dreams of China) will walk as we please with great strides toward the city."[23] Xu seems to believe he, at least, has left behind all illusory images of the landscape of the past and, it seems, all illusory images altogether. In a familiar early modernist gesture, for instance, he declares his preference for "modern factories" over "ancient ruins" (*guji*).[24] Part of Xu's modern vision is the defeat of the old by the new; and yet this defeat creates phantasms and monsters, which lead one to suspect that the distinction between new and old, rational and dream, is not as clear-cut as he first presents it. For Xu depicts the city's modern buildings as phantoms that stalk into the city at dawn, or as monsters that grow up beside "low Chinese-style, houses . . . [and] push the low houses away without scruple, or crush them to pieces." This struggle between architectures leaves the old in ruins and the new, in Xu's words, "raising its head high over this place of the 'past.'" It is noteworthy, however, that what the new raises its head over *is* still the place of the past; Xu revealingly remarks of the stores and banks of the Bund that "the deeper their foundations enter the pile of rotten stuff thickly layered with distant eras, the more they will manifest their strength."

The cartoonist and essayist Feng Zikai extended Xu Shushan's image of rooted buildings in a cartoon that appeared in *Dongfang zazhi* in 1933, entitled "Jianzhujia zhi meng" (The architect's dream; figure 3.1). On first examination, this cartoon appears to represent, in counterpoint to Xu Shushan's dreams of the past in magazine images, a charming dream of roots in a place without roots, in an empty space that appears without a past or with its past already cleared away. Indeed, perhaps what the architect dreams of is a clear space in which to plant the new. But what makes the cartoon poignant is that these buildings do not originate in the soil of Shanghai, for the architect is planting not seeds but sprouts. Just as the city dwellers have been uprooted from the countryside, the buildings that make up the city have been transplanted.

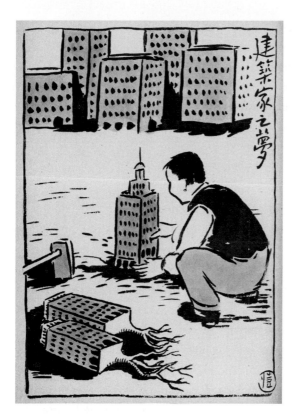

FIGURE 3.1 Feng Zikai,
"Jianzhujia zhi meng"
[The architect's dream],
Dongfang zazhi (1933).

In an essay published in the same year, however, the architect's dream becomes Feng's worst nightmare: it turns out that the transplanted condition of modern buildings is at the root, so to speak, of what Feng now identifies as their demonic nature. "Skyscrapers," he writes, "could be called the 'guardian demons of commerce'" (*shangye de jialan*).[25] They both are a form of "advertising art" representing the interests of capitalism and are a product of capitalism's circulation of culture through time and space. These demons appear as images of the past in the present: because the purpose of such advertising art is to strike the eye, a change in architectural form Feng identifies is the "use of ancient styles in order to seek something formally 'eye-catching.'"[26] At the same time, these demons are the product of colonialist capitalism, which detaches architectural styles of the past from their contexts and circulates them to places colonized to serve as icons of authority.[27] For Feng, however, the main culprit here is not so much colo-

nialism as capitalism. Thus, Feng notes the use of Gothic forms of cathedral architecture for modern skyscrapers and the use of columns from Greek, Roman, and Egyptian temples for banks. This use of architectural style does not so much create the new as raise the dead, Feng claims, for "who would have thought [that the] great columns" of Greece and Egypt would, "after two thousand years, come back to life [*fuhuo*] in today's marketplace!"²⁸ Such an uncanny pastiche gives rise to a feeling of temporal disjunction, or time out of joint. "But the businessman's purpose," Feng concludes, "is precisely the desire to use the strange condition of a 'temporal disjunction' to grab your attention."²⁹ The icons Feng identifies in Shanghai do not so much mediate between present and past as they refer to still other images circulated from elsewhere. For Feng, history now appears as a projection on the surface of the land, and Shanghai as a composite of projected images.

The temporal and spatial contradictions represented by such texts and images lie mostly on Shanghai's surfaces. But as is revealed by Xu's image of the foundations of modern architecture, there was also at this time a common representation of the past as lying in layers beneath the earth's surface. This was particularly the case in the many discussions in popular magazines at this time about archaeology. Curiously, however, the conception of memory these popular texts on archaeology often betrayed did not take the form of rootedness in the past's subterranean layers. Rather, memory in these texts was conceived of as the excavation and global circulation of fragments of the past, and even of spaces of the past, in the form of layers of distant eras that, paradoxically, could be uprooted and transplanted elsewhere. Now, with the discovery of Tutankhamen's tomb in Egypt in 1922, this era was, of course, a "golden age" of archaeology. The most recent discoveries by Western archaeologists were widely reported in Shanghai magazines, and motifs drawn from the fragments discovered entered the popular culture as well. The spaces excavated were almost invariably tombs — spaces, that is, whose artifacts made the remote past uncannily immediate. Given this collapsing of time, such buried homes of the dead became the underground sites where contemporary anxieties about the past were played out. While nothing might seem more rooted than an ancient tomb buried deep in the earth for thousands of years, these articles pay much attention to the circulation of their excavated contents. An article introducing the dis-

covery of Tutankhamen's tomb and the mummy within, for example, exults in what an "amazing thing" it is "to excavate the tomb of a king of three or four thousand years ago, to seek out . . . a myriad wonderful and strange valuables, and then to bear out the corpse of a king who died thousands of years ago and yet has not decayed, and to place it in a modern museum."[30]

The movement of such objects to the West is, of course, well known. What is remarkable here is the extent to which such relics of the past, having passed through the West, circulated to Shanghai—or rather, such images of the past. For Egyptian and other excavated relics appeared in Shanghai mostly in the form of photographs in illustrated magazines; relics, that is, appeared as projected and replicated images. The mummy, in particular, appeared as a concentrated and complex figure: it was a body that had been transformed into an image which, excavated centuries later, represented a collapse of time and, circulated abroad, the dislocation of the past. Egyptomania was, as is well known, a major craze in the West in the 1920s and early 1930s, but this fascination with Egypt took on a particular poignancy at this time in Shanghai popular culture. Egypt presented China with the fearful image of an ancient civilization that had died out and been completely colonized.[31] It also presented a spectacle of seeing one's own past circulate the world and return in the form of simulacra and images. In some articles on Egypt and archaeology, there was also a less prominent but still noticeable consciousness of the colonial politics of these images and their circulation, for Egypt at this time was also a place that was actively resisting the plunder and removal of its ancient images—mummies, objects from tombs, architectural ruins—by foreigners.

These questions of colonialism, the return of the past, and the circulation of its images converged on what Michael North argues "might be considered the first truly modern media event": Howard Carter's opening and excavation of King Tutankhamen's tomb in 1922. This excavation, well covered in such print media as *Xiandai* over several years, became the site of a prolonged struggle between Carter, who wanted to remove the tomb's contents and regarded Egyptians as mere grave robbers, and the Egyptian government, which asserted a growing political independence in trying to prevent the removal of its past's remains.[32] The key moment, however, with the widest repercussions in Western and Shanghai popular culture, was the

水牛約翰｜遇鬼了。｜花瓶裏跳｜出中國人，｜棺材裏爬｜起木乃伊，｜偶像的熊｜的口中伸｜出土耳其｜人。

FIGURE 3.2 "Shuiniu Yuehan yu gui le" [John Bull has encountered ghosts], *Dongfang zazhi* 24, no. 21 (1927).

No doubt the best-known motif in these fictions is the revenge of the mummy against those who excavate its resting place.[44] A political subtext of such fictions is brought to the fore in a cartoon published in *Dongfang zazhi* in 1927, entitled "Shuiniu Yuehan yu gui le" (John Bull has encountered ghosts; figure 3.2). The ghosts the British symbol John Bull encounters include a Chinese man leaping out of a flower vase and a mummy rising from its sarcophagus. The archaeological artifacts displaced and collected by the empire harbor ghosts of their respective pasts, which "return" to haunt their "repressor." At the same time, these phantoms of colonialism, made equivalent by their juxtaposition in the picture, take the forms of various kinds of images: not only the mummy as a body-become-image returned to life but also the outmoded image of a Chinese man wearing a queue from the recent imperial past, which, as such, appears as a colonialist stereotype, that is, a dead image, now come back to life to attack.[45] While one assumes that a critique of colonialism was the primary reason for publishing such a

cartoon in Shanghai, the cartoon also figures the uncanny return of the past in Shanghai specifically in the form of images that have been displaced and circulated. Indeed, the implicit association of Egypt and China throughout these materials, which Shi Zhecun seems to have identified and seized upon in "Demon's Way," suggests that Egypt could be viewed as a figure for the global circulation and return of images that appeared to mediate China's own cultural past. Of course, the sense of modernity represented in numerous magazines in Shanghai was surely meant to be as much a product of the contrast such images of the Chinese past seemed to offer as it was a product of images of the urban scene. But by locating Shanghai's modernity through the visualization in the West of that which was supposed to be invisible in Shanghai, illustrated magazines — and, in particular, the many photographs they published — made that modernity peculiarly spectral.

Now, if spectrality was a product of photographic images, in Shanghai at this time spectrality also became an explicit theme in popular photographs that transformed relics of the past (and artifacts of everyday life) into shadows. The modern city, with its high-rise structures, was understood in Shanghai to produce new forms of shadow (a point also central to the work of Brassaï and Bill Brandt, among other photographers in the West), even as shadows become a way of thinking about the displacement and circulation of the past in a modern city understood to be largely without a past. At the same time, shadow photographs played off the literal meaning of the word for photography in Chinese, *sheying—she*, meaning "to absorb, or take in," and *ying*, meaning an image, particularly a projected image such as a reflection or shadow. But as was observed in a short text entitled "Heiying xizuo" (Shadow studies) published in 1930 in the illustrated magazine *Shanghai manhua* (Shanghai sketch), shadows *in* photography had the power to make familiar things strange and transform them into abstract designs: "Ordinarily one does not feel anything strange about ordinary solid objects, but just when sunlight or lamplight shines down upon them, one cannot but feel they have a certain peculiarity . . . [and] because of . . . the shadows cast off by the light, they become a design photograph."[46]

A particularly popular motif for layouts displaying these photographs was the juxtaposition of artifacts of the past and mass-produced commodities. In the layout in figure 3.3, for example, entitled "Meishu tu'an sheying"

FIGURE 3.3 "Meishu tu'an sheying" [Artistic design photography]. *Liangyou huabao* 103 (1935).

(Artistic design photography) and published in *Liangyou huabao*, a picture of a traditional Chinese architectural motif faces a picture of flowerpots. The photograph on the right, created by Situ Guang, makes a common element of the built environment remaining from the past strange in the same way the flowerpots are strange: its framing and angle of vision remove a fragment of a continuing pattern from its familiar context and abstracts it into a photographic design. Indeed, the very juxtaposition of the railing against the picture of flowerpots in this layout of shadow studies implies that what matters here is not so much the identity of the place or thing represented but rather that photography can make both remainders of the past and mass-produced and mass-circulated objects equivalent to each other, by seeing them both as material for images of shadows and designs. Furthermore, this photograph suggests that what makes possible this

photographic fragmentation and circulation of the past is *projection*. That is, if a photograph is the taking in of a shadow, as the Chinese term *she-ying* suggests, then this photograph foregrounds its composition of precisely this element, for the lower left half of the picture is composed of the shadow the railing projects.

Shadows, according to a 1936 essay by Zhang Hui'an on shadow photography, are usually "overlooked" or forgotten because of their very intangibility, in favor of what she calls things that have a "real, material existence."[47] But shadows, she continues, have a special power, for while "all things have a shadow . . . shadows are unfixed. The form of a shadow is fluid, ceaselessly changing, never exactly the same."[48] That is, a shadow photograph stages the unfixing of material forms by shadows. Thus, she writes, "In my own photographic practice I prefer to allow shadows to occupy a better position than material things."[49] Her photographs render material objects insignificant or even invisible, while the immaterial shadow is left behind. The goal of shadow photography was, she wrote, "to show complete stories through the use of shadows without having to photograph the subjects [*zhuti*]" projecting them—a storytelling in which shadows replace words.[50] In the Situ Guang photograph in figure 3.3, however, we find that even the railing as a material thing is transformed, for what we actually see of it is not so much its actual form but rather the contiguous shadows formed on its surface as it blocks the light, so that the substance of the railing is virtually indistinguishable from its shadow. Indeed, the framing of the entire image works to collapse the distinction between a material thing and its projection; substance and shadow are dissolved into a single, abstract design—spectralized material to complement the mummy Gautier called a "materialized specter." In simultaneously fragmenting and decontextualizing a material remainder of the past and transforming it into an unfixed, disembodied shadow-image that could be reproduced and circulated, this photograph stages one way in which the past could be made spectral.

Of course, in this layout, the shadows of the past are quite innocuous. But a related theme in photography and film in Shanghai represented projected shadows literally as haunting and threatening specters. The photograph entitled *Xuhuan zhi ying* (Phantasmal shadow), published in *Shang-*

hai manhua in 1928, is dominated by an ominous shadow, as the title suggests, but one that is projected by a demonic artifact of the past. In other photographs and films, shadows become detached from any visible referent projecting them and, like John Bull's mummy, take on a life of their own and proceed to haunt and even threaten the unwary. For instance, a 1932 issue of *Liangyou huabao* advertises a new Chinese detective film entitled *Heiying* (The shadow), in which a male shadow threatens a terrified woman (figure 3.4).[51] Moreover, the same issue featured a British photograph of a shadow-face — again without any visible mask casting it — threatening an unsuspecting woman: the Chinese title the editors of *Liangyou huabao* give to the photograph is the same as that of Shi Zhecun's story "Demon's Way": namely, *Mo dao* (figure 3.5). This peculiarly modern form of haunting, however, was also informed by still another aspect of photographic shadows: their reproducibility and proliferation. This aspect of photography is suggested by an image of a nude woman published in *Liangyou huabao* in 1932, simply entitled *Ying* (Shadow) in Chinese, along with the English title, *Limbs and Shadow* (figure 3.6). For this "shadow" is actually a negative photographic image — the negative from which positive images can be produced and proliferated. Or, as Victor I. Stoichita puts it, "the object forms its shadow double" in a photograph, and subsequently "the photo redoubles everything by opening up to the infinite sequence of all possible reproductions."[52] All these pictures depict shadows as detached from the objects that cast them, circulated on their own or proliferated, and enlivened in the mutating forms of the demonic and phantasmagoric.

It was a paradox of this historical moment that Shi Zhecun grasped in his essay "Written on the Back of a Photograph of Xiangguo Temple" that fragmented, projected, and circulating photographic images were a primary medium through which the past continued to appear in Shanghai. The very act of representing the past seemed to dislocate it and return it as a haunting other. One can well imagine, then, that the sense of cultural location that these visual technologies could produce was also highly vulnerable to being disintegrated by those same processes. The fragmented image had become one of the major vehicles of the circulation of culture across the globe. If this was the nature of reality and its representation in which the

FIGURE 3.4 "Heiying/Scenes from *The Shadow*," *Liangyou huabao* 66 (1932).

FIGURE 3.5 B. Ludham,
Mo dao/Phantasm,
Liangyou huabao 66 (1932).

Phantasm

By B. Ludham

作咸李國英　　道　魔

past appeared, how might one still engage with the past *through* this new cultural situation rather than passively accept the images one was offered or ignore them altogether? And how might one engage with this transformed visual culture in or through literary texts?

Written on the Back of a Photograph

One possibility widely considered through critical essays and translations was imagist poetry, which dominated the pages of the modernist literary magazines *Xiandai* (Les contemporains) and *Wenyi fengjing* (Literary landscape) as did no other poetry in translation.[53] Indeed, given the well-known explorations by Ezra Pound, Amy Lowell, and others into East Asian written characters and poetry, and their resulting conceptualization of modernist poetry as a form of material-visual image, one might expect that, circulated "back" to China, imagism would be of interest precisely be-

影

FIGURE 3.6 *Ying/Limbs and Shadow, Liangyou huabao* 69 (1932).

Limbs and shadow.

cause of its use of Chinese characters as a model for such images. After all, in *The Chinese Written Character as a Medium for Poetry* — a work whose semi-understanding of the nature of Chinese writing was seminal to Ezra Pound's conceptualization of images — Ernest Fenollosa supposes the Chinese were able to "build up a great intellectual fabric from mere picture writing" because such writing uses "material images to suggest immaterial relations" and hence passes "from the seen to the unseen."[54] And yet while discussions of imagism in *Xiandai* and *Wenyi fengjing* almost invariably do mention the importance of Chinese and Japanese poetry to its development, nowhere is there a discussion of Chinese written characters as a medium for poetry. Instead, the central concerns are with the implication of East Asian aesthetics in conceiving images as both material and immaterial, as both visual and verbal.

The recurring focal point for this cluster of concerns in these discussions is Japanese haiku. Shi Zhecun translated several Anglo-American poems

in *Wenyi fengjing* in 1934 that he selected specifically, as he explains, because in them one can "very obviously discern that they are full of a haiku mood" that had "influenced many of the imagist poets."[55] In comments appended to his translations of a selection of imagist poems in *Xiandai*, An Yi notes "the flavor of Tang regulated verse and Japanese haiku" in Amy Lowell's work, as well as how Evelyn Scott's sequence of poems entitled "Designs" is written using "the methods of design painting" (*tu'an huifa*), such as those found in illustrated magazines (see chapter 1), although he does not elaborate on what those methods are.[56] Shao Xunmei connects this association in imagism of East Asian classical poetry with picturing to imagism's conception of images as both visual and material, noting that the imagist poets "feel that Japanese haiku is the most solidified [*ninggu*] form; thus in their poems there are . . . numerous material words [*shizhi de ziyan*]."[57] Through such language the imagists created "transparent carvings" (*touming de diaoke*).[58]

The fullest discussion of imagism to appear in any of the Shanghai modernist journals goes on to suggest that imagist poems, so conceived, were crucial to engaging with the transformation of verbal and visual image culture through photography. This essay, entitled "Yixiangpai de qige shiren" (Seven poets of the imagist school) and written by the poet Xu Chi, thus opens with an opposition between two kinds of image: that of imagist poetry and that of photography. At first, this may appear to be a simple opposition between verbal and visual images, but the matter is more complicated than that, as, expanding upon Anglo-American imagist calls for "direct treatment of the 'thing'" (Ezra Pound), and "to produce poetry that is hard and clear" (Richard Aldington and Amy Lowell),[59] Xu Chi insists with enthusiastic redundancy that the verbal images of imagist poetry are themselves material and tactile:

> What kind of thing is the imagist image [*yixiang*]? An image, to put it succinctly, can be rightly said to be a thing [*dongxi*], a linked series of things [*yi chuan dongxi*]. . . . It can be picked up!

> An image is hard. Clear. Concrete in nature and not abstract. It's a likeness [*xiang*]. A plaster likeness or a bronze likeness. What all eyes can see together. It's what can be felt through sense perception.[60]

Now, for Fenollosa and Pound, the idea of concrete images whose juxtaposition represents immaterial concepts and feelings is based on the idea of a medium that dissolves the boundary between the visual and the verbal — that is, Fenollosa claimed, the Chinese written character. The inadequacy of Fenollosa's claims is well known, and indeed, Xu Chi does not mention the appeal of Chinese characters as a form of writing that itself can be seen as a visual image, even as he does mention Pound's Chinese translations. Instead, as the other half of the opening opposition of his article, Xu Chi very consciously contrasts the "concrete" verbal image of imagist poetry against the visual medium of photography:

> The beauty of the external world, is absolutely not something that can be exhaustively expressed by a photograph [*sheying*] of a flower.

> To make new sounds, new colors, new smells, new feelings, new tastes permeate a poem, this is the task of imagist poetry, and at the same time is imagist poetry's purpose. We, including common people, and we who are poets cannot be satisfied by a picture plane.[61] On the Velox paper of a photograph of a flower, perspective [or "distance," *yuanjin*], size, closeness to reality, all of these praiseworthy and admirable qualities are just self-deceptions.[62]

For Xu Chi, a photograph produces an image that is both inadequate (it cannot fully "express" things) and deceptive. That is, unlike numerous writers on photography at this time (as well as writers taking photography as a model for realist fiction), Xu Chi does not believe that a photograph merely registers the world and its objects "as they really are," or even their traces, but rather that the material qualities of its pictorial surfaces produce illusions, registering, that is, the interactions of a specific configuration of light and shadow and a specific photographic emulsion, namely, Velox. The Velox paper that is the particular target of Xu Chi's disdain both was one of the first commercially viable photographic papers (and thus helped to make possible both the mass popularity of photography and the proliferation of photographs in print media) and rendered its images in high contrasts of highlights and shadows, with limited tonal range in between.[63] That is, Velox paper helped make possible the mass proliferation of photographic shadows.

Indeed, Xu Chi vehemently objects to the creation by such mass-produced images of what he regards as an illusory realism of planes and surfaces. For the critic Li Hongliang, the only way to prevent photography from deceptively mutating the appearance of the world into odd perspectives and murky grays was learning the art of what he called the "formless translation" of "scenes" into "flat, monochrome photographs."[64] For Xu Chi, however, all such picture planes are deceptive, in contrast to the three-dimensional solids that he claims the verbal images of imagist poems form: "A poem should live in solidity. It needs strength! It needs to have muscles! It needs to have warmth, tissue, a skeleton, the system of a body! A poem needs to have life, and life does not exist on a surface-plane of black shadows."[65] In this passage, the solidity of an image and the flatness of a photograph give way to an odder contrast between a verbal image as a living body and the lifeless shadows of a photograph. One wonders whether Xu Chi insists on this contrast between poetry as flesh and photography as shadow not because the shadows are lifeless but because they seem to have all too much of a life of their own. Imagist poetry, itself created in part out of the global circulation of East Asian aesthetics, appears here as a resistance against photography as a surface composed of shadow.

Having established this opposition between the verbal images of imagist poetry against photographic images in the opening of his article, Xu Chi goes on to describe what he calls a "history of images" (*yixiang de lishi*), which he understands to be founded upon and driven by this binary opposition between verbal and illusory or misleading images.[66] At this point, Xu Chi's concern is not—or not yet—to define Chinese culture through this relationship. Indeed, Xu's history does not begin with the foundational myth in Chinese literary culture of the unity of writing and image, in which Fu Xi derives the eight trigrams of the *Yijing* (I Ching, or, Book of changes) from the "images in the heavens" and the "patterns on earth."[67] Rather, Xu begins with one of the foundational oppositions between word and image in the West: the biblical prohibition of the creation of graven images.[68] Presumably Xu Chi would allow other forms of images, for according to his account, it is because of this particular prohibition that the Hebrews turned their image-making practices away from surface marking and toward "ver-

bal creation," filling their classical texts with poetic images. "This state of affairs," Xu asserts, "continued until 1914" with Ezra Pound's publication of the anthology *Des Imagistes*. Xu Chi's history of images, then, has just two events: the biblical prohibition on graven images and the separation of verbal from visual images, and the coming of Ezra Pound. For Xu Chi, what he calls the "sculpture-like poetic style" (*diaoke si de shi de fengge*)[69] of Pound and others would seem to reconcile the opposition between poetic language and graven images within language, and hence reassert the dominance of language over other kinds of images.

While, strictly speaking, imagist poetry is impossible in Chinese (one cannot really use Chinese written characters to revisualize poetry that is already written in Chinese characters), for Xu Chi imagism is important because its conflation of verbal and concrete images seems to resist images that are mere traces and shadows. For Xu Chi believes that imagist images, conceived as at once verbal, visual, and material, have an access to reality unmediated by the photographic images that were increasingly reproducing and circulating fragments of China and the world through Shanghai. Furthermore, as Xu Chi's own essay reveals, while it is what he sees as the fleshly materiality of a poetic image that for him raises it above the "common," in the context of early twentieth-century visual culture, such images are haunted by that which he feels they must overcome, namely, mass-produced and circulating images created by a medium of flatness and shadows at once material and immaterial. Xu Chi seemed to understand that a photograph is not a trace of an object that has imprinted *itself* on film or paper; rather, a photograph registers the shadow or light cast by an object. Xu Chi's strong reaction against photography so conceived seems to suggest that photography is a ghostly medium or, as Shi Zhecun's essay "Written on the Back of a Photograph of Xiangguo Temple" indicates, a medium for ghosts. Indeed, it is just this kind of conception of uncanny representation that would stimulate Shi Zhecun's own thematic and formal exploration of Shanghai as haunted by circulating traces of the past. Verbal images, for Shi, could not be called upon to resist and overturn photography. If we take Shi's early essay at its word, turning over his verbal text would reveal the photographic image that is its other and invisible side. But for Shi Zhecun

this was more than simply a matter for aesthetic debate. For these paradoxes of images and writing, of materiality, shadows, and fragments, were also being played out in Shanghai culture at large, with often uncanny effects.

Hence while Xu Chi would resist transforming the visible world into shadow through verbal images, Shi Zhecun explored ways of imaging the unseen relations underlying Shanghai's place in the world and its relations to the past. Indeed, as evinced by the essay on the Xiangguo Temple photograph, Shi Zhecun refuses to accept a simple relationship — let alone a binary opposition — between verbal and visual images, nor does he believe one can simply collapse the differences between them. Instead, he imagines a complex interdependence and inseparability of writing and photography, much as Fu Lei would describe in his essay "Literature's Pursuit of External Realities" (1934).[70] This is apparent in the verbal description of the visual image with which the essay opens. For while of course the Xiangguo Temple photograph only appears to the reader within the essay's text, the conceit of the title, "Written on the Back of a Photograph of Xiangguo Temple," is that the text, in turn, was originally inscribed upon or affixed to the back of the actual photograph it was describing. Word describes image, but word here is also parasitic upon an image as a material medium, even as that medium — the photograph — is turned over and so transformed into "nothing" but a blank piece of paper upon which to write. Photographic traces and traces of Shi's pen occupy opposite sides of the same medium. Thus, verbal images, for Shi, could not be called upon to resist and overturn photography. If we take Shi's early essay at its word, turning over his verbal text would reveal the photographic image that is its other and invisible side.

Now, of course, Shi did not actually write his stories on the backs of photographs. Nor did he include photographs as part of his texts. However, I do want to argue that Shi Zhecun's story "Demon's Way" is just such an attempt to engage with the past through its displaced images by means of a writing conceived through such images. The narrator's Shanghai and its surroundings form a landscape of hidden depths, of catacombs and tombs to be excavated. From out of these depths is excavated a mummy, both erotic and horrifying, who haunts both the rural landscape and Shanghai's streets. But in addition to his bricolage of popular motifs, Shi conceives of writing not so much as a mirror realistically reflecting modern Shanghai or the tra-

ditional countryside, or their divisions, but rather writing as itself a kind of photography, one that makes visible the shadowy negative of the past out of which the modern city's image has been developed, and that is composed out of a series of projections, black shadows, phantasms, and images that fragment, circulate, and combine as composites—dead images (or things transformed into shadow) and images that come to life. For the story is driven not by a linear narrative logic but rather through transformations of images from the material into the spectral and from the spectral into the material, and, in Zhang Hui'an's terms, through a series of images projected without a visible subject, which collapse the spatially and temporally distant past into modern Shanghai and its surroundings. The text, that is, proceeds not so much according to a narrative logic as according to a logic in which narrative motifs are treated as if they were images that mutate from one to another or are projected upon each other to form a composite. For through this often elusive process, Shi's text dismantles and parodies images of the past that modern Shanghai has produced, in which the past is a fixed place based on binaries of city and country, present and past, foreign and Chinese. If Feng Zikai's essay on Chinese art's "triumph" over modernism can be, as I suggested in chapter 1, read as a dreamwork of the image culture of historical moment, then Shi's text is quite consciously constructed as the dreamwork of the past in Shanghai, "not," to use Freud's photographic conceptualization of the dreamwork, "a faithful translation or a point-to-point projection of the dream-thoughts, but a highly incomplete and fragmentary version of them," that is, a "composite figure" produced "by projecting two images on to a single plate."[71]

Thus the "fixed place" of the past in "Demon's Way" is a tomb in the Central Plains, traditionally held to be the place of origin of Chinese civilization. And yet, of course, the tomb the narrator imagines being excavated, and in which he imagines the resurrection of an Egyptian mummy, is *not* in the Central Plains, which is actually located hundreds of miles to the northwest of Shanghai. If the origin of Chinese culture, an important issue in the Shanghai media at this time, itself becomes the place of another past, then the entire site of the Central Plains becomes not a place of depths but rather a projection on the landscape of Shanghai's outskirts. Not only is China's past not fixed in this vision but the very scene of the excavation of

origins itself originates as a projection and becomes what could be called a transportable scene, that is, a landscape image that itself can be replicated and circulated through space from place to place.[72]

Shi's use of the foreign image of a circulating mummy in this scene further undermines the idea of the authentic past as rooted in women kept in the past's places. Because it is gendered female, the Egyptian-style mummy leaving its tomb displaces the idea of the past figured as a pure Chinese woman fixed in the unchanging old home. Much to the rather comic horror of the story's male narrator, the old sorceress, the mummy, and later young women inside and outside Shanghai not only refuse to keep in place but, disembodied by the narrator's imagination, mutate into one another, or are projected as a composite, as they are displaced across the landscape. Indeed, against the erotic vision of the excavation of a beautiful mummy I quoted earlier, the text juxtaposes a contrasting nightmarish scene in the opened tomb: "Perhaps the stone chamber would be pitch-black. Perhaps they would chisel through seven doors, and from within would emerge a mysterious, hideous, old hag. Yes, demonic, monstrous old women often take up residence in the catacombs of antiquity. Then, they would throw aside their chisels and crowbars in a panic and flee, and she would make a thick black smoke belch from the chamber and seal the entrance."[73] This juxtaposition of two contrasting fragments of mummy stories establishes a dialectic of old woman and black shadow, on the one hand, and mummy in white and projected image, on the other, that runs throughout the rest of the story. The narrator makes just this connection when he wonders, "What if the mummy of the beautiful concubine were the metamorphosis of this sorceress?"[74] Herein lies an ambivalence central to Shi's story. For while it is this transformation of women as material bodies into spectral images and back that enables the unfixing of women from the places of the past, one may well ask why the text stages such a photographic rendering of material into shadow through women in the first place. On the one hand, the male narrator's fears of women out of place also render real women insubstantial or nearly invisible in favor of silent, circulating images. And yet, on the other, the composition of the text, which exceeds the narrator's consciousness, also turns the circulation of images against the idea of the stillness of the true. For the text detaches this shadow and image of sorceress and

mummy from the projected site of the past from which they originate—moreover, it also detaches the projected site of the past itself from the hillock in which it first appears. Indeed, the old woman on the train and the hillock do not reappear in the story, but the rest of the story is composed of their projected images as well as that of the mummy.

The imagined scene of the mummy's tomb itself becomes a transportable scene in which is staged the fearsome burial of the mummy and her slaves, which in turn becomes an image projected at sunset onto a stereotypical rural landscape of a bamboo grove and an ancient pool:

> A myriad colors dazzled my eyes. The brilliance of the setting sun was overwhelming. I saw the vermilion of painted coffins and golden-yellow chains, all arrayed on the distant horizon. What else? Over there, those must be men and women slaves buried alive with their masters, arrayed in splendid garments and tumbling all over. Betrayed in their faces were the ghastly fear and despair of those who have just realized that the entrance to the mausoleum has been sealed—an everlasting fear and despair! But what is that spot of black? It is so thick, so lustrous, and yet it seems so transparent.[75]

The tomb that is the ground of the narrator's hallucinated image of excavation earlier in the text here becomes a figure projected upon the bamboo grove. The black spot that appears within this image—a figure projected upon the projected image of the tomb, transforming the tomb back into ground—is a transformation of the old woman in black that follows and haunts the narrator across the rural and urban landscapes. Indeed, throughout the story, it is in order to avoid looking at this black spot that the narrator keeps turning his attention to the landscape—only to view such projected images of the circulating past as we have seen. Yet this black spot, the narrator fears, is also the metamorphosis of the mummy in white: the "sorceress" and mummy keep transforming into each other. Indeed, this vision of black—most often as a black shadow (*heiying*)—is what links together these scenes of excavation, as well as such images of "traditional" landscape as the bamboo grove. The scenes of excavation and burial both end in a vision of black (the smoke belching from the tomb, the black spot in the midst of the sunset vision), and then in a series of black shadows that reappear in Shanghai and develop again into a phantasmagoric image of

"mummies [who] have all climbed out of the catacombs and are walking along the tarmac road." Black shadows, that is, not only connect but also circulate and reproduce these scenes in country and city and, indeed, render them disturbingly equivalent. The haunting of the narrator, then, operates through this transformation of mummy into sorceress, white image into shadow: an image of the rooted past transforms into its black shadowy negative image, and it is as this shadow that the scene of the past is then circulated to compose its next site. Haunting, or the illusory *mo*, that is, is the movement of an image from one medium to another. What is most disconcerting to the narrator, then, is that this negative is not simply a unique image representing a specific landscape of excavation. It is both a projected image detached from any object, and it is a trace of the past that can proliferate.

Whether as image or shadow, mummy or relic, the past in Shi Zhecun's fictions of Shanghai is uncannily immediate. It is located within the modern everyday, and yet its return is mediated through the artifacts of a remote world. Indeed, in much of his modernist fiction, Shi represents events in which the return of the past disrupts unitary identity, the purity of place, and linear narratives from past to present, even as he represents the disruptions of globalizing capitalism. All his fiction of the past both creates and is derived from a space between modernity and the past, the Chinese and foreign, fantastic and real, historical and fictional, verbal and visual. Hence, even when it is not thematized, as in his historical fiction, the modern city and its frontiers are the context of the past in Shi's work. For as we have seen, in the Shanghai of Shi Zhecun's fiction, the transmission of the Chinese past is inextricably swept up in the global translation of culture. And yet, the past is never swept away entirely; even in the modern city, it remains.

4

MONTAGE LANDSCAPES

If, in "Demon's Way," Shi Zhecun constructs a landscape of Shanghai and its environs out of a composite of projected and ghostly images from displaced pasts, within three years the use of montage and collage in photography and film would become something of a commonplace in representing modern Shanghai. Perhaps the most widely circulated use of photocollage appeared in *Liangyou huabao*, most notably in the February 1934 issue in a layout depicting "Intoxicated Shanghai," or what the Chinese caption called "urban stimulations" (*duhui de ciji*), and in a similar layout in the May 1934 issue entitled "Ruci Shanghai" (Such is Shanghai), a fragmentary spectacle composed of women (with an emphasis on women's legs), cinemas (as the sites of a new urban culture of the spectacle), and urban built forms gendered and eroticized through their cutting and pasting on the page (figure 4.1). A much darker photomontage playing upon similar themes, however, had appeared in the previous month in the inaugural issue of a new publication, *Shidai manhua* (Modern sketch; figure 4.2). This image, called *Shanghai fengjing* (Shanghai landscape), is also composed of the signifiers of a colonial modernity, ranging from gambling (money, cards, mah-jongg tiles) and stimulants (alcohol and opium) to fashionable shoes, guns, and a Sikh policeman. The cheery boosterism of the *Liangyou huabao* layout, that is, here is a representational violence—not only because of the thematic presence of a gun and a policeman but because of the cutting apart of bodies into image fragments. The women's legs that are simply emphasized in "Intoxicated Shanghai" here appear either on a body without a head or disembodied entirely and placed instead next to a similarly excised breast. Indeed, it would be impossible to recompose this explosion of body parts and material objects into a coherent image of a body. While the image does

suggest a somewhat naturalistic placement of male body parts, with a head at the top, a hand holding a gun to the lower right, and a shoe at the bottom, the posture of the whole female nude at the image's center seems to be trying to protect from view precisely the legs and breasts that are exposed in dismembered form to her upper left. Furthermore, while the faces of the man at the top and of the two women are blocked from view, the viewer is addressed by a plethora of disembodied eyes and lips that haunt the entire image. Excised from their proper places on the human body, these eyes and lips stare and smile out from the lower back of the nude, from the jar replacing the head of the woman at the upper right, and from the money and mah-jongg tiles, as if to bring these fragments to life, lure the viewer into the image, and make him or her complicit in the fetishization of body parts and objects of urban pleasures.

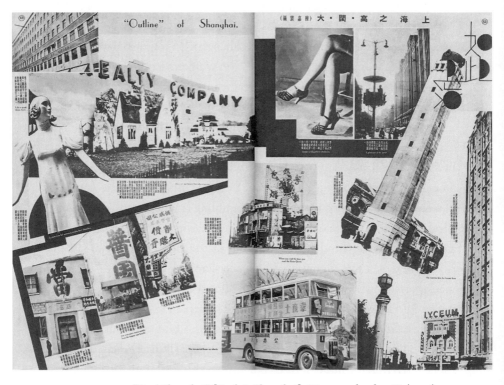

FIGURE 4.1 "Ruci Shanghai" [Such is Shanghai], *Liangyou huabao* 88 (1934).

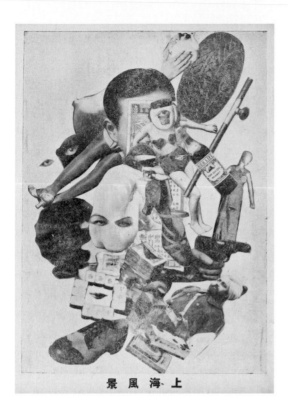

Such "dismembered embodiments of modern life," as Brigid Doherty has observed of the photomontages of Berlin Dada, made in the traumatic wake of the First World War, together create a "composite image of a figure whose parts do not match."[1] Again, this unsettling mixture of fetishism and violence is not produced only through the thematic content of the image but also through its representational violence, what Sabine Kriebel calls in the German artist John Heartfield's contemporaneous work a "semantics of rips, fissures, gaps, hastily cut-and-pasted passages [that] convey a rhetoric of savagery, issuing a disturbing psychic charge."[2] Such an image "correlate[s] the disruptive experiences of modernity—rationalized production, capitalist phantasmagoria, technologized warfare, destabilized gender roles—with the assaults of photomontage."[3]

Through the violence of its own representational practices, then, the *Shidai manhua* photomontage could be said to re-present the intoxications

and stimulations of modern life of the *Liangyou huabao* layout as conceal-
ing a fetishistic violence. Furthermore, both of these images are presented
to their viewers as representations of place, but the urban intoxications and
stimulations in *Liangyou huabao* become the very "scene" or "landscape"
of Shanghai in *Shidai manhua*. Indeed, the *Shidai manhua* photomontage
consists entirely of figures against an empty ground, as if the landscape of
Shanghai were composed not of architectural forms but of a juxtaposition
of cut-and-pasted body parts. Such composition of place though the frag-
mentation of bodies was a common pictorial and literary practice in Shang-
hai at this time, whether these images were produced through photography,
painting, or texts. Of course, the violent dismemberment of bodily images
was central to montage practices in the West in the aftermath of the First
World War, but as the title of the *Shidai manhua* photomontage shows,
in Shanghai even a composite of the dismembered embodiments of mod-
ern life was intended primarily as an intervention into the idea of place.
Image fragments were treated as opaque traces of different places and times
that constituted both a representation of a location and the location of
the viewer of the image, both how the viewer sees the world and how the
viewer is placed within it. Indeed, as I shall explore throughout this chap-
ter, montage in Shanghai was not only a means of representing place; it was
itself conceptualized pervasively as a spatial practice, a geographic aesthetic.
Whether by emphasizing the disjunctiveness of cut-and-pasted images, as
in the *Shanghai Landscape* or in texts such as the fiction of Mu Shiying,
or by composing pictures out of the projections of fragments of multiple
negatives, or by rephotographing material fragments of visually disjunctive
images in order to conceal their joins, different practitioners across the po-
litical spectrum emphasized the continuities or discontinuities of montage,
utilizing the disjunctive spatial and temporal relationships in such images
to think concretely about the landscapes and locations of modern China
and the subjectivities they compose.

Montage: Spaces Lost and Created

Let me begin by returning to Fu Lei's wide-ranging essay "Literature's Pur-
suit of the External World's Reality" (Wenxue duiyu waijie xianshi di zhui-

qiu; 1934). No one in Chinese critical discourse of this time linked the aesthetics of fragmentation and juxtaposition to geographic space more vividly than Fu Lei in his discussion in that essay of collage and especially montage, which follows from his photographic redefinition of language I touched upon in chapter 1. Fu Lei seems to rewrite Pierre Reverdy's abstract conception of images as the juxtaposition of distant realities, as we have seen in chapter 2, in terms of a particular historical and geographic dilemma:

> Our reality is not completely the same reality as that of our fathers' generation: it is not as stable as it was in the past, but rather is even more complex. . . . A number of scientific discoveries — such as film, the phonograph, etc. — have made it possible for us to take an image we have captured of a person and decompose (décomposer) it: thereupon any singer can send his voice from Paris to Tokyo, and simultaneously, his face, gestures, and actions — not, that is, his fleshly body — can travel by transatlantic ocean liner to the capital of Argentina or New York to greet the masses on the silver screen. Ordinary people have not yet paid much attention to the seriousness of this situation: for it is proof that one kind of connection holding together the particles of the universe has been eliminated; or in other words, humanity itself has disintegrated [*fenhuale*], and is simply lost in space.[4]

The distance that for Reverdy is constituent of an image here becomes global space. Indeed, for Fu Lei the constitution of modern images across global space is the source of their power, as images are made and fragmented in one of modernity's centers and reassembled elsewhere.

But Fu Lei does more than rewrite Reverdy's concept of an image geographically. Fu Lei's geographic composition of an image also entails a traumatic human fragmentation, such as we have seen in Reverdy's poem and in the cartoon about cubist techniques. Of course, while Fu Lei specifically denies that a fleshly body is fragmented, but rather "only" its image is captured, yet the effect of this fragmentation of images, so Fu's argument goes, is to leave humanity placeless and deterritorialized. Taken literally, this is an extraordinary claim. This passage combines the idea of an image as a material thing that can be broken up and recombined across space with the idea of an image as an immaterial entity, the self-representation of a person (in the form of voice, face, gestures, and actions) as opposed to a "fleshly

body." Why does this conception of an image as both material and immaterial, decomposed and juxtaposed, lead to a vision of dislocation, disintegration, and loss? One might be tempted to dismiss this passage as merely melodramatic, but that would not explain the prevalence of this kind of claim. What links a fleshly body to fragmentation and placelessness here is precisely the idea of an image that both is a picture of a person or place and is created out of marks made upon a photosensitive surface by the light reflected and blocked by what is represented. An image is, to use Fu Lei's words, "captured" from a person (not simply made by itself) and materialized on film (or, according to a similar principle, on a phonographic record); thus made material, it not only can be linked together, as in Reverdy, but also can be decomposed, circulated, and recomposed. What Fu Lei considered to have changed the nature of reality is not simply the circulation of images but rather the idea that one's traces can be proliferated and circulated to appear anywhere, simultaneously. The effects of this global circulation and juxtaposition of visual traces must have been truly startling and uncanny, to a degree that a stable sense of place was dismantled.

This passage also moves from the idea of an image as passively disembodied, dismembered, and dislocated to an image as having agency and a voice, "greeting the masses on the silver screen." For, working through this bleak vision of disintegration, Fu Lei finds that this phenomenon also offers the means of new modes of representation. Furthermore, despite the visual orientation of the passage just cited, the mode of representation with which Fu Lei's article is concerned, as its title indicates, is literary. Significantly, however, this article on writing was published in an avant-garde journal of the visual arts, *Yishu* (L'art). This suggests a complex conception of the relationships between the verbal and the visual, and indeed, Fu Lei reconceives writing *through* these new visual technologies and the realities they make visible. Such reconceived writing, Fu Lei argues, is best suited to representing this new—and what he calls "fantastic"—reality:

> Current scientific, literary, aesthetic, and film theory more or less share a certain commonality, although they don't realize it themselves.
>
> However, film has had an especially important effect on the gestation of the colors of the new fantastic, for its technique in and of itself makes it so that

film, before it can express "reality," must first decompose reality and, using a new kind of rhythm, recompose it according to an order completely different from that to which we are accustomed. The lenses' shrinkage, magnification, and crosscutting [*jiaocuo*, literally, "crisscrossing"] of objects, . . . in a word, everything in film, evolves according to the principles of illusion, not according to those of real life. On the other hand, current fiction and drama also have taken up the same kind of principle, and in the same way shrink, magnify, and crosscut realities, so that they rapidly alternate with each scene.[5]

Fragmentation and juxtaposition, Fu claims, has become more than just one technique of representation among others; given the changed cultural conditions, he believes that the representation of reality is only possible *through* such montage practices. If, as in Reverdy's poem "False Portal or Portrait," an inextricable part of the fragmented world is the fragmentation of the spectator who observes it, then Fu Lei argues for the use of a technique of representation whose very form mediates, on the one hand, a position or point of view situated in a particular location in global space and, on the other, the global makeup of that perspective. According to Fu Lei's conception, the particular importance of montage in the pursuit of the modern world's reality lay in its ability to create spaces and subjectivities on the peripheries out of fragmented, transmitted, and juxtaposed images of different places and times. Moreover, this technique — which can only operate through transmission across space and the juxtaposition of different spaces together — *itself* has been transmitted across the globe in a number of modern visual media and actively circulated to China. Indeed, for the Shanghai avant-garde, montage practices of fragmentation and juxtaposition could do more than leave one lost in space; they also became means of composing a space or critiquing the ideologically charged composition of a space.

In Fu Lei's essay, it is for the most part places outside the European imperial center that become the sites of the recombination or juxtaposition of fragments. To a significant degree, these qualities drove the most intense experimentation and reflection on cinematic montage in this period: that which was carried out in films and writings by Soviet directors such as Sergei Eisenstein, Dziga Vertov, and Vsevolod Pudovkin. As is made clear in a brief article in the popular magazine *Dongfang zazhi* (The eastern

miscellany), the work of all three of these directors (including Eisenstein's *Battleship Potemkin* and *The General Line*, Pudovkin's *End of St. Petersburg*, and Vertov's *Man with the Movie Camera*) was known and discussed, and particular attention was drawn to the distinctiveness of their montage and camera work.[6] To be sure, Alexander Rodchenko's politically charged photomontages were known in Shanghai, but for the most part the actual theorization of various forms of montage that appeared in the Shanghai print media draws upon Soviet filmmakers such as Eisenstein and Vertov.[7] All of these films use the juxtapositional aesthetic of montage to represent the city and the frontier in an era of uneven development. Pudovkin's film *Heir of Genghis Khan* depicts the revolutionary potential of the remainders of the past in the frontiers of Mongolia, while Eisenstein's film *The General Line* depicts abrupt changes in rural life, its other title being *Old and New*. An essay, "Xin yishu xingshi de tanqiu" (New art's explorations of form), by the Japanese Marxist critic Kurahara Korehito, translated and published in *Xin wenyi* (La nouvelle litterature) in 1929, situated not only the contents of these films but also the very montage *practices* of Eisenstein and Vertov, as well as those of the German Walter Ruttman's film *Berlin: Symphony of a Great City*, specifically in the context of developing (not "fully developed") modern cities.[8] Kurahara's larger purpose was to advocate "proletarian realism" in literature. Kurahara argued that in the creation of proletarian realism an ideological stance and experimental *form* were inseparable, and further linked the necessity of formal experimentation precisely with an era of nonsynchronicity, for in most of the art and literature of this era, proletarian ideology and petty capitalist and feudal psychology "cohabit," so that "their forms uncritically use Naturalism, Expressionism, and New Perceptionism [*xin ganjuezhuyi*]."[9] While Kurahara gives little indication of the form proletarian realism itself would take, he does argue that it cannot grow on the basis of "ancient" (i.e., traditional realist) forms but rather must critically draw upon—even as it moves beyond—cubism, futurism, and especially constructivism. Such movements represented to the Shanghai modernists not simply aesthetics of the new but languages of construction that had been created through experiences of temporal unevenness. Indeed, as Kurahara's discussion of "new art's explorations of form" suggests, throughout its genealogy, the fragmentation-juxtaposition practice

of collage and montage itself had traveled from one unevenly developed region to another, from French and Spanish cubism, to the futurist collage of Italy, to the constructivist practices of Russia, and on into montage film; within a few years, it would leap again to the fiction of John Dos Passos.[10] At the same time, each of these practices traveled to Japan and China, both individually and recombining in the montage fiction of Shanghai.

Now, decomposition and recomposition are, as Fu Lei had observed, basic to any film's representation of reality. Indeed, the style of mainstream Hollywood film derived in part from fitting together a series of visual fragments (i.e., shots). As James Lastra has argued, the emergence of classical Hollywood cinema depended upon the emergence of "a logic of pictorial combination that allowed for a temporally and spatially additive, unidirectional, and continuous connection of fragments into a coherent series."[11] For the Soviet montage filmmakers, too, it was important to think through the linking of framed, fragmentary images, or through images as composites. But these latter directors sought logics of picturing that did not arrange visual fragments into what would seem like natural, coherent series but rather that allowed for multidirectional, discontinuous, and disturbing juxtapositions of fragments. For, as Fu Lei stressed, the place where an image is framed is not necessarily the same place where it is combined and consumed. The critical point was the temporal and geographic space *between* the creation of image fragments and their combination, a space that, for Eisenstein and Vertov — as well as many of the Shanghai modernists — it was crucial to keep open.

Vertov's claims for montage are perhaps the clearest expression of the kind of appeal montage had to Shanghai modernists. Vertov's striking term for montage cinema is "kino-eye." More than simply a way of editing a film, Vertov regarded montage as "the organization of the visible world" and was fascinated by the power of montage to construct space. Addressing the viewer, Vertov writes, "I have placed you, whom I've created today, in an extraordinary room which did not exist until just now when I also created it." The nature of this "room" — and the viewing subject created with it — was strikingly different from those constructed by Eisenstein, for each of its many "walls" was "shot . . . in various parts of the world."[12] Filmic montage could create a single "room" or space out of different spaces and

times through the juxtaposition of different shots. For instance, "You're walking down a Chicago street today in 1923, but I make you greet Comrade Volodarsky, walking down a Petrograd street in 1918, and he returns your greeting."[13] Thus kino-eye made possible an unprecedented way of seeing, locating between fragments an unprecedented perspective on time and geography. As Vertov wrote in one of his more hyperbolic manifestos:

> Kino-eye means the conquest of space, the visual linkage of people throughout the entire world based on the continuous exchange of visible fact. . . .
>
> Kino-eye means the conquest of time (the visual linkage of phenomenon separated in time). . . .
>
> Kino-eye uses every possible means in montage, comparing and linking all points of the universe in any temporal order.[14]

This utopian — even imperial — tone of Vertov's manifesto, however, which imagines montage landscapes created through the "conquest" of space and time, stands in marked contrast to Fu Lei's vision of humanity as "lost in space." At the same time, Vertov's all-seeing and all-powerful kino-eye works through a conflation of vision and editing (the cutting and splicing of montage) far removed from the fragmented vision of Reverdy's poem, in which the eye both is one of the fragments juxtaposed within a frame and blocks vision through its own physicality. Perhaps the difference between Vertov and Fu Lei reflects the predicament that while China and the Soviet Union could both be said to have been located on the semiperipheries of modernity in the 1920s, China could hardly have been said to be at the center of world revolution (not yet, anyway). Yet lacking in Vertov is the conception of images we have seen in Shanghai of an image not simply as transparent but as at once material and immaterial, a representation and a bodily trace or relic.

Shanghai Collage

Symptomatic of this difference is a pair of landscapes that were constructed in Shanghai in 1931 out of fragments of distant spaces and times. These paintings were created by Pang Xunqin one year after his return to Shang-

hai from an extended period of study in France.[15] The two paintings are very similar in their collage aesthetic, as well as in their titles: *Ruci Bali* (Such is Paris; plate 3), and *Ruci Shanghai* (Such is Shanghai; plate 4); the latter of the two was reproduced in *Liangyou huabao* in 1932 under the title *Rensheng zhi yami* (The riddle of life).[16] Pang does not create, in Vertov's terms, a room whose walls were shot in Paris and Shanghai, a single painting that juxtaposes images from both places. Rather, the division of the two places into two separate paintings, and even the resulting space implied between the paintings, is significant, for it anticipates the way in which Fu Lei suggests images from one part of the world can be reassembled in another. Also significant, however, is that both of these cityscapes are constructed not so much out of fragments of different places as of juxtaposed bodies, isolated objects, and markers of place. Both paintings juxtapose blankly staring faces with the accoutrements of money and pleasure. Upon his return to China from years in Paris, Pang had been disgusted by the pervasive influence of money in Shanghai.[17] This disillusionment with the effects of circulating capital adds a political overtone to the remarks with which he prefaces a call for artists to "stand in society and observe society," an evocation of Henri Bergson along with Heraclitus that leads Pang to comment in a remark that resonates with Liu Haisu's Bergsonian account of Shitao's paintings I discussed in chapter 1, "Everything in the world flows [*liudong*], and we ourselves flow. So how can one seize hold of a fixed school [of painting] with which to express the feelings and thoughts of flow?"[18] Fu Lei expanded on this point in an essay on Pang Xunqin's paintings published in 1932 that seems to bridge the terms of Liu Haisu's essays and some of the claims Fu would make in his essay "Literature's Pursuit of the External World's Reality," writing that Pang "observes, experiences, analyzes like a mathematician, then he organizes, generalizes and synthesizes like a philosopher. Having analyzed, he synthesizes, and having synthesized, he analyzes again, evolving ceaselessly; this is because life is a restless flow, and every day evolves."[19] While Pang's varied body of work indeed resists holding firmly to a single school of art, this pair of paintings, with their dialectic of analysis and synthesis, does provide one solution to the problem of representing the global circulation of people — or at least their images — along with money. Pang's stylistic choices here evoke synthetic cubism, whose

collage and pastiche aesthetic creates images out of fragments that appear to have disparate origins and combine to create an ambiguous figure and ground, rather than analytic cubism, whose images appear to be composed of fragments originating from the figure and ground being represented—but to adapt Fu Lei's scheme, the images depicted in these paintings are made and fragmented in Paris, to be recombined in Shanghai.[20] Indeed, the two pictures virtually repeat a very similar woman's face, appearing in the upper-right corner of the Paris picture and in the lower-right corner of the Shanghai picture, along with the theme of monetary chance and circulation represented by playing cards.

Yet the intervening global space effects a number of differences on these images. The manner of representation in *Such Is Paris*, with its three-dimensional perspective and modeling of individual forms, seems to suggest people of material substance, even as their status as images is underscored by their stereotypicality (the capitalist with top hat and fat cigar, for instance). Furthermore, Pang—who made his own version of the familiar claim that photography has rendered realist painting obsolete—imitates photographic means of representation to fragment these images, aggressively cropping the faces and overlapping them like a photomontage.[21] Yet for all of this fragmentation and overlapping, *Such Is Paris* creates a remarkable homogeneity of time and place: not only do the figures all wear modern dress, but the images of a lamp, a window seen from the outside, and signs or advertisements all compose a scene of modern boulevard life.

As Fu Lei's essay would have it, it is the images of people—not their fleshly bodies—that are transmitted to the Shanghai periphery. For the three-dimensional modeling of figures in the Parisian picture gives way to a deliberate flatness. Furthermore, the head of the king has been removed from the playing card on which it would have first appeared and is juxtaposed on the same plane and in the same size as the other faces in the painting; in this way the king's image is made equivalent to the reality of the other figures: all, emphatically, are "merely" images. Yet these facial images are not cropped as radically as in the Parisian scene. Instead, while the figures in the Paris scene appear fairly substantial, in the Shanghai picture, the images of people are more translucent: one can see through the overlaps as if the painting were created through photographic double exposures. The

Shanghai figures appear as ghostly, dislocated images, "lost," as Fu Lei put it, "in space." Indeed, the locational signs in the Paris picture have disappeared to leave large open spaces between the Shanghai figures, seeming to suggest a lack of connection between them. Furthermore, these faces do not interact with each other but rather face outward toward the viewer, even as their gazes are averted past or away, denying any interaction with the viewer as well. Instead, the only things that seem to connect them are money and playing cards. Yet for all of their separation from each other, these faces do not appear as figures distinct from a background; instead, these figures *are* the ground, or, rather, the landscape of Shanghai is composed precisely of fragmented images of faces and objects.

But if Pang's Shanghai figures occupy an ambiguous space, what is even more ambiguous is the time in which they are located. Indeed, the temporal discrepancy between Paris and Shanghai in these paintings is marked by their differing representations of males. In Paris, the males appear as modern urban authority figures—a capitalist and a policeman—but in Shanghai these images of male authority have become a playing-card king and a warrior from a traditional Chinese opera. The temporality and status of these males are ambiguous. Of course Shanghainese were playing cards and watching traditional operas in the 1930s—in which case these figures do not *embody* authority as do the capitalist or policeman but rather, deprived of their context, are images of Chinese and foreign authorities of the past. Yet, as I have suggested, Pang's composition seems to set these male images on the same plane of reality as the modern women. To move from one painting to the other, then, is to visualize Paris, a metropolitan core, as a homogeneous time-space, which is fragmented, circulated, and juxtaposed in Shanghai, a semiperiphery whose heterogeneous space is the location of a heterogeneous temporality—a simultaneity in which the past, with all its multiple origins, is still very much present.

Shanghai's Contemporaries: Modernist Historical Geographies

In the critical discourses of modernism in Shanghai, this notion of "simultaneism" was of crucial importance. In one of a series of articles on mod-

ernist art published in the magazine *Yiban* (General) in 1928 and 1929, the cartoonist and essayist Feng Zikai writes that simultaneism is "a common question in cubism and Futurism" and is "born of necessity" out of such arts' practices of fragmentation and juxtaposition.[22] The term "simultaneism" is translated in two ways in Feng's account, for it is both temporal (*tongshixing*, "the quality of the same time") and spatial (*tongcunxing*, "the quality of existing together"). It describes the representation in cubist painting of "seeing all at the same time objects relating to different times" and of "looking within a single plane of space [and] being able to see simultaneously many different planes."[23] While Feng does not explicitly say so, these two forms of simultaneism seem to refer to the two major forms of cubism practiced by Picasso and Braque: while Feng's description of temporal simultaneity (*tongshixing*) indicates the different objects brought within a single picture in collage and synthetic cubism, his conception of spatial simultaneity (*tongcunxing*) seems to indicate both analytic cubism's attempts to see different aspects of a single object at the same time and synthetic cubism's juxtaposition of different objects on the same pictorial plane.[24]

Now, just as the Shanghai modernists concretized Reverdy's conception of an image as a juxtaposition of fragments of different places and times, so they also radicalized the idea of simultaneism Feng describes.[25] For the Shanghai modernists, temporal and spatial simultaneity as a theme and formal principle became an essential means of constructing as well as representing Shanghai's own location on the "margins" of modernity. Indeed, central to their interest in both collage and montage practices was the idea that modernist bricolage can be a device for representing world space precisely from the world's margins and semiperipheries. Writing from within a fragmented Shanghai, the quality of modernism that most persistently fascinated the contributors to Xiandai in particular was its production of what Franco Moretti calls "world texts." Such texts — modernist works such as *Ulysses*, *U.S.A.*, and *The Waste Land* but also precursors such as *Faust* — are characterized by "the supra-national dimension of [their] represented space."[26] Moretti observes that significant portions of these world texts are also composed out of fragments of figures and styles from different epochs which, seemingly freed from their original historical positions, are made

to coexist within the same text.[27] Such pastiches are created not by utterly rejecting the past but through discovering new functions for themes and methods that already exist or, more radically, creating the new from the past "as in bricolage: old materials, new treatment."[28]

Moretti argues that literary bricolage composes world texts not through the arrangement of different historical eras into a linear sequence but rather through their synchronic juxtaposition, and thus manifests the German cultural critic Ernst Bloch's concept of "non-contemporaneity" (*Ungleichzeitigen*).[29] Bloch's concept, which he developed in a classic essay in 1932, is intended to represent a condition of modernity in which different peoples, while living in the same temporal moment, manifest forms of cultural, social, and political organization that seem to remain from different epochs of development in the past and present. Now, such a conception of uneven development can reflect a standardizing linear narrative of the progressive evolution of civilization that denies contemporaneity to peoples outside the metropolis.[30] Yet the matter is more complicated than that. True, a Hegelian notion of history—which has been extremely influential in China—maps such a narrative of historical progress onto geographic, national space, so that the modern West represents the fulfillment of such a narrative, while China, India, and Africa are left either at earlier stages of historical progress or outside of history altogether.[31] Moretti, however, argues that the "world texts" can offer alternative readings of the existence of different epochs existing "alongside" each other at the same time, readings that challenge teleological narratives of history: "The ideology of progress . . . privileges *non-contemporaneity* of the contemporaneous: the 'Alongside' becomes a 'Before-and-After,' and geography is rewritten as history. Well, for the modern epic the opposite is true: *contemporaneity* of the non-contemporaneous moves into the foreground: the 'Before-and-After' is transformed into an 'Alongside'—and history thus becomes a gigantic *metaphor for geography*."[32] Moretti links the challenge that world texts can pose to teleological history to their emergence in the modern world system's semiperipheries: the early nineteenth-century Germany of Goethe, the twentieth-century Ireland of Joyce, the Colombia of García Márquez. For, Moretti argues, while the modernized metropolitan core is relatively homogeneous (a homogeneity produced by the representation of difference

as inferior and beyond the core), the semiperiphery is composed of "sites of combined development: where historically non-homogeneous social and symbolic forms, often originating in quite disparate places, coexist in a confined space. In this sense, *Faust* is not 'German,' just as *Ulysses* is not 'Irish' or *One Hundred Years of Solitude* 'Colombian': they are all *world* texts, whose geographical frame of reference is no longer the nation-state, but a broader entity—a continent, or the world-system as a whole."[33]

Hence while a colonizing power can use the ideology of progress to legitimate its domination over the "backwards" peripheries, a world text can turn the tables and represent the world system in which it is positioned from the peripheries.[34] Through its bricolage aesthetic, Moretti argues, such a world text can offer a critical reading of modern historical geography.

This idea of an aesthetic that understands place as a simultaneity of different times and spaces created through juxtaposition is the conception of literary montage that underlies most accounts of its practice in *Xiandai*. The poet and critic Shao Xunmei, for instance, described T. S. Eliot's poetry in a 1934 essay as "cosmopolitanist" or, literally, "worldist" (*shijiezhuyi*), by which he meant the combination of different historical and cultural fragments, a quality he took to be the defining characteristic of modernist poetry.[35] Eliot constructs his poem *The Waste Land*, Shao writes, out of such fragments through the use of "narrative discontinuity" (*gushi de duanxu*).[36] Shao qualifies this term rather cryptically, stating that "Eliot is not relating a story, but rather is relating the quality [*xingzhi*] of a story."[37] Shao seems to have in mind a montage aesthetic that breaks up a story or stories into fragments, and then either uses these fragments to allude to the larger stories from which they were broken off or combines fragments of different stories into a single, new context that is organized by a more abstract narrative structure (or "quality"). In either case, the importance of the joins between the fragments making up the collage text lies in their paradoxicality, for as Shao observes, "The places where [Eliot's] narrative is broken are precisely where the connections are." Indeed, Shao's term for this kind of narrative, *duanxu*, which I am translating as "discontinuity," itself expresses the paradoxical nature of each juxtaposition, as it is itself composed of the juxtaposition of the characters *duan*, meaning "break," and *xu*, meaning "continue." But Shao goes further, for this manner of constructing a narrative out of

discontinuous fragments is precisely what makes possible for Shao the temporal simultaneism of the text. Shao illustrates Eliot's "relating of a story's nature" by noting how in Eliot's poetry "one often can see a person from the ancient past appear within modern society."[38] The simultaneity of the nonsimultaneous is linked together by the discontinuity of the narrative.

The editor, critic, and literary scholar Zhao Jiabi regarded such narrative discontinuity precisely as "an innovative method of realism." In the essay "Meiguo xiaoshuo zhi chengzhang" (The growth of American fiction), published in *Xiandai* in 1934, Zhao argues that this form of realism works through a multiplicity of perspectives through which "the reader cannot see a single surface of a single thing, but rather from numerous angles derives the true likeness [*zhenxiang*] of a single thing's many facets."[39] For Zhao, the writer whose work best exemplifies a realism constructed through a juxtapositional aesthetic was John Dos Passos, who was widely discussed and influential in Republican Shanghai as a writer whose fictions pursued modern realities through montage. As Zhao as well as Du Heng describe it in a series of articles published from 1933 to 1936 in *Xiandai* and *Zuojia* (Writer), Dos Passos's trilogy of novels, *U.S.A.*, is entirely constructed of innumerable fragments—conceived of as photographic traces and shots on film, as historical materials from diverse times and places, and as fragments of diverse individual lives and impressions—that are juxtaposed into a vast montage representing the world system of contemporary history and individual subjectivities within it. Zhao was fascinated by Dos Passos's explorations of form—particularly the "Newsreel" sequences that appear throughout the trilogy—precisely as technical means through which to represent social, economic, political, and historical forces governing modern life. According to Zhao, such forces, in the present era, are like enormous waves that "surge ceaselessly day and night, yet are not concretely manifest before our eyes."[40] This representational problem, of making visible the invisible and complex forces determining modern life, was, for Zhao, beyond the capacities of nineteenth-century realist and naturalist novelists such as Tolstoy, Balzac, and Zola (who were—not coincidentally—the central influences on China's dominant social realist novelist, Mao Dun).[41]

For Zhao, the work of these novelists, despite its length and capaciousness, still could not contain enough of the world, for, he argues, every loca-

tion in the twentieth-century world — particularly its cities — was created at the intersection of an unprecedented number and complexity of peoples, classes, and events. Rather than attempt to represent contemporary history by either creating in narrative a temporal and spatial continuum or concentrating on one or a small number of characters as embodiments of social and historical experiences, as in more traditional fiction, Dos Passos employs what Zhao calls *hengduan*. To this Chinese term Zhao adds the term "breadthwise cutting," in English, but by *hengduan* he seems to indicate the cinematic "crosscutting" of multiple and simultaneously unfolding narratives, as well as a variety of other montage techniques.

Zhao considers montage narration to be the most realistic way in which to tell individual, national, and global histories and to represent the complex nature of modernity. Montage for Zhao achieves this "realism" precisely because it is an aesthetic of cutting across and joining different spaces. For what is most inadequate to Zhao is the idea promoted by literary naturalism of a "slice of life" (*rensheng de pianduan*), which, as his translation of the term suggests, he regards as an isolated individual fragment that by itself can only represent a "fragmentary life" (*pianduan de rensheng*).[42] The fictional slice of life has often been linked to photography, especially snapshots, which created visual fragments that seem to have been broken from the larger continuity of reality. Zhao does not, however, advocate a linkage of such fragments into a coherent unity offered by traditional realist fiction — or, for that matter, classic Hollywood film — which, "progressing according to an order of temporal succession, uses one point of view to depict a particular event within a particular time."[43] Instead, he argues for the importance of a montage of these fragments of individual lives, events, and places through "breadthwise cutting" according to space.[44] Zhao initially draws his terms — "breadthwise," "lengthwise" — from a passage in André Gide's novel *Les Faux-monnayeurs* (The counterfeiters), arguing for a new form of fiction.[45] But in redescribing this technique as a means for representing the complexities and contradictions of modern capitalist social reality, Zhao likens it both to a photomontage or, in his words, "a societal photograph of breadthwise-cut planes" (*yi fu hengduan mian de shehui xiang*),[46] and to a cinematic montage that "unfolds the story in space" (*zai kongjian shang ba gushi zhankai*) through using a "complex point of view

to write in segments [or fragments, *fenduan*] the different stories of numerous different characters."[47] The montage narrative of *U.S.A.* is created, as it were, out of the photographic traces of individual lives. These traces of individuals are also the traces of historical moments, for Zhao repeatedly refers to the characters and other fragments of which *U.S.A.* is constructed as "real history,"[48] or "historical materials."[49] But if it is not enough for these fragments to be represented in isolation, it is also not enough for these materials to be simply "piled together";[50] rather, Zhao believes they must be brought into provocative juxtapositions in order to ignite their explosive force. Zhao echoes Pierre Reverdy's claim that powerful images are created out of the distant relationship of two juxtaposed realities, writing that the "juxtapositional method" (*binglie de fangfa*) is based on difference, "writing of different people's different lives, these characters' differences."[51] But, once again, Reverdy's fragmented images of the mind are concretized as particular times and places. For, as Zhao insists, Dos Passos's montage techniques make visible the multiple temporalities that both coexist within a single historical period—early twentieth-century America—and locate that period itself as a space in between, showing "how the old society is disintegrating, and how the new society is just growing."[52] For Zhao, then, montage, or crosscutting, is both "about" uneven development and "about" simultaneity—or, rather, it is a technique that reveals them to be two sides of the same coin. Indeed, Ernst Bloch's concept of the contemporaneity of the noncontemporaneous mentioned earlier appears in a book of historical analysis that not only is constructed according to the principles of montage but also devotes a large section to the idea of montage itself.[53] Elsewhere, Bloch characterizes montage as a principle in literature and painting as well as film whose "disruptive and interpolative techniques" reveal reality to be discontinuous. If, as Zhao writes, the old society is disintegrating (even as it tries to conceal its breakdown in continuous linear narratives), then montage "strives to exploit the real fissures in surface inter-relations and to discover the new in their crevices."[54]

Indeed, if we reflect that most of the texts and images of practicing or analyzing collage and montage date from 1931 through 1935, it is difficult not to observe that Shanghai modernists took up these practices in the midst of a growing crisis in which the dialectic of disintegration and the

new became particularly acute. For by this time, the impact of the explosion of image culture in Shanghai since the mid-1920s had reached its full force; but during the same period, an explosion of imperialist violence in Manchuria as well as Shanghai threatened to fragment (in the most literal ways) the ground upon which Chinese stood.[55] Indeed, the most radical literary montage to be produced in Shanghai during these years was written out of and reflected upon the intersection of these experiences. This was the fiction of Shi Zhecun's colleague Mu Shiying, especially his story "Yezonghui li de wuge ren" (Five in a nightclub), published in *Xiandai* in 1933. To begin with, the five characters of this story are disconnected and circulated as images in a way that gives a critical edge to Reverdy's vision of a fragmentary mirror in his poem "False Portal or Portrait." Young women in the Shanghai nightclub, for instance, trying to transform themselves into the very image of women desirable to men, "powder their noses reflected in [their] tiny mirrors."[56] Under the pressure of such objectifying desire, the women do not find an image of a whole self reflected in the mirror, "they don't see the whole face"; rather, "they only see a nose, or an eye, or the curve of a lip, or a wisp of hair."[57] That is, the women's bodies are dismembered into fragmentary images in order to circulate among men. This seeming critique of a male objectifying gaze insinuating itself into women's self-images, however, is not really where the originality of his story lies. Rather, it is one instance of how, in Fu Lei's words, people's images are captured and decomposed in a Shanghai that itself is depicted as a fantastically unstable landscape constructed out of displaced and projected images.

On such unstable ground there can perhaps be little plot to speak of. Instead, the story's three major sections formally embody the processes of fragmentation, circulation, and recombination so widely theorized in Shanghai. Part I cuts between "five people who have fallen down from life" at the same moment in various parts of Shanghai: a speculator loses his entire fortune on the gold exchange; a student loses his lover in spite of a sentimental song he writes for her; a woman contemplates the loss of youth in the eyes of passing men; a scholar contemplates the loss of meaning in a world of proliferating translations; and a senior clerk in the mayor's office is abruptly and arbitrarily dismissed.[58] Having presented these fragments in part I, the story moves on in part II to presenting Shanghai itself as a space

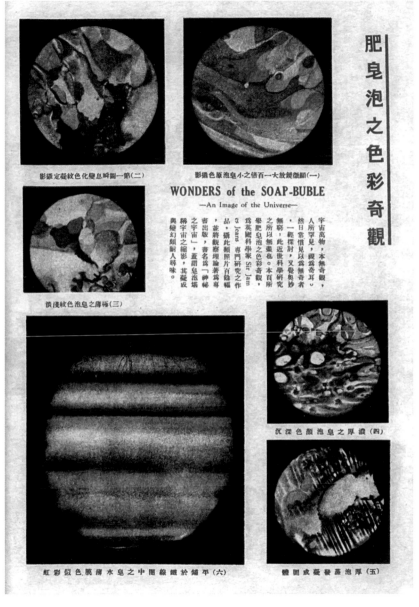

PLATE 1 "Feizao pao zhi secai qiguan/Wonders of the Soap Bubble," *Liangyou huabao* 69 (1932).

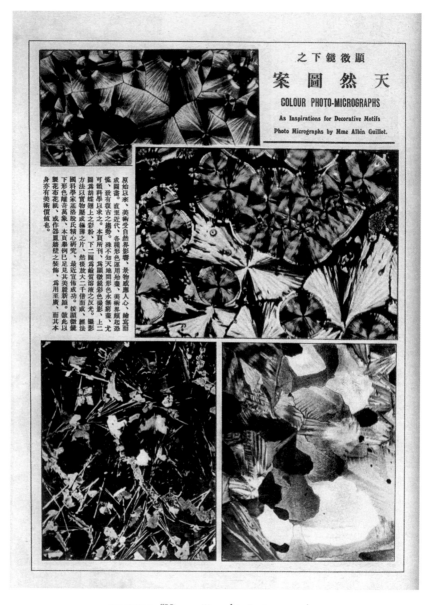

PLATE 2 "Xianweijing zhi xia tianran tu'an
[Natural designs under the microscope] / Colour Photo-
Micrographs," *Liangyou huabao* 61 (1931).

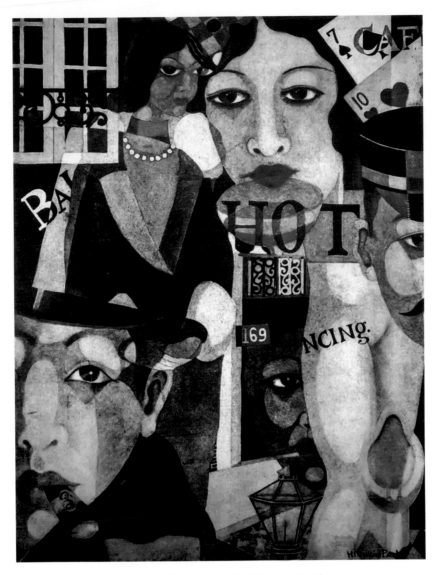

PLATE 3 Pang Xunqin, *Ruci Bali* [Such is Paris], 1931.
Watercolor on paper, destroyed. Courtesy of Kuiyi Shen.

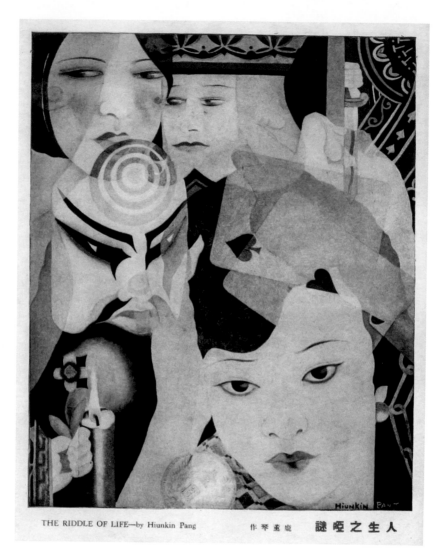

THE RIDDLE OF LIFE—by Hiunkin Pang 作琴薰龐 謎啞之生人

PLATE 4 Pang Xunqin, *Rensheng zhi yami*/The riddle of life
(also entitled *Ruci Shanghai* [Such is Shanghai]),
Liangyou huabao 71 (1932).

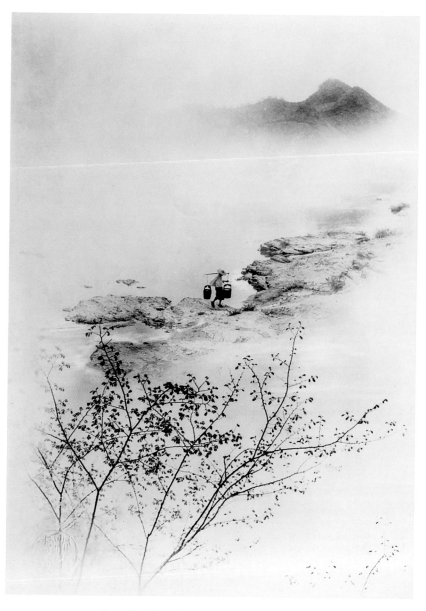

PLATE 5 Lang Jingshan, *Qian jiang xiao ji/Riverside Spring*, 1934.
Composite photograph. Lang Jingshan [Chin-san Long], *Selected Works of
Chin-San Long* (Taipei: Zhonghua xueshuyuan sheying yanjiusuo, 1971).
Courtesy of Eve Long.

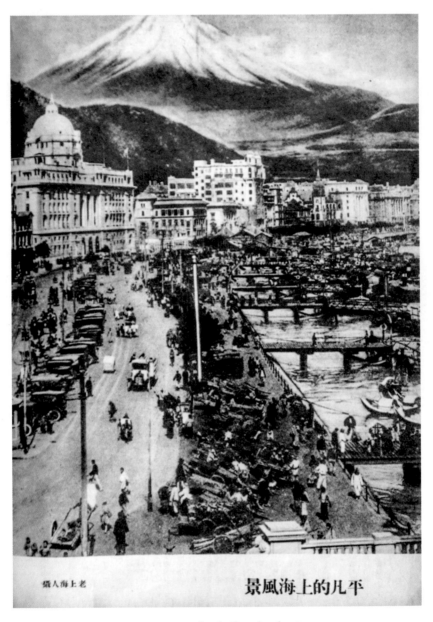

老上海人猿

景風海上的凡平

PLATE 6 *Pingfan de Shanghai fengjing*
[An ordinary Shanghai landscape], *Shidai manhua* (1936).

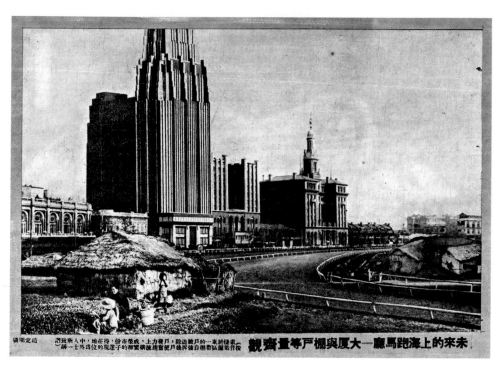

PLATE 7 *Weilaide Shanghai paomachang: Dasha yu penghu dengliang qiguan*
[The Shanghai racetrack of the future: High buildings and huts seen as equals],
Shidai manhua (1937). Special Collections and University Archives,
Colgate University Libraries.

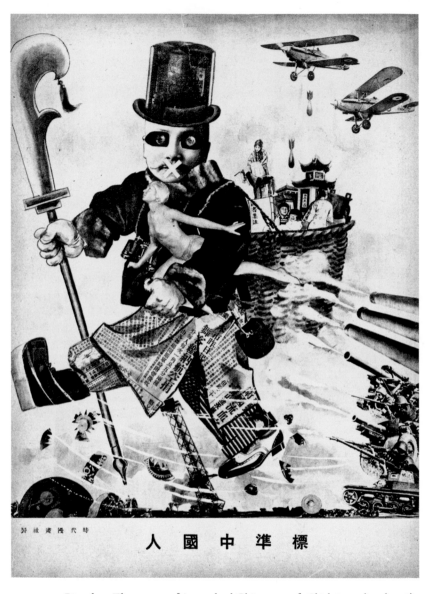

標準中國人

時代漫畫社製

PLATE 8 *Biaozhun Zhongguoren* [A standard Chinese man], *Shidai manhua* (1936).
Special Collections and University Archives, Colgate University Libraries.

composed of circulating images. In part III the five characters themselves meet, circulate, and recombine in a nightclub; they only cease when the speculator commits suicide and the others, in a coda, gather at his funeral. Yet even as the story focuses on the fragmentation and juxtaposition of these five characters, their own circulation is situated within a global space that simultaneously circulates, is conquered, and collapses.

The opening of the story is reminiscent of Pang Xunqin's painting *Such Is Shanghai*, for it composes the ground of Shanghai out of the juxtaposition of disconnected and alienated figures. Each of the five short sections that make up part I introduces a different character, but these sections all begin with the same temporal marker—"Saturday Afternoon, 6 April 1932"—and all end with variations on the same sentence. These five sections, then, are meant to be read as simultaneous, presenting, as their opening sentences claim, the same moment in different parts of Shanghai. But the effect of their simultaneity is also reinforced, if not produced, by their very repetitiveness, for while this repetition appears to produce these five "unique" individuals as copies in a series, the repetition of the same moment in different places of Shanghai has the effect of momentarily stilling and spatializing time. This stillness, however, is hardly the "timeless" effect often attributed to spatial narratives; rather, these opening snapshots of different places in Shanghai represent space itself to be highly unstable, even insubstantial. Indeed, this instability of space is the ground that links the story's characters and their despair.

The first section, for instance, which takes place at the gold exchange, links Shanghai into what is literally a world of speculation, in which an event elsewhere in the world immediately affects the local economy and sends the value of gold tumbling. Appropriately enough, the event is an earthquake in Japan: the instability of the earth leads to instability in Shanghai. But while in this instance geographic instability leads to an unstable market, we soon find that the speculation and circulation of capitalism as well as colonialism make place itself unstable. This connection is most vivid in the third section of part I, which takes place, so to speak, in the French Concession of Shanghai. What we are shown in the scene's "establishing shot" is "Avenue Joffre, a boulevard transplanted [*yizhiguolaide*] from Europe."[59] Yet this place out of place (which has, of course, dislocated the place that was already there)

is itself, as Mu Shiying describes it, not just a material location upon which one can walk; for, "soaked in golden sunlight and paved with broad shadows [*yingzi*] of leaves," this place is also composed of projected images, a theme Mu will return to throughout the story.[60] Indeed, anticipating the fragmented images in which women in the nightclub subsequently appear, the woman walking down the boulevard of transplanted images is herself made of images, both in the eyes of the men who evaluate her looks and in the shop window to which she rushes to "look at her reflection" (*yingzi*).[61] By playing in this short passage on the multiple meanings of *yingzi* as both shadow and reflection, Mu links the circulation of colonial place to a colonial subject's image in the mirror of a place of commodity circulation.

Indeed, throughout part I, Mu Shiying equates the location of Shanghai and its subjects as the landscape transforms from an unstable ground of speculation to a "photographic" image of light and shadow, and then into a puff of smoke. Small wonder, then, that after these characters have all assembled in the nightclub in part III, they veer between keeping themselves circulating deliriously and clinging to a collapsing world. The text represents the collapse of global space comically:

> As Miao Zongdan danced he noticed a sagging string of helium balloons above his head. He jumped up and snatched one down, then he patted Zhijun on the cheek with it and instructed her: "Hold on to this! This is the world!" Zhijun took the balloon and held it between their faces, laughing:
>
> "Then you're in the western hemisphere and I'm in the eastern one!"
>
> Someone must have pricked their balloon, because it popped. Miao Zongdan's smiling face suddenly grew serious: "That was the world! That balloon which popped . . . that popped balloon!" Miao Zongdan pushed his chest against Zhijun's and skated through the crowd, weaving in search of dancing room.[62]

Miao Zongdan's reaction, however, is far from comic; indeed, it is in order to avoid contemplating the spectacle of a "global space" that has gone from being lighter than air to nothingness that he frenetically keeps himself moving.[63] It is precisely this spectacle that is the structural center of the story

around which the characters spin. Indeed, to extend the global metaphor, according to the text, the world of a Shanghai Saturday night "is a cartoon globe spinning on the axis of jazz — just as quick, just as crazed; gravity loses its pull and buildings are launched into space."[64] Jazz, which of course is largely an unfixed and improvisatory music, is seen in this story as a foreign chaotic and elemental (and, later, "primitive") force: this is what anchors a world in which all is dislocated. Mu Shiying, then, represents a Shanghai that goes far beyond what Fu Lei would later imagine, for not only is "humanity" lost in space, but even place itself floats away into space.

Mu most vividly represents the cityscape of Shanghai in part II, a montage sequence that intervenes between the initial presentation of the characters and their subsequent assembly at the nightclub. Here Mu takes the vision of Avenue Joffre as a projection of images to an extreme: all of Shanghai appears as a montage of circulating and juxtaposed places and images, a vortex on the periphery of a world system of land speculation, commodification, and imperialist violence. In Trumbull's translation (slightly amended), the central passage of part II goes as follows:

Streets:
(Puyi Realty accrued annual interest totaling 33% of capital investment
Has Manchuria fallen
No, our volunteers are still fighting in the snow with Japs to the last man
COUNTRYMEN COME PLEDGE MONTHLY DONATIONS
The Mainland Daily circulation now totals 50,000
1933 Bartók
free meal-line)

"Evening Post!" The newsboy opened his blue mouth to reveal blue teeth and a blue tongue. The blue neon high-heeled shoe across from him pointed straight at his mouth.

"Evening Post!" Suddenly the boy's mouth turned red. He stuck out a red tongue to catch wine being poured from an enormous neon bottle across the street.

Red streets, green streets, blue streets, purple streets. . . . City clad in strong colors! Dancing neon light — multi-colored waves, scintillating waves, colorless waves — a sky filled with color. The sky now had

everything: wine, cigarettes, high-heels, clock-towers. . . .

Try White Horse Whisky! Chesterfield cigarettes are kind to a smoker's throat.

Alexander's Shoestore, Johnson's Bar, Laslo's Tobacco Shop, Dizzy's Music World, chocolate and candy shops, the Empire Cinema, Hamilton Travel Agency. . . .

Swirling, endlessly swirling neon lights.

Suddenly the neon lights focus:

EMPRESS NIGHTCLUB[65]

The first line says it all through the relationship its colon establishes between "streets" and what follows: Shanghai streets (themselves, as streets, places of circulation) *are* composed of a series of verbal and visual images. The spatial juxtaposition of the verbal fragments of the following eight lines (here the form of Mu Shiying's text is reminiscent of a Newsreel from Dos Passos's trilogy) constitutes the streets of Shanghai out of fragments that connect the city spatially far beyond its boundaries, even as those same fragments collapse together in Shanghai. Most of these lines play on the idea of the circulation of land. Land speculation by a real estate company (whose name, one suspects, may have been chosen in this context to pun on the newly established chief of Manchukuo, the last Qing emperor, Puyi), leads to a battle over land on the periphery of China (for which, appropriately, money is solicited); these real struggles over land, in turn, become the headlines that boost the circulation of a newspaper itself titled, also appropriately, the *Mainland Daily*. Against these fragments of land circulation are juxtaposed an apparently random reference to Western modernism (Bartók) and a reference to the poverty of displaced people within Shanghai.

All these headlines are reminders of real struggles for food and land. Yet, given their visual presentation in the story as headlines, these words are also images of how words are presented in newspapers, or words as images, freely circulatable in Shanghai's streets. This permeability of the boundaries between words and images, the places of which they are traces and the places they compose, is what makes the Shanghai of this text seem at once so material and so very insubstantial. Moreover, immediately following the headlines, the people inhabiting Shanghai are drawn into this vortex

through the figure of a boy who sells the newspapers from which such head-lines were cut. In its depiction of the boy, the rhetoric of the text dissolves the boundaries between his "fleshly body" and the images composing the surrounding cityscape: his face both is colored by neon advertising images (his face is a distinct surface upon which images are projected) and inter-acts on the same plane of reality as these images (his tongue can catch wine poured from an image). The text does not, however, present the "true face" of the boy lying beneath these images; his mouth simply "is" blue or red ac-cording to which advertising image is being projected. The street on which the boy stands is similarly ambiguous: they both *are* the colors of neon images, and, "clad in strong colors," they are the media of such images. And in this city in which gravity has lost its pull, even the sky is filled both with floating images and with their disembodied, seductive voices: if the ground is composed of places invaded and dislocated by imperialism, the sky is an assemblage of foreign traces created through foreign capital. It is only appropriate that the one place in Shanghai swirling images can bring into "focus" is itself a place of gathering and circulation, the nightclub, which is literally under the sign ("empress nightclub") of either foreign empire or of China's imperial past—a neon sign that is now itself a commodified icon.

Mu Shiying's montage creates a composite image of Shanghai, but it is an image that forces its readers to consider the diverse origins of its fragments. Moreover, while Mu Shiying may briefly invoke Dos Passos's Newsreel se-quences of texts and headlines cut and pasted together, there is notably no mastery of a Vertovian kino-eye that brings these fragments together in Shanghai and either motivates or composes this landscape or is composed by it; the neon lights at the end of the passage quoted earlier, for instance, are not focused, or brought into focus, but rather simply focus themselves. Rather, if Mu's montage, in Vertov's terms, creates "you" and the "room" you are placed in, both subject and place here are constantly circulating, floating, and collapsing. While these fragments both capture Shanghai and maintain their distinct foreignness, they dissolve, as we have seen, other kinds of boundaries. The materiality of places and subjects is transformed into circulatable images, and juxtaposed images create material places; place is displaced and recombined through capitalism's circulating images, even as it is fragmented and dislocated by colonialism. More than any other text,

Mu Shiying's literary montage makes visible in Shanghai the general perception with which I began, namely, that circulating images are part of a general disintegration of person, landscape, and place into space.

Reoriented Landscapes

The montage landscapes envisioned and composed in Pang Xunqin's paintings, in the critical essays by Fu Lei, Shao Xunmei, and Zhao Jiabi, and in Mu Shiying's fiction all made the location of modern China — and, in particular, Shanghai — into a question. If Shanghai is composed of material and immaterial images circulated from abroad, as we have seen it represented, then where does one locate China in all these images, or is China simply displaced altogether? And if these images are conceived or actually made through modern Western visual technologies, then have they replaced China's own methods of verbal and visual image-making? Then as now, one's answers to such questions could be fraught with political weight, as they cannot but be implicated in what one means by the idea of a "modern China," the ways in which "China" and "modern" may be related to each other, and the ways in which such relationships might be represented.[66] Fu Lei, Pang Xunqin, Zhao Jiabi, Mu Shiying, and others may well have answered that their practice and discussion of collage and montage were intended precisely to engage with problems of modern China's location in a global imperial landscape of circulating images that could not be wished away but, rather, required new modes of representation in order to be clarified and critiqued. Others, however, may well have replied that the practices of Pang, Mu, and others were not answers to the problem and, by representing Shanghai through the juxtaposition of fragmented and globally circulating images, only exacerbated it. Indeed, they might want to turn around the entire problem and contain modern images within an aesthetics they conceived of as originating in China, while others might try to seek modernism's relations to such aesthetics.

Thus, another answer to the question of the location of modern China may be found in plate 5. This image appears to leave far behind a modern world of fragmented bodies and dislocated places to find instead an apparently timeless scene. Indeed, it is the representation of this tranquil space

that is particularly valued in a text commenting on the picture: "This picture has one of the traditional merits of Chinese paintings: namely *space* and *atmosphere*, which, according to the Six Canons of Chinese Paintings [*sic*], is called 'Chi Yun Sheng Dong,' or Rhythmical Vitality. Chinese artists love to have space in their paintings. Looking at [it], one feels quietude and rest."[67] This, however, is not a traditional Chinese painting. It is a photograph made by Lang Jingshan in 1934. In this rural scene, entitled *Qian jiang xiao ji* (Riverside spring),[68] Lang seems to have overcome the urban fragmentation and dislocation that characterized the texts and images we have surveyed. But what is particularly astonishing about this photograph, apart from its extraordinary resemblance to a traditional Chinese painting, is the technique through which Lang achieved this resemblance. For this is actually a photomontage. The layout in figure 4.3 comes from an article Lang published a number of years after he made this picture, in which he explained how he produced it. We can see that the picture was made of three fragments cut from two separate photographs — the mountain peak and the man crossing the stream from the upper photograph, and the foliage from the photograph below. Indeed, Lang writes of going out to the countryside to gather fragments, taking pictures of this plant or that mountain, not to represent them in their "natural setting" but to use them later in these photomontages.[69] Thus he defines this kind of picture as a *jihe duoshu di pian zhi jingwu*, a "scene collected together out of multiple negatives."[70]

Now, Lang's photographs represent something quite different from an avant-garde desire to create a new and critical vision through photographic technology. As his essay stresses, they are also to be distinguished from what he calls "trick pictures" made with "scissors and paste" out of "odds and ends," and whose "makers simply do not take the trouble to conceal the joining parts." Lang denigrates such images, whose "story or . . . idea," he claims, is more important than the "picture itself," by associating them only with "advertising images" and remaining silent about avant-garde practices. His own composite pictures, by contrast, he defines as "an accomplished art."[71] While to Lang this *was* a method through which to combine fragments of different spaces and different times, the point was not to create and emphasize joins or fissures through radical juxtaposition, but rather to *conceal* the joins in order to compose a unified location — here, the empty

FIGURE 4.3 Lang Jingshan, "Qian jiang xiao ji/Riverside Spring." Layout from Lang Jingshan [Chin-San Long], *Techniques in Composite Picture-Making*, rev. ed. (Taipei: China Series Publishing Committee, 1958).

space of a natural boundary: a river. This photographic method Lang conceptualized through the sixth-century artist and critic Xie He's influential Six Principles [*Liufa*] of painting (which Lang's text refers to as the "Six Canons of Chinese Paintings"). Lang's account of his work calls special attention to the importance in the composition of a traditional Chinese landscape of blank spaces and mists — his point being that this preference for mists can be used both to structure a photomontage and to obscure the fact that a picture is a photomontage. In other words, Lang tries to overcome the fragmentation and dislocation of the Chinese past and its landscapes through visual technology, by reconceiving that foreign technology both as contained within an aesthetics he conceived of as "essentially" Chinese and as a fulfillment of that aesthetic.[72]

Lang Jingshan's work is representative of a variety of efforts at this time to use elements of Chinese culture to work through or contain the problems of fragmented images and place — to "re-orient," as it were, these placeless images. But such attempts led to unforeseen (if not unseen) complications. For to use what, from considerably different perspectives, both Feng Zikai and Lang Jingshan regarded as "essentially Chinese" methods of representation to conceive new technologies often meant that China's place (both as cultural-geographic location and as a role in image-making practices) was reduced to a few timeless essential qualities, even as modern image-making technologies complicate methods of representing place — that is, landscape — seen as "essentially Chinese."

Lang's conservative attempt to create a Chinese landscape through photography conceals the troubled relationships among landscape, place, space, images, and traces common in the print culture of Shanghai in this period. Yet the contradictions in Lang's landscape photograph *Riverside Spring* are there to be seen right on its surface. On the one hand, as a photograph, it claims to register a particular view of landscape "as it really is." That is, it seeks to validate a way of seeing landscape: the Chinese land "really" looks the way it is represented in a Chinese ink painting. On the other hand, by reproducing in photography the effect of a Chinese painting's representation of landscape, Lang's photograph is not an image of landscape but an image of an image. Furthermore, as a composite of different photographs, there can be no single original (such as, say, a painting by Guo Xi) that it is

reproducing. Lang avoids this question by seeing composite images themselves as Chinese. As he asks, "Have not Chinese artists been making composite picture[s] all the time?"[73] This question is not so easily answered, however, and Lang resorts to two lengthy texts to address the contradictions within such images. The process through which Lang produces his landscape and the ways he conceives it in his texts register the difficulties (and Lang's ingenuity) in making photography a manifestation of Chinese landscape aesthetics.

Lang's effort to create place out of fragmented images is a struggle against the power — or, rather, what he calls the "deficiencies of machinery" — of the camera's eye. This mechanical eye was, of course, originally created to produce images according to Western conceptions of perspective; Lang must overcome it to produce "spiritual" Chinese landscapes.[74] Thus in a section of his essay that draws its name from one of the Six Principles of painting, *Ying wu xiang xing* (Responding to things, image their form),[75] Lang claims that the dictum "The longer the focus the better [the] picture" is "exactly in accord with the Chinese rule of painting."[76] Lang seems to make this connection because a lens of long focal length — that is, a telephoto lens — has the effect of "imaging forms" whose planes are flattened, and whose distance perspective is reduced. Thus, a "Western" way of seeing can be reduced even in the production of a fragment out of which Lang will build his pictures. Lang then argues that the photographic fragments should be composed together according to the "perspective view" of Chinese landscape painting, which divides space into three major planes. Each of these three distances, which, according to the eleventh-century painter Guo Xi, should all appear in a landscape painting, presupposes a different position from which a viewer looks at mountains, and a different distance into which the viewer looks.[77] In Lang's own work, if each photo fragment represents one of these distances, as is the case in *Riverside Spring*, then by combining them Lang can both practice Chinese landscape aesthetics and overcome the camera's single-point perspective with an image created of multiple and simultaneous perspectives. Since for Lang, a Chinese landscape is created out of the juxtaposition of several views, locations, and planes, he can both naturalize photomontage as Chinese and make the creation of Chinese landscapes in photography dependent on montage.

Lang Jingshan's overcoming of the camera's eye through montage may sound oddly reminiscent of Vertov's kino-eye. Lang even claims that through his method, "neither time nor space need hereafter be an obstacle."[78] Yet Lang's purpose is far from a jarring, let alone revolutionary, linkage of different places and times; nor, indeed, does it produce for him Fu Lei's anxious experience of being "lost in space." Rather, Lang wants to transcend the particularity of place altogether and transform different fragmentary scenes into an ideal landscape, what he calls a "Land of [the] Heart's Desire."[79] This desire is not as innocent as it may sound. First of all, while Lang wants his images to transcend the particularity of place, the image fragments of which his pictures are composed are, in fact, a record of Lang's own movements through space: for Lang, of course, actually had to travel to the particular places whose traces he captures on film. These hidden journeys themselves trace a spatial organization of center and periphery, for if, as Lang writes, he has made use of composite pictures "since coming back from my last trip in the interior,"[80] the implication is that the peripheries supply the fragments that will be juxtaposed together in China's modern center of Shanghai. Yet, of course, all traces of the particularity of places and the journey between them must be erased. Thus, Lang suggests, the line of poetry "Bai yun shen chu you ren jia" (Hidden among the clouds there is habitation), which "comes automatically to travelers' minds when thinking of their homes far away," also creates a "fondness for clouds" in Chinese painting; this fondness, in turn, is "a great help to Composite Pictures," for "if there are some clouds or fog or . . . waters, [then] nobody will notice the joins" between image fragments.[81] For Lang, the juxtaposing of image fragments through montage serves not to represent or reveal the many particular locations and images that compose a single place. To the contrary, the cutting of photographic images allows him first to cut out "undesirable interference with the view"—stones or trees that might identify a particular place—and then create instead a seamless whole, an ideal, timeless, and placeless landscape. Indeed, even the individual image fragments that make up such landscapes are somewhat disembodied, for Lang does not cut from printed photographs and paste them together, as is the case in *Shanghai Landscape* in *Shidai manhua*. Rather, each piece of a landscape is projected, one by one, onto the photographic paper from a series of

negatives in the enlarger, making of the picture as a whole a seamless landscape of projected images.

Lang's appeal to this aesthetic of empty space in landscape and its production of rest and quietude, a "Land of the Heart's Desire" in which the mind can wander, is where his work is most closely linked to China's own genres of imperial landscape. It is especially noteworthy that Lang's photomontages take the form of combining particular places and an empty void to create a noplace for the mind, for a similar process is at work in the dominant genre of travel and landscape writing of imperial China.[82] Lang's efforts to overcome a sense of spatial fragmentation, as well as the domination of a Western way of representing place, thus lead him to base his "vision" of an essentialized Chinese landscape on an ideological practice that empties fragments of place of their local particularity and connects them into a seamless, placeless, and virtual landscape of the mind.

Place Out of Place

Where *Shidai manhua*'s first photomontage located Shanghai's landscape in a violently incoherent assemblage of body parts and objects, Lang Jingshan's answer to the question of where China is through his seamless projections of place and blankness is, quite precisely, nowhere. Several years later, *Shidai manhua* seems to have produced something of a rejoinder to Lang's landscapes, for the magazine's montageurs' attention shifted from bodies to an exploration of space, place, and landscape, and from a nearly Dadaist jumble of many fragments to juxtapositions of two or three images, apparently as seamless as Lang's landscapes. Only apparently seamless, of course. For where in *Riverside Spring* blank space conceals the seams between projected images, in *Pingfan de Shanghai fengjing* (An ordinary Shanghai landscape) of 1936 (plate 6) or *Weilaide Shanghai paomachang: Dasha yu penghu dengliang qiguan* (The Shanghai Racetrack of the future: High buildings and huts seen as equals) of 1937 (plate 7), the seam between landscape fragments is the horizon line itself. In both of these images, the seams are rendered nearly invisible, most likely through a process of cutting photographic prints, assembling the fragments and pressing them together under glass, retouching and rephotographing the composite image, and

then retouching the resulting negative before making a final print before publication.[83] The continuity of surface of the photomontage produced in this way makes all the more disorienting and shocking the discontinuity of these landscapes, whether they visualize the collapse of country and city (only implicit in Lang's recomposition of hinterland sites in an urban dark-room) with the displacement of rural populations, or critically imagine the fragmented, collapsed, and reconnected geography of Japanese colonialism, in which Mount Fuji looms as a new background for the Shanghai water-front. Indeed, the very disjunctions composing place in these two images play upon the apparent photographic unity of place. In the racetrack image, for instance, the perspective of the rural dwellings and the urban buildings is kept consistent, even as both images make visible the anxious fractures of colonial modernity reaching a moment of crisis with the imminent Pacific War and the subsequent revolution. As Sabine Kriebel comments on John Heartfield's use of similar techniques in his photomontages from the early 1930s, the violence of such images "operates not on the register of vicious cut-and-paste but on that of psychological discomfort, generated by the disturbingly realistic representation."[84]

Between the fragmentation of bodies in the early *Shanghai Landscape* and the seamless recomposition of places in the later two landscapes appeared the most complexly constructed of all of the *Shidai manhua* photomontages, *Biaozhun Zhongguoren* (A standard Chinese man; 1936), which depicts a man striding through a thin landscape of warfare (plate 8). The figure in the image is a composite of parts of photographs and newspapers, drawings and brushstrokes. The diverse body parts, as well as the objects used in place of body parts and clothing, are here assembled according to a bodily logic that is not quite seamless, even if it is far from the extremity of bodily fragmentation of *Shanghai Landscape*. That is, the body assembled here is complete and integrated in a way it is not in the earlier photomontage, even as the emphasis of the picture is not on the idea of landscape but of person. And yet that very pictorial integration is composed of a much greater temporal disjunction among image fragments than is to be found in *Shanghai Landscape*: binoculars, a halberd, a wingtip oxford shoe on the left foot, and on the right a *houdi xue*, or thick-soled boot worn by court officials in the Qing dynasty and in Beijing opera. Despite the intricacy with

5

SHANGHAI SAVAGE

By juxtaposing "Shanghai" and "savage," I want to call attention to a little-discussed disjuncture in the culture of Republican Shanghai. Alongside images of modern life in the print media were numerous representations of "the savage" both abroad and on China's frontiers. These included photographs purporting to represent "primitives" and "savages," as well as ethnographic texts circulating lurid tales of head-hunting, cannibalism, and slaughter. A 1927 article by Xu Weinan, "Taiwan shengfan de yishu wenhua" (The artistic culture of the Taiwanese barbarians), represents this stereotypical discourse well. The first sentence reads, "The barbarians of Taiwan are just like other savage races, they usually fill people with terror — the terror of being slaughtered by them."[1] This slaughter, Xu adds, takes the form of head-hunting. Xu's article goes on to suggest that head-hunting and the marking of the face with tattoos, which his text identifies as artistic or image-making practices, serve as the primary markers of the cultural difference of the "Taiwanese barbarians." For Xu, such forms of violence and image-making mark a difference so extreme that the civilized and the savage are filled with utter hatred for each other, and should they encounter each other, they will "fight to the death."[2]

Ling Changyan identified this fascination with "barbarous landscapes" of "primitive desire" in a 1934 text as a specifically urban phenomenon, claiming that "modern life's essential element is the return to primitive savagery."[3] Yet perhaps it would be more accurate to say that the "essential element" of "primitive savagery" was its circulation within modern life. For many of these texts and images were produced abroad, and many others were produced all over China, but the Shanghai media during this period showed a strong interest in collecting, sometimes sponsoring, and publish-

ing such representations. Under the epithets "savage" and "primitive," such representations conflated not only the peoples of China's frontier regions but also the peoples of Africa and the South Pacific. (In order to avoid a tedious overuse of scare quotes, I will assume the reader's awareness of the racist connotations of the terms "savage," "primitive," and "civilized," and that my attempt to read Republican Shanghai culture through their usage by no means marks my endorsement of them.) As in the imperial metropolises of the West, the savage and its images became demeaning ways of thinking, producing, and representing racial difference, and in particular blackness. Yet the widespread presence of such material in the mass culture of Shanghai raises the question of how race and the savage were represented in the semicolonial metropolis. To ask this question of representation, however, is to ask questions of the place of savage images in Shanghai's own self-representation and self-understanding. Why, when China was so often on the receiving end of Western racialist discourses, was the savage such a common image in Shanghai mass culture? An exploration of this question must involve more than simply identifying a discourse of race in modern China, one comparable to such discourses in the West.[4] Rather, one must seek to understand how racialist discourses of the savage both circulated globally and were produced out of global circulation, even as Shanghai's local mass and elite cultures appropriated them.

Indeed, writings such as those of Xu and Ling suggest that this fascination with "barbarous landscapes" aimed to negotiate Shanghai's own uneasy temporal and spatial location within the landscape of Republican China, differentiating Shanghai from China's own margins as a center of modernity, even as Shanghai itself was constituted as lying on the margins of global modernity. As I shall argue throughout this chapter, questions of location, self-representation, and the savage in Shanghai were intertwined with questions of the relationships between the image of the savage and ideas of representation itself. That is, many visual and verbal images of the savage defined ethnic and cultural others in terms of their image-making practices. At the same time, the image of the savage was frequently called on at critical points in numerous discussions of the representation of the real — at a historical moment in which the relations between visual and verbal representational practices were also undergoing revolutionary changes.

It is thus fitting that Ling Changyan's claim that urban "modern life's essential element is the return to primitive savagery" is actually part of an article he published in the modernist magazine *Xiandai* in which he connects the formal self-consciousness of William Faulkner's novels to their narratives of "characters who crisscross the borderlands of civilization and savagery."[5] For, in China as well, a number of experiments with various literary modernisms produced — and were produced out of — the complex relationships among race, the savage, and Shanghai's self-representation during the late 1920s and early 1930s. Two passages from such modernist texts self-consciously link problems of verbal representation to Shanghai's particular cultural predicament. These passages prove particularly revealing because they mark relatively incidental moments within the texts in which they appear. The first appears in Mu Shiying's dizzying verbal montage of semicolonial Shanghai, "Yezonghui li de wuge ren" (Five in a nightclub; 1932), whose composition of the urban space out of projected image fragments I discussed in the previous chapter. The central location within that composite space is the nightclub of the story's title, which the text introduces as follows:

> Tablecloths: white linen, white linen, white linen — white . . .
>
> On the white linen: dark beer and black coffee — darkness, blackness . . .
>
> By the white tablecloths sit men dressed in formal evening attire: layers of black and white: black hair, white faces, black eyes, white collars, black ties, white starched shirts, black jackets, white waistcoats, black pants . . . black and white . . .
>
> Beyond the tablecloths stand the waiters in their white suits and black caps. Black piping runs down their white pants . . .
>
> White man's happiness, black man's misery. Music from the cannibal rituals of Africa; the loud-soft thunder of drums, the trumpet's wail, and in the center of the dance-floor a row of indigent Russian princesses performing the black man's tap-dance; scores of white legs kick below black-clad torsoes: —
>
> Duh-duh-duh-duh-da!
>
> More layers of black and white! Why is it that two white patches are sewn into the black silk wrapping their breasts, and why is there a third white patch

over the belly? Tap-dancing, Russian princesses; dancing, the white legs, the white chests and belly; dancing, the layers of white and black . . . the layers of white and black. Everyone contracts this malaria. Fevered music; ah, the deadly mosquitoes of African jungles.[6]

The racist connotations called on to represent jazz are all too familiar from the global mass culture of this period: conflating African Americans with black Africans under the sign of the savage, jazz in Mu's text is both "music from the cannibal rituals of Africa" and "the black man's tap-dance." Yet the matter proves more complicated than that, for this conflation appears as part of a larger, alternating series of associations that the text produces with blackness and whiteness. Of course, one could say these associations were simply drawn from elements visible in the nightclub. These elements are, for the most part, fragments of bodies and clothing, colored black and white. Yet given the logic of Mu's text, it is not quite accurate to say that such fragments are simply "drawn" from a Shanghai nightclub. Rather, it is precisely the vertiginous repetition of black and white that fragments bodies and their adornments (themselves metonymies of bodies) into a series of hair, faces, eyes, collars, ties, legs, torsos, and so on. These fragments are themselves assembled not according to any particular narrative logic but instead according to a *visual* logic of opposed colors. The coding in such a visual logic quickly becomes apparent as the opposition of body parts and clothing transforms into an opposition between the "white man" and the "black man," which itself spins from an expressed concern for racial and colonialist injustice to a play with racial stereotypes. In this opposition of black and white, the Chinese themselves do not seem to be located anywhere; yet what this entire passage does in Mu's text is to produce a specific location in Shanghai (the nightclub) out of fragmented and juxtaposed body parts, black and white.

A second passage of modernist writing from the same period, however, locates Mu's black-and-white world at once within the psyche of a Shanghai male and within a global geography. This story is Shi Zhecun's "Mo dao" (Demon's way), a text that, as I showed in chapter 3, is composed of projections of Egyptian-style tombs onto a "traditional" Chinese landscape, and an apparition that metamorphoses from an old woman into a witch in

black, a mummy in white, a spot of blackness, and a shadow. The narrator of the story is haunted by the unseen—which makes all the more significant what he does "see" when he projects onto the sunset over a rural Chinese landscape a vision of the riches of the mummy's tomb, and within this vision, a disturbing blackness:

> But what is that spot of black? It is so thick, so lustrous, and yet it seems so transparent! It is a speckle—a speckle, who says? Do I mean that it is like that spot on the windowpane? . . . That clearly was a speck of opium, thick and sticky on the windowpane. Only opium has that kind of glossy sheen . . . it definitely is not an ink stain, although it's black enough, haha! Precious things are always black. The Great Black Pearl of India, er, what else, can't remember, I have heard that there is black jade in Tibet. . . But black women are not precious at all, although they can dance the Hula, and women to be exquisite must be white . . . it's a puff of black cloud.[7]

As I have argued, much of Shi Zhecun's surrealist fiction of modern life concerns a Shanghai haunted by a past it always seems to lack, or which circulating images of foreign pasts have displaced. The mummy, which the narrator of "Demon's Way" imagines as emerging from the Chinese countryside and entering Shanghai, presents perhaps the most vivid instance of such a colonial image, an emblem in the West at this time of both colonial plunder and colonizers' fears of the "return" to life of those whom they had repressed.[8] The metamorphosing blackness, of which the mummy is but one manifestation, seems throughout much of Shi's text merely to evoke an atmosphere of dread and gloom: blackness constitutes the object of attraction and repulsion for the narrator, an image of the unseen haunting him (none of the other characters can see what he does). This brief passage, however, makes visible the associations by which the narrator tries to define this blackness, and in doing so, Shi's text performs a critical move that exceeds the narrator's consciousness. To redeploy Frantz Fanon's terms for analyzing nightmares of blackness and shadows in another colonial context, this passage critically "restores" this nightmare image "to its proper time . . . and to its proper place."[9] The otherwise unseen "proper place" of the blackness that haunts the narrator is a geography mapped by colonialist fantasies of desire and repulsion. The possibility of explaining away the blackness as a

spot of opium — a trace of the lucrative global trade whose effects "haunted" all too many Shanghainese at this time — suggests to the narrator clichéd colonialist images of the material wealth of India, and of the territory occupied by China's own borderlands. Yet blackness also conjures in the narrator's mind dancing black women, an apparent conflation of images of Africa and the South Pacific that is achieved by the word "hula" — which, appearing in the Chinese text in the roman alphabet, is a verbal image of Western exoticism that itself had circulated from abroad. Even as fantasies of hula dancing seem to suggest the narrator's desire, he also distances black women as "not precious at all."

Thus we can situate a particular narrator's titillating and terrifying fantasies of otherness between India and Tibet, Africa and the South Pacific. But my larger purpose in invoking Fanon's historicizing psychoanalysis at this juncture is not only to suggest the linkages between blackness and race in Shi's text but also to enable a reading of Shi, Mu, and the cultural moment of which they were a part that situates these linkages within their "proper place." Both of the texts I have quoted point to blackness as an otherness crucial to constituting what Mu represents as the place of Shanghai, or what Shi indicates was its cultural unconscious. In both of these texts, race is figured through fragmentary images of the savage or primitive, fragments of other places that have circulated to Shanghai to compose its urban landscape or haunt its unconscious. Race, that is, is figured both through and as fragments. At the same time, ideologies of racial difference remain inseparable from the representational experiments these texts perform. For even as circulating images of racial difference are shown to produce Shanghai's self-representation, it is the black-and-white logic of racialist ideologies that produces the streams of images out of which these texts are composed.

Such images were hardly confined to a few modernist texts. Indeed, they permeated the mass culture of Republican Shanghai. The flurry of Shanghai studies in recent years has remained curiously silent on the subject, but if one leafs through the pages of such pictorial magazines as *Liangyou huabao* (The young companion) or *Shanghai manhua* (Shanghai sketch), it is difficult to miss the disturbing dialectic of the modern and the savage of which these modernist texts are a part and to which they call attention. I believe, however, that experimental texts can provide a particularly valu-

able lens through which to scrutinize the pervasive images of the savage. For literary experimentalism, as both practiced and discussed in Shanghai texts, made self-conscious another dialectic both determining and determined by that of the modern and the savage at this time, one latent in a wide variety of visual and verbal images in the mass culture of this period: namely, a dialectic of race and representation. For while many images represented racial difference through the savage, frequently the boundary between the civilized and the savage was itself staked out on the concepts of images writers in Shanghai understood savages to have. Furthermore, discourses of race and the savage at crucial moments informed conceptions of images, their composition, and their representational power. As I have been arguing throughout this book, modernism in literature and art most importantly constituted a means of engaging with the mass visual culture of Republican Shanghai, which was being rapidly transformed by image technologies such as cinema, illustrated magazines, and photography. Experimental practices in literary texts were conceived of through an understanding of modern images as something whose capacity for fragmentation and juxtaposition made them the primary medium of global cultural circulation. Crucially, experimentalists' understandings of circulating images and their relations to place and space were frequently conceived of through representations of racial difference.

The concern of this chapter, then, is to examine the idea of blackness and the savage in Shanghai's fragmented images, their conception, and their constitution of the borders of modern China. I shall do so by understanding race and representation dialectically: if literary experimentalism enables us to read critically the production of race as image, attention to images of race will make visible the assumptions on which understandings of literary experimentalism turned. Through a genealogy of critical, ethnographic, and fictional texts and images, I shall explore the ways in which understandings of literary modernism in Shanghai were paradoxically both complicit with and critical of the ways in which mass culture represented race both *through* and *as* images to be fragmented, circulated, and juxtaposed. Race often appears at crucial moments in writings on modernism reflecting on the changing nature of representation. Yet, as I shall show by way of conclusion, precisely because of the intertwining of race and representation that

modernism's circular logic made visible, it is also in Shanghai modernist literary texts that we find rare attempts to dismantle such racial images. To understand how this is so, I shall first consider the ways in which race was used to think about representation in Republican Shanghai, before considering ways in which race itself was represented.

Blackness Unseen

The critics Zhao Jiabi and Fu Lei conceived of a modernist verbal text through visual images, either by reconceiving a text as a kind of image or by arguing that modern texts must replicate the effects of modern visual technologies. They both believed that only writing reconceived imagistically could make visible otherwise invisible realities underlying the changing times and spaces of modernity. At crucial moments in their texts, however, their understandings of visuality, images, and representation turn explicitly on concepts of race and conflated notions of blackness and the primitive. Zhao, for instance, argued that the representational problem of making visible the invisible and complex forces determining modern life lay beyond the capacities of the nineteenth-century realist and naturalist novelists who influenced numerous Chinese writers in the 1920s and 1930s. Instead, for Zhao, John Dos Passos's verbal montage in his trilogy *U.S.A.* makes for the most *realistic* way in which to tell individual, national, and even global histories and to represent the complex nature of modernity because of its aesthetic of cutting across and joining different spaces.[10] Zhao's most striking claim, however, is that the work of Gertrude Stein also exemplifies this transformed understanding of realism.[11] Zhao explores Stein's representation of hidden or "inner" realities and her reconfiguration of time and space in such texts as *The Making of Americans* and "Melanctha"; the latter text, an excerpt of which was translated and appended to Zhao's article, tells the story of an African American woman and her relationships with men. Drawing on the work of Carl Van Vechten and Edmund Wilson, Zhao tries to show how Stein's literary experiments are enabled by her engagement with the paintings of Cézanne and with "the lives of black people."[12] Intertwined in Zhao's argument, that is, one finds both a reconception of writing through experimental visual images and a conception of race. Paradoxically,

Zhao claims that as a result, Stein's writing renders race invisible, for in "Melanctha," "Stein is the first in the history of American literature to take a black person's life and write it so that the reader has no sense that the skin color of the character in the book is black."[13] While the work of Michael North and others shows that this characteristic is a far more complicated matter than what Zhao calls "writing the lives of black people and the lives of white people in the same way," crucial to my argument here is the visibility of race everywhere in Zhao's own account of the representation of the invisible.[14] Indeed, for Zhao, modernist writing overcomes the presumed inadequacies of conventional realism to represent reality precisely through its "primitivism" — an idea that itself rests on an assumed equivalence between the primitive and blackness.

What Zhao develops through Stein's texts, in other words, is a conception of a primitivist realism. Writers of the past, Zhao claims, could only create characters that had human forms but no vitality; other writers simply carved out slices of time and space to serve as the subjects of their writing. As a result, literature has been "forcibly occupied" by "fragmentary corpses" and "mummies from a museum."[15] On the other hand, "what we demand of twentieth-century writers is to grasp the entirety of life in all its dynamism in space and reinsert time into it."[16] Zhao understands modern "realism" to be a matter of revitalization, of bringing dead representations back to life through a temporalization of space. He has in mind the radical experiments characterizing "Melanctha" and *The Making of Americans*, in which the narrative advances through the relentless repetition of phrases, characters, and objects, all of them slightly altered each time they appear: "This is not static repetition, but rather transformation within advancement."[17] Stein's texts thus "make" the identities of their characters through procedures in which change is made manifest through repetition, and sameness is made manifest through difference. While Zhao in passing places the time-space of Stein's texts within the world of Einstein and Bergson, he specifically links Stein's experiments with repetition to what he understands to be "the speech of children and savages, [for] they often repeat every word or sentence several times before they can express their wishes."[18]

This equivalence of the minds of children and savages constituted a persistent motif in primitivist thinking in the West as well as in China. In addi-

tion to the obviously racist supposition that ethnic others somehow never developed mentally beyond the level of a child, this motif also suggested that moderns, peoples whose vision was blocked by the overrefinement of their "advanced civilization," were "shifting their gaze onto the primitives [literally, "onto the bodies of primitives"] who had not been destroyed by culture," for such a presumed lack of culture in the "childlike" mind of the primitive gave it direct access to the real.[19] This real, which Stein's texts try to represent, Zhao conceives of as that which remains internal and unseen. Thus, he writes, the "demand" of recent artists has been "to cast off the showiness of external culture and pursue their inner essence [*neizai be ben-zhi*]."[20] This pursuit of unseen, inner realities through the savage, Zhao claims, marks the common characteristic of Gauguin's move to the South Pacific to "write native life," Cézanne's abstraction of nature, and Stein's imitation of a child's language.[21] Zhao's text makes equivalent racial difference and formal exploration, or rather, visual images transform writing by means of the primitive; only then, Zhao suggests, is writing able to make visible the unseen.

For the critic and translator Fu Lei, whose exploration of montage I examined in the previous chapter, "literature's pursuit of external reality" also at a crucial moment turns upon similar clichés about Africans, blackness, and the primitive. Like Zhao, Fu believes that "one of modern literature's important responsibilities is to discover in reality phenomena that until now have never been seen."[22] Fu, however, is more specific than Zhao in defining what he means by the nature of modern reality, as well as the purpose of representing the unseen. As will be remembered from chapter 4, Fu argues that modern reality is "not as stable as it was in the past," for such media technologies as cinema, photography, and the phonograph "have made it possible for us to take an image we have captured of a person and decompose it"; such an image can be transmitted simultaneously to different parts of the world and then recomposed.[23] As in Mu's text, Fu imagines a world rendered less substantial by the circulation of images, even as it also seems to be composed of them. While Zhao calls for a temporalization of space in modern writing, Fu believes that the simultaneity of image transmission has resulted in a collapse of space. Indeed, as a result of such a transformation of reality by image technologies, he writes, "we ourselves are lost

edly truer reality. The unseen reality that the landscape conceals — or that Fu represents it as concealing — is temporal difference. Spatial collapse is understood as temporal juxtaposition. That is, what writers long to excavate within the familiar is the strange, that which once had only been discoverable in places like the "shores of Africa." Or, more critically, the strange is a product of writers' longings: the familiar landscape must be rendered strange by concealing (or projecting) within it a "true" reality exotically and temporally different — which can then be excavated.

Still more striking in this passage is the means through which concealed temporal difference is to be "excavated," or represented. For while the exotic and the familiar may have collapsed into a single landscape, Fu's first example of the excavation of local color is Paul Gauguin's representation of islanders in the South Pacific. Fu's introduction of Gauguin into this passage is rather telegraphic, but it seems to indicate that temporal difference within the familiar landscape is made representable through racial difference. The sentence Fu cites comes from *Noa Noa*. In this passage, Gauguin fulfills his longing to make a portrait of "a young woman of pure Tahitian extraction," in which the process of visual representation appears as a process moving from violation and refusal to temptation and seduction — and finally possession. The sentence Fu quotes, which I italicize in the following passage, reads even more forcefully in Gauguin's text:

> While she was curiously examining certain religious compositions of the Italian primitives, I hastened, without her noticing it, to sketch her portrait.
>
> She saw it, and with a pout cried out abruptly, "*Aïta* (no)!" and fled.
>
> An hour later she returned, dressed in a beautiful robe with the *tiaré* behind the ear. Was it coquetry? Was it the pleasure of consenting of her own free will after having refused? Or was it simply the universal attraction of the forbidden fruit which one denies oneself? Or more probably still, was it merely a caprice without any other motive, a pure caprice of the kind to which the Maoris are so given?
>
> Without delay I began to work, without hesitation and all of a fever. *I was aware that on my skill as painter would depend the physical and moral possession of the model*, that it would be like an implied, urgent, irresistible invitation.[31]

Perhaps it is best to read Fu's own difficult essay as itself an exercise in cutting and juxtaposing, in which we as readers must restore the passage of which the Gauguin sentence is a part and then read it in the context of Fu's essay. For the Gauguin sentence, while brief, serves as a pivot between Fu's identification of the desire to excavate familiar landscapes and his introduction to the aesthetic program that constitutes the goal of his essay: a modern fantastic. The representation of racial difference literally mediates between Fu's call for the excavation of temporal difference from within local place, on the one hand, and, on the other, his identification of such an excavation as a "modern fantastic" and analysis of its representational strategies. The juxtaposition of the Gauguin passage with the longing to excavate seems to equate the landscape of local color with the body of a racial other—in order for representation of difference to be possible, one must be excavated and the other must be possessed in order to make visible his or her unseen "inner life." Or, pushing farther, the medium Fu's text suggests that makes possible the representation of the landscape of the modern fantastic is the body of a racial other. The representation—and, more to the point, the conception—of the unseen in modern life is based upon the relentless visualization of an exoticized other.

These texts of Zhao Jiabi and Fu Lei, as well as those of Mu Shiying and Shi Zhecun, all share a conception linking blackness with Africa and the South Pacific and with a generalized discourse of the primitive and savage. Mu and Shi represent this cluster of associations of blackness as the "other side" or "unconscious" of Shanghai, and yet an unconscious or otherness located spatially outside of China. Zhao's and Fu's texts are similarly composed of a dialectic of the unseen and space, in which the figure of the primitive is called on to make the unseen visible, as well as to conceptualize the perceived collapse of the exotic other into the modern everyday—or indeed to mediate the relations between the unseen, place, and space. The relations of race and representation in these texts are highly circular: Zhao and Fu both need a conception of the primitive to get to their conceptions of a modernist, fragmentary representation of the real; and yet the representations of the primitive on which they depend are themselves produced through globally circulating images. Paradoxically, however, while

the *effects* of such savage images are present throughout these texts, what remains vague—or invisible—are the savage images on which they depend.

Race in Fragments

The task of the rest of this chapter thus must be to make visible again the savage images once so prevalent in Shanghai print culture and on which modernists founded their understandings of images of the unseen in modernity. The savage, after all, was hardly unseen in Shanghai during this period but rather was visible everywhere—as an image. Indeed, Fu Lei's text—whose description of a world changed by fragmented and circulating images is authorized by images produced by and of others in distant parts of the world—calls attention to the nexus in which such "savage images" must be read, a nexus of primitivism and modernism, the seen and the unseen, space, place, and temporality, and of the representations made possible by new media technologies. It is from within this nexus that I now propose to read verbal and visual representations of race in Shanghai as ways of thinking of the place of Shanghai and Chinese modernity in a world of circulating images.

While writers like Shi, Zhou, and Fu sought to pursue "inner realities" through the image of the savage, the first thing that might strike a reader of such popular Republican Shanghai journals as *Dongfang zazhi*, *Liangyou huabao*, or *Shanghai manhua* is the degree to which numerous texts and images define the savage not by its own inner realities but rather by its exterior surfaces. Texts purporting to describe the "strange customs" (*qisu*) of Africans and Pacific Islanders seem fixated on the transformation of bodies into images. Such transformations can operate through the marking of skin with tattoos (and to a lesser extent the covering of the face with masks). But also, as Xu Weinan's article "The Artistic Culture of Taiwanese Barbarians" suggests, these texts treat as a kind of image-making practice the fragmentation of the body through head-hunting. A severed head, in these texts, serves both as the index of the person to whom it had belonged and as a visual symbol of something else—love, desire, victory, identity, as well as, for the civilized, savagery itself. Such representations of the transformation of bodies into images are reproduced in these texts at the level of form, for

the texts, too, are composed entirely of fragmentary surfaces. Most consist of a sweeping introduction followed by a series of brief, disconnected examples of customs, and no conclusion: they are illustrations without an argument. I should comment at the outset that the truth or falsity of particular cultural practices mentioned in the texts and images I shall consider is not at issue in the present chapter; rather, the problem is the function served by collecting such representations of savage representational practices in Republican Shanghai. For the effect of such fragmentary textual and image practices is, paradoxically, to produce from multiple specific locations across the globe a largely undifferentiated and globally repeatable representation of the savage.

A text entitled "Dong Fei turen de qisu" (Strange customs of East African natives), which appeared under the name Wei Zhi in *Dongfang zazhi* in 1929, exemplifies this production of the savage as a fragmentary image by dividing and conflating "natives" through a series of fragmentary examples united in their presentation of "strangeness." The opening of the article, in particular, gestures toward difference among Africans, only, it seems, to render more forceful its sweeping generalizations: a mode of representation that divides and conquers, as it were. "African natives, it goes without saying," the text begins, "are all a black race with glossy-black faces and curly hair."[32] The text's first move in this sentence is to establish a sameness among Africans that implicitly also creates a field of absolute difference for Africans from, presumably, the Chinese writer and audience, a distinction based on visible features so obvious to the writer that they both obviate the need for speech and are spoken just the same. Within this undifferentiated mass of blackness, however, Wei immediately establishes a series of differences: "However, although the same as a black race, blackness has degrees of depth and paleness, differences in curliness of hair, and other [differences] such as the length of hands and feet, squareness or roundness of the face, fullness or scrawniness of the muscles; if one carefully distinguishes according to each characteristic, there are actually no fewer than fifty kinds. The languages they use are different, their customs and habits are different, levels of knowledge and personality are all different."[33] Yet while the rest of the opening paragraph continues to differentiate various "kinds" (*zhong*) within the "black race" (*heise renzhong*), the text contains

all difference within the single rubric "native" (*turen*) from the second paragraph onward. The only difference that matters throughout the rest of the article is that between the "native," on the one hand, and Westerners and "our country" (*woguo*) — that is, China — on the other.

At the same time, the mostly physical differences among Africans the opening paragraph imagines give way to the foreclosure of any differences in character and custom by the topic sentences of successive paragraphs. In such sentences, Wei asserts that "the personalities of natives are extraordinarily naive and innocent, they have no anxieties, no irritations, they work for the sake of life, but as soon as life['s needs] have only just been satisfied, they are no longer willing to work"; "natives lack self-restraint, they are moody, just like children"; "natives are extraordinarily gentle and yielding, and also extraordinarily stupid"; "natives have no education, much less any culture to speak of, but their race is also ancient, with every kind of custom carried down through the ages."[34] This litany of racist clichés operates in a manner common to much primitive discourse at this time: the supposed characteristics of natives do not so much characterize them as empty them of history or identity. As in the text that represents them, natives have no narrative or meaningful difference; rather, they are composed of a collection of timeless traits drawn together to illustrate each generalization.[35] Appropriately enough, these "strange customs and weird habits" (*qifeng guaisu*) mark not a collective history or individual lives but an eternally recurring life cycle of birth, circumcision, marriage, and death. Indeed, each of these moments in the life cycle is itself represented as a kind of marking, a marking of visual difference.[36] At the same time, "representative" customs of different peoples in East Africa are broken up, decontextualized, and fitted into this overriding structure of a human life cycle, which organizes the remaining sections of the text. These textual operations make different cultures both exemplify the same pattern of "native life" and become interchangeable with any other African culture — even when a whiff of historical change can be sensed from a given example. Thus, for instance, in a description of "qualifications for marriage," we are told that "in the past, the Masai race required attacking another tribe and obtaining someone's head [*shouji*] in order to boast of one's own bravery; now, because the government strictly forbids it, [the practice has been] completely abandoned."[37]

Similarly, for the "natives of Kilimanjaro," death ritual consists primarily in "ornamenting the bodies of the dead and applying makeup to their faces."[38]

Numerous articles on the savage follow this pattern of first calling attention to visible, physical difference, then denying the existence of culture, and finally suggesting instead tattoos, body and facial marking or mutilation, and decapitation as the most salient customs of the savage. The representational violence of such texts in so reducing the identities of others is displaced onto the savage, as the implied marker of difference between the civilized and the savage becomes the violent marking of difference purportedly practiced by all savages themselves. The erasure these texts practice of historical, cultural, and geographic differences among other peoples is concealed by a focus on the savage's own practices of marking visually differences of ethnicity and—most often in these texts—gender.

Exemplary of this textual operation is a 1928 article from *Dongfang zazhi*, signed by one Zhe Sheng, entitled "Wei liangxing douzheng de gongju de Feizhou heiren mimi shehui" (African blacks' secret societies as tools in the struggle of the sexes). Even as this article contains a diversity of local cultures within no specific place and a single name, Africa, the essay concerns identity formation through the process of gender differentiation. Predictably, the specific cultural practices that the text situates within a nexus of eroticism and differentiation are head-hunting and body marking. At the same time, however, titillating "facts" about savage violence are themselves placed in a context that both equates others' present with "our" past and seems to suggest, on "our" part, a range of male anxieties. For the overriding factor that Zhe Sheng uses to explain African behavior and differentiate it from that of modern societies is matriarchy, which he characterizes as "a regime in which women hold the power," which is "just like the ancient social life recorded by the ancients."[39] Under such a regime, "males have been deprived of power over household affairs, [and thus] they have no choice but to struggle for their power through warfare, in order to win the favor of a wife. Consequently, the custom of *head-hunting* [the word appears in Chinese and English] can frequently be seen in matriarchal societies."[40] Head-hunting, in Zhe Sheng's account, becomes the only recourse for males deprived of power in a society controlled by women. Indeed, the article does not consider matriarchy as a valid form of social orga-

nization but rather either as an abnormal social formation that (literally) engenders violence or as a limit to presumably natural masculine power that must be overcome.[41] Thus in Zhe Sheng's text, practices such as the transformation of body parts into images through head-hunting, or of the skin into an image through tattooing, or the concealment of the face by masks are all located at crucial moments of gender differentiation and the development of gender relations that—albeit within matriarchal society— ultimately serve to reinforce male power. This power that head-hunting affords a male is measured in desire and desirability, for, we are told, "If a young man wants to show his worth before the girl he loves, the first thing he will do is to take the head of an enemy and present it to the girl as his spoils of war."[42] Furthermore, while a young male may use another's head to win favor with a girl, we are repeatedly informed of how the transformation of males is based on the masking of their own faces, not so much in order to erase male identity as to terrorize young women.[43] Indeed, as the author also informs his readers several times, it is the young girls whose identities are both marked and concealed through tattooing, painting, and carving their own flesh.[44]

Zhe Sheng's own representational strategies in his text effectively render the diversity of black Africa into a single unit through the tropes of head-hunting, body marking, and masks. This Zhe Sheng achieves through a textual strategy that itself tears its subjects out of context and covers them in sameness or cuts and erases the identities of others in order to mark off implicitly the writer and audience as civilized members of a patriarchal society. The article's relentless fascination with the relationships of eroticism and violence in others displaces or conceals the voyeuristic and violent representation of savages in the text.

While such texts were a common feature in the print media, photographic (and to a lesser extent cinematic) images constituted the primary medium of the primitive at this time. The imbrication of gender and ethnic differentiation in the making of images becomes all too visible in the photographic layouts frequently featured in Republican Shanghai's illustrated magazines, even if the violence making such visual images possible was invariably unrepresentable within them. From their earliest appearance in the

late 1920s, and well into the 1930s, illustrated magazines like *Liangyou hua-bao* or *Shanghai manhua* presented images of primitives or savages with an insistence that was aggressively repetitive. Numerous layouts created stark binaries between the savage and the civilized by juxtaposing photographs, circulated from abroad, of Africans and Pacific Islanders with those of Westerners (usually) and Han Chinese (occasionally).

The first issue of *Liangyou huabao*, for instance, most familiar for its photographs and photocollages of modern life, features the layout repro-duced in figure 5.1, entitled "Wen ye minzu guanyu lianbu jingbu zui shimao zhuangshi de bijiao" (A comparison of civilized and savage races with re-gard to their most fashionable facial and neck ornaments). While the title, at first glance, uses the idea of fashion to mock other peoples through the equivalence it seems to offer, it may be that what the layout really—if in-advertently—shows (like Xu Weinan's description of the artistic culture of the "Taiwanese barbarians") is that the face is a medium used among civilized peoples for marking their own difference. At the same time, an operation similar to that which we have seen in various texts, conflating widely different peoples and cultures under the term "savage," enables this difference. The photograph on the upper left, depicting, according to the caption, an "African chieftain's facial tattoo's new ornamentation," is mis-marked, as the "African" is actually a New Zealand Maori. Thus, *Liangyou huabao*'s opening representation of the savage is created out of a conflation of the South Pacific and Africa; or, rather, the sign or mark of the savage works to erase differences among cultural and ethnic others. Appropriately enough, the actual human figure has virtually vanished from the photo-graph; the only traces of him left behind are the facial tattoos. Furthermore, as Virginia-Lee Web has shown, the photographer often drew in such marks after developing the photograph: this image of a savage consists of little but traces indexical of a civilized hand.[45]

The other crucial operation in eliding differences among Africans and Pacific Islanders is carried out by the text the editors have placed below the photograph, which, in turn, depends for its effect on the overall layout of the photographs. Indeed, here text and image collude to produce the effects we have already seen in *Dongfang zazhi*'s articles on Africans. Savages are

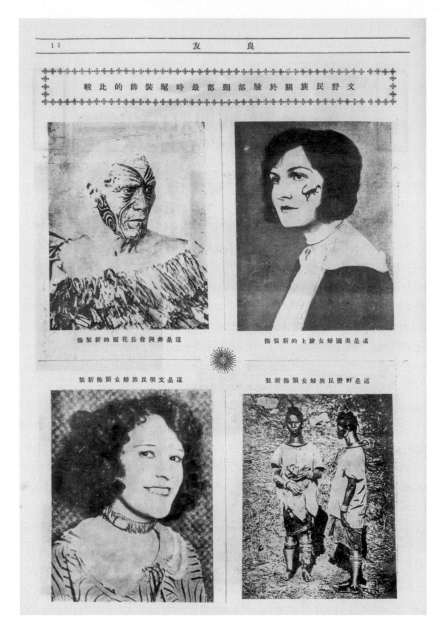

較比的飾裝尾時最部頸部臉於關族民野文

這是澳洲奢會長花面的新裝飾　　　這是美國婦女臉上的新裝飾

這是文明民族婦女頸新裝飾　　　這是野蠻民族婦女頸新裝飾

FIGURE 5.1 "Wen ye minzu guanyu lianbu jingbu zui shimao zhuangshi de bijiao" [A comparison of civilized and savage races with regard to their most fashionable facial and neck ornaments], *Liangyou huabao* 1 (1926).

conflated with each other and marked off from the civilized through technologies of representation. For while the apparent hand-marking of the face in the photographic image means to distinguish the savage from the civilized, the text renders different savages interchangeable. At the same time, however, the layout suggests a mocking equivalence between the civilized and the savage. Whom, one might ask, does the layout mock? Does the layout imply that the civilized are at heart savage, or that savages are more civilized than we think? The joke, one still suspects, is meant to be on the savages. Yet while both a man (upper left) and two women (lower right) represent the savages, Caucasian women, not men, represent the civilized. We have already seen how Zhe Sheng's text suggests that the savagery of men is attributable to a social order organized around women. Does this photo layout, then, mean to suggest that women are more proximate to or interchangeable with the savage than men? Indeed, the arrangement of photographs in the layout seems designed to imply just this kind of interchangeability: the civilized are not kept together on one side, with the savage on the other; rather, the placement is reversed whether one reads horizontally or vertically. Or, are Caucasian women here made to serve as a site of differentiation between the civilized and the savage — precisely, perhaps, because of a supposed closeness of women to the savage?

In other photo layouts, this discourse of the savage and primitive gave not a tattoo of difference but a cloak of science to eroticized nude pictures of other peoples — usually women — which, one assumes, could be used to increase the circulation of magazines. A running feature in *Shanghai manhua*, entitled "Shijie renti zhi bijiao" (A comparison of human bodies of the world), juxtaposed such pictures — again, mostly circulated from abroad — with texts whose pseudoscientific rhetoric first isolates for inspection women's breasts, lips, and buttocks. The objectified and fetishized fragments produced by such representational violence then form the basis of comparison among various ethnic groups.[46] This feature puts into practice, with unconscious irony, the very association of sexuality with bodily fragmentation attributed in *Dongfang zazhi* to Africans. Subsequently, however, a "complete collection" brought together all the pictures in this series, advertising them in the layout reproduced in figure 5.2, with the following claim:

are composed of static, atemporal descriptions — verbal fragments — of the appearance and customs of others, cut from any meaningful historical and cultural context, and reassembled as instances of a largely undifferentiated notion of the savage and its "strange customs."[49] Indeed, it is the very *fragmentary* nature of the forms of these images and texts that enables the circulation and composition of the savage and the primitive. The fragmentary image, that is, constitutes the crucial medium of representing and circulating the savage. But equally crucial is that this form itself enacts the marking and fragmentation of the bodies of the others it represents, both through its focus on tattooing and head-hunting and through its practices of marking photographic images and cutting apart the bodies of others through captioning and cropping. If the identity both invisible and central to these articles and layouts is a modern Han Chinese one, it is an identity created of a fragmentary style of writing and imagining race, a montage composed of examples torn from their historical and cultural contexts, cut apart, and pasted back together in Shanghai. It is an identity created out of bricolage, out of collecting fragments, but in this instance the bricoleur must first create fragments to collect — and these fragments are created out of the identities of others.

In all these texts and images, difference is marked through marking bodies as images or fragmenting bodies through image technologies. These marked, fragmentary images are then juxtaposed to create an image that positions Shanghai, if not China, in global space. But it is also these relationships among fragmentation, visuality, and images that have composed, as Frantz Fanon has eloquently argued, "the fact of blackness." Fanon describes an extremely difficult experience of identity formation in which, under the objectifying look of the white man, "I burst apart," and the resulting "fragments [are] put together again by another self."[50] Conceiving identity formation as "a slow composition of my *self* as a body in the middle of the spatial and temporal world," Fanon argues that for a black man this process becomes one of fragmentation and juxtaposition — carried out through the eye of a white other. Visual and verbal operations carried out by the white man "completely dislocate" a black man's sense of self. First, it is "the white man's eyes" that shatter his "self as body," and the place of his

"corporal schema" is "taken by a racial epidermal schema" — his self-as-body becomes an alienating image under an other's eyes.[51] Then, the black man finds himself woven back together by the white man "as out of a thousand details, anecdotes, stories."[52] That is, shattered as a visual image, the black man, according to Fanon, is recomposed out of verbal fragments, so that "if I discovered my blackness, my ethnic characteristics," immediately "I was battered down" by details and anecdotes of, among other things, "tom-toms, cannibalism, intellectual deficiency, fetichism [*sic*], racial defects."[53] The result, Fanon writes elsewhere in the same book, is to make of the black man a lifeless image, "to fasten him to the effigy of him, to snare him, to imprison him, the eternal victim of an essence, of an *appearance* for which he is not responsible."[54]

The texts and images from the Shanghai print media we have been examining perform the operation Fanon describes only too well. In *Shanghai manhua*, for instance, racial difference is produced literally through bodily fragmentation under a camera eye. Furthermore, while in writing of Gertrude Stein, Zhao Jiabi shares Fanon's abhorrence of lifeless images — wanting to overcome a literature of fragmented corpses and mummies, if not effigies — Zhao argues that the way out of such a representational crisis is the revitalization of literature through a temporalization of space. Such a temporalization, Zhao implies, would be enabled by a shift of the modern gaze onto the bodies of primitives — precisely the kind of representation that Fanon shows battering down black identities. Zhao's text, however, inadvertently discloses the precariousness of his own position — and, indeed, of a subject position for a Shanghai (if not Chinese) identity implicit throughout many of these texts and images. Clearly all these representations of the savage are meant to deny any identification of Chinese with Africans and Pacific Islanders. Moreover, while Chinese themselves are invisible throughout these collages of photographs and anecdotes, these collages are structured so that by denying African peoples, Chinese can identify themselves with civilized whites. And yet, composed as they are in semicolonial Shanghai, these representations are as much under the dislocating "white man's eyes" as the black man Fanon describes. While the Shanghai editors and writers who created such layouts and articles may

had knowledge, with their intrinsic artistic culture, they could occupy a high position in East Asia. One must realize that a strong artistic culture is a most valuable thing![59]

Xu wants to restore the strength of barbarians and their image-making by bestowing freedom and wisdom, and yet the subtext of this and other texts on China's frontiers, as we shall see, claims that one's own vitality is to be found in the fragments of others. Indeed, Xu's account of Taiwanese barbarians could serve as an extended metaphor for the "artistic culture" of the Republican Shanghai print media, which asserted a semicolonial metropolitan identity by fragmenting and marking others in charged spaces of struggle between external and internal colonialisms.

Curiously, although Xu's article on barbarian artistic culture appeared in an art journal, *Yishu jie* (Art world), it is not illustrated with reproductions of artworks. Indeed, despite the widespread fixation in the Shanghai media on head-hunting as a visible marker of savage difference, not once, to my knowledge, does the print media produce an image of any aspect of this practice. The many photographs of savages produce, to use Fanon's terms, a "racial epidermal schema" through their images, but the acts of violence that supposedly define the savage only appear in the "details, anecdotes [and] stories" of texts. All these "artistic" and image-making practices are told through texts and stories — self-consciously so in Xu's text, as indicated by the title of one of its sections, "Pitou de langmanshi" (Romantic histories of decapitation).[60] Indeed, one can read Xu's entire text as a story of visual images or, more precisely, an account of how a desire to produce images instead produces stories of how, under colonialism, certain images can no longer be produced.

Such a split of the savage between text and image on the frontiers of colonialism may account for the self-consciousness with which the act of image production is prominently displayed in numerous texts recounting the search for the still-vital savages on China's borders. Indeed, these texts seem to imply that the very vitality of the savage somehow depends on their being made visible by modern technologies. The intended audience for such images, however, was the consumer in the semicolonial metropolis, who was to find in them relief from the anxieties of urban life. This intention

was not, of course, without its ironies. A text, "Jiantao yinmu shang duiyu yuanshi shenghuo de simu" (Discussion of the yearning for primitive life on the silver screen), which appeared in a film magazine edited by the modernist writer Liu Na'ou, argues that the primitive provides an escape from the alienation of mechanistic capitalist modernity, even as the text also makes it clear that the primitive is made visible in the metropolis on a "pictorial surface" (*huamian*), which in film is constructed of the "beautifully rhythmic music" that is "the motion of a machine."[61]

Thus it is no coincidence that at this time both the new Shanghai pictorial magazine *Liangyou huabao* and a number of Chinese interested in "ethnic investigation" (*minzu diaocha*) recognized the inadequacy of simply collecting representations of the savage — if for different reasons. For an illustrated magazine, it would of course be a commercial advantage to produce, if possible, sensational images of savage violence through actual encounters between an urbanite and the savage. Indeed, a surprising number of texts about China's frontier minorities published in *Liangyou huabao* and elsewhere turn out to be tales of dangerous journeys to remote landscapes that center on producing images of the savage. What images of violence and terror did these journeys produce? One such image was featured in *Liangyou huabao* in 1934 (figure 5.3). The English caption of this wonderfully self-reflexive photograph best describes how the savage could be produced within China's borders: "This remarkable photograph was taken by Mr. S. T. Wang during his tour of western China. Two women as shown here enjoying reading the Young Companion Magazine belong to the Lolo [i.e., Luoluo] tribe, one of the fierce aboriginal tribes on the south-west borders of Szechuan Province. The Lolos are excluded from civilization, and are murderously cruel. The photographer has experienced much predicament before he could approach their chieftain and obtain his approval for photo-taking."[62] The production and circulation of such images literally made possible the creation of the modern savage in Shanghai. Tellingly, this account of the production of an image links together questions of geographic location, ethnic difference, and violence. A photographer locates the primitive on China's borders through a journey, the goal of which is to stage an event representing the contrast between the civilized and the savage. Yet despite the caption's evocation of a particular geographic loca-

FIGURE 5.3 *Luoluo nüren* [Luoluo women], *Liangyou huabao* 85 (1934).

tion, the photograph is framed so that the landscape is almost invisible; the savages here are not so much located as dislocated. Furthermore, for all the rhetoric of savage violence, such violence is actually not to be seen in this or any other photograph of the savage in *Liangyou huabao*. Yet the location of an incongruous and condescending contrast between the savage and the civilized in the figures of these women is produced through a struggle for power between males beyond the image's frame and behind the camera's viewfinder. Invisible within the image, this struggle becomes "visible" only in the caption, which seeks to direct the photograph's meaning by both raising the issue of violence and projecting it entirely on the Luoluos within and outside the image.[63]

This story of the desire to produce visual images of violent savages for Shanghai's urban audience was played out in numerous variations in more extended and purportedly ethnographic narratives in *Liangyou huabao* and

other periodicals.[64] Yet the scenes of such image production end up revealing not so much the figure of the savage as the violence in the framing or production of the image. A story that most tellingly reveals the projects served by the production of images of savage violence was serialized in a journal with an equally telling name: *Zhibian yuekan* (Border development monthly).[65] This now little-known journal, produced in Shanghai, carried out and published ethnographic and geographic investigations of the frontiers — mostly inhabited by ethnic minorities — and promoted the transplantation there of majority Han Chinese, all in order to integrate the borderlands more closely with the modern nation and strengthen China against foreign colonialism. The ambiguity of the Chinese name of the society that published *Zhibian yuekan*, namely, Zhibian — which critics read to mean "Colonizing the Borders" — suggested, however, that its real purpose was domestic colonialism.[66] The vitality of the Chinese nation and the strength of its borders, the journal's project suggests, is to be created out of the fragments of the so-called primitives currently occupying the frontier. In practice, however, *Zhibian yuekan* strengthened the borders by creating texts and images for urban consumption.

The article to which I would like to call attention, one of several travel records and diaries serialized in the journal, is a text narrating the production of an image. Ironically enough, in this case, the disclosure of a forgotten historical narrative unravels the project of producing a border-strengthening image. Anxieties such as we have seen over modern colonialism become enmeshed in a struggle over the erasure or revelation of local, internal colonial histories. The writer, Wei Zhitang, sets off to "a site of human mystery" to take photographs and compile a history of the Yao ethnicity but does so by accompanying the Yilian Film Company, which was shooting a film entitled *Yaoshan yanshi* (An amorous history of Yao Mountain).[67] The journey begins with a stock scene of hearing lurid tales of Yao encounters with Han people in which "they'll slaughter and eat you like a pig."[68] Wei, however, does not encounter any cannibals at all. Instead, he meets only sinicized Yao who live atop a high mountain, "an exotic country above the clouds."[69] The Yao, however, repeatedly resist Wei's attempts to photograph them. Even the landscape seems to resist Wei's efforts to create images of the savage, for the same mysterious clouds that define such a clear (if romantic) border be-

tween the worlds of the Yao and the Han also make it virtually impossible to photograph or film anything.[70] Yet this same landscape that resists the filming of an "amorous history" of Yao savages instead reveals the sites of another history, a mythical history of ethnic violence. For, Wei is informed, the Three Kingdoms era political and military strategist Zhuge Liang "took the Yao people to be savages [*yeman de ren*]. After he defeated the Yao, he drove them up into the mountains, and seized all of the fields they had opened or cultivated. In the mountains, the Yao had nothing to eat, and could only use tree leaves for food. There were some who ate so many tree leaves that their bodies grew fur, and they did turn into savages."[71] Here, we have a different twist on the quest for savage images. While Wei seems to heed Fu Lei's call to discover an unseen exotic, a site of temporal difference, within a Chinese landscape, the landscape resists altogether the making of images serving the interests of the semicolonial metropolis. Instead, it reveals a hidden history of the making of savages, or rather, of the violence through which a people were long ago transformed into an image of the savage.

While Wei's project might have been to strengthen China by producing images of the savage, it is undone by local history. Indeed, invisible histories may well have been the most vulnerable point of all these savage images; certainly local history is the one thing excised from all these accounts of other peoples. This may be why one of the few critiques of this primitivist discourse came precisely from a writing of history that could simultaneously employ the techniques of fragmentation and juxtaposition to reveal rather than conceal hidden pasts while at the same time critiquing the effects of such techniques through its formal experimentation. This kind of historical writing can be found in the modernist fiction of Shi Zhecun.

Recomposing Race in History

Throughout this chapter, I have tried to unpack the cluster of motifs that made up the savage in Republican Shanghai: a conjunction of race, image, visibility and invisibility, desire, location, and identity. Whether collected in the metropolis or created through journeys to the border, race as an image was used in print media to compose locations for China within the world,

and for Shanghai within China. Race was conceived of through images, and visual images were conceived of through race: both conceptions fragmented others, from Africa to China's borders, in an attempt to unify and strengthen a self in semicolonial Shanghai. Modernist texts laid bare the devices making such representational operations possible. The cut-and-paste aesthetic practices of such texts often made them complicit with similar procedures in mass media representations of racial difference, as in Mu Shiying's text, whose experimentalism seems powered by racial clichés. However, the very self-consciousness available to modernist texts also enabled a means of critical engagement with such practices of representing race.

Thus, by way of conclusion, I turn to a story by Shi Zhecun, which constitutes not only one of the first self-consciously modernist texts produced in China but also a rare instance of critique of savage images. Shi's text, however, does not directly engage with the peoples of Africa or China's contemporary borders. Instead, it thoroughly dismantles the entire representational apparatus of the savage in Shanghai by turning against that apparatus its own nexus of image-making and body fragmentation. Against the use of fragmentation to erase historical and cultural context, Shi uses images of the savage to fragment and rejoin Chinese historical and literary texts. Against the differentiation of race based on the production of images, Shi produces images of mixture or reverses savage images entirely. Against stories of the desire to produce images of the savage in which urban consumers can recognize themselves by viewing their others, Shi narrates a story of the production of an image through bodily fragmentation — but it is an image whose viewing is repeatedly denied by the text, or in which no identity can be recognized at all.

The Shi Zhecun text I have in mind is "Jiangjun di tou" (The general's head), which self-consciously critiques verbal and visual images of the savage by also narrating a violent encounter with savage others on China's borders. "The General's Head" tells of the fate of General Hua Jingding, a part-Han Chinese, part-Tufan soldier of the Tang dynasty sent to protect a border town in Sichuan from invasion from Tufan (roughly the same as modern Tibet). General Hua despises his Han troops for their brutal violence against the peoples and armies they defeat, even as the Han soldiers engage in erotic fantasies about *manyi*, or "southwestern barbarians."

river in Lang's photograph serves to obscure the joins composing it, in Shi's story, the river is a fissure in which to examine the circulation of culture, and especially to question rather than reaffirm the binaries of the savage and the civilized. In creating this location, Shi's text makes the one connection the binaries created in Shanghai photographic layouts seem to avoid: he locates the savage *within* the Chinese historical past.

While such a mixture of the civilized and the savage would seem to be precisely what the image of differentiation in the Shanghai print media denied, such a mixture does not lead Shi to conclude his text in a celebration of unity. Rather, Shi transforms the general's head into the very locus of a subject split between two identities. Furthermore, focusing on the general's head as the central image of the text allows Shi to subvert savage images by reversing them, producing, as it were, a photographic negative of savage images, in which black becomes white. For while in *Dongfang zazhi* the diversity of Africans is subdivided and then conflated according to degrees of blackness, or while in *Liangyou huabao* the savage is marked by facial tattoos, in Shi's story the head of the exoticized other—Hua Jingding—is pale white, a blank.[75] Indeed, General Hua's attractive visibility in the story stands in marked contrast to his near invisibility in the historical record. And while women's bodies were objectified, fragmented, and fetishized in the Shanghai print media, in the present story, it is the general's head that becomes the locus of intense desire: the text repeatedly describes it as beautiful and seductive, while the text consistently links this seductiveness and the desire it provokes with fragmentation.[76] Even the first description of General Hua's face is composed of sentence fragments, which both stand out and block the momentum of a text otherwise composed of long, flowing sentences.[77] But throughout "The General's Head," Shi's text repeatedly links desire with bodily fragmentation, echoing the "romantic" tales of decapitation we have seen from Africa and Taiwan. Hua's first talk with the Han girl he comes to desire, for instance, is characterized by its "lascivious tone," yet its subject matter is the Han soldier's recent beheading.[78] Indeed, one effect of Shi's well-known use of psychoanalysis in this story is to raise the specter of a fear of castration, but here it makes literally fantastic and ridiculous the anxieties over the loss and reassertion of male power expressed in texts like Zhe Sheng's on head-hunting. For Hua's own decapita-

tion at the end leads neither to a vision of horror nor to the fulfillment of erotic desires; instead, the Han girl laughs at Hua's headless form. By literalizing fragmentation as decapitation, Shi's text takes to a parodic extreme the Shanghai print media's photographic fragmentation and eroticization of body parts of ethnic others, as well as its persistent eroticization of decapitation in texts on savage customs and artistic practices.

Finally, having produced a savage image by cutting and pasting historical texts and reversing the visual clichés of the Shanghai print media, Shi's text goes on both to deny the voyeuristic desire to see images of savage violence and the body fragments of others and, in its closing moments, to critically indulge such a desire. The plot of "The General's Head" itself revolves around a recurring form of fragment, and on the levels of both plot and narration, much of the text manifests a powerful ambivalence toward the spectacle of those fragments. Consider the scene in which the Han soldier who has molested the young woman is put to death: "Severely, the general issued the order: 'Cut the bastard's head off, and hang it from that tree.' The spectators roared in unison, women covered their faces and withdrew to the rear. The head of the cavalryman who had broken the law was displayed for a moment by a guard, who then hung it on the branch the general had indicated."[79] This passage constitutes a gap, a narrative blank, for the one thing this account of a decapitation elides is the process of decapitation. The text's suppression of the spectacle of bodily fragmentation is echoed within the story by the women covering their faces, while the spectators' act of looking is represented only by the sound they make. Yet the body fragment produced by this invisible act of decapitation haunts the rest of the narrative. Each appearance of such an image provokes both another empty space in the narrative and a refusal or blockage of vision. This relationship between body fragment, image, and narrative empty space shifts along the course of the story, as can be seen a few pages later, when the young woman who had been molested and her brother invite the general home for dinner:

> In his heart, the general hesitated, but his mouth had already decided for him: "It wouldn't be too much trouble, would it?"
>
> When the general, who was returning to his barracks below the late evening moon, passed beneath that tree from which there hung a head, his whole

body shuddered. . . . For the whole time since he had sat down with that hospitable warrior and his sister under the orange lamplight to eat a quiet meal, the smirking face of the executed cavalryman had kept floating dimly before the general's eyes. . . . Now, as long as the evening wind blew on the branch from which the head hung, so clearly defined in the moonlight, the brave general could only cover his face.[80]

Here, the dinner scene that seemingly should have followed the warrior's invitation is left blank, only to reappear briefly submerged within the vision of the hanging head. Rather than being blanked out by a narrative gap, this body fragment of the executed soldier now in effect blanks out part of the narrative. But as in the first incident, here again the spectacle of the body fragment provokes a blocking of vision. Whereas numerous ethnographic materials in the Shanghai print media supplemented fragmentary photographs of bodies with texts narrating acts of savage violence, in Shi's complex text, narrative events perform a blocking of vision of the creation of a body image, even as an imagined leering image disrupts any compensatory narrative continuity.

The final scene of the story draws together many of the motifs in Republican Shanghai print culture of the savage and the violent production of its images in order to indulge the unfulfilled desire to see the savage other and differentiate the civilized self central to all the texts and images we have been considering. Shi's text does so by replacing the defining scene of photography with precisely the scene that the images of the savage inevitably fail to produce: an act of extreme violence, a decapitation, no less. But General Hua's decapitation by a Tufan soldier at the surreal close of the story leads not to a final and absolute differentiation of the civilized and the savage — after all, here both the civilized and the savage, whoever they may be, practice decapitation. Rather, Hua's decapitation leads to a final exploration of the borders of desire and identity, for the headless general's final search for the Han girl leads him instead to the stream forming the border between China and Tufan. Blindly, he picks up the head of the Tufan soldier, thinking it is his own. This moment is highly ironic, as Hua's crisis of subjectivity over whether he is Han Chinese or Tufan, civilized or savage, is only "resolved" by trading heads. The final page of the story depicts the

space created of such fragments with telling ambivalence: "The general got down from his horse at the edge of a sandy bluff, and walked in to the edge of the stream. The general thought it strange, why is the water so turbid, I can't see reflected my own image [*zhaobujian ziji di yingzi*]."[81]

Desiring a pure identity, the general now wants to clean himself of blood. Yet the text implies the impossibility of Hua purifying himself of his mixed blood with the water of the border. That is, unlike the river or clouds that clearly divide the landscapes in the narratives of Yang Cheng-zhi and Wei Zhitang, and unlike the empty, pure, in-between spaces in Lang Jingshan's landscape, the border in Shi's story is turbid and mixed because it both is the meeting point of two cultures and is now stained with Hua's blood. Furthermore, this moment subverts the kinds of images that we have seen as produced by the scenes of encounter with savage violence. For while General Hua seems unable to see his reflection because of the stream's tur-bidity (not to mention his own decapitation), what the general does "see" in the mixed waters of the border is precisely his own reflection. But his ob-session with clarifying his identity will not allow him to recognize his own image as essentially mixed. Instead, "the general suddenly felt a rush of hol-lowness"; his "hands grasped toward empty space" where his head should have been, and he collapses.[82]

It is with this image of the severed head that Shi Zhecun expresses his critical ambivalence toward the image of the savage and its location in Shanghai. Shi's text both tells the story of the creation of an image of the savage and utterly dismantles such an image. Indeed, the connections Shi is able to make by dismantling and recombining others' strategies of repre-senting the savage, from Africa to China's borders, make visible what the savage images of ethnic and cultural difference work to conceal. Through constructing on modern China's boundaries such complex images as the general's head or the shadow-mummy figure in "Demon's Way," Shi returns the heterogeneous fragments which modern ideologies conflating geo-graphic location with cultural essentialism must repress or evacuate. And yet Shi is acutely self-conscious of how images — and the often violent con-flicts through which they are produced — also threaten to conceal the land-scapes on which these violent histories are based. For all too often in the cultural location out of which Shi wrote, the collection of images of the

violence of others led not to remembering but to dismembering—a history of Shanghai in the representations of others only visible in fragments.

Hence for all their darkness and representational violence, perhaps there is something of a utopian gesture—an often compromised and, given the historical moment, arguably a futile gesture—concealed within the spaces of modernism in Shanghai, and indeed to which more recent modernisms in both mainland China and Taiwan have returned. It was an art of constituting and dismantling boundaries out of images that do not confirm cultural essences but disturb the orders upon which essences are based and the histories which they repress. An art of the border, the in-between, that strives through its aesthetic of the fragment, as Ernst Bloch put it in a contemporaneous moment of utopian futility, "to exploit the *real* fissures in surface inter-relations and to discover the new in their crevices."[83] Perhaps what the modernists in Shanghai were searching for existed in what the Argentinean poet Roberto Juarroz called "those spaces without space": images and shadows.[84]

NOTES

INTRODUCTION

1. Fu Lei, "Wenxue duiyu waijie xianshi di zhuiqiu — xia: Huangdan guaiyi de secai" [Literature's pursuit of the external world's reality — part two: Colors of the fantastic], *Yishu* 2 (1934): 1–2. All translations throughout this book are my own unless otherwise indicated.

2. Mu Shiying, "Yezonghui li de wuge ren" [Five in a nightclub], *Xiandai* 2, no. 4 (1933): 568.

3. Lou Shiyi, "Shi Zhecun de xin ganjuezhuyi: Dule 'Zai Bali Daxiyuan' yu 'Mo dao' zhihou" [Shi Zhecun's new perceptionism: After reading "At the Paris Cinema" and "Demon's Way"], rpt. in *Shi Zhecun*, ed. Ying Guojing (Hong Kong: Sanlian shuju, 1988), 305–306.

4. Lou Shiyi, "Shi Zhecun's New Perceptionism: After Reading 'At the Paris Cinema' and 'Demon's Way,'" 305.

5. Shu-mei Shih, *The Lure of the Modern: Writing Modernism in Semicolonial China, 1917–1937* (Berkeley: University of California Press, 2001), 13, 347.

6. Leo Ou-fan Lee, *Shanghai Modern: The Flowering of a New Urban Culture in China, 1930–1945* (Cambridge, MA: Harvard University Press, 1999), 125.

7. For a critique of the ideology of linear narratives of national histories at this time, see Prasenjit Duara, *Rescuing History from the Nation: Questioning Narratives of Modern China* (Chicago: University of Chicago Press, 1995).

8. While this book is more concerned with Feng Zikai's work as a critic than as an artist, his influence and reputation rest primarily on his *manhua* cartoons. For an extensive and sensitive account of his life and work, see Geremie Barmé, *An Artistic Exile: A Life of Feng Zikai (1898–1975)* (Berkeley: University of California Press, 2002).

9. I am indebted to W. J. T. Mitchell's influential argument that the boundary between words and images — conceived of not as a reified binary opposition but rather

as a dialectic—is defined and redefined in particular historical contexts, "a struggle that carries the fundamental contradictions of our culture into the heart of theoretical discourse itself." W. J. T. Mitchell, *Iconology: Image, Text, Ideology* (Chicago: University of Chicago Press, 1986), 44. For an account of this struggle in a specific historical moment, the German sixteenth century, see Joseph Leo Koerner, *The Reformation of the Image* (London: Reaktion Books, 2004), and a fictional exploration of such struggles amid conflicting pictorial orders in sixteenth-century Istanbul, Orhan Pamuk, *My Name Is Red*, trans. Erdag Goknar (New York: Vintage, 2002).

10. This was the Song dynasty poet and critic Su Shi's influential remark about the work of the poet-painter Wang Wei.

11. The only term that comes close is *xiezhen*, made up of two characters meaning writing or a transcription (*xie*) and the real or true (*zhen*). This combination of characters had been used during Southern Dynasties period (fifth through sixth centuries CE) to mean "to describe realistically," and during the Song dynasty (960–1279 CE) to mean a portrait or painting. The term was adopted in Japan by the early nineteenth century as *shashin* to signify, as Maki Fukuoka has shown, a visually accurate relationship between an object and its representation for the purposes of observational verification; with this complex range of meaning, the term was adopted in Japan by the 1870s to mean photography. Maki Fukuoka, "Toward a Synthesized History of Photography: A Conceptual Genealogy of Shashin," in "Photography's Places," ed. William Schaefer, special issue, *Positions: East Asia Cultures Critique* 18, no. 3 (2010): 571–597; Maki Fukuoka, *The Premise of Fidelity: Science, Visuality, and Representing the Real in Nineteenth-Century Japan* (Stanford, CA: Stanford University Press, 2012). While the term *xiezhen*'s usage as "photography" subsequently did return to China—in, for example, the translator and publisher Wang Tao's use of it in this sense in a 1879 text—such usage was rare, and instead, the term was used for the most part to mean an image or portrait. Lydia H. Liu designates *xiezhen* as a "return graphic loan," a Japanese term derived from classical Chinese that later returned to China. The usage during the Southern Dynasties is from the *Wenxin diaolong* (The literary mind and the carving of dragons), while the Song usage is by Wang Anshi. Lydia H. Liu, *Translingual Practice: Literature, National Culture, and Translated Modernity—China, 1900–1937* (Stanford, CA: Stanford University Press, 1995), 320. On early Western photographic discourse, see Joel Snyder, "Inventing Photography, 1839–1879," in *On the Art of Fixing a Shadow*, ed. Sarah Greenough et al. (Washington, DC: National Gallery of Art, 1989), 33–38, and Geoffrey Batchen, *Burning with Desire: The Conception of Photography* (Cambridge, MA: MIT Press, 1997).

12. My definitions follow those to be found in *Han-Ying da cidian* [Chinese-English dictionary], 2 vols. (Shanghai: Jiaotong daxue chubanshe, 1996).

13. Interestingly, this term seems to have developed out of a term coined by missionaries to China during the nineteenth century, namely, *zhaoxiangfa*, which emphasizes not a thing's appearance in itself but rather an image or likeness of a thing. Liu, *Translingual Practice*, 277.

14. William Henry Fox Talbot, "Some Account of the Art of Photogenic Drawing, or, The Process by Which Natural Objects May Be Made to Delineate Themselves without the Aid of the Artist's Pencil," in *Photography: Essays and Images: Illustrated Readings in the History of Photography*, ed. Beaumont Newhall (New York: Museum of Modern Art, 1980), 25. Indeed, the *Cihai* definition is anachronistic, as it seems to suggest taking snapshots. Snapshots did not become possible until the turn of the twentieth century, while the term *sheying* was used as early as 1844 by Talbot's contemporary Zou Boping. Jiang Qisheng et al., *Zhongguo sheying shi, 1840–1937* [A history of Chinese photography, 1840-1937] (Beijing: Zhongguo sheying chubanshe, 1987), 11.

15. For a discussion of photographs as made by shadows, see Patrick Maynard, "In Praise of Shadows," in *The Engine of Visualization: Thinking through Photography* (Ithaca, NY: Cornell University Press, 1997), 149–190. Joel Snyder made a similar point about the commonly implied idea of photography as capturing floating images in his lecture course, The History of Photography, University of Chicago, Winter 1999.

16. Michel de Certeau, *The Writing of History*, trans. Tom Conley (New York: Columbia University Press, 1988), 4.

17. De Certeau, *The Writing of History*, 314.

18. Michael Sullivan, *The Meeting of Eastern and Western Art* (Berkeley: University of California Press, 1989), 244–256 passim.

19. Julia F. Andrews and Kuiyi Shen, *The Art of Modern China* (Berkeley: University of California Press, 2012), xv, 81.

20. Andrews and Shen, *The Art of Modern China*, xiii.

21. Andrews and Shen, *The Art of Modern China*, xiii.

22. Shih, *The Lure of the Modern*, 361–362.

23. Shih, *The Lure of the Modern*, 34–35.

24. Shih, *The Lure of the Modern*, 246. This opposition, proposed by Andreas Huyssen and others, has been critically revised by recent work that excavates and examines far more complex relationships between formal experimentation, mass cul-

ture, and aesthetic politics. See, for example, T. J. Clark, *Farewell to an Idea: Episodes from a History of Modernism* (New Haven, CT: Yale University Press, 1999); Enda Duffy, *The Subaltern Ulysses* (Minneapolis: University of Minnesota Press, 1994); Patricia Leighten, *Re-ordering the Universe: Picasso and Anarchism, 1897–1914* (Princeton, NJ: Princeton University Press, 1989); Michael North, *Reading 1922: A Return to the Scene of the Modern* (Oxford: Oxford University Press, 1999). And, of course, contemporaneous to the Shanghai modernists, Walter Benjamin practiced a leftist politics by means of aesthetic formalism in his *Arcades Project*, ed. Rolf Tiedemann and trans. Howard Eiland and Kevin McLaughlin (Cambridge, MA: Harvard University Press, 1999). Huyssen's text is *After the Great Divide: Modernism, Mass Culture, Postmodernism* (Bloomington: Indiana University Press, 1986).

25. Shih, *The Lure of the Modern*, 332. For an essential discussion of the situation of black Americans in Shanghai during this period, see Andrew F. Jones and Nikhil Pal Singh, Guest Editors' Introduction to "The Afro-Asian Century," special issue, *positions: east asia cultures critique* 11, no. 1 (2003): 1–9.

26. James Elkins, *The Domain of Images* (Ithaca, NY: Cornell University Press, 1999), especially chap. 1, "Art History and Images That Are Not Art."

27. In addition to the works cited above see Barmé, *An Artistic Exile*.

28. See Edwin Kin-keung Lai, "The Life and Art Photography of Lang Jingshan (1892–1995)" (PhD diss., University of Hong Kong, 2000).

29. Li Zhongsheng, "Ershi shiji huihua de chufadian" [Assumptions of twentieth-century painting], *Meishu zazhi* 3 (1934): 69.

30. David Summers, *Real Spaces: World Art History and the Rise of Western Modernism* (London: Phaidon, 2003).

31. Duara, *Rescuing History from the Nation*, especially chap. 1, "Linear History and the Nation-State."

32. Octavio Paz, "Pasado en Claro/A Draft of Shadows," in *A Draft of Shadows*, ed. and trans. Eliot Weinberger (New York: New Directions, 1979), 155.

CHAPTER 1. PICTURING PHOTOGRAPHY

1. This translation of the term *shengdong* as "enlivenment" was suggested to me by the inspired conference organized by Eugene Wang, "What Makes and Keeps Images Alive? The Chinese Art of Enlivenment: A Symposium," Harvard University, October 24–25, 2008.

2. Feng Zikai [Ying Xing, pseud.], "Zhongguo meishu zai xiandai yishu shang de

shengli" [The triumph of Chinese fine art over modern art], *Dongfang zazhi* 27, no. 1 (1930): 14–18.

3. Christopher S. Wood, Introduction to *The Vienna School Reader: Politics and Art Historical Method in the 1930s* (New York: Zone Books, 2003), 9.

4. See chapter 2 for a further discussion of Wölfflin's work and its presence in the Chinese artistic discourse of the 1930s.

5. The classic text outlining this concept and its methods is Heinrich Wölfflin, *Principles of Art History: The Problem of the Development of Style in Later Art*, trans. M. D. Hottinger (Mineola, NY: Dover, 1950), especially the introduction. Feng Zikai cites the idea of *Sehformen* in his "Zhongguo hua de tese: Hua zhong you shi" [The distinguishing quality of Chinese painting: In paintings there are poems], *Dongfang zazhi* 24, no. 11 (1927): 41–50.

6. Feng Zikai, "The Triumph of Chinese Fine Art over Modern Art," 5.

7. Feng Zikai, "The Triumph of Chinese Fine Art over Modern Art," 5.

8. Feng Zikai, "The Triumph of Chinese Fine Art over Modern Art," 4.

9. Feng Zikai, "The Triumph of Chinese Fine Art over Modern Art," 18.

10. Zong Baihua, "Lun Zhong-Xi huafa de yuanyuan yu jichu" [On the sources and foundations of Chinese and Western modes of picturing], *Wenyi congkan* 1, no. 2 (1934); rpt. in *Zong Baihua quanji* [Complete works of Zong Baihua], ed. Lin Tong-hua (Hefei: Anhui jiaoyu chubanshe, 1994), 98.

11. Zong Baihua, "Chinese and Western Modes of Picturing," 98.

12. Zong Baihua, "Chinese and Western Modes of Picturing," 99.

13. Zong Baihua, "Chinese and Western Modes of Picturing," 104.

14. Zong Baihua, "Chinese and Western Modes of Picturing," 100.

15. Zong Baihua, "Chinese and Western Modes of Picturing," 100.

16. Zong Baihua, "Chinese and Western Modes of Picturing," 100, 101.

17. Feng Zikai, "The Triumph of Chinese Fine Art over Modern Art," 16.

18. Feng Zikai, "The Triumph of Chinese Fine Art over Modern Art," 16.

19. "The meaning of so-called formal likeness is precisely realism [*xieshi*, literally the 'transcription of the real']." Feng Zikai, "The Triumph of Chinese Fine Art over Modern Art," 15.

20. Wassily Kandinsky, *Concerning the Spiritual in Art*, trans. M. T. H. Sadler (New York: Dover, 1977), 29.

21. Kandinsky, "On the Question of Form," in *The Blaue Reiter Almanac*, ed. Wassily Kandinsky and Franz Marc (New York: Viking Penguin, 1974), 153.

22. Feng Zikai, "The Triumph of Chinese Fine Art over Modern Art," 15–16.

23. Kandinsky, *Concerning the Spiritual in Art*, 29; Feng Zikai, "The Triumph of Chinese Fine Art over Modern Art," 8. Feng also bases his argument upon Theodor Lipp's theory of empathy, or literally "feeling-into" (*Einfühlung*). Feng was not alone in seeing a connection between *qiyun shengdong* and *Einfühlung*; the scholar and art critic Teng Gu made a similar claim in his essay "Qiyun shengdong lue pan" [A brief critique of *qiyun shengdong*; 1926], in *Teng Gu yishu wenji* [Teng Gu's essays on art], ed. Shen Ning (Shanghai: Shanghai renmin meishu chubanshe, 2003), 64–66. For a translation of some of the key texts concerning empathy theory, see Harry Francis Mallgrave and Eleftherios Ikonomou, eds. and trans., *Empathy, Form, and Space: Problems in German Aesthetics, 1873–1893* (Santa Monica, CA: Getty Research Institute, 1994).

24. Feng Zikai, "The Triumph of Chinese Fine Art over Modern Art," 15.

25. Kandinsky, *Concerning the Spiritual in Art*, 31.

26. Thomas Harrison, *1910: The Emancipation of Dissonance* (Berkeley: University of California Press, 1996), 57. For an illuminating demonstration of how Kandinsky's abstract motifs emerge out of the "derealization of the physical world," see the exhibition catalog Hartwig Fischer and Sean Rainbird, *Kandinsky: The Path to Abstraction* (London: Tate Publishing, 2006).

27. Harrison, *1910*, 56–58.

28. Feng Zikai, "The Triumph of Chinese Fine Art over Modern Art," 5.

29. Feng Zikai, "The Triumph of Chinese Fine Art over Modern Art," 5.

30. Feng Zikai, "Meishu de zhaoxiang" [Artistic photography], in *Feng Zikai wenji* [Collected texts of Feng Zikai] (Hangzhou: Zhejiang wenyi chubanshe, 1996), 1:64.

31. Zong, "Chinese and Western Modes of Picturing," 105.

32. Zong, "Chinese and Western Modes of Picturing," 104. This opposition operated in the contemporaneous discourse of graphic design; Lin Yunde, who wrote and translated numerous texts on design, declared that the fundamental "difference between ornamental designs and pictures" is that designs are "not transcriptions of existing realities, but are creations of the future." Lin Yunde, "Zhuangshi tu'an yu tuhua de qubie" [The differences between ornamental designs and pictures], *Yifeng* 2, no. 11 (1934): 29.

33. Advertisement for Rolleiflex, *Liangyou huabao* 86 (1934): n.p.; advertisement for Rolleicord, *Liangyou huabao* 88 (1934): n.p.

34. Advertisement for Kodak Verichrome film, *Liangyou huabao* 64 (1931): 4. This greater tonal range was due in part to Verichrome's increased sensitivity to color. The registration of blue was a particular and perennial problem for black-and-white film, especially at that time, resulting not only in washed-out skies but also in dimin-

ished shadows (outdoor shadows generally reflecting blue from the sky) and hence diminished textures of surfaces.

35. The Japanese rendition of the term *nongdan*, i.e., *notan*, became a key element in one of the most influential texts on design and composition at the turn of the twentieth century, Arthur Wesley Dow, *Composition* (1899; rpt., Berkeley: University of California Press, 1977).

36. Cai Yunsan, "Youxuan zhi zhifa yu jingyan" [Methods and experiences with bromoil], *Liangyou huabao* 55 (1931): 31.

37. Xu Dexian, "Sheying xin'an/Photographical paintings," *Liangyou huabao* 116 (1935): 38–39.

38. Caption to Lang Jingshan, "Banqiao huaben/Bamboo Leaves" [An album by Banqiao], *Liangyou huabao* 38 (1929): 15.

39. Cited in Feng Zikai, "The Triumph of Chinese Fine Art over Modern Art," 16.

40. As László Moholy-Nagy, Kandinsky's colleague at the Bauhaus, put it in a 1927 text, "The means afforded by photography [in] extending the limits of the depiction of nature and the use of light as a creative agent [was] chiaroscuro in place of pigment." László Moholy-Nagy, *Painting, Photography, Film*, trans. Janet Seligman (Cambridge, MA: MIT Press, 1973), 7.

41. Elkins's point is to call for an expansion of the purview of art historical study beyond the realm of art per se (which, as he observes, is merely one specialized, if highly charged, field of images) and into the vastly wider domain of nonart images. Such a wider exploration of nonart and art images is, he argues, essential for understanding the nature of images as such. James Elkins, *The Domain of Images* (Ithaca, NY: Cornell University Press, 1999).

42. Wu Liande, "Wei Liangyou fayan" [Statement on *Liangyou huabao*], *Liangyou huabao* 25 (1928): 7. Carrie Waara has observed that the claims commonly made at this time about periodicals echo contemporaneous claims for the importance of aesthetic education in national strengthening, particularly in texts by Cai Yuanpei. See Carrie Waara, "The Bare Truth: Nudes, Sex, and the Modernization Project in Shanghai Periodicals," in *Visual Culture in Shanghai, 1850s–1930s*, ed. Jason C. Kuo (Washington, DC: New Academia Publishing, 2007), 174–175.

43. Wu Liande, "Statement on *Liangyou huabao*," 7.

44. Huang Tianpeng, "Wushi nian lai huabao zhi bianqian" [The transformation of illustrated magazines over the past fifty years], *Liangyou huabao* 49 (1930): 36–37.

45. "Wushi nian lai huabao zhi qucai" [Progress made in the past fifty years by pictorial periodicals published in China], *Dazhong* 14 (1934): 10.

46. "Progress Made in the Past Fifty Years by Pictorial Periodicals Published in China," 10.

47. "Bianzhe yu duzhe" [Editor and readers], *Liangyou huabao* 83 (1933): 86. Indeed, during this period of ongoing experimentation with new printing technologies in the publication of the magazine, the editors would insist repeatedly upon measuring the quality and range of the subject matter of pictures in terms of the clarity (*qingchu*) and sharpness (*jing*) of their printing. Huang, "The Transformation of Illustrated Magazines," 36.

In addition to numerous texts such as I shall discuss here, a call for investment in stock in *Liangyou huabao* appeared in several issues of the magazine for the specific purpose of expanding both circulation and print quality by financing better equipment. This call both follows up on Wu Liande's 1928 manifesto and anticipates changes in the appearance of the magazine to come. See, for example, *Liangyou huabao* 34 (1929): 3–4.

48. Huang, "The Transformation of Illustrated Magazines," 36.

49. Richard Benson, *The Printed Picture* (New York: Museum of Modern Art, 2008), 222.

50. "Bianji zhi yan" [Editor's comments], *Liangyou huabao* 44 (1930): n.p.

51. On duotone printing, see Benson, *The Printed Picture*, 226.

52. "Bianzhe jianghua" [Editor's chat], *Liangyou huabao* 45 (1930): n.p. For a discussion and examples of photogravure in book, newspaper, and magazine publishing, see Benson, *The Printed Picture*, 236–239.

53. Huang, "The Transformation of Illustrated Magazines," 37.

54. For the idea of technologies, including photography, as amplifiers and suppressors or filters, see Patrick Maynard, *The Engine of Visualization: Thinking through Photography* (Ithaca, NY: Cornell University Press, 1997), 78–82.

55. Walter Benjamin, "Little History of Photography," in *Selected Writings*, vol. 3, *1927–1934*, ed. Michael W. Jennings, Howard Eiland, and Gary Smith (Cambridge, MA: Harvard University Press, 1999), 112–115.

56. Lu Xun claims that such photographs manifest the at once arrogant and servile nature of what he regarded as the Chinese national character. Lu Xun, "Lun zhaoxiang zhi lei" [On photography and such], in *Lu Xun quanji* [Complete works of Lu Xun], 16 vols. (Beijing: Renmin wenxue chubanshe, 1981), 1:185. Translated as "On Photography" by Kirk A. Denton in *Modern Chinese Literary Thought: Writings on Literature, 1893–1945* (Stanford, CA: Stanford University Press, 1996), 200.

57. Wang Jiezhi, "Xiang yu buxiang" [Likeness and nonlikeness], *Feiying* 9 (September 1936): 17.

58. I am very much indebted to the work of Joel Snyder for this conception of photography. See Joel Snyder and Neil Walsh Allen, "Photography, Vision, and Representation," *Critical Inquiry* 2 (1975): 143–169; and Joel Snyder, "Inventing Photography: 1839–1879," in *On the Art of Fixing a Shadow: One Hundred and Fifty Years of Photography*, ed. Sarah Greenough et al. (Washington, DC: National Gallery of Art, 1989), 3–38.

59. "Xianweijing zhi xia tianran tu'an [Natural designs under the microscope]/ Colour Photo-Micrographs," *Liangyou huabao* 61 (1931): 23.

60. "Xuehua de yanjiu" [A study of snow crystals], *Liangyou huabao* 64 (1931): 21.

61. "A Study of Snow Crystals," 21.

62. "Zhiwu de yishu" [The art of plants], *Liangyou huabao* 67 (1932): 22.

63. Huang Jiezhi, "Tu'an sheying tan" [Discussion of design photography], *Changhong* 10 (1935): 3.

64. Liu Haisu, "Shitao de yishu jiqi yishu lun" [Shitao's art and his discourse on art], *Hua xue yuekan* [Studies in painting monthly] 1, no. 1 (September 1932): 14.

65. In his own painting, Liu adopted a postimpressionist style emphasizing flattened planes of color and a prominent use of line then common in Chinese and Japanese art. Liu himself professed particular admiration for the work of the Dutch painter Vincent van Gogh. For a brief survey, see Julia F. Andrews and Kuiyi Shen, *The Art of Modern China* (Berkeley: University of California Press, 2012), 40–41, 64–68.

66. Liu Haisu, "Shitao's Art and His Discourse on Art," 14.

67. Liu Haisu, "Shitao's Art and His Discourse on Art," 14.

68. Liu Haisu, "Shitao's Art and His Discourse on Art," 14.

69. Liu Haisu, "Shitao's Art and His Discourse on Art," 14.

70. Feng Zikai, "The Triumph of Chinese Fine Art over Modern Art," 4.

71. Feng Zikai, "The Triumph of Chinese Fine Art over Modern Art," 4.

72. Feng Zikai, "The Triumph of Chinese Fine Art over Modern Art," 8. Although in his text Feng provides the English term "grotesque" as a translation of *jixinghua*, I choose the more literal translation of the term, "deformation," because the English critic Roger Fry used it in his work on Cézanne, which Feng in part seems to have drawn upon. Indeed, Fry notes in passing and without evidence, example, or elaboration that "deformation also occurs constantly in early Chinese art, and doubtless at the dictates of the same instinctive feeling." Roger Fry, *Cézanne: A Study of His Development* (New York: Macmillan, 1927), 48.

73. Feng Zikai, "The Triumph of Chinese Fine Art over Modern Art," 18.

74. Feng Zikai, "The Triumph of Chinese Fine Art over Modern Art," 5; Liu

sion of the introduction of Bergson's thought into China and its importance to and resonance with thinking on cinema, see Weihong Bao, *Fiery Cinema: The Emergence of an Affective Medium in China, 1915–1945* (Minneapolis: University of Minnesota Press, 2015), 74–75, 93–94, 400n108.

95. Henri Bergson, *Creative Evolution*, trans. Arthur Mitchell (Mineola, NY: Dover, 1998), 302 (emphasis in original).

96. Bergson, *Creative Evolution*, 305.

97. Bergson, *Creative Evolution*, 3. The model of vision offered by the camera obscura and of pictures traced from its projected images was certainly known in China during the seventeenth century and may well have been available to Shitao, as Anne Burkus-Chasson has shown. But rather than adopt such "an instrument that isolated the observer from the external world," Shitao's *Recorded Remarks on Painting* evinces a model of perception with an affinity to that proposed in the work of the sixteenth-century philosopher Wang Yangming, in which "visuality . . . was predicated on the notion that the mind is one body with all the myriad things [*wanwu*]. . . . The eye was not dissociated from the world it rendered visible." Burkus-Chasson, "Shitao's *Waterfall on Mount Lu* and Practices of Observation," 184–185.

98. Feng Zikai, "The Distinguishing Quality of Chinese Painting," 44.

CHAPTER 2. FALSE PORTALS

1. Li Zhongsheng, "Ershi shiji huihua de chufadian" [Assumptions of twentieth-century painting], *Meishu zazhi* 3 (1934): 69. Li Zongsheng was an active member of the prominent modernist group in Shanghai and Guangzhou, the Storm Society (Juelan she). After 1949 he moved to Taiwan, where he went on to practice abstract expressionist painting.

2. Li Zhongsheng, "Assumptions of Twentieth-Century Painting," 69.

3. Li Zhongsheng, "Assumptions of Twentieth-Century Painting," 69.

4. Li Zhongsheng, "Assumptions of Twentieth-Century Painting," 69. Liang Xihong, another modernist painter in the Storm Society, in his "Theory of Abstract Forms" (1935), similarly differentiates between two conceptions of form: one in which an artist "takes true qualities [of the thing depicted] as the rationality of expression, objectively composed, and the second is where what the eye directly experiences transforms the form of appearances into a subjective experience"; in other words, an opposition between depicting the "inherent" material qualities of things or a visual perception. Liang Xihong, "Chouxiang xingti de lilun" [Theory of abstract forms], *Yifeng* 3, no. 8 (1935): 60.

5. Heinrich Wölfflin, *Principles of Art History: The Problem of the Development of Style in Later Art*, trans. M. D. Hottinger (Mineola, NY: Dover, 1950), 18. Wölfflin's definition of line, with its appeal to touch and texture and detail, is almost the opposite of that of Feng Zikai, for whom line is an abstracting force and not tactile in any sense.

6. "The tracing out of a figure with an evenly clear line has still an element of physical grasping. The operation which the eye performs resembles the operation of the hand which feels along the body, and the modeling which repeats reality in the gradation of light also appeals to the sense of touch. A painterly representation, on the other hand, excludes this analogy. It has its roots only in the eye and appeals only to the eye, and just as the child ceases to take hold of things in order to "grasp" them, so mankind has ceased to test the picture for its tactile values. A more developed art has learned to surrender itself to mere appearance." Wölfflin, *Principles of Art History*, 21.

7. Wölfflin, *Principles of Art History*, 20.

8. Wölfflin, *Principles of Art History*, 21.

9. Clement Greenberg, "Post Painterly Abstraction," in *Collected Essays and Criticism*, ed. John O'Brien (Chicago: University of Chicago Press, 1993), 4:193.

10. Li Zhongsheng suggests an equivalence between language and pictorial surface in introducing the idea of the painterly, writing that if a philosopher's thought "is not expressed in language, it does not become true thought. As for a painter, he absolutely must express everything on the pictorial surface. Hence, 'pictorial surface' is the philosopher's language, the poet's speech. . . . And so it can be said that the pictorial surface is the beginning and the end of painting." Li Zhongsheng, "Assumptions of Twentieth-Century Painting," 69. On the materiality of pictorial surfaces as resisting language, see James Elkins, "Marks, Traces, 'Traits,' Contours, 'Orli,' and 'Splendores': Nonsemiotic Elements in Pictures," *Critical Inquiry* 21, no. 4 (1995): 822–860.

11. Henri Lefebvre, *The Production of Space*, trans. Donald Nicholson-Smith (Oxford: Blackwell, 1991), 287, 52.

12. Quruixi is, most likely, a transliteration of a foreign name, but I have as yet been unable to track down the photographer.

13. Chen Chuanlin, "Zhaopian de jiegou" [Photographic structure], in *Zhongguo jindai sheying yishu meixue wenxuan* [Anthology of modern Chinese texts on photographic art and aesthetics], ed. Long Xizu (Tianjin: Renmin meishu chubanshe, 1986), 470.

14. Chen Chuanlin, "Photographic Structure," 470–471.

15. "Jihe" [Geometry; English title, "The geometry of modern traffic"], *Liangyou huabao* 64 (1931): 19.

and disjunctive phrases in place of conventional narration in Blaise Cendrars's novel *L'Or* (1925).

48. Fu Lei, "Literature's Pursuit of the External World's Reality — Part One: Novel Stimulations and the Exotic," 3.

49. Shao Xunmei, "Xiandai Meiguo shitan gaiguan" [An overview of modern American poetry circles], *Xiandai* 5, no. 6 (1934): 883–884; An Yi, trans., "Meiguo san nuliu shi chao" [A selection of poetry by three American women], *Xiandai* 1, no. 3 (1932): 427. The work of Evelyn Scott that An Yi has in mind is "Designs," in *Precipitations* (New York: N. L. Brown, 1920), 53–55. For an indispensable history of Shanghai modernist journals, see Shu-mei Shih, *The Lure of the Modern: Writing Modernism in Semicolonial China, 1917–1937* (Berkeley: University of California Press, 2001), 239–257.

50. Shi later commented that, as he was the sole editor of the first two volumes of *Xiandai*, those volumes most closely reflected his own artistic temperament. It is also noteworthy that Shi had an abiding interest in Picasso's painting. Shi Zhecun, "Chongyin quanfen *Xiandai* yinyan" [Preface to the reprint of the complete run of *Xiandai*], preface to *Xiandai* (rpt., Shanghai: Shanghai shudian, 1984), 1:ii. On Shi's interest in Picasso's painting, see Shi Zhecun to Dai Wangshu, October 25, 1934, in *Xiandai zuojia shujian*, ed. Kong Lingjing (Guangzhou: Huacheng chubanshe, 1982), 85.

51. An article Dai Wangshu translated from the French marks this linkage, although it criticizes such writing for its escape from the narrative (*xiaoshuoxing*) into the painterly (*huihuaxing*), seeming to mistake cubism's distortion of external forms for a desire to escape social reality and pursue "pure art." Bernard Fay [Beerna Fayi], "Shijie dazhan hou de Faguo wenxue" [French literature after the World War], trans. Dai Wangshu, *Xiandai* 1, no. 4 (1932): 490–491.

52. The story first appeared in an early volume by Apollinaire, entitled *L'hérésiarque et cie* (The heresiarch and co.), which is assembled out of bits of arcane knowledge and diverse geographic locations in a manner that anticipates the work of Jorge Luis Borges. As the translator, Chen Yuyue, remarks, Apollinaire is "a great cubist poet and its creator. . . . Just like his poetry, his fiction is brimming with cosmopolitanism. He loves monks who have returned to secular life, strange priests . . . and outlaws of all stripes, and as for the setting of his fiction, sometimes it's Warsaw, sometimes it's Prague, sometimes it's the banks of the Rhine, and sometimes it's Spain." Chen Yuyue, "Abaolinaier" [Apollinaire], *Xiandai* 1, no. 1 (1932): 19.

53. Apollinaire [Abaolinaier], "Shiren de shijin" [The poets' napkin], trans. Chen Yuyue, *Xiandai* 1, no. 1 (1932): 21; Apollinaire, "La serviette des poètes," in *Oeuvres en*

prose (Paris: Gallimard, 1977), 1:193. For an English translation see Apollinaire, "The Poets' Napkin," in *The Heresiarch + Co.*, trans. Rémy Inglis Hall (Cambridge, MA: Exact Change, 1991), 125.

54. On the Veronica image and its various relations to other kinds of images and relics, see Hans Belting, *Likeness and Presence: A History of the Image before the Era of Art*, trans. Edmund Jephcott (Chicago: University of Chicago Press, 1994).

55. Jennifer Pap, "The Cubist Image and the Image of Cubism," in *The Image in Dispute: Art and Cinema in the Age of Photography*, ed. Dudley Andrews (Austin: University of Texas Press, 1997), 156.

56. Pierre Reverdy, "Fausse porte ou portrait," trans. Patricia Terry, in *Selected Poems*, selected by Mary Ann Caws (Winston-Salem, NC: Wake Forest University Press, 1991), 78. Reverdy's original text runs as follows: "Dans la place qui reste là / Entre quartet lignes / Un carré où le blanc se joue / La main qui soutenait ta joue / Lune / Une figure qui s'allume / Le profil d'un autre / Mais tes yeux / Je suis la lampe qui me guide / Un doigt sur la pauper humid / Au milieu / Les lames roulent dans cet espace / Entre quartet lines / Une glace" (79).

57. Pierre Reverdy [Bayer Hefoerdi], "Jiamen huo xiaoxiang" [Fausse porte ou portrait], "Hefoerdi shi chao" [A selection of Reverdy's poetry], trans. Chen Yuyue, *Xiandai* 1, no. 2 (1932): 270.

58. For a reading that expands upon this point, see Andrew Rothwell, *Textual Spaces: The Poetry of Pierre Reverdy* (Amsterdam: Editions Rodopi, 1989), 82–83.

59. Pap, "The Cubist Image and the Image of Cubism," 171.

60. Rothwell, *Textual Spaces*, 82. My reading also has benefited from Peter Nicholls, *Modernisms* (Berkeley: University of California Press, 1995), 249–250.

61. Chen Yuyue, "Bayer Hefoerdi" [Pierre Reverdy], *Xiandai* 1, no. 2 (1932): 269.

62. Pierre Reverdy, *Nord-Sud, Self-defence et autres écrits sur l'art et la poésie (1917–1926)* (Paris: Flammarion, 1975), 73; quoted and translated in André Breton, "Manifesto of Surrealism," in *Manifestoes of Surrealism*, translated by Richard Seaver and Helen R. Lane (Ann Arbor: University of Michigan Press, 1972), 20. Whether or not Chen, Shi, and their colleagues had access to this Reverdy text in its entirety, Shi did have access to this particular passage through his ownership of a copy of Breton's "Manifesto of Surrealism." Shi Zhecun to Dai Wangshu, n.d., in *Xiandai zuojia shujian*, ed. Kong Lingjing (Guangzhou: Huacheng chubanshe, 1982), 77–78.

63. Pierre Reverdy, *Le livre de mon bord: Notes 1930–1936* (Paris: Mercure de France, 1948), 132, quoted and translated in Nicholls, *Modernisms*, 247.

64. Rothwell, *Textual Spaces*, 125.

65. For a discussion of the synthetic force of edge-to-edge contact in the collage aesthetics of Picasso, Juan Gris, William Carlos Williams, and Gertrude Stein, see Charles Altieri, *Painterly Abstraction in Modernist American Poetry* (Cambridge: Cambridge University Press, 1989), 236–247.

CHAPTER 3. PROJECTED PASTS

1. Unlike countries such as India, whose territories were completely taken over by a single colonizer, China was partly colonized by multiple colonizers. Shanghai itself was divided and ruled by separate administrations, and included the French Concession, the International Settlement (primarily British and American, and later Japanese), and a Chinese city, whose distinctive architectures are still part of Shanghai's urban collage.

2. According to the project's website, "Shanghai Xintiandi [is] a place where old meets new, east meets west . . . and where yesterday meets tomorrow in Shanghai today." See www.xintiandi.com.

3. Mu Shiying, "Yezonghui li de wuge ren" [Five in a nightclub], *Xiandai* 2, no. 4 (1933): 568.

4. Prasenjit Duara, "The Regime of Authenticity: Timelessness, Gender and National History in Modern China," *History and Theory* 37, no. 3 (1998): 301.

5. Shi Zhecun, "Mo dao" [Demon's way], in *Xin ganjue pai xiaoshuo xuan* [Anthology of new perceptionist fiction], ed. Leo Ou-fan Lee [Li Oufan] (Taipei: Yunchen wenhua, 1988), 90–91. All translations are mine unless otherwise noted. I have consulted Paul White's translation, "Devil's Road," in Shi Zhecun, *One Rainy Evening* (Beijing: Panda Books, 1994), 56–80.

6. Lou Shiyi, "Shi Zhecun de xin ganjuezhuyi: Dule 'Zai Bali Daxiyuan' yu 'Mo dao' zhihou" [Shi Zhecun's new perceptionism: After reading "At the Paris Cinema" and "Demon's Way"], rpt. in *Shi Zhecun*, ed. Ying Guojing (Hong Kong: Sanlian shuju, 1988), 306, 307, 305. Shi was soon to give in to such criticism and give up his experiments in surrealism. Indeed, no doubt because of his experience, by 1934, Shi had decided that surrealism, as a movement, was futile in Shanghai, despite his own predilections. Although he was well aware of (and in some cases published) work of artists such as Pang Xunqin, Zhou Duo, and Lin Fengmian who were interested in surrealism at this time, he turned down an offer from Eugene Jolas, editor of the European avant-garde journal *transition* and sometime surrealist poet, to collaborate on a special issue of *Xiandai* to be devoted to introducing European surrealism. Shi

Zhecun, "Miluo de hua" [The paintings of Miró], in *Shi Zhecun qishinian wenxuan* [A collection of Shi Zhecun from over seventy years], ed. Chen Zishan and Xu Ruqi (Shanghai: Shanghai wenyi chubanshe, 1996), 336. On Jolas's relationship to surrealism, as well as the significance of *transition* in connecting and promoting various modernisms in the West, see Eugene Jolas, *Man from Babel*, ed. Andreas Kramer and Rainer Rumold (New Haven, CT: Yale University Press, 1998).

Part of the problem may have been that some writers in Shanghai saw surrealism purely as an exploration of subjective states in complete rejection of an external reality then in crisis. This of course is a common enough understanding of surrealism in the West as well as China, and indeed, it was not held only by surrealism's detractors, such as Lou Shiyi, but also by some of its promoters. Writing in 1934 in *Yishu* (L'art)—a magazine that promoted surrealism most among various modernisms—the painter and critic Ni Yide noted how surrealism grew out of Dadaism, and seemed to praise surrealism for how it "abandoned Dadaism's concern for the other [*dui ta de guanxin*], and moved toward a pure concern for the interior [*dui nei de guanxin*]." Ni Yide [Ni Te, pseud.], "Chaoxianshizhuyi de huihua" [Surrealist painting], *Yishu* 1 (1934): 1. (Each article in this journal is paginated separately, that is, they all begin on page 1.) Ni Yide goes on to conceptualize surrealism as a surfacing of what is hidden in such psychological depths: "Just as if a jellyfish were to float to the surface of the ocean, bathing in the brilliant sunlight, the clear blue sky and the mysterious bottom of the ocean come into communication with each other." "Surrealist Painting," 1.

7. Guo Renyuan, "Biantai de xingwei" [Abnormal behavior], *Dongfang zazhi* 24, no. 23 (1927): 72.

8. Guo Renyuan, "Abnormal behavior," 67.

9. Guo continues: "Some patients frequently chat with ghosts, and some patients say their whole bodies are encircled with poisonous snakes." "Abnormal behavior," 70–71. In an article discussing debates over the existence or nonexistence of ghosts, Zhang Dongsun turns this idea around and argues that one explanation for the existence of ghosts is that they are the product of "abnormal" personalities who claim to see what they really cannot, or who suffer from a "disintegration of personality." Zhang Dongsun, "Xin you gui lun yu xin wu gui lun" [New theories of the existence of ghosts and new theories of the nonexistence of ghosts], *Dongfang zazhi* 27, no. 5 (1930): 58–59.

10. "This uncanny is in reality nothing new or alien, but something which is familiar and old-established in the mind and has become alienated from it only through

the process of repression. . . . The uncanny [is] something which ought to have remained hidden but has come to light." Sigmund Freud, "The 'Uncanny,'" in *Art and Literature*, ed. Albert Dickson (Harmondsworth: Penguin, 1990), 363–364.

11. Shi Zhecun, personal communication to the author, August 24, 1993; Shi Zhecun, "The Paintings of Miró," 334–337. Also see Lydia H. Liu, *Translingual Practice: Literature, National Culture, and Translated Modernity—China, 1900–1937* (Stanford, CA: Stanford University Press, 1995), 134–136.

12. André Breton, "Manifesto of Surrealism," in *Manifestoes of Surrealism*, trans. Richard Seaver and Helen R. Lane (Ann Arbor: University of Michigan Press, 1972), 39. This is also true of the protagonists of Shi's other surrealist fictions of modern Shanghai, "Yaksha" [Yecha] and "Travel Lodge" [Lüshe].

13. Elza Adamowicz, *Surrealist Collage in Text and Image: Dissecting the Exquisite Corpse* (Cambridge: Cambridge University Press, 1998), 38.

14. Walter Benjamin, "Surrealism: The Last Snapshot of the European Intelligentsia," in *Selected Writings*, vol. 2, *1927–1934*, ed. Michael W. Jennings, Howard Eiland, and Gary Smith (Cambridge, MA: Harvard University Press, 1999), 210.

15. Louis Aragon, *Paris Peasant*, trans. Simon Watson-Taylor (Boston: Exact Change, 1994), 13, 14.

16. Hal Foster, *Compulsive Beauty* (Cambridge, MA: MIT Press, 1993), 163.

17. Foster, *Compulsive Beauty*, 164. Also see Max Ernst, *Une semaine de bonté* (1934; reprint, New York: Dover, 1976).

18. Ni Yide, "Surrealist Painting," 2. See chapter 4 for a discussion of the idea of "crosscutting" (*jiaocuo*) as a spatial and narrative concept in several critical texts on modernism published in Shanghai at this time. André Breton also likened surrealism to a magic art. Breton, "Manifesto of Surrealism," 29. In developing this point, Ni cites Franz Roh's concept of "magic realism" (which Ni translates as *moshu de xieshizhuyi*). In his 1925 essay, Roh defines this as a kind of realism that both follows and is informed by the innovations and spirit of expressionism, which, he writes, "shows an exaggerated preference for fantastic, extraterrestrial, remote objects. Naturally, it also resorts to the everyday and the commonplace for the purpose of distancing it, investing it with a shocking exoticism." With the word "magic," Roh means to "indicate that the mystery does not descend to the represented world, but rather hides and palpitates behind it." Franz Roh, "Magic Realism: Post-expressionism," in *Magical Realism: Theory, History, Community*, ed. Lois Parkinson Zamora and Wendy B. Faris (Durham, NC: Duke University Press, 1995), 16. Years later, incidentally, Roh's essay would become the origin of the term used to describe Latin American fiction of recent decades.

19. Breton, "Manifesto of Surrealism," 20–21.

20. Breton, "Manifesto of Surrealism," 4.

21. Shi Zhecun, "Shu Xiangguo si sheying hou" [Written on the back of a photograph of Xiangguo Temple], in *Dengxia ji* [Beneath the lamp] (Beijing: Kaiming chubanshe, 1994), 3–4.

22. I resort to this contorted definition in order to keep present something of the multiple mediations elided by the usual critical definitions of "the photograph" as a simple "index" or "imprint" of the real.

23. Xu Shushan, "Shanghai," *Wenyi chahua* 1, no. 3 (1932): 8.

24. Xu Shushan, "Shanghai," 9.

25. Feng Zikai, "Shangye yishu" [Commercial art], in *Yishu conghua* [Collected talks on art] (Shanghai: Liangyou gongsi, 1935), 30. This article was originally written in 1933 for *Xin Zhonghua* [New China].

26. Feng Zikai, "Commercial Art," 31.

27. On colonialist circulation of architectural styles and the incorporation of the built environment into the world system, see Anthony D. King, *Urbanism, Colonialism, and the World-Economy: Cultural and Spatial Foundations of the World Urban System* (New York: Routledge, 1991).

28. Feng Zikai, "Commercial Art," 32.

29. Feng Zikai, "Commercial Art," 31.

30. W Sheng [pseud.], "Aiji fajue gumu ji" [Record of the excavation of an ancient tomb in Egypt], *Dongfang zazhi* 20, no. 6 (1923): 57. Also see the sequel, Yu Zhi, "Aiji wang ling fajue xuji" [Continuation of a record of the excavation of the tomb of an Egyptian king), *Dongfang zazhi* 22, no. 1 (1925): 129–135.

31. I am grateful to Andrew F. Jones for this point and for also informing me that this image of Egypt appeared in a number of Chinese nationalist songs from this period.

32. While, as I have shown, *Xiandai* was not always critical of what of course was plunder by foreign colonizers, this struggle is alluded to in W Sheng, "Record of the Excavation of an Ancient Tomb in Egypt," 69. There are a number of accounts of this conflict in English; a concise account that situates the opening of Tutankhamen's tomb within questions of modernism, and which has been very helpful for my own thinking, is in Michael North, *Reading 1922: A Return to the Scene of the Modern* (New York: Oxford University Press, 1999), 19–20. Also see Neil Asher Silberman, *Between Past and Present: Archaeology, Ideology, and Nationalism in the Modern Middle East* (New York: Henry Holt, 1989), 159–168.

33. North, *Reading 1922*, 20. Another discussion, which shows the linkages be-

graphic art and aesthetics], ed. Long Xizu (Tianjin: Tianjin renmin meishu chuban-she, 1988), 490.

48. Zhang Hui'an, "Idle Talk on Shadows," 491.

49. Zhang Hui'an, "Idle Talk on Shadows," 493.

50. Zhang Hui'an, "Idle Talk on Shadows," 492.

51. The film, according to the advertisement, was made by the Great Wall Film Company (Da Changcheng yingpian gongsi).

52. Victor I. Stoichita, *A Short History of the Shadow*, trans. Anne-Maries Glasheen (London: Reaktion Books, 1997), 194–195. Stoichita is writing specifically of Man Ray's photograph *Man*, of an eggbeater and its shadow.

53. See An Yi, trans., "Meiguo san nüliu shi chao" [A selection of poetry by three American women], *Xiandai* 1, no. 3 (1932): 422–427, which includes H.D., "The Pool," "Oread," and "Moonrise" (from her collection *The God*); Evelyn Scott, "Tropic Moon" and "Winter Moon" (from her *Precipitations*); and Amy Lowell, "A Lady" and "A Gift" (from her *Sword Blades and Poppy Seed*). Also see Shi Zhecun, trans., "Xiandai Meiguo shi chao" [A selection of modern American poetry], *Xiandai* 5, no. 6 (1934): 1199–1213, which includes Amy Lowell, "Summer Night Piece" (from her *What's O'Clock*), "Bright Sunlight," "A Sprig of Rosemary," and "The Fisherman's Wife" (from her *Pictures of the Floating World*), and "Towns in Color: Red Slippers" (from her *Men, Women and Ghosts*); Ezra Pound, "Meditatio" and "Black Slippers: Bellotti" (from his *Lustra*) and "A Girl" (from his *Ripostes*); H.D., "The Pear Tree" and "Evening" (from her *Sea Garden*); and John Gould Fletcher, "In the Theatre" and "Irradiations" (from *Some Imagist Poets*).

Translations of imagist poetry also appear in two articles in *Xiandai*. See Xu Chi, "Yixiangpai de qige shiren" [Seven poets of the imagist school], *Xiandai* 4, no. 6 (1934): 1013–1025, which includes work by H.D., William Carlos Williams, Ezra Pound, Amy Lowell, John Gould Fletcher, Richard Aldington, and F. S. Flint); and Shao Xunmei, Xiandai Meiguo shitan gaiguan" [An overview of modern American poetry circles], *Xiandai* 5, no. 6 (1934): 874–890, which includes work by T. E. Hulme and H.D.). Also see Benjamin Goriely [Gaolieli], "Yesaining yu Eguo yixiang shi pai" [Essinin and the Russian imagist school], trans. Dai Wangshu *Xiandai* 5, no. 3 (1934): 411–421.

54. Ernest Fenollosa, *The Chinese Written Character as a Medium for Poetry*, ed. Ezra Pound (San Francisco: City Lights Books, 1991), 22. The character *jian* (to see), for instance, suggests to Fenollosa an eye moving through space by representing "running legs under an eye," producing the meaning "to see" by creating a kind of "thought-picture." Fenollosa, *The Chinese Written Character as a Medium for Poetry*, 8.

The "tenets" of imagism that were translated in *Xiandai*, in Shao Xunmei's article on cosmopolitan poetry, were those reflecting the thought and work of Richard Aldington, Amy Lowell, and H.D., whose similar principles of imagism appear in the preface to the 1915 anthology *Some Imagist Poets* (which did not include Pound). This unsigned preface was written by Aldington and revised by Lowell. Particularly noteworthy in the present context is the call "to produce poetry that is hard and clear" (*jianying yu qingchu*, in Shao's translation). The relation of this conception of materiality to visual images is signaled by the call "to present an image." For as the preface continues, "We are not a school of painters, but we believe that poetry should render particulars exactly," as, this seeming non sequitur implies, do paintings. Preface to *Some Imagist Poets* (Boston: Houghton Mifflin, 1915), vi–vii; Shao Xunmei, "An Overview of Modern American Poetry Circles," 883.

55. Shi Zhecun, "Ying-Mei xiao shi chao" [A selection of Anglo-American short poems], *Wenyi fengjing* 1, no. 1 (1934): 103.

56. An Yi, "A Selection of Poetry by Three American Women," 427. Also see Evelyn Scott, "Designs," in *Precipitations* (New York: N. L. Brown, 1920), 53–55.

57. Shao Xunmei, "An Overview of Modern American Poetry Circles," 883.

58. Shao Xunmei, "An Overview of Modern American Poetry Circles," 884.

59. Ezra Pound, *Gaudier-Brzeska: A Memoir* (New York: New Directions, 1970), 83; Aldington, Lowell, and H.D., preface to *Some Imagist Poets*, vi–vii.

60. Xu Chi, "Seven Poets of the Imagist School," 1014.

61. Xu Chi's word is simply "plane" [*pingmian*], but his wider context makes it clear he is referring to a picture plane, and so I add "picture" for clarity's sake.

62. Xu Chi, "Seven Poets of the Imagist School," 1014.

63. Velox paper was invented around 1890 by Leo Hendrik Baekeland, who sold the rights in 1899 to George Eastman and his Kodak Company for $1 million. For an account in a popular Shanghai publication of the properties of Velox and other such "gaslight" photographic papers, see Cao Yuanyu, "Dengguangzhi de yinxiang" [Imprinted images of lamplight paper], in *Sheying shu* [The art of photography] (Shanghai: Shangwu yinshuguan, 1930), 106–118.

64. Li Hongliang, "Tan ying" [On photography], *Yifeng* 9, no. 1 (1935): 28–29.

65. Xu Chi, "Seven Poets of the Imagist School," 1014.

66. Xu Chi, "Seven Poets of the Imagist School," 1016.

67. This story is recorded in the *Da chuan* [Great Commentary] of the *Yijing*. For a translation, see *The I Ching, or Book of Changes*, rendered into English from Richard Wilhelm's translation by Cary F. Baynes (Princeton, NJ: Princeton University Press, 1969), 328–329.

the 1930s. His paintings were promoted both by Fu Lei, who wrote about them, and by Shi Zhecun, who published a sample (not the two under discussion) in *Xiandai*. See Fu Lei, "Xunqin de meng" [Xunqin's dream], *Yishu xunkan* 1, no. 3 (1932): 1–3. Also see Pang's work in *Xiandai* 1, no. 6 (1932): facing 826. For a history of Pang's work and that of other modernist painters during this period, see Ralph Croizier, "Post-impressionists in Pre-war Shanghai: The Juelanshe (Storm Society) and the Fate of Modernism in Republican China," in *Modernity in Asian Art*, ed. John Clark (Broadway, New South Wales, Australia: Wild Peony, 1993).

16. Unfortunately, at the outset of the Cultural Revolution in 1966 Pang himself destroyed those of his modernist paintings that had not already been lost in the late 1930s during the war with Japan. Kuiyi Shen, "The Lure of the West: Modern Chinese Oil Painting," in Julia F. Andrews and Kuiyi Shen, *A Century in Crisis: Modernity and Tradition in the Art of Twentieth-Century China* (New York: Abrams, 1998), 173. Thus Pang's work now can only be seen in poor reproductions in Republican Shanghai periodicals and recent art books reprinted from them.

17. Kuiyi Shen, "The Lure of the West: Modern Chinese Oil Painting," 176.

18. Pang Xunqin, "Xunqin suibi" [Xunqin's random jottings], *Yishu xunkan* 1, no. 4 (1932): 10.

19. Fu Lei, "Xunqin's Dream," 13.

20. It is revealing in this context that almost all of the numerous reproductions of cubist painting in Shanghai books and magazines such as *Yishu* (whose title the editors rendered in French as *L'art*) are of synthetic cubism rather than analytic cubism. Editors and writers on cubist painting had access to samples of analytic cubism but almost always chose not to reprint them. Numerous analytic cubist paintings appear in Amédée Ozenfant and Charles Edouard Jeanneret [Le Corbusier], *La peinture moderne* (Paris: Les Éditions G. Crès et cie, 192?), from which the selection of cubist paintings printed in *Yishu* 2 (1934) seems to have been reproduced. The only painting in the *L'art* layout that could represent analytic cubism is that by Metzinger. The paintings are untitled in the *L'art* layout and largely untitled in Ozenfant and Jeanneret. The paintings include the following (pages in Ozenfant and Jeanneret, *La peinture moderne*, on which the paintings appear are indicated in parentheses after the year of the painting, where known): Picasso, *Green Still Life* (1914; 121) and *Guitar* (1920; n.p.); Braque, *Guitar and Glass* (1917; 123) and *The Water of Life* (1921; n.p.); Léger, *Acrobats in the Circus* (1918; n.p.), printed upside down; Metzinger, *Teatime* (1911; 92); and one painting each by Gliezes (misspelled as "Gliez"; n.p.) and Lhote (1918; 115), whose titles I have been unable to identify.

21. Pang Xunqin, "Xunqin's Random Jottings," 11.

22. Feng Zikai, "Xing ti geming yishu—litipai" [Formally and structurally revolutionary art—cubism], in *Xiyang huapai ershi jiang* [Twenty lectures on schools of Western art] (Shanghai: Kaiming shudian, 1930); reprinted in *Feng Zikai wenji* [Collected works of Feng Zikai], 7 vols., ed. Feng Chenbao (Hangzhou: Zhejiang wenyi chubanshe, 1990), 1:434.

23. Feng Zikai, "Formally and Structurally Revolutionary Art," 434.

24. The Italian futurists seem to have been the first to actually use the term "simultaneism"—meaning for them a simultaneous depiction of what Feng calls "a succession of instants" (*shunjian de lianxu*) within a single painting—in order to express their obsession with speed and dynamism. The effect of such representation, Feng claims, is that "the Futurists see space as time." Feng Zikai, "Ganqing baofa de yishu—weilaipai yu chouxiangpai" [Emotionally explosive art—futurism and abstraction], in *Xiyang huapai ershi jiang* [Twenty lectures on schools of Western art] (Shanghai: Kaiming shudian, 1930); reprinted in *Feng Zikai wenji* [Collected works of Feng Zikai], 7 vols., ed. Feng Chenbao [Hangzhou: Zhejiang wenyi chubanshe, 1990], 1:445. Originally published as the second half of "Cubism, Futurism, Abstraction."

Despite their superficial formal resemblance, this ideology of speed and dynamism set futurist collage apart from cubism. Marjorie Perloff, *The Futurist Moment: Avant-Garde, Avant Guerre, and the Language of Rupture* (Chicago: University of Chicago Press, 1986), 54–55. The term, however, was quickly adopted by others and was broadened in its applications. In another introduction to modern art, the modernist painter Ni Yide mentions somewhat cryptically how Robert Delaunay, using "cubism's methods of assemblage [*zonghe*], assembles the 'simultaneity' (Simultanité) [*tongcunxing*] obtained in futurism." Ni Yide, "Litizhuyi" [Cubism], in *Xiandai huihua gaiguan* [A survey of modern art] (Shanghai: Shangwu yinshuguan, 1934), 79. An earlier version of this article appeared in the same issue of *L'art* as Fu Lei's essay on the decomposition and recomposition of realities discussed earlier, as Ni Yide [Ni Te, pseud.], "Litizhuyi ji qi zuojia" [Cubism and its artists], *Yishu* 2 (1934): 1–7. Parts of this essay—not including the passage on Delaunay and simultaneity—are translated from Jan Gordon, *Modern French Painters* (London: The Bodley Head, 1923), 139–147.

Robert Delaunay conceived of simultaneity in terms of a dynamic contrast of colors in a nonrepresentational painting. Robert Delaunay, "On the Construction of Reality in Pure Painting," in *Art in Theory: 1900–1990*, ed. Charles Harrison and Paul Woods (Oxford: Blackwell, 1992). Sonia Delaunay, however, took her husband's ideas much farther in her collaboration with Blaise Cendrars on his work, *The Prose of*

the "Wandering Rocks" in particular as the novel's method and structure as a whole (182). Yet while he notes the revolutionary potential of Joyce's form, which he describes as contracting time and expanding space (181), for Zhao this potential is lost in the obscurity of the stream of consciousness sequences that he believes occupy most of the novel. In another article on Dos Passos, also published in *Xiandai*, Du Heng also excoriates Joyce for what he took to be an empty formalism that gives experimental fiction a bad name. Du Heng is particularly irritated by what he sees as a disparity between adventurous formal experiment and trivial, insipid content. To this, Du Heng contrasts experimentalism that is driven by a literary work's content. See Du Heng, "Pasuosi de sixiang yu zuofeng" [Dos Passos's thought and style], *Xiandai* 5, no. 6 (1934): 993–994.

Both Zhao Jiabi and Du Heng contrast Joyce with Dos Passos, considering the latter to be "a writer who uses rational revolutionary form to write meaningful contents." Du Heng, "Dos Passos's Thought and Style," 994. For the "meaningful content" that Zhao and Du found lacking in Joyce is history. Of course, the accusation that spatial form necessarily "contracts time" — or destroys the representation of time altogether and by implication denies the historicity of the world — was hardly limited to Shanghai. See Jeffrey R. Smitten and Ann Daghistany, eds., *Spatial Form in Narrative* (Ithaca, NY: Cornell University Press, 1981).

Yet for Zhao, spatial form and historicity are not at all mutually exclusive; rather, spatial form is specifically an effective way to represent modern history. Indeed, recent work on Joyce has revealed precisely the ways in which his literary experimentalism, far from providing an "escape" from history, enables a powerful engagement and critique of modern Irish historical experience. Examples include Moretti, *Modern Epic*; David Lloyd, "Adulteration and the Nation," in *Anomalous States: Irish Writing and the Post-Colonial Moment* (Durham, NC: Duke University Press, 1993), 881–24; and Enda Duffy, *The Subaltern Ulysses* (Minneapolis: University of Minnesota Press, 1994). Chapter 2 of the latter book offers a striking examination of Joyce's use of crosscutting in critiquing colonialism.

48. Zhao Jiabi, "From the Crosscut Novel to Dos Passos," 190.

49. Zhao Jiabi, "Dos Passos," 222.

50. Zhao Jiabi, "Dos Passos," 228.

51. Zhao Jiabi, "From the Crosscut Novel to Dos Passos," 189.

52. Zhao Jiabi, "From the Crosscut Novel to Dos Passos," 190.

53. Bloch, *Heritage of Our Times*, esp. pt. 3, "Upper Middle Classes, Objectivity and Montage."

54. Ernst Bloch, "Discussing Expressionism," in *Aesthetics and Politics*, ed. Fredric

Jameson (London: Verso, 1986), 22. As the title of his article indicates, Bloch is writing specifically about expressionism, but his comments have been widely considered to apply to much of modernist art.

55. The years 1931–1934 were framed by the Mukden Incident (which Japanese soldiers staged and used as an excuse for a full-scale invasion of Manchuria), the resulting establishment of the puppet state of Manchukuo, and the "re-coronation" of the last Qing emperor as the emperor of Manchukuo. These incidents had direct repercussions in Shanghai: Chinese boycotted the Japanese; in January 1932 the Japanese used their clashes with Chinese as an excuse to bomb Zhabei, a working-class residential district in northeastern Shanghai; and in May 1932 Japanese forces created a "neutral zone" around the city. For a brief summary of these events, see Jonathan D. Spence, *The Search for Modern China* (New York: Norton, 1990), 391–396.

56. Mu Shiying, "Yezonghui li de wuge ren" [Five in a nightclub], *Xiandai* 2, no. 4 (1933): 582.

57. Mu Shiying, "Five in a Nightclub," 582. Here I quote Mu Shiying, "Five in a Nightclub," trans. Randolph Trumbull, *Renditions* 37 (Spring 1992): 20. I am silently changing Trumbull's otherwise fine translation to present tense, as I think it better captures the frenetic temporality of Mu's text.

58. Mu Shiying, "Five in a Nightclub," 561; Mu Shiying, trans. Turnbull, "Five in a Nightclub," 5–8.

59. Mu Shiying, "Five in a Nightclub," 568; Mu Shiying, trans. Turnbull, "Five in a Nightclub," 7.

60. Mu Shiying, "Five in a Nightclub," 568; Mu Shiying, trans. Turnbull, "Five in a Nightclub," 7.

61. Mu Shiying, "Five in a Nightclub," 569; Mu Shiying, trans. Turnbull, "Five in a Nightclub," 7.

62. Mu Shiying, "Five in a Nightclub," 5805–81; Mu Shiying, trans. Turnbull, "Five in a Nightclub," 18.

63. And in case we miss the connection between these five figures and the ground they occupy, it is when they must finally come to a halt with the closing of the nightclub that each of them in turn is also described as "a popped balloon." Mu Shiying, "Five in a Nightclub," 583; Mu Shiying, trans. Turnbull, "Five in a Nightclub," 20.

64. Mu Shiying, "Five in a Nightclub," 570; Mu Shiying, trans. Turnbull, "Five in a Nightclub," 9. Here I alter Trumbull's translation, which renders *zai kongzhong* as "skyward."

65. Mu Shiying, "Five in a Nightclub," 571; Mu Shiying, trans. Turnbull, "Five in a Nightclub," 9–10.

into imperial landscape. Bernard Faure has described how the numerous Chan (i.e., Zen) Buddhist stories of dialogues between Buddhist monks and local gods and their struggles over geographic sites serve as allegories for the confrontation between two worldviews: the *unlocalized* and universalizing ideology of Chan Buddhism and the *localized* religious ideologies of popular religion: "Buddhists . . . felt compelled to convert or subdue the local deities, to erase the memory of the places, to convert or desacralize spaces, to decode and re-encode legends." In all these stories, "the disruptive power of a *local* spirit is pacified by the Buddhist teaching, that is, by the revelation of a higher understanding of reality, one that implies an overall, *unlocalized* vision." The localized, particular site or place of local religion is destroyed or emptied out and incorporated into the totalized, abstract space of Chan. Bernard Faure, *Chan Insights and Oversights: An Epistemological Critique of the Chan Tradition* (Princeton, NJ: Princeton University Press, 1993), 157–159.

This emptying of place into space, Faure argues, is closely related to the Chan concept of the mind. As one Chan master, Zhida, put it: "All obstacles and errors are created by the mind. To gaze at the mind is to gaze at the unlocalized. The unlocalized is your mind. . . . Unlocalized means the absence of any mind (or dharma)" (cited and translated in Faure, *Chan Insights and Oversights*, 165).

83. For a detailed account of this process in the later photomontages of John Heartfield, see David Evans, *John Heartfield, AIZ/VI, 1930–1938* (New York: Kent Fine Art, 1991), 23. See also Kriebel, "Manufacturing Discontent," 65.

84. Kriebel, "Manufacturing Discontent," 63–64.

85. Doherty, "'*See: We Are All Neurasthenics!*,'" 129.

CHAPTER 5. SHANGHAI SAVAGE

1. Xu Weinan, "Taiwan shengfan de yishu wenhua" [The artistic culture of the Taiwanese barbarians], *Yishu jie* 17 (1927): 1. All translations are my own unless otherwise indicated.

2. Xu Weinan, "The Artistic Culture of the Taiwanese Barbarians," 1.

3. Ling Changyan, "Fuerkena: Yige xin zuofeng de changshizhe" [Faulkner: An experimentalist of new styles], *Xiandai* 5, no. 6 (1934): 1003.

4. For such an approach, see Frank Dikötter, *The Discourse of Race in Modern China* (Stanford, CA: Stanford University Press, 1992).

5. Ling Changyan, "Faulkner," 1003.

6. Mu Shiying, "Yezonghui li de wuge ren" [Five in a nightclub], *Xiandai* 2, no. 4

(1933): 568. Translated as "Five in a Nightclub" by Randolph Trumbull, *Renditions* 37 (1992): 10–11.

7. Shi Zhecun, "Mo dao," in *Xin ganjue pai xiaoshuo xuan* [Anthology of new perceptionist fiction], ed. Leo Ou-fan Lee [Li Oufan] (Taipei: Yunchen wenhua, 1988), 97. Translated by Paul White as "Devil's Road" in Shi Zhecun, *One Rainy Evening* (Beijing: Panda Books, 1994), 57. I have modified the punctuation of the translation to make it more consistent with Shi's text; first ellipsis mine.

8. On this colonialist gothic, see Patrick Brantlinger, *Rule of Darkness: British Literature and Imperialism, 1830–1914* (Ithaca, NY: Cornell University Press, 1988).

9. Frantz Fanon, *Black Skin, White Masks*, trans. Charles Lam Markmann (New York: Grove, 1967), 104. For Fanon's critical and historicizing analysis of nightmares of blackness and shadows in colonized Malagasy, see 100–107.

10. See Zhao Jiabi, "Pasuosi" [Dos Passos], *Xiandai* 4, no. 1 (1933): 220–229, and Zhao Jiabi, "Cong hengduan xiaoshuo tandao Dusi Pasuosi" [From the crosscut novel to Dos Passos], *Zuojia* 2, no. 1 (1936): 179–192. For a brief discussion of the latter text, see Shu-mei Shih, *The Lure of the Modern: Writing Modernism in Semicolonial China, 1917–1937* (Berkeley: University of California Press, 2001), 250.

11. Stein's work was discussed in several Shanghai journals in 1934, thanks, it seems, to her growing popularity resulting from the publication of her *Autobiography of Alice B. Toklas* the previous year. See, for example, Shao Xunmei, "Xiandai Meiguo shitan gaiguan" [An overview of modern American poetry circles], *Xiandai* 5, no. 6 (1934): 886.

12. Zhao Jiabi, "Xieshizhuyizhe de Shitaiyin" [Gertrude Stein the realist], *Wenyi fengjing* 1, no. 1 (1934): 82. Also see Carl Van Vechten, introduction to Gertrude Stein, *Three Lives* (New York: Modern Library, 1933), v–xi, and Edmund Wilson, "Gertrude Stein," in *Axel's Castle: A Study of the Imaginative Literature of 1870–1930* (New York: Scribner's, 1931), 237–256.

13. Zhao Jiabi, "Gertrude Stein the Realist," 82.

14. For a brilliant discussion of how "the step away from conventional verisimilitude into abstraction is accomplished by a figurative change of race" in Stein's work, see Michael North, "Modernism's African Mask: The Stein-Picasso Collaboration," in *The Dialect of Modernism: Race, Language and Twentieth-Century Literature* (New York: Oxford University Press, 1994).

15. Zhao Jiabi, "Gertrude Stein the Realist," 84.

16. Zhao Jiabi, "Gertrude Stein the Realist," 84.

17. Zhao Jiabi, "Gertrude Stein the Realist," 87.

and customs of ethnic others on China's borderlands. Robert Ford Campany, *Strange Writing: Anomaly Accounts in Early Medieval China* (Albany: State University of New York Press, 1996).

50. Fanon, *Black Skin, White Masks*, 109.

51. Fanon, *Black Skin, White Masks*, 111, 110, 112; emphasis in original.

52. Fanon, *Black Skin, White Masks*, 111.

53. Fanon, *Black Skin, White Masks*, 112.

54. Fanon, *Black Skin, White Masks*, 35; emphasis in original.

55. Xu Weinan, "The Artistic Culture of the Taiwanese Barbarians," 2, 3.

56. Xu Weinan, "The Artistic Culture of the Taiwanese Barbarians," 2.

57. Xu Weinan, "The Artistic Culture of the Taiwanese Barbarians," 3.

58. Xu Weinan, "The Artistic Culture of the Taiwanese Barbarians," 3.

59. Xu Weinan, "The Artistic Culture of the Taiwanese Barbarians," 3.

60. Xu Weinan, "The Artistic Culture of the Taiwanese Barbarians," 3.

61. Ying He, "Jiantao yinmu shang duiyu yuanshi shenghuo de simu" [Discussion of the yearning for primitive life on the silver screen], *Xiandai dianying* 1, no. 3 (1933): 23.

62. *Liangyou*, February 1934, facing 19. The photograph has both English and Chinese captions. The content of the Chinese caption is essentially the same, although differently organized; it also informs the reader about the Luoluos' customs regarding food and clothing, war and slavery.

63. *Luoluo* is considered a derogatory expression; this ethnicity is now officially called the *Yi*.

64. See, for example, Yang Chengzhi, "Minzu diaocha maoxian ji" [A record of the dangers of ethnic investigation] *Liangyou huabao*, December 1929, 10–11, 16.

65. I base this translation on the explanation of the name given in Yu Li, "'Zhibian' bushi 'zhimin'" ["Developing the borders" is not "colonialism"], *Zhibian yuekan* 2, nos. 3–4 (1933): 2–3.

66. Yu Li, "'Developing the Borders' Is Not 'Colonialism,'" 2–3. This must have been a sensitive issue, for *Border Development Monthly* carried a four-page article specifically (if not entirely convincingly) denying that this was the case. This article explained that the character *zhi* in the compound *zhibian* (developing the borders) should not be regarded as the character *zhi* in the compound *zhimin* (colonize), but rather the *zhi* in words such as *kenzhi* (plow) or *zhongzhi* (plant, cultivate) and thus means in English "o plow, to develop barren lands." Yu Li, "'Developing the Borders' Is Not 'Colonialism,'" 2–3. The article adds that when the society registered for

permission to publish in Shanghai's French Concession, it did so under the name la Société de l'exploitation sur les frontières de la Chine and not la Société de la colonisation de frontière chinoise.

67. This text was deemed to be of enough general interest to have been reprinted in what appears to have been the *Reader's Digest* of its day, *Wenhua* 5 (1936): 109–112.

68. Wei Zhitang, "Guangxi Yaoshan youji" [A travel record of Yao Mountain, Guangxi], *Zhibian* 2, nos. 5–6 (1933): 11–12.

69. Wei Zhitang, "Guangxi Yaoshan youji" [A travel record of Yao Mountain, Guangxi], *Zhibian* 2, no. 7 (1934): 11.

70. Wei Zhitang, "Guangxi Yaoshan youji" [A travel record of Yao Mountain, Guangxi], *Zhibian* 2, no. 9 (1934): 11.

71. Wei Zhitang, "Guangxi Yaoshan youji" [A travel record of Yao Mountain, Guangxi], *Zhibian* 2, no. 8 (1934): 15.

72. The poems are 366/38 and 104/4 in William Hung, comp., *A Concordance to the Poems of Tu Fu* (Cambridge, MA: Harvard–Yenching Institute Sinological Index Series, 1966). For a loose translation, see William Hung, *Tu Fu: China's Greatest Poet* (New York: Russell and Russell, 1953), 178–179.

73. Liu Xu, ed., *Jiu Tang shu* [Old history of the Tang] (Beijing: Zhonghua shuju, 1975), 5:3319, 3331.

74. Shi Zhecun, "Jiangjun de tou" [The general's head], in *Xin ganjue pai xiaoshuo xuan* [Anthology of new perceptionist fiction], ed. Leo Ou-fan Lee [Li Oufan] (Taipei: Yunchen wenhua, 1988), 6. All further references to this edition will be indicated in the text by a "G" and page number.

75. Shi Zhecun, "The General's Head," 4.

76. Shi Zhecun, "The General's Head," 3–4.

77. Shi Zhecun, "The General's Head," 3.

78. Shi Zhecun, "The General's Head," 26.

79. Shi Zhecun, "The General's Head," 23.

80. Shi Zhecun, "The General's Head," 26.

81. Shi Zhecun, "The General's Head," 39.

82. Shi Zhecun, "The General's Head," 39.

83. Ernst Bloch, "Discussing Expressionism," in *Aesthetics and Politics*, Theodor Adorno et al. (London: Verso, 2010), 16.

84. Roberto Juarroz, "Poesía Vertical VIII.1," in *Poesía Vertical*, ed. Diego Sánchez Aguilar (Madrid: Cátedra, 2012).

BIBLIOGRAPHY

Adamowicz, Elza. *Surrealist Collage in Text and Image: Dissecting the Exquisite Corpse.* Cambridge: Cambridge University Press, 1998.

Alberti, Leon Battista. *On Painting.* Translated by Cecil Grayson. Harmondsworth: Penguin, 1991.

Aldington, Richard, Amy Lowell, and H.D. Preface to *Some Imagist Poets.* Boston: Houghton Mifflin, 1915.

Altieri, Charles. *Painterly Abstraction in Modernist American Poetry.* Cambridge: Cambridge University Press, 1989.

An Yi, trans. "Meiguo san nüliu shi chao" [A selection of poetry by three American women]. *Xiandai* 1, no. 3 (1932): 422–427.

Anderson, Marston. *The Limits of Realism: Chinese Fiction in the Revolutionary Period.* Berkeley: University of California Press, 1990.

Andrews, Julia F., and Kuiyi Shen. *The Art of Modern China.* Berkeley: University of California Press, 2012.

Apollinaire. "The Poets' Napkin." In *The Heresiarch + Co.*, translated by Rémy Inglis Hall, 122–125. Cambridge, MA: Exact Change, 1991.

———. "La serviette des poètes." In *Oeuvres en prose.* Paris: Gallimard, 1977.

——— [Abaolinaier]. "Shiren de shijin" [The poets' napkin]. Translated by Chen Yuyue. *Xiandai* 1, no. 1 (1932): 19–22.

Aragon, Louis. *Paris Peasant.* Translated by Simon Watson-Taylor. Boston: Exact Change, 1994.

Bao, Weihong. *Fiery Cinema: The Emergence of an Affective Medium in China, 1915–1945.* Minneapolis: University of Minnesota Press, 2015.

Barmé, Geremie. *An Artistic Exile: A Life of Feng Zikai (1898–1975).* Berkeley: University of California Press, 2002.

Batchen, Geoffrey. *Burning with Desire: The Conception of Photography.* Cambridge, MA: MIT Press, 1997.

Baudelaire, Charles. "The Painter of Modern Life." In *Baudelaire: Selected Writings on Art and Artists*, edited by P. E. Charvet, 390–435. Cambridge: Cambridge University Press, 1981.

Bazin, André. "The Ontology of the Photographic Image." In *What Is Cinema?*, vol. 1, edited and translated by Hugh Gray, 9–16. Berkeley: University of California Press, 1967.

Belting, Hans. *Likeness and Presence: A History of the Image before the Era of Art*. Translated by Edmund Jephcott. Chicago: University of Chicago Press, 1994.

Benjamin, Walter. *The Arcades Project*. Edited by Rolf Tiedemann and translated by Howard Eiland and Kevin McLaughlin. Cambridge, MA: Harvard University Press, 1999.

———. "Little History of Photography." In *Selected Writings*, vol. 3, *1927–1934*, ed. Michael W. Jennings, Howard Eiland, and Gary Smith, 507–530. Cambridge, MA: Harvard University Press, 1999.

———. "Surrealism: The Last Snapshot of the European Intelligentsia." In *Selected Writings*, vol. 2, *1927–1934*, edited by Michael W. Jennings, Howard Eiland, and Gary Smith 207–221. Cambridge, MA: Harvard University Press, 1999.

———. "The Work of Art in the Age of Its Technological Reproducibility: Third Version." In *Selected Writings*, vol. 4, *1938–1940*, edited by Howard Eiland and Michael W. Jennings, 251–283. Cambridge, MA: Harvard University Press, 2003.

Benson, Richard. *The Printed Picture*. New York: Museum of Modern Art, 2008.

Bergson, Henri. *Creative Evolution*. Translated by Arthur Mitchell. Mineola, NY: Dover, 1998.

Bernard, Emile. "Paul Cézanne." In *Conversations with Cézanne*, edited by Michael Doran, 32–44. Berkeley: University of California Press, 2001.

"Bianji zhi yan" [Editor's comments]. *Liangyou huabao* 44 (1930): n.p.

"Bianzhe jianghua" [Editor's chat]. *Liangyou huabao* 45 (1930): n.p.

"Bianzhe yu duzhe" [Editor and readers]. *Liangyou huabao* 83 (1933): 86.

Bloch, Ernst. "Discussing Expressionism." In *Aesthetics and Politics*, Theodor Adorno, Walter Benjamin, Ernst Bloch, Bertold Brecht, and Georg Lukás, 16–27. London: Verso, 2010.

———. "Summary Transition: Non-contemporaneity and Obligation to Its Dialectic." In *Heritage of Our Times*, translated by Neville and Stephen Plaice, 97–148. Berkeley: University of California Press, 1991.

Brantlinger, Patrick. "Imperial Gothic: Atavism and the Occult in the British Adventure Novel, 1880–1914." In *Rule of Darkness: British Literature and Imperialism, 1830–1914*, 227–253. Ithaca, NY: Cornell University Press, 1988.

Breton, André. "Manifesto of Surrealism." In *Manifestoes of Surrealism*, translated by Richard Seaver and Helen R. Lane, 1–47. Ann Arbor: University of Michigan Press, 1972.

Burkus-Chasson, Anne. "'Clouds and Mists That Emanate and Sink Away': Shitao's *Waterfall on Mount Lu* and Practices of Observation in the Seventeenth Century." *Art History* 19, no. 2 (1996): 169–190.

Bush, Susan, and Hsio-yen Shih. *Early Chinese Texts on Painting*. Cambridge, MA: Harvard University Press, 1985.

Cai Yunsan. "Youxuan zhi zhifa yu jingyan" [Methods and experiences with bromoil]. *Liangyou huabao* 55 (1931): 31.

Campany, Robert Ford. *Strange Writing: Anomaly Accounts in Early Medieval China*. Albany: State University of New York Press, 1996.

Cao Yuanyu. "Dengguangzhi de yinxiang" [Imprinted images of lamplight paper]. In *Sheying shu* [The art of photography], 106–118. Shanghai: Shangwu yinshuguan, 1930.

Cendrars, Blaise. *The Prose of the Trans-Siberian and of Little Jeanne of France*, trans. Ron Padgett. In *Poems for the Millennium: The University of California Book of Modern and Postmodern Poetry, Volume One: From Fin-de-Siècle to Negritude*, edited by Jerome Rothenberg and Pierre Joris, 162–171. Berkeley: University of California Press, 1995.

Chen Chuanlin. "Zhaopian de jiegou" [Photographic structure]. In *Zhongguo jindai sheying yishu meixue wenxuan* [Anthology of modern Chinese texts on photographic art and aesthetics], edited by Long Xizu, 470–473. Tianjin: Renmin meishu chubanshe, 1986.

Chen Yuyue. "Abaolinaier" [Apollinaire]. *Xiandai* 1, no. 1 (1932): 19.

———. "Bayer Hefoerdi" [Pierre Reverdy]. *Xiandai* 1, no. 2 (1932): 269.

Cheng Jihua, Li Shaobai, and Xing Zuwen. *Zhongguo dianying fazhan shi* [History of the development of Chinese cinema]. 2 vols. Beijing: Zhongguo dianying chubanshe, 1980.

Chow, Rey. *Woman and Chinese Modernity: The Politics of Reading between East and West*. Minneapolis: University of Minnesota Press, 1991.

Clark, T. J. *Farewell to an Idea: Episodes from a History of Modernism*. New Haven, CT: Yale University Press, 1999.

Croizier, Ralph. "Post-impressionists in Pre-war Shanghai: The Juelanshe (Storm Society) and the Fate of Modernism in Republican China." In *Modernity in Asian Art*, edited by John Clark, 135–154. Broadway, New South Wales, Australia: Wild Peony, 1993.

Daly, Nicholas. "That Obscure Object of Desire: Victorian Commodity Culture and Fictions of the Mummy." *Novel* 28, no. 1 (1994): 36.

de Certeau, Michel. *The Writing of History*. Translated by Tom Conley. New York: Columbia University Press, 1988.

Delaunay, Robert. "On the Construction of Reality in Pure Painting." In *Art in Theory: 1900–1990*, edited by Charles Harrison and Paul Wood, 152–154. Oxford: Blackwell, 1992.

"Dian shi cheng jin" [Touch stone and transform it into gold]. *Liangyou huabao* 105 (1935): 26.

Dikötter, Frank. *The Discourse of Race in Modern China*. Stanford, CA: Stanford University Press, 1992.

Doherty, Brigid. "'*See: We Are All Neurasthenics!*' or, The Trauma of Dada Montage." *Critical Inquiry* 24 (Autumn 1997): 82–132.

Dow, Arthur Wesley. *Composition*. 1899. Reprint, Berkeley: University of California Press, 1977.

Du Heng. "Pasuosi de sixiang yu zuofeng" [Dos Passos's thought and style]. *Xiandai* 5, no. 6 (1934): 993–1001.

Duara, Prasenjit. "The Regime of Authenticity: Timelessness, Gender and National History in Modern China." *History and Theory* 37, no. 3 (1998): 287–308.

———. *Rescuing History from the Nation: Questioning Narratives of Modern China*. Chicago: University of Chicago Press, 1995.

Duffy, Enda. *The Subaltern Ulysses*. Minneapolis: University of Minnesota Press, 1994.

Elkins, James. *The Domain of Images*. Ithaca, NY: Cornell University Press, 1999.

———. "Marks, Traces, 'Traits,' Contours, 'Orli,' and 'Splendores': Nonsemiotic Elements in Pictures." *Critical Inquiry* 21, no. 4 (1995): 822–860.

Ernst, Max. *Une semaine de bonté*. 1934. Reprint, New York: Dover, 1976.

Evans, David. *John Heartfield, AIZ/VI, 1930–1938*. New York: Kent Fine Art, 1991.

Fabian, Johannes. *Time and the Other: How Anthropology Makes Its Object*. New York: Columbia University Press, 1983.

"Fanfu er hexie de tu'anhua sheying" [Complex yet harmonious design photographs]. *Liangyou huabao* 47 (1930): 20–21.

Fanon, Frantz. *Black Skin, White Masks*. Translated by Charles Lam Markmann. New York: Grove, 1967.

Faure, Bernard. *Chan Insights and Oversights: An Epistemological Critique of the Chan Tradition*. Princeton, NJ: Princeton University Press, 1993.

Fay, Bernard [Beerna Fayi]. "Shijie dazhan hou de Faguo wenxue" [French litera-

ture after the World War]. Translated by Dai Wangshu. *Xiandai* 1, no. 4 (1932): 488–494.

Feng Zikai. *Feng Zikai wenji* [Collected works of Feng Zikai], 7 vols., edited by Feng Chenbao. Hangzhou: Zhejiang wenyi chubanshe, 1990.

———. "Ganqing baofa de yishu—weilaipai yu chouxiangpai" [Emotionally explosive art—futurism and abstraction]. In *Xiyang huapai ershi jiang* [Twenty lectures on schools of Western art]. Shanghai: Kaiming shudian, 1930; rpt. in *Feng Zikai wenji* [Collected works of Feng Zikai], edited by Feng Chenbao, vol. 1, 439–449. Hangzhou: Zhejiang wenyi chubanshe, 1996.

———. "Meishu de zhaoxiang" [Artistic photography]. In *Feng Zikai wenji* [Collected works of Feng Zikai], edited by Feng Chenbao, vol. 1, 63–74. Hangzhou: Zhejiang wenyi chubanshe, 1996.

———. "Shangye yishu" [Commercial art]. In *Yishu conghua* [Collected talks on art], 20–42. Shanghai: Liangyou gongsi, 1935.

———. "Xing ti geming yishu—litipai" [Formally and structurally revolutionary art—cubism]. In *Xiyang huapai ershi jiang* [Twenty lectures on schools of Western art]. Shanghai: Kaiming shudian, 1930; rpt. in *Feng Zikai wenji* [Collected works of Feng Zikai], edited by Feng Chenbao, vol. 1, 428–438. Hangzhou: Zhejiang wenyi chubanshe, 1996.

———. "Zhongguo hua de tese: Hua zhong you shi" [The distinguishing quality of Chinese painting: In paintings there are poems]. *Dongfang zazhi* 24, no. 11 (1927): 41–50.

——— [Ying Xing, pseud.]. "Zhongguo meishu zai xiandai yishu shang de shengli" [The triumph of Chinese fine art over modern art]. *Dongfang zazhi* 27, no. 1 (1930): 1–18.

Fenollosa, Ernest. *The Chinese Written Character as a Medium for Poetry*. Edited by Ezra Pound. San Francisco: City Lights Books, 1991.

Fischer, Hartwig, and Sean Rainbird. *Kandinsky: The Path to Abstraction*. London: Tate Publishing, 2006.

Foster, Hal. *Compulsive Beauty*. Cambridge, MA: MIT Press, 1993.

Freedberg, David. *The Power of Images: Studies in the History and Theory of Response*. Chicago: University of Chicago Press, 1989.

Freud, Sigmund. *The Interpretation of Dreams*. Translated by James Strachey. Harmondsworth: Penguin, 1992.

———. "The 'Uncanny.'" In *Art and Literature*, edited by Albert Dickson, 335–376. Harmondsworth: Penguin, 1990.

Fry, Roger. *Cézanne: A Study of His Development*. New York: Macmillan, 1927.

Fu Lei. "Wenxue duiyu waijie xianshi di zhuiqiu—shang: Xinqi ciji yu wailai qing-
diao" [Literature's pursuit of the external world's reality—part one: Novel stimu-
lations and the exotic]. *Yishu* 1 (1934): 1–8.

———. "Wenxue duiyu waijie xianshi di zhuiqiu—xia: Huangdan guaiyi de secai"
[Literature's pursuit of the external world's reality—part two: Colors of the fan-
tastic]. *Yishu* 2 (1934): 1–6.

———. "Xunqin de meng" [Xunqin's dream]. *Yishu xunkan* 1, no. 3 (1932): 12–13.

Fukuoka, Maki. *The Premise of Fidelity: Science, Visuality, and Representing the Real in
Nineteenth-Century Japan.* Stanford, CA: Stanford University Press, 2012.

———. "Toward a Synthesized History of Photography: A Conceptual Genealogy
of Shashin." In "Photography's Places," edited by William Schaefer, special issue,
Positions: East Asia Cultures Critique 18, no. 3 (2010): 571–597.

Gasquet, Joachim. *Cézanne*, new edition. Paris: Les Éditions Bernheim-Jeune, 1926.

———. *Joachim Gasquet's Cézanne: A Memoir with Conversations.* Translated by
Christopher Pemberton. London: Thames and Hudson, 1991.

Gauguin, Paul. *Noa Noa: The Tahitian Journal.* Translated by O. F. Theis. New York:
Dover, 1985.

Gautier, Théophile. *The Romance of a Mummy.* Vol. 5 of *The Works of Théophile Gau-
tier.* Translated by F. C. de Sumichrast. New York: George D. Sproul, 1901.

Gide, André. *The Counterfeiters.* Translated by Dorothy Bussy. New York: Vintage,
1973.

Gordon, Jan. *Modern French Painters.* London: The Bodley Head, 1923.

Goriely, Benjamin [Gaolieli]. "Yesaining yu Eguo yixiang shi pai" [Essinin and the
Russian Imagist School]. Translated by Dai Wangshu. *Xiandai* 5, no. 3 (1934):
411–421.

Greenberg, Clement. "Post Painterly Abstraction." In *Collected Essays and Criticism*,
vol. 4, edited by John O'Brien, 192–197. Chicago: University of Chicago Press,
1993.

"Gudai de Dongfang wenming/xiandai de Xifang wenming" [Ancient Eastern civili-
zation/modern Western civilization]. *Liangyou huabao* 46 (1930): 22–23.

Gumbrecht, Hans Ulrich. *In 1926: Living at the Edge of Time.* Cambridge, MA: Har-
vard University Press, 1997.

Guo Renyuan. "Biantai de xingwei" [Abnormal behavior]. *Dongfang zazhi* 24, no.
23 (1927): 65–74.

Hansen, Miriam. "The Mass Production of the Senses: Classical Cinema as Vernacu-
lar Modernism." *Modernism/Modernity* 6, no. 2 (1999): 59–77.

Harrison, Charles. "The Effects of Landscape." In *Landscape and Power*, edited by W. J. T. Mitchell, 203–240. Chicago: University of Chicago Press, 1997.

Harrison, Thomas. *1910: The Emancipation of Dissonance*. Berkeley: University of California Press, 1996.

Hay, Jonathan. *Shitao: Painting and Modernity in Early Qing China*. Cambridge: Cambridge University Press, 2001.

"Heiying xizuo" [Shadow studies]. *Shanghai manhua* 110 (1930): 6.

"Huahua shijie" [The world of flowers]. *Liangyou huabao* 69 (1932): 22.

Huang Jiezhi, "Tu'an sheying tan" [Discussion of design photography]. *Changhong* 10 (1935): 3.

Huang Tianpeng. "Wushi nian lai huabao zhi bianqian" [The transformation of illustrated magazines over the past fifty years]. *Liangyou huabao* 49 (1930): 36–37.

Huang Zhenxia. "Aiji meiren" [An Egyptian beauty]. *Liangyou huabao* 28 (1928): 35.

Hung, William, comp. *A Concordance to the Poems of Tu Fu*. Cambridge, MA: Harvard–Yenching Institute, 1966.

———. *Tu Fu: China's Greatest Poet*. New York: Russell and Russell, 1953.

Huyssen, Andreas. *After the Great Divide: Modernism, Mass Culture, Postmodernism*. Bloomington: Indiana University Press, 1986.

I Ching, or Book of Changes. Rendered into English from Richard Wilhelm's translation by Cary F. Baynes. Princeton, NJ: Princeton University Press, 1969.

Jiang Qisheng, Shu Zongqiao, Gu Di, Hu Zhichuan, Ma Yunzeng. *Zhongguo sheying shi, 1840–1937* [A history of Chinese photography, 1840–1937]. Beijing: Zhongguo sheying chubanshe, 1987.

"Jihe" [Geometry; English title, "The geometry of modern traffic"]. *Liangyou huabao* 64 (1931): 19.

"Jin zai buyan zhong" [In wordlessness]. *Liangyou huabao* 81 (1933): 24.

Jolas, Eugene. *Man from Babel*. Edited by Andreas Kramer and Rainer Rumold. New Haven, CT: Yale University Press, 1998.

Jones, Andrew F. "Portable Monuments: Architectural Photography and the 'Forms' of Empire in Modern China." In "Photography's Places," edited by William Schaefer, special issue, *Positions: East Asia Cultures Critique* 18, no. 3 (2010): 599–531.

Jones, Andrew F., and Nikhil Pal Singh. Guest Editors' Introduction. In "The Afro-Asian Century," edited by Andrew F. Jones and Nikhil Pal Singh, special issue, *Positions: East Asia Cultures Critique* 11, no. 1 (2003): 1–9.

Juarroz, Roberto. *Poesía Vertical*. Edited by Diego Sánchez Aguilar. Madrid: Cátedra, 2012.

Kandinsky, Wassily. *Concerning the Spiritual in Art*. Translated by M. T. H. Sadler. New York: Dover, 1977.

———. "On the Question of Form." In *The Blaue Reiter Almanac*, edited by Wassily Kandinsky and Franz Marc, 147–187. New York: Viking Penguin, 1974.

———. *Point and Line to Plane*. Translated by Howard Dearstyne and Hilla Rebay. New York: Dover, 1979.

King, Anthony D. *Urbanism, Colonialism, and the World-Economy: Cultural and Spatial Foundations of the World Urban System*. New York: Routledge, 1991.

Koerner, Joseph Leo. *The Reformation of the Image*. London: Reaktion Books, 2004.

Krauss, Rosalind. "Tracing Nadar." *October* 5 (1978): 29–47.

Kriebel, Sabine. "Manufacturing Discontent: John Heartfield's Mass Medium." *New German Critique* 107 (2009): 53–88.

Kurahara Korehito. "Xin yishu xingshi de tanqiu" [New art's explorations of form]. Translated by Ge Momei. *Xin wenyi* 1, no. 4 (1929): 607–632.

Lai, Edwin Kin-keung. "The Life and Art Photography of Lang Jingshan (1892–1995)." PhD diss., University of Hong Kong, 2000.

Lang Jingshan [Chin-San Long]. "Composite Pictures and Chinese Art." *Photographic Journal* 82 (February 1942): 30–32.

———. *Jingshan jijin zuofa* [(Lang) Jingshan's techniques in composite picture-making]. Rev. ed. Taipei: China Series Publishing Committee, 1958.

"Lang Jingshan meishu sheying zuopin" [Lang Jingshan's fine art photographic works]. *Liangyou huabao* 63 (1931): 18–19.

Lant, Antonia. "The Curse of the Pharaoh, or How Cinema Contracted Egyptomania." *October* 59 (1992): 86–112.

Lastra, James. "From the Captured Moment to the Cinematic Image: A Transformation in the Pictorial Order." In *The Image in Dispute: Art and Cinema in the Age of Photography*, edited by Dudley Andrews, 263–291. Austin: University of Texas Press, 1997.

Lee, Leo Ou-fan. *Shanghai Modern: The Flowering of a New Urban Culture in China, 1930–1945*. Cambridge, MA: Harvard University Press, 1999.

——— [Li Oufan], ed. *Xin ganjue pai xiaoshuo xuan* [Anthology of new perceptionist fiction]. Taipei: Yunchen wenhua, 1988.

Lefebvre, Henri. *The Production of Space*. Translated by Donald Nicholson-Smith. Oxford: Blackwell, 1991.

Leighten, Patricia. *Re-ordering the Universe: Picasso and Anarchism, 1897–1914*. Princeton, NJ: Princeton University Press, 1989.

Li Hongliang. "Tan ying" [On photography]. *Yifeng* 9, no. 1 (1935): 28–29.

Li Zhongsheng. "Ershi shiji huihua de chufadian" [Assumptions of twentieth-century painting]. *Meishu zazhi* 3 (1934): 69–70.

Liang Fu. "Yuzhongbutong de Sulian dianying yishu" [Extraordinary Soviet cinematic art]. *Dongfang zazhi* 27, no. 18 (1930): 97–99.

Liang Xihong. "Chouxiang xingti de lilun" [Theory of abstract forms]. *Yifeng* 3, no. 8 (1935): 60–66.

Lin Yunde. "Zhuangshi tu'an yu tuhua de qubie" [The differences between ornamental designs and pictures]. *Yifeng* 2, no. 11 (1934): 29–30.

Ling Changyan. "Fuerkena: Yige xin zuofeng de changshizhe" [Faulkner: An experimentalist of new styles]. *Xiandai* 5, no. 6 (1934): 1002–1009.

Liu, Lydia H. *Translingual Practice: Literature, National Culture, and Translated Modernity—China, 1900–1937*. Stanford, CA: Stanford University Press, 1995.

Liu Haisu. "Shitao de yishu jiqi yishu lun" [Shitao's art and his discourse on art]. *Hua xue yuekan* [Studies in painting monthly] 1, no. 1 (September 1932): 12–15.

———. "Shitao yu houqiyinxiangpai" [Shitao and postimpressionism]. *Guohua* [Chinese painting] 10 (1936): 6–12.

Liu Tsung-yuan [Liu Zongyuan]. "Eight Pieces from Yung Prefecture." In *Inscribed Landscapes: Travel Writing from Imperial China*, translated and edited by Richard E. Strassberg, 141–147. Berkeley: University of California Press, 1994.

Liu Xu, ed. *Jiu Tang shu* [Old history of the Tang]. Beijing: Zhonghua shuju, 1975.

Lloyd, David. "Adulteration and the Nation." In *Anomalous States: Irish Writing and the Post-colonial Moment*. Durham, NC: Duke University Press, 1993, 88–124.

Lou Shiyi. "Shi Zhecun de xin ganjuezhuyi: Dule 'Zai Bali Daxiyuan' yu 'Mo Dao' zhihou" [Shi Zhecun's new perceptionism: After reading "At the Paris Cinema" and "Demon's Way"]. In *Shi Zhecun*, edited by Ying Guojing, 305–307. Hong Kong: Sanlian shuju, 1988.

Lowell, Amy. *Men, Women and Ghosts*. New York: Macmillan, 1919.

Lu Xun. "Lun zhaoxiang zhi lei" [On photography and such]. In *Lu Xun quanji* [Complete works of Lu Xun], 1:181–190. Beijing: Renmin wenxue chubanshe, 1981.

———. "On Photography." In *Modern Chinese Literary Thought: Writings on Literature, 1893–1945*, edited by Kirk A. Denton, 196–203. Stanford, CA: Stanford University Press, 1996.

Mallgrave, Harry Francis, and Eleftherios Ikonomou, eds. and trans. *Empathy, Form, and Space: Problems in German Aesthetics, 1873–1893*. Santa Monica, CA: Getty Research Institute, 1994.

Maynard, Patrick. *The Engine of Visualization: Thinking through Photography*. Ithaca, NY: Cornell University Press, 1997.

Merleau-Ponty, Maurice. "Cézanne's Doubt." In *The Merleau-Ponty Reader*, edited by Ted Toadvine and Leonard Lawlor, 69–84. Evanston, IL: Northwestern University Press, 2007.

Minick, Scott, and Jiao Ping. *Chinese Graphic Design in the Twentieth Century*. London: Thames and Hudson, 1990.

Mitchell, W. J. T. *Iconology: Image, Text, Ideology*. Chicago: University of Chicago Press, 1986.

———. "Imperial Landscape." In *Landscape and Power*, edited by W. J. T. Mitchell, 5–34. Chicago: University of Chicago Press, 1997.

Moholy-Nagy, László. *Painting, Photography, Film*. Translated by Janet Seligman. Cambridge, MA: MIT Press, 1973.

Moretti, Franco. *Modern Epic: The World System from Goethe to García Márquez*. Translated by Quintin Hoare. New York: Verso, 1996.

Mu Shiying. "Five in a Nightclub." Translated by Randolph Trumbull. *Renditions* 37 (Spring 1992): 5–22.

———. "Yezonghui li de wuge ren" [Five in a nightclub]. *Xiandai* 2, no. 4 (1933): 567–584.

Ni Yide. "Litizhuyi" [Cubism]. In *Xiandai huihua gaiguan* [A survey of modern art], 66–85. Shanghai: Shangwu yinshuguan, 1934.

———. [Ni Te, pseud.] "Chaoxianshizhuyi de huihua" [Surrealist painting]. *Yishu* 1 (1934): 1–5.

———. [Ni Te, pseud.] "Litizhuyi ji qi zuojia" [Cubism and its artists]. *Yishu* 2 (1934): 1–7.

Nicholls, Peter. *Modernisms*. Berkeley: University of California Press, 1995.

North, Michael. "Modernism's African Mask: The Stein-Picasso Collaboration." In *The Dialect of Modernism: Race, Language and Twentieth-Century Literature*, 59–76. New York: Oxford University Press, 1994.

———. *Reading 1922: A Return to the Scene of the Modern*. Oxford: Oxford University Press, 1999.

Orvell, Miles. *The Real Thing: Imitation and Authenticity in American Culture, 1880–1940*. Chapel Hill: University of North Carolina Press, 1989.

Ozenfant, Amédée, and Charles Edouard Jeanneret [Le Corbusier]. *La peinture moderne*. Paris: Les Éditions G. Crès et cie, 1925.

Pamuk, Orhan. *My Name Is Red*. Translated by Erdag Goknar. New York: Vintage, 2002.

Pang Xunqin. "Xunqin suibi" [Xunqin's random jottings]. *Yishu xunkan* 1, no. 4 (1932): 10–11.

Pap, Jennifer. "The Cubist Image and the Image of Cubism." In *The Image in Dispute: Art and Cinema in the Age of Photography*, edited by Dudley Andrews, 155–180. Austin: University of Texas Press, 1997.

Paz, Octavio. *A Draft of Shadows*. Edited and translated by Eliot Weinberger. New York: New Directions, 1979.

Perloff, Marjorie. *The Futurist Moment: Avant-Garde, Avant Guerre, and the Language of Rupture*. Chicago: University of Chicago Press, 1986.

Pound, Ezra. *Gaudier-Brzeska: A Memoir*. New York: New Directions, 1970.

Pratt, Mary Louise. *Imperial Eyes: Travel Writing and Transculturation*. New York: Routledge, 1992.

Read, Herbert. "The Significance of Primitive Art." In *Art Now*, 45–48. New York: Harcourt, Brace, 1934.

"Renti xuehua tu'an" [Human snowflake designs]. *Liangyou huabao* 76 (1933): 26–27.

Reverdy, Pierre. "False Portal or Portrait." Translated by Patricia Terry. In *Selected Poems*, selected by Mary Ann Caws, 79. Winston-Salem, NC: Wake Forest University Press, 1991.

——— [Bayer Hefoerdi]. "Jiamen huo xiaoxiang" [Fausse porte ou portrait]. In "Hefoerdi shi chao" [A selection of Reverdy's poetry], translated by Chen Yuyue. *Xiandai* 1, no. 2 (1932): 270.

———. *Nord-Sud, Self-défence et autres écrits sur l'art et la poésie (1917–1926)*. Paris: Flammarion, 1975.

Riding, Laura, and Robert Graves. *A Survey of Modernist Poetry*. London: William Heinemann, 1927.

Roh, Franz. "Magic Realism: Post-expressionism." In *Magical Realism: Theory, History, Community*, edited by Lois Parkinson Zamora and Wendy B. Faris, 15–31. Durham, NC: Duke University Press, 1995.

Rothwell, Andrew. *Textual Spaces: The Poetry of Pierre Reverdy*. Amsterdam: Editions Rodopi, 1989.

Scott, Evelyn. *Precipitations*. New York: N. L. Brown, 1920.

Shao Xunmei. "Xiandai Meiguo shitan gaiguan" [An overview of modern American poetry circles]. *Xiandai* 5, no. 6 (1934): 874–890.

Shen, Kuiyi. "The Lure of the West: Modern Chinese Oil Painting." In Julia F. Andrews and Kuiyi Shen, *A Century in Crisis: Modernity and Tradition in the Art of Twentieth-Century China*, 172–180. New York: Abrams, 1998.

Shi Zhecun. "Chongyin quanfen *Xiandai* yinyan" [Preface to the reprint of the complete run of *Xiandai*]. Preface to *Xiandai*. Reprint, Shanghai: Shanghai shudian, 1984.

———. "Devil's Road." Translated by Paul White. In *One Rainy Evening*, 56–80. Beijing: Panda Books, 1994.

———. "Miluo de hua" [The paintings of Miró]. In *Shi Zhecun qishinian wenxuan* [A collection of Shi Zhecun from over seventy years], edited by Chen Zishan and Xu Ruqi, 334–337. Shanghai: Shanghai wenyi chubanshe, 1996.

———. "Mo Dao" [Demon's way]. In *Xin ganjue pai xiaoshuo xuan* [Anthology of new perceptionist fiction], edited by Leo Ou-fan Lee [Li Oufan], 87–106. Taipei: Yunchen wenhua, 1988.

———. Shi Zhecun to Dai Wangshu, n.d. In *Xiandai zuojia shujian*, edited by Kong Lingjing. Guangzhou: Huacheng chubanshe, 1982.

———. Shi Zhecun to Dai Wangshu, October 25, 1934. In *Xiandai zuojia shujian*, edited by Kong Lingjing. Guangzhou: Huacheng chubanshe, 1982.

———. "Shu Xiangguo si sheying hou" [Written on the back of a photograph of Xiangguo Temple]. In *Dengxia ji* [Beneath the lamp], 1–8. Beijing: Kaiming chubanshe, 1994.

———, trans. "Xiandai Meiguo shi chao" [A selection of modern American poetry]. *Xiandai* 5, no. 6 (1934): 1199–1213.

———. "Ying-Mei xiao shi chao" [A selection of Anglo-American short poems]. *Wenyi fengjing* 1, no. 1 (1934): 95–103.

Shih, Shu-mei. *The Lure of the Modern: Writing Modernism in Semicolonial China, 1917–1937*. Berkeley: University of California Press, 2001.

"Shijie renti zhi bijiao (22)" [A comparison of human bodies of the world (22)]. *Shanghai manhua* (March 1929): 3.

Silberman, Neil Asher. *Between Past and Present: Archaeology, Ideology, and Nationalism in the Modern Middle East*. New York: Henry Holt, 1989.

Smitten, Jeffrey R., and Ann Daghistany, eds. *Spatial Form in Narrative*. Ithaca, NY: Cornell University Press, 1981.

Snyder, Joel. "Inventing Photography: 1839–1879." In *On the Art of Fixing a Shadow: One Hundred and Fifty Years of Photography*, edited by Sarah Greenough, Joel Snyder, David Travis, and Colin Westerbeck, 3–38. Washington, DC: National Gallery of Art, 1989.

———. "Picturing Vision." In *The Language of Images*, edited by W. J. T. Mitchell, 219–246. Chicago: University of Chicago Press, 1980.

Snyder, Joel, and Neil Walsh Allen. "Photography, Vision, and Representation." *Critical Inquiry* 2 (1975): 143–169.

Spence, Jonathan D. *The Search for Modern China*. New York: Norton, 1990.

Stoichita, Victor I. *A Short History of the Shadow*. Translated by Anne-Maries Glasheen. London: Reaktion Books, 1997.

Strassberg, Richard. *Enlightening Remarks on Painting by Shih-t'ao*. Pasadena, CA: Pacific Asia Museum, 1989.

Sullivan, Michael. *The Meeting of Eastern and Western Art*. Berkeley: University of California Press, 1989.

Summers, David. *Real Spaces: World Art History and the Rise of Western Modernism*. London: Phaidon, 2003.

Talbot, William Henry Fox. "Some Account of the Art of Photogenic Drawing, or, The Process by Which Natural Objects May Be Made to Delineate Themselves without the Aid of the Artist's Pencil." In *Photography: Essays and Images: Illustrated Readings in the History of Photography*, edited by Beaumont Newhall, 23–31. New York: Museum of Modern Art, 1980.

Teng Gu. "Qiyun shengdong lue pan" [A brief critique of *qiyun shengdong*]. In *Teng Gu yishu wenji* [Teng Gu's Essays on Art], edited by Shen Ning. Shanghai: Shanghai renmin meishu chubanshe, 2003.

Van Vechten, Carl. Introduction to *Three Lives*, by Gertrude Stein. New York: Modern Library, 1933.

Vertov, Dziga. *Kino-Eye: The Writings of Dziga Vertov*. Edited by Annette Michelson and translated by Kevin O'Brien. Berkeley: University of California Press, 1984.

W Sheng [pseud.]. "Aiji fajue gumu ji" [Record of the excavation of an ancient tomb in Egypt]. *Dongfang zazhi* 20, no. 6 (1923): 57–62.

Waara, Carrie. "The Bare Truth: Nudes, Sex, and the Modernization Project in Shanghai Periodicals." In *Visual Culture in Shanghai, 1850s–1930s*, edited by Jason C. Kuo, 163–203. Washington, DC: New Academia Publishing, 2007.

Wang Jiezhi,. "Xiang yu buxiang" [Likeness and nonlikeness]. *Feiying* 9 (September 1936): 17.

Wang Laosheng. "Qujing shi sheying chenggong de guanjian" [Selecting the view is the key to successful photography]. In *Zhongguo jindai sheying yishu meixue wenxuan* [Anthology of modern Chinese texts on photographic art and aesthetics], edited by Long Xizu, 376–380. Tianjin: Renmin meishu chubanshe, 1986.

Webb, Virginia-Lee. "Manipulated Images: European Photographs of Pacific Peoples." In *Prehistories of the Future: The Primitivist Project and the Culture of Mod-

ernism, edited by Elazar Barkan and Ronald Bush, 175–201. Stanford, CA: Stanford University Press, 1995.

Wei Zhi. "Dong Fei turen de qisu" [Strange customs of East African natives]. *Dongfang zazhi* 26, no. 15 (1929): 87–90.

Wei Zhitang. "Guangxi Yaoshan youji" [A travel record of Yao Mountain, Guangxi]. Pts. 1–4. *Zhibian* 2, nos. 5–6 (1933): 11–12; 2, no. 7 (1934): 11; 2, no. 8 (1934): 15; 2, no. 9 (1934): 11.

Wilson, Edmund. "Gertrude Stein." In *Axel's Castle: A Study of the Imaginative Literature of 1870–1930*. New York: Scribner's, 1931.

Wölfflin, Heinrich. *Principles of Art History: The Problem of the Development of Style in Later Art*. Translated by M. D. Hottinger. Mineola, NY: Dover, 1950.

Wood, Christopher S. *The Vienna School Reader: Politics and Art Historical Method in the 1930s*. New York: Zone Books, 2003.

Wu Liande. "Wei Liangyou fayan" [Statement on *Liangyou huabao*]. *Liangyou huabao* 25 (1928): 7.

"Wushi nian lai huabao zhi qucai" [Progress made in the past fifty years by pictorial periodicals published in China]. *Dazhong* 14 (1934): 10.

"Xianweijing zhi xia tianran tu'an [Natural designs under the microscope] / Colour Photo-micrographs." *Liangyou huabao* 61 (1931): 23.

Xu Chi. "Yixiangpai de qige shiren" [Seven poets of the imagist school]. *Xiandai* 4, no. 6 (1934): 1013–1025.

Xu Dexian. "Sheying xin'an/Photographical paintings." *Liangyou huabao* 116 (1935): 38–39.

Xu Shushan. "Shanghai." *Wenyi chahua* 1, no. 3 (1932): 8.

Xu Weinan. "Taiwan shengfan de yishu wenhua" [The artistic culture of the Taiwanese barbarians]. *Yishu jie* 17 (1927): 1–3.

"Xuehua de yanjiu" [A study of snow crystals]. *Liangyou huabao* 64 (1931): 21.

Yang Chengzhi. "Minzu diaocha maoxian ji" [A record of the dangers of ethnic investigation]. *Liangyou huabao* 42 (1929), 10–11, 16, 24, 36.

Ying He. "Jiantao yinmu shang duiyu yuanshi shenghuo de simu" [Discussion of the yearning for primitive life on the silver screen]. *Xiandai dianying* 1, no. 3 (1933): 23.

Yu Li. "'Zhibian' bushi 'zhimin'" ["Developing the borders" is not "colonialism"]. *Zhibian yuekan* 2, nos. 3–4 (1933): 2–3.

Yu Zhi. "Aiji wang ling fajue xuji" [Continuation of a record of the excavation of the tomb of an Egyptian king]. *Dongfang zazhi* 22, no. 1 (1925): 129–135.

Zhang Dongsun. "Xin you gui lun yu xin wu gui lun" [New theories of the existence

of ghosts and new theories of the nonexistence of ghosts]. *Dongfang zazhi* 27, no. 5 (1930): 57–65.

Zhang Hui'an. "Xianhua yinying" [Idle talk on shadows]. In *Zhongguo jindai sheying yishu meixue wenxuan* [Anthology of modern Chinese texts on photographic art and aesthetics], edited by Long Xizu, 490–494. Tianjin: Tianjin renmin meishu chubanshe, 1986.

Zhao Jiabi. "Cong hengduan xiaoshuo tandao Dusi Pasuosi" [From the crosscut novel to Dos Passos]. *Zuojia* 2, no. 1 (1936): 179–192.

———. "Meiguo xiaoshuo zhi chengzhang" [The growth of American fiction]. *Xiandai* 5, no. 6 (1934): 839–859.

———. "Pasuosi" [Dos Passos]. *Xiandai* 4, no. 1 (1933): 220–229.

———. "Xieshizhuyizhe de Shitaiyin" [Gertrude Stein the realist]. *Wenyi fengjing* 1, no. 1 (1934): 82.

Zhe Sheng. "Wei liangxing douzheng de gongju de Feizhou heiren mimi shehui" [African blacks' secret societies as tools in the struggle of the sexes]. *Dongfang zazhi* 25, no. 3 (1928): 92–97.

"Zhiwu de yishu" [The art of plants]. *Liangyou huabao* 67 (1932): 22.

Zong Baihua. "Lun Zhong-Xi huafa de yuanyuan yu jichu" [On the sources and foundations of Chinese and Western modes of picturing]. *Wenyi congkan* 1, no. 2 (1934); rpt. in *Zong Baihua quanji* [Complete works of Zong Baihua], ed. Lin Tonghua, vol. 2, 98–112. Hefei: Anhui jiaoyu chubanshe, 1994.

Baudelaire, Charles, 57

Bazin, André, 242n37

Benjamin, Walter, 43, 117, 223n24

Bergson, Henri, 57–59, 155, 188, 232n97

Berlin: Symphony of a Great City (Ruttman), 152

Bernard, Émile, 55–57

Biaozhun Zhongguoren (A standard Chinese man), 177–78, PLATE 8

blackness. *See* racial otherness

Bloch, Ernst, 83, 159, 163, 220

Blossfeldt, Karl, 47

"Botanical Art" (Blossfeldt), 47–48

Brandt, Bill, 129

Brantlinger, Patrick, 243n45

Braque, Georges, 103, 158, 248n20

Brassaï, 128–29

Breton, André, 117–18, 237n62, 240n18

Broadway ("Ancient Eastern civilization/ modern Western civilization"), 82–87

bromoil processes, 34–35

Cahill, James, 230n79, 254n72

camera obscura, 58–59, 232n97

Campany, Robert, 259n49

cannibalism, 180, 182–83, 205, 211

Carter, Howard, 125–27, 243n42

Cendrars, Blaise, 249n24

Certeau, Michel de, 11, 17

Cézanne, Paul, 19, 30, 54–59; Gertrude Stein's writing and, 187, 189; on saturation by images, 56–57

Chan (Zen) Buddhism, 254n82

Changhong (Rainbow) magazine, 49–51

Chen Chuanlin, 16, 67–72

Chen Yuyue, 102, 105–9, 236n52, 237n62

Chinese painting, 8, 26, 34; enlivenment

and spirit resonance of, 12, 29–34, 37, 61, 254n72; Feng Zikai on, 53, 58, 60, 173, 229n72; landscapes in, 254n72; Lang Jingshan's composite pictures and, 170–76, PLATE 5; penetrating observation (*guancha*) of, 28–29; Xie He's Six Principles of, 54, 171–74, 254n72

The Chinese Written Character as a Medium for Poetry (Fenollosa), 135–37, 244n54

Chinese written characters, 135–37, 139, 244n54

cinematic montage, 151–54, 169, 176, 246n6

collage and montage aesthetics, 2, 9, 16–17, 21–22; comparative layouts and, 83–94, 95f; dematerialized and gendered objects in, 87–94, 95f; in design photography, 51, 87–91; in fiction, 21, 153, 157–70, 187–88, 213; in landscape photomontage, 145–79; reconceptualization of language and, 95–110, 236n51; simultaneism and, 249n24; in Soviet cinema, 151–54, 169, 175, 246n6; traditional Chinese aesthetics and, 170–76, 254n72, PLATE 5. *See also* juxtapositions of modernity and the past

comparative layouts, 78–94, 95f. *See also* collage and montage aesthetics

"A Comparison of Civilized and Savage Races with Regard to Their Most Fashionable Facial and Neck Ornaments," 199–201, 203, 259n45

"Complex Yet Harmonious Design Photographs," 87–91

Concerning the Spiritual in Art (Kandinsky), 30
copperplate printing, 40–41
Courbet, Gustave, 32
Creative Evolution (Bergson), 58–59
critical discourses on photography, 25–
 60; binary global cultural geography
 in, 26–27, 38; on Chinese abstraction
 versus Western mimesis, 25–34, 38,
 45, 59, 141, 225n32, 230n79; on en-
 livenment and spirit resonance, 12,
 26, 29–34, 41, 59, 61, 224n1, 226n23,
 254n72; in illustrated magazines, 38–
 51, 228n56; on layout of images, 42;
 on modes of abstraction, 26, 28–34;
 on nonrepresentation and postimpres-
 sionism, 51–60, 229n65, 230n80; on
 photographical paintings versus sharp
 images, 34–42, 62, 226n34, 227n47;
 on pursuit of photographic art, 42–51,
 228n56
crosscutting, 240n18
cubism, 68, 102–9, 152–58, 248n20,
 249n24
Cultural Revolution, 248n16
"Curious Photography," 90–94

Dai Wangshu, 5, 236n51
Daly, Nicholas, 243n44
Dazhong (The cosmopolitan), 3–4, 40–41,
 96–97, 98f
Delaunay, Robert, 249n24
Della pittura (On painting) (Alberti), 29
"Demon's Way" (Shi Zhecun), 21; black-
 ness and hauntings in, 183–85, 191,
 219–20; Egyptomania and, 18, 129;
 haunted shadows of, 126, 132, 140–45,

246n72; mutation and displacement
 in, 114–18
density and thinness (*nongdan*), 29, 34,
 227n35
design photography, 47–51, 87–91,
 228n56
"Designs" (Scott), 136
Des Imagistes (Pound), 139
Dianshi zhai huabao (Touchstone Studio
 pictorial), 17, 39–40
"Discussion of Design Photography"
 (Huang Jiezhi), 49–51
Doherty, Brigid, 147, 178
Dongfang zazhi, 116, 122–23, 128, 194–
 201, 216
"Dong Fei turen de qisu" (Strange cus-
 toms of East African natives) (Wei
 Zhi), 195–97
Dos Passos, John, 21, 102, 153, 161–63,
 168–69, 187, 251n47
Dr. Pascal (Zola), 56
Duara, Prasenjit, 114
Du Fu, 214–15
Du Heng, 102, 161, 251n47
duotone printing, 41
Dürer, Albrecht, 63

Egyptomania, 17–18, 125–26, 242n34.
 See also Tutankhamen's tomb
Einstein, Albert, 188
Eisenstein, Sergei, 102, 151–54
Eliot, T. S., 160–61
Elkins, James, 15, 38, 227n41
End of St. Petersburg (Pudovkin), 152
enlivenment (*shengdong*): critical dis-
 courses on, 26, 29–34, 41, 59, 224n1,
 226n23, 254n72; gendering of, 91–94;

Jihe/The Geometry of Modern Traffic, 65, 69–73

"Jin zai buyan zhong" (In wordlessness), 97–99

Jiu Tang shu (Old history of the Tang), 214–15

Jolas, Eugene, 238n6

Jones, Andrew, 86, 241n31

Joyce, James, 160, 251n47

Juarroz, Roberto, 220

"Juemiao xingrongci tujie" (Pictorial interpretations of ingenious turns of phrase), 95–97

juxtapositions of modernity and the past, 1–5, 10–18, 20–22; artifacts and modern commodities in, 129–31; collage and montage aesthetics in, 2, 9, 16–17, 21–22, 154–57; in comparative layouts, 82–87; contextualist approach to, 14–18; geographic and cultural dislocation in, 1–5, 8, 10–12; in illustrated magazines and journals, 17–18, 129–31; novel stimulations and disjunctions of, 82–87; in photographic encounters with shadow relics, 119–34, 241n22; in Shi Zhecun's surrealist fiction, 114–19; simultaneism of, 157–60, 249n24, 251–52nn45–47. *See also* presence of the past

Kandinsky, Wassily, 8, 12, 64, 230n79; discourse on painting of, 30; on the elements of abstraction, 30–32, 74–77, 87, 234n25; Feng's discussion of, 8, 30–32, 74, 254n72

kino-eye, 153–54, 169, 175

Krauss, Rosalind, 242n37

Kriebel, Sabine, 147, 177

Kurahara Korehito, 102, 152–53, 247nn9–10

landscape photomontage, 145–79; fetishized body parts in, 145–47; Fu Lei on disjunctive images in, 148–55; idea of place in, 148; of Lang Jingshan, 6, 8, 21–22, 170–76, 179, 254n68, 254n72, 255n82, PLATE 5; in literary simultaneism, 157–70, 249n24, 251–52nn45–47; of Pang Xunqin, 4, 6, 154–57, 165, 170, 247–48nn15–16, PLATES 3, 4; of Shanghai, 145–48, 154–57, 170, 176–79, PLATES 4, 6, 7; *Shidai manhua*'s experiments in, 2, 9, 21–22, 145–48, 176–79, PLATES 6–8; violent representational practices in, 147–48. *See also* collage and montage aesthetics

Lang Jingshan, 4, 15, 254n72; *Banqiao huaben/Bamboo Leaves* of, 35–38; composite pictures of, 6, 8, 21–22, 171–76; on ideal landscapes, 175–76, 255n82; juxtaposed photos (*Noise* and *Tranquility*) of, 79–82; *Qian jiang xiao ji/Riverside Spring* of, 170–76, 179, 215–16, 219, 254n68, 254n72, PLATE 5

language. *See* literary modernism

Lastra, James, 153

Lee, Leo Ou-fan, 5, 14–15

Lefebvre, Henri, 65, 78

"Left Unspoken" (In wordlessness), 97–99

Léger, Fernand, 248n20

Leng Can, 65–68

"Letters under the X-ray," 96–97, 98*f*

Lhote, André, 248n20

Liang Fu, 246n6

Liang Huang, 72–74

Liang Xihong, 232n4

Liangyou huabao (The young companion), 3–4, 17, 34, 126; comparative layouts in, 78–94, 95*f*; critical discourse on photography in, 38–49; design photography in, 42–51, 87–91, 228n56; explorations of visuality and picturing in, 64–101; investigations of China's frontier minorities in, 209–11; landscape photomontage in, 145–48, 154–57, 165, PLATE 4; literary experimentation in, 95–110; photomicrography in, 45–49, PLATES 1, 2; presentation of racial otherness in, 185, 194, 199–205, 216, 259n45, 259n49, 260nn62–63; printing technologies used by, 40–42, 227n42; representations of urban spaces in, 65–78; shadow projections in, 132–34, 135*f*. *See also* illustrated magazines and journals

Li Hongliang, 138

linear style, 62–64

Lin Fengmian, 238n6

Ling Changyan, 180–82

Linquan gaozhi (The lofty message of forests and springs) (Guo Xi), 37

Lin Yunde, 226n32

Lipp, Theodor, 12, 226n23

literary modernism: contexts of, 8, 14–18; female gendering in, 91–94; Fu Lei's essay on, 82–87, 100–102, 140, 148–54; of imagist poetry, 134–40, 244n53; and Japanese haiku, 135–36; language of modern visual culture in, 20, 64–65, 77–78, 95–110, 187–88, 236n51; pairing of words with photos in, 95–99; representation of racial

otherness in, 22, 180–220; Shi Zhecun's surrealist disjunction of modernity and the past in, 113–19, 139–44, 238n6; simultaneism and montage aesthetics in, 21, 101–2, 153, 157–70, 187–88, 249n24, 251–52nn45–47; surrealist disjunction of modernity and the past in, 2, 5–6, 11, 18, 20–21; Western influences on, 77–78, 101–10, 134–37, 236n51, 244n53; world texts and cosmopolitanism in, 158–61, 252n47

"Literature's Pursuit of External Realities" (Fu Lei), 1–3, 82–87, 100–101, 140, 148–55, 189–94. *See also* Fu Lei

"Litipai ji litipai yihou gezhong zhuguan hui biaoxianfa biyu tu" (A Comparative Table of Methods of Expression in Cubist and Postcubist Subjective Painting), 103

Liu, Lydia H., 222n11

Liufa (Six Principles of Chinese painting), 54, 171–74, 254n72

Liu Haisu, 19, 51–60, 155, 229n65; on Cézanne and postimpressionist painting techniques, 52–60, 230n80; on nonrepresentation and expression, 51–53

Liu Na'ou, 5, 101–2, 209

Liu Zongyuan, 254n82

Li Zhongsheng, 19, 61–64, 77–78, 232n1, 233n10

Lou Shiyi, 2, 13, 115–16, 238n6

Lowell, Amy, 77, 102, 134, 136, 244–45nn53–54

Ludham, B., 134*f*

Luoluo nüren (Luoluo women), 209, 210*f*, 215, 260nn62–63

Punkt und Linie zu Fläche (Point and line to plane) (Kandinsky), 74–77, 234n25
pure visuality. *See* visuality

Qian jiang xiao ji/*Riverside Spring* (Lang Jingshan), 170–76, 179, 215–16, 219, 254n68, 254n72, PLATE 5
Qian Xingcun, 247n10
qiyun shengdong. See spirit resonance
Quruixi, 67, 68*f*, 233n12
"Quweide sheying" (Curious photography), 90–94

racial otherness discourses, 22, 180–220; aesthetics of fragmentation in, 180, 185–86, 194–206, 217–20, 259n49; on China's frontier minorities, 206–12, 260nn62–63, 260n66; contrast with Han Chinese in, 199, 203–4, 211–20; exoticism in, 188–94; Fanon's critique of, 184–85, 204–5, 208; focus on primitivism in, 180–81, 186–88, 194, 196–98, 204–12, 216–17, 258n35, 259n41; global circulation of, 181; in Shanghai's self-representation, 181–87, 193–94, 206; Shi Zhecun's explorations of, 22, 183–85, 191, 193, 212–20
Recorded Remarks on Painting (Shitao), 54–56
"Red Slippers" (Lowell), 77–78
Rembrandt, 63
Rensheng zhi yami (The riddle of life) (Pang Xunqin), 154–57, 165, PLATE 4
"Renti xuehua tu'an" (Human bodies forming snowflake designs), 95*f*
Reverdy, Pierre, 20, 102–10, 118; "Fausse porte ou portrait" of, 105–9, 151, 154,

164, 236n56; on fragmentation of images, 149–51, 154, 158, 163
Ricci, Matteo, 58
The Riddle of Life (Pang Xunqin), 154–57, 165, PLATE 4
Riegl, Alois, 27
Riichi, Yokomitsu, 247n9
Riverside Spring (Lang Jingshan), 170–76, 179, 215–16, 219, 254n68, 254n72, PLATE 5
Rodchenko, Alexander, 152
Roh, Franz, 240n18
Le roman de la momie (The romance of the mummy) (Gautier), 126–27, 243n43
Rothwell, Andrew, 107
Ruci Bali (Such is Paris) (Pang Xunqin), 154–57, PLATE 3
Ruci Shanghai (Such is Shanghai) (Pang Xunqin), 154–57, 165, PLATE 4
"Ruci Shanghai" (Such is Shanghai), 145–46
Ruttman, Walter, 152

Schiff, Richard, 104–5
Scott, Evelyn, 102, 136, 244n53
Sedlmayr, Hans, 27
"La serviette des poètes" (Shiren de shijin) (Apollinaire), 103–5, 236n52
"Seven Poets of the Imagist School" (Xu Chi), 136–40
Shanghai: colonial occupation of, 3, 113, 177, 206, 238n1; contexts of modernist art and literature in, 8, 14–18; Egyptomania in, 125–26; Japanese bombing of, 16–17, 164, 177–79, 206, 248n16, 253n55; landscape photomontage of, 145–48, 154–57, 170, 176–79, PLATES 4, 6, 7; racialized self-representation

of, 180–87, 193–94, 206; redevelopment projects in, 113. *See also* illustrated magazines and journals; modernist aesthetics in Shanghai

"Shanghai" (Xu Shushan), 121–24

Shanghai fengjing (Shanghai landscape), 145–48

Shanghai manhua (Shanghai sketch), 129, 131–32, 185–86, 194, 199–206

The Shanghai Racetrack of the Future: High Buildings and Huts Seen as Equals, 176–79, PLATE 7

Shao Xunmei, 136, 160–61, 170, 244–45nn53–54

Shen, Kuiyi, 12, 14, 15

shengdong. See enlivenment

sheying (photography), 9–10, 129, 223n14

"Sheying xin'an/Photographical Paintings" (Xu Dexian), 35f

Shidai manhua (Modern sketch), 2; anonymous photomontage artists of, 4; radical photomontage of, 2, 9, 21–22, 145–48, 176–79, PLATES 6–8

Shih, Shu-mei, 5, 13–15, 223n24, 249n24

"Shijie renti zhi bijiao" (A comparison of human bodies of the world), 201–3

Shitao, 19, 51–60, 155, 230n79, 232n97

"Shitao de hishu jiqi ishu lun" (Shitao's art and his discourse on art) (Liu Haisu), 52–53

"Shitao yu houqiyinxiangpai" (Shitao and Postimpressionism) (Liu Haisu), 19, 52–60

Shi Zhecun, 4–6, 20, 113–44; critical response to, 13–15, 115–16, 223n24, 238n6; on inseparability of writing and photography, 140–44; literary experimentation of, 101–2, 109, 237n62; on

photographic encounters with shadow relics, 119–34, 139–40; psychoanalytic tales of, 118; publishing activities of, 102, 236n50, 238n6, 247n15; on racial otherness, 22, 183–85, 191, 193, 212–20; surrealist fiction of, 2, 5–6, 11, 18, 20–21, 114–19, 140–44, 238n6, 239nn9–10; terms for photography used by, 10; translation of Western poets by, 77–78, 135–36, 244n53. *See also* "Demon's Way"

Shizi jietou (At the crossroad) (Liang Huang), 72–74

"Shuiniu Yuehan hu gui le" (John Bull has encountered ghosts), 128–29

"Shu Xiangguo si sheying hou" (Written on the back of a photograph of Xiangguo Temple) (Shi Zhecun), 119–34, 139–40

simultaneism, 157–60, 249n24, 251–52nn45–47

Situ Guang, 130–31

Six Principles of Chinese painting (*Liufa*), 54, 171–74, 254n72

Snyder, Joel, 45, 223n15, 229n58

Soviet cinematic techniques, 151–52, 175, 246n6

spatial simultaneity, 158

spirit resonance (*qiyun shengdong*), 12, 30–32, 37, 226n23, 254n72. *See also* enlivenment

A Standard Chinese Man, 177–78, PLATE 8

Stein, Gertrude, 102, 187–89, 205, 257n10

Stoichita, Victor I., 132

Storm Society (*Juelan she*), 232n1

"Strange Customs of East African Natives" (Wei Zhi), 195–97

A Study in Lines and Corners (Quruixi), 67–69, 71

"A Study of Designs by Photographs" (Zhang Jinwen), 48–49

Such Is Paris (Pang Xunqin), 154–57, PLATE 3

Such Is Shanghai (Pang Xunqin), 154–57, 165, PLATE 4

Su Dongpo, 54

Sullivan, Michael, 12

surrealism: Breton's manifesto on, 117, 237n62, 240n18; definitions of, 118; disjunction of modernity and the past in, 113–19, 139–44, 239n9; imagist poetry and, 134–40; in photography, 118–34, 240n18; tombs, archeology, and mummies in, 17–18, 124–29, 140–44, 241n32, 242n37, 243nn42–45. *See also* Shi Zhecun

Su Shi, 222n10

Su Xiaoxiao's tomb, 119–20

synthetic cubism, 155–58, 248n20

"Taiwan shengfan de hishu wenhua" (The artistic culture of the Taiwanese barbarians) (Xu Weinan), 180–81, 194–95, 206–8

Talbot, William Henry Fox, 9, 223n14

tattoos and facial marking, 180, 192, 197–201, 204–7

technologies of image-making, 4–5, 34–42; bromoil and screening, 34–35; copperplate printing, 40–41; duotone printing, 41; lithography, 39–41; mass reproduction, 17; photogravure printing, 41; photomicrography, 45–51; sharpness and clarity in, 34, 41–42,

226n34, 227n47; soft-focusing lenses and filters, 35–37

temporal simultaneity, 158

Terry, Patricia, 106

texts. *See* literary modernism

"Theory of Abstract Forms" (Liang Xihong), 232n4

traditional Chinese art. *See* Chinese painting

Tranquility (Lang Jingshan), 79–82

"Tu'anhua de sheying/A Study of Designs by Photographs" (Zhang Jingwen), 48–49

"Tu'an sheying bisai" (Design photography competition), 50f

"Tu'an sheying tan" (Discussion of design photography) (Huang Jiezhi), 49–51

Tutankhamen's tomb, 17–18, 124–29, 241n32, 243n42

Ulysses (Joyce), 158–60, 251n47

the uncanny, 116, 239n10

"Urformen der Kunst" (Art Forms in Nature) (Blossfeldt), 47–48

U.S.A. trilogy (Dos Passos), 158–59, 161–63, 168–69, 187

Van Vechten, Carl, 187

Vertov, Dziga, 1, 151–55, 169, 175, 246n6

visuality, 61–110; comparative layouts and, 78–94; dematerialized bodies and objects and, 64, 77–78, 87–94; enlivenment (*shengdong*) and, 78–79, 90–94; gendering of images in, 91–94, 95f; Kandinsky's analysis of, 74–77, 87, 234n25; literary experimentation and, 20, 64–65, 77–78, 95–110, 236n51; pictorial surface (*huamian*) in, 55, 62,

71–78, 234n19; pure seeing of opaque surfaces in, 61–65, 232–33nn4–6, 233n10; in representations of urban spaces, 65–71; structures of containment in, 71–78

visual mass culture. *See* modernist aesthetics in Shanghai

Waara, Carrie, 227n42

Walls and Corners (Leng Can), 65–69, 71, 79

"Wandering Rocks" episode, *Ulysses* (Joyce), 251n47

Wang, S. T., 209

Wang Anshi, 222n11

Wang Jiezhi, 44–45

Wang Laosheng, 234n19

Wang Tao, 222n11

Wang Wei, 54, 222n10

Wang Yangming, 232n97

"Wanwu de nüxing biaoqing/There Is Always Some Feminine Charm in Things We See Every Day" (Expressions of the feminine in myriad things), 91–94

The Waste Land (Eliot), 158–61

Web, Virginia-Lee, 199

Weilaide Shanghai paomachang: Dasha yu penghu dengliang qiguan (The Shanghai racetrack of the future: High buildings and huts seen as equals), 176–79, PLATE 7

"Wei liangxing douzheng de gongju de Feizhou heiren mimi shehui" (African blacks' secret societies as tools in the struggle of the sexes) (Zhe Sheng), 197–98, 201

Wei Zhi, 195–97

Wei Zhitang, 211–12, 214, 219

Wen Fong, 254n72

"Wenxue duiye xianshi di zhuiqiu" (Literature's pursuit of the external world's reality) (Fu Lei), 1–3, 82–87, 100–101, 140, 148–55, 189–94. *See also* Fu Lei

"Wen ye minzu guanyu lianbu jingbu zui shimao zhuangshi de bijiao" (A comparison of civilized and savage races . . .), 199–201, 203, 259n45

Wenyi fengjing (Literary landscape), 101–2, 134–36

Williams, William Carlos, 244n53

Wilson, Edmund, 187

Wölfflin, Heinrich, 27, 62–64, 233nn5–6

"Wonders of the Soap Bubble," PLATE 1

Wood, Christopher S., 27

world texts, 158–61

Worringer, Wilhelm, 12, 32–33

writing. *See* literary modernism

"Written on the Back of a Photograph of Xiangguo Temple" (Shi Zhecun), 119–34, 139–40

Wujiao qianggen/Walls and Corners (Leng Can), 65–69, 71, 79

Wu Liande, 38–39, 227n47

"X guang xia de xinjian" (Letters under the X-ray), 96–97, 98f

Xiandai (*Les Contemporains*), 5–6, 10, 236n50, 238n6, 247n15; explorations of racial otherness in, 182; imagist poetry in, 134–36, 244–45nn53–54; modernist literature in, 101–10, 164–70; on Tutankhamen's tomb, 125, 241n32, 242n35; world texts in, 158–61, 251n47

"Xianweijing zhi xia tianran tu'an [Natural designs under the microscope]/ Color Photo-Micrographs," 46–47, PLATE 2

Xian yu jiao zhi yanjiu (A study in lines and corners) (Quruixi), 67–69, 71

Xie He: Six Principles of painting of, 54, 171–74, 254n72; on spirit resonance, 12

xiezhen (photography), 222n11

Xin Wenyi (*La nouvelle litterature*), 5, 101–2

"Xin yishu xingshi de tanqiu" (New art's explorations of form) (Kurahara), 152–53

"Xi zuo Hua qing ge" (A playful song concerning my young friend General Hua Jingding) (Du Fu), 214–15

Xu Chi, 10, 136–40

Xu Dexian, 35*f*

Xuhuan zhi ying (Phantasmal shadow), 131–32

Xu Shushan, 121–22, 124

Xu Weinan, 180–81, 194–95, 206–8

Yang Chengzhi, 219

Yao ethnicity, 211–12

Yaoshan yanshi (An amorous history of Yao Mountain), 211–12

Ye Lingfeng, 126, 242n35

"Yezonghui li e wuge ren" (Five in a nightclub) (Mu Shiying), 14, 18, 164–70, 182–83, 203, 253n63

Yifeng (Art wind), 103

Yijing (I Ching, or Book of changes), 138, 245n67

Ying/Limbs and Shadow, 132, 135*f*

Yishu (L'art), 150, 208, 248n20

"Yixiangpai de qige shiren" (Seven poets of the imagist school) (Xu Chi), 136–40

Youyi (Tranquility) (Lang Jingshan), 79–82

Yuefi's tomb, 119–21

Yu Li, 260nn65–66

Zhang Dongsun, 239n9

Zhang Hui'an, 131, 141

Zhang Jingwen, 48–49

Zhang Yanyuan, 30

Zhao Jiabi, 20, 170; on montage narration, 161–63, 251–52nn45–47; on racial otherness, 187–89, 193–94, 205

zhaoxiang (to photograph), 9–10, 223n13

Zheng Banqiao, 37

Zhenxiang huabao (The true record), 17

Zhe Sheng, 197–98, 201

"'Zhibian' bushi 'zhimin'" (Developing the borders is not colonialism) (Yu Li), 260nn65–66

Zhibian yuekan (Border development monthly), 211–12, 260nn65–66

zhiguai writing (record of the strange), 259n49

Zhou Duo, 238n6

Zhuge Liang, 212

Zola, Émile, 56

Zong Baihua, 4, 7–8, 37–38; on Chinese ink saturation, 34; on Eastern and Western pictorial practices, 18–19, 25–34, 59, 225n32, 230n79; on enlivenment and abstraction, 28–34, 44, 47, 59, 61; on interwoven lines and design, 74; on patterns, 50; on transparency of photography, 19

Zou Boping, 223n14